Students and External Readers	Staff
DATE DUE FOR RETURN	D/
13.MAR85	

The Garden of Love
in Tuscan Art
of the Early Renaissance

The Garden of Love
in Tuscan Art
of the Early Renaissance

Paul F. Watson

Philadelphia
The Art Alliance Press
London: Associated University Presses

Associated University Presses, Inc.
Cranbury, New Jersey 08512

Associated University Presses
Magdalen House
136–148 Tooley Street
London SE1 2TT, England

Library of Congress Cataloging in Publication Data

Watson, Paul F 1940–
 The garden of love in Tuscan art of the early Renaissance.

 Bibliography : p.
 Includes index.
 1. Painting, Italian—Italy—Tuscany. 2. Painting, Renaissance—
Italy—Tuscany. 3. Garden of love in art.
I. Title.
ND619.T9W37 759.5′5 75-33476
ISBN 0-87982-019-5

PRINTED IN THE UNITED STATES OF AMERICA

To Liz

Contents

Illustrations

Acknowledgments

The Garden of Love is a secular theme in Italian art of the late Middle Ages and the early Renaissance that hitherto has not received the careful study it deserves. I hope this book will serve two purposes: to improve our understanding of the Garden of Love; and to encourage discussion, debate, and further discoveries in secular art of the fourteenth and fifteenth centuries.

My interest in the Garden of Love quickened at Yale University, where I wrote my doctoral dissertation on the iconographic sources of Florentine cassone painting. I owe much to Professor Charles Seymour, Jr., who directed my research, encouraged me to make some of my findings public, and was kind enough to summarize some of my observations in his recent catalogue of early Italian paintings in the Yale University Art Gallery. Much is also owed to several who read that dissertation, including Sheldon Nodelman and Rab Hatfield.

The research for this book, and the dissertation preceding it, was undertaken at many institutions. Thanks go to the courteous staffs of the Kunsthistorisches Institute in Florence, the British Museum and the Warburg Institute in London, the Frick Art Reference Library in New York, and the Library of the Philadelphia Museum of Art. I have enjoyed looking at manuscripts in the Biblioteca Marciana in Venice, the Biblioteca Laurenziana in Florence, and the Bibliothèque nationale in Paris. Among many museum curators answering queries were Michael Kauffmann of the Victoria and Albert Museum, London; Cynthia Carter of the Metropolitan Museum of Art; and Miss Elizabeth Chase, formerly Docent of the Yale University Art Gallery. The Canada Council and the Subcommittee on Faculty Awards of the University of Pennsylvania subsidized important phases of my research abroad.

It is a delight to acknowledge my debts to colleagues and students at the University of Pennsylvania. An early version of this book was read as a paper to the Seminar on the Renaissance at the University of Pennsylvania; Roland Frye, Werner Gundersheimer, and Humphrey Tonkin all offered valuable suggestions. I learned much from discussions with two doctoral candidates, Lygeia Fontaine of the Department of English, who has been unstinting of her Spenserian wit, and Roberta Favis of the Department of the History of Art, whose dissertation on Netherlandish Gardens

of Love deserves to see the light of day. Among my students great debts are outstanding to Susan Smith, Mary Banks Breckenridge Kocher, Amy Neff McNeary, Claudine Majzells, and Carolyn Diskant.

Three colleagues in the Department of the History of Art contributed more than I can say to the making of this book: Charles Minott, who offered his critical eye and iconographic acumen; Malcolm Campbell, who cheerfully gave of his knowledge of Renaissance and Baroque imagery, as well as his impeccable sense of historical logic and literary form; and above all, David Robb, Professor Emeritus of the History of Art, whose wisdom, learning, and support have been immensely encouraging.

A special word of thanks is directed to Jean Ingram, who dealt ably with all sorts of questions. Linda Safran's assistance with all manner of technical problems proved invaluable. I wish too to thank my editor, Mrs. Mathilde E. Finch, whose sensitivity and patience much improved my manuscript.

The best part of all is paying homage to several scholars, "donne gentili, coronate d'alloro," to paraphrase Giovanni Boccaccio: Ellen Callmann, who first suggested that I investigate the Garden of Love; Wendy Sheard, who always raised the right questions; Frances Smith, who asked about the relationship of art to poetry; and my colleague, Victoria Kirkham, who has opened my eyes to many things. The most patient muse is my wife, whom the dedication affectionately acknowledges.

I would also like to thank the following for permission to quote from books under copyright:

David Higham Associates Limited for permission to quote from Dorothy L. Sayers and Barbara Reynolds, translators, *The Divine Comedy* by Dante Alighieri, © 1949–1962 by Penguin Books Limited.

Penguin Books Limited for permission to quote from Harold Isbell, trans., *The Last Poets of Imperial Rome,* Copyright © Harold Isbell, 1971.

Philadelphia

16 November 1975

The Garden of Love
in Tuscan Art
of the Early Renaissance

1

Introduction: Thickets and Streams

THE nature of love could once be represented in art by nature itself, conceived as a pleasant garden sheltering people in love. This landscape of allegory played a major role in the development of secular art all over western Europe at the turn of the fifteenth century. In fact, it survived in northern Europe long after the generation of the Limbourg brothers and Jan van Eyck. Rubens in the seventeenth century, and Watteau in the eighteenth, continued to paint Gardens of Love. In Tuscany, during the shift from the late Middle Ages to the early Renaissance, the Garden of Love became an important theme, adorning all manner of works of art, most of which were commissioned for marriages. Its appearance followed shortly after the first flowering of Italian vernacular poetry, especially the amatory verse of Dante, Petrarch, and Boccaccio, in which allegorical gardens flourished. Despite such respectable cultural underpinnings, however, the Tuscan version of the Garden of Love proved to be remarkably short-lived. Emerging as a developed type late in the Trecento, it disappeared during the last half of the Quattrocento. No Italian counterpart of Rubens or Watteau ever revived it. Several questions, then, naturally follow: what constituted the Garden of Love in Tuscany? what texts explain its significance? what was its history, and why was its duration so brief?

Answering these questions is no simple task. The fundamental evidence lies in the works of art themselves, each of which is entangled in a thicket of minute controversies about dating and attribution. So thorny are these controversies that larger issues tend to fade into a remote distance. Yet, to push on with iconographical investigations while pushing away stylistic matters seems futile. Perhaps the best way to introduce the problems surrounding the Garden of Love, and thereby to penetrate the thicket, is to select one painting as a specific instance of the general type, examine the questions of content and style intrinsic to it, and from that experience deduce ways to approach the greater problems of meaning and duration.

The delights of the Garden of Love abound in a panel painting now in New Haven (pl. 1). In front of a range of gray mountains an extensive meadow sprinkled with flowers is divided at its center by a narrow, arched gate. The first garden at the left side contains a pavilion pitched beside a grove, while a splendid fountain splashes in the second. Above both gardens hovers Cupid. In the first he appears as a mischievous blindfolded boy aiming arrows at lovers below. In the next garden Cupid, now unblindfolded, receives the homage of lords, poets, and warriors. My provisional title for this painting, *The Realms of Love*, acknowledges the presence of the god of love and emphasizes the importance of the garden as a stage for narrative, allegory, and mythology intricately combined.

Four people, a couple in love and a couple to guide them, move through these realms of love. They appear first at the pavilion (pl. 2). Blind Cupid has wounded a young man, clad entirely in red, who kneels before three women enthroned in the tent. At the right sits a lady gowned in cloth-of-gold, while at the left a second woman, glorious with golden rays, gazes gravely at the lover. Her long gown would originally have been of silver but now only the undercoat remains. Between these ladies of silver and gold sits the young man's beloved, wearing a robe once silver and still trimmed in blue. Like her suitor this lady has been pierced by Cupid's arrow. These four then pass through the central gate (pl. 3). The woman dressed in gold leads the way to the second Cupid, the lover gazes tenderly at his lady, and the silvered woman follows them through Cupid's gate. At the border of the second garden love abruptly ends (pl. 4). The beloved lady removes Love's arrow from her breast, abandons her lover, and departs in a chariot driven by the aureoled guide. Between love's inception and its conclusion unfolds an abundance of amatory experience—the bustle of a dance, the passions of the pagan gods, and the stately triumph of the god of love.

The viewer effortlessly follows the journey the lovers undertake through the gardens. The dance and the triumph, the most complex figural passages, flow smoothly across the surface of the panel. Brightly colored costumes of purple and red relieve the darker hues of grove and meadow. Touches of gold and silver flicker and glow, even in the painting's present battered state. Those who enact the allegory are comely to behold and subtly characterized: witness the tender glances dancing lovers exchange in the left-hand garden and the muted sorrow shared by all in the final episodes. Sly, humorous touches, such as pipers perched birdlike in the trees, give life to the *Realms of Love*.

The most pressing question raised by this painting is its content. Three detailed descriptions appearing in museum catalogues published from the time of the American Civil War to the present have successively isolated key aspects of the allegory. In 1860 James Jackson Jarves called the panel a "Triumph of Love" and described its events almost as a matrimonial novel:

the first garden sets the stage for a wedding ceremony, in which the bride sits with her parents in the pavilion receiving the groom's proposal; priests of love then escort the bridal pair to the next garden, where Charlemagne and Semiramis, together with three Florentine poets, Dante, Petrarch, and Boccaccio, participate in Cupid's triumph; finally the bride leaves her husband and escapes with a priest "appointed to conduct true lovers to the happy kingdom of eternal love."[1] In 1917 Osvald Sirén revised Jarves's account, chiefly by suppressing much of his Pre-Raphaelite detail. Sirén suggested that the initial scenes represent the first stages of love rather than a wedding. The "priests" and the "parents" become identical. They are a Titianesque pair, *Amor sacro* and *Amor profano*. It is the former, so distinguished by her golden rays, who escorts the beloved lady to a purer world. Sirén also stressed the importance of symbolic landscape by renaming the picture a "Garden of Love."[2] Writing in 1970, Charles Seymour drew attention once more to the figural events by calling the panel an "Allegory of Love." Although his description of its episodes follows Sirén's, his conclusions are much more generalized. The picture embodies a conflict between chaste and unchaste love, given form by the persistent dualism of its imagery. Important here are the contrasting Cupids, representing capricious and noble modes of love. Seymour's account remains deliberately tentative. He leaves as open questions, for example, the identities of the poets by the fountain and the women accompanying the couple from realm to realm.[3]

These descriptions all fall short because they treat the problem of content as an issue to be divorced from other questions. As a result the *Realms of Love* becomes detached from its proper historical context. The problem of content needs now to be considered first with questions of style, as a step to reconstructing its original context.

The *Realms of Love* was painted in Florence around 1440. Borrowings from the art of Gentile da Fabriano, Masolino, and Fra Angelico, as well as more distant echoes of the predellas of Masaccio and the reliefs of Ghiberti, sufficiently establish its place of origin and time of execution. In 1927 Richard Offner attributed the panel to Paolo di Stefano, called Schiavo (1396–1478), a follower of Masolino who gained some prominence in Florence during the 1430s. Offner advanced this attribution with some diffidence because little in Schiavo's documented work is as splendid as the *Realms of Love*.[4] Most authorities have accepted Offner's arguments, sometimes tepidly as a matter of convenience, sometimes enthusiastically but without rigorous examination. A minority continues to deny Schiavo's participation in the painting, using Offner's reservations as justification.[5]

A *Madonna of Humility* in the Fitzwilliam Museum should dispel doubts about the authorship of the *Realms of Love* (pl. 5). Nearly fifty years ago Offner recognized that this altarpiece bears the stamp of Schiavo's documented work of the 1430s. Citing the painting quite briefly, he did not draw

attention to the remarkable paintings of the frame.[6] Such small figures as the Mary Magdalen, coolly gazing at the viewer, or Saint Francis gently examining his wounds, are akin to the lovers and dancers in the *Realms of Love* (pl. 6). Moreover, the crisp handling of detail in the frame differs sharply from the uninspired execution of the larger Virgin and Child. In the predella Adam and Eve stand before trees intertwined to form a grove exactly like that in the first garden of the amatory allegory (pl. 7). As in the secular painting, shafts of wit lighten this religious narrative. Rarely was Eve shown as greedy as she appears here, and rarely were lilies so saucily placed. There can be little doubt that the painter of the *Realms of Love* also did the ancillary panels of the *Madonna of Humility*. The differences between the central panel and the frame may mean that Paolo Schiavo employed a shop assistant more talented than he was, an unsung Leonardo to his Verrocchio. The altarpiece may also demonstrate that, like many masters of the Quattrocento, Paolo Schiavo was simply at his best when working on a small scale. On balance, the latter view seems much more plausible than the former. Furthermore, common figural types and shared quirks of drawing firmly link the large and small panels of the Cambridge *Madonna*. The *Realms of Love* is Paolo Schiavo's.

Resolving the question of attribution begins to shed light on the content of the *Realms of Love*. By profession Paolo Schiavo was a painter of frescoes and altarpieces for churches and convents. For him the panel now in New Haven would have been an occasional piece in both senses of that term, an infrequent secular painting and a picture commissioned for a particular event. As the long proportions of the panel indicate, the *Realms of Love* originally formed the front of a cassone, or bridal chest. It would have been one of a pair of cassoni commissioned for a wedding to house the bride's trousseau. Long ago the chests were dismembered and separated, so that no evidence in the form of heraldry (like the escutcheons between Adam and Eve in Schiavo's altarpiece) survives to show which families commissioned the *Realms of Love* or when the wedding took place. Stylistic evidence, however, indicates that the companion panel to the amatory allegory survives.

In 1928 Roberto Longhi ascribed to Paolo Schiavo a cassone panel depicting the story of Callisto, then in Amsterdam and now in Springfield, Massachusetts (pl. 8). Clearly this must be by the same artist responsible for the Cambridge *Madonna* and the *Realms of Love*. Like those panels, it can be dated around 1440.[7] It is the only other secular painting by Schiavo to come to light. A casual glance at both cassone panels reveals a common figural scale as well as shared conventions of landscape and narrative. Although not enough evidence has been presented to prove Seymour's claim that the *Myth of Callisto* and the *Realms of Love* once formed a pair,[8] the mythology obviously deserves closer inspection.

In painting the *Myth of Callisto,* Paolo Schiavo adhered closely to the tale of seduction, punishment, and transformations told by Ovid in the *Metamorphoses.* At the left Diana and seven of her nymphs pursue their prey over rocky mountains (pl. 9). Flying through the heavens above, kingly Jupiter catches sight of one of Diana's maidens, Callisto, who has retired to rest after the hunt in a forest. Jupiter swiftly disguises himself as Diana, enters the grove, and then rapes the nymph in his own proper guise. Callisto flees to the wilderness in shame, only to be summoned back to nymphean society by the true Diana, charmingly imperious in her chariot. Now Callisto's troubles begin in earnest (pl. 10). Her pregnancy comes to light when Diana compels her to strip and bathe with the other nymphs. After Diana angrily expels Callisto from her company, she delivers a baby, Arcas, whom she nurses in solitude. Juno then exacts her revenge by changing poor Callisto into a bear. Many years later Jupiter transforms Callisto and her son, who is about to slay her, into the constellations that shine brightly at the extreme right of Paolo Schiavo's panel. Jupiter's generosity only provokes Juno's wrath. Her chariot cresting the waves, she commands Oceanus never to permit Ursa Major and Ursa Minor to rest in his waters.[9]

The *Myth of Callisto* yields an unexpected clue to one of the mysteries of the *Realms of Love.* Paolo Schiavo consistently depicts Diana as a comely blond woman, clad in a loosely fitting, double-girdled robe derived ultimately from classical art. The other nymphs, as well as the music-making angels in the Cambridge *Madonna,* wear similar costumes. An aureole of golden rays establishes Diana's divinity, just as symbolic light sanctifies the Virgin in the altarpiece. Midway through the cassone panel Diana rides in a chariot drawn by white stags, as she brandishes a longbow as a sign of sovereignty. The same radiant figure appears in the concluding episodes of the *Realms of Love,* riding in a stag-drawn chariot away from Cupid's kingdom (pl. 4). She also follows the lovers through the gate marking the center of the panel and sits beside the heroine in the pavilion. One of the key figures of the *Realms of Love,* then, is neither a priest of true love nor *Amor sacro,* but the goddess Diana herself.[10]

The incursion of the goddess of chastity into Cupid's territory comes as a surprise. It implies that the *Realms of Love* must reflect ideas more arcane than those commonly associated with cassone painting. Recognizing the panel's sophistication was Edgar Wind, who in a lecture delivered at Yale University in 1941 proposed an elaborate Neoplatonic program. Wind argued that the painting presented opposites reconciled, a theme that he was to elaborate with other materials in later publications.[11] If the dating of ca. 1440 for the painting is correct, however, then it seems misleading to interpret it using ideas fashionable a generation later at the time of Botticelli. A quite different intellectual context for the panel was proposed by Frank Jewett Mather in 1907. He claimed, without elaboration, that the painting's literary

source was a poem of the fourteenth century, the *Amorosa Visione* by Gio-
vanni Boccaccio.[12] A swift perusal of that text suggests that Mather must have
recognized affinities between the complexities of the cassone panel and the
ornate imagery of medieval poetry. The *Amorosa Visione*, unfortunately,
cannot be the source of the *Realms of Love*, because Diana appears nowhere
in it.

Another way of finding a context for the *Realms of Love* is to compare
its elements with the conventions of contemporary secular art. In an essay
on relationships between early Renaissance painting and poetry published in
1928, Ezio Levi observed that the chief figural acts of the panel, the dance
and the triumph, were stock motifs in Florentine cassone painting.[13] A few
years later Raimond Van Marle stressed the iconographic importance of
another visual commonplace, the garden. In the second volume of his *Ico-
nographie de l'art profane*, published in 1932, Van Marle singled out the
Realms of Love as the most important example of the Garden of Love. Simply
by listing other instances of the type, Van Marle helped put the panel into
its essential context.[14]

A brief paragraph in the *Iconographie de l'art profane* still remains the
standard description of the Garden of Love. In defining the type, Van Marle
distinguished between naturalistic images of love-making in gardens, gallantly
characterized as "les rapports entre les deux sexes,"[15] and allegorical repre-
sentations of love. As "une sorte de pays du rêve d'Amour, avec une signi-
fication abstraite," the Garden of Love pertains to allegory. Van Marle's
examples of the Garden included a few Italian pictures, chiefly cassone panels
and other types of painted furniture, and several early Netherlandish engrav-
ings. Touching on the question of literary sources, Van Marle suggested that
the Garden of Love came from a French allegory of the thirteenth century,
the second part of the *Roman de la Rose*. He argued more emphatically that
the true source of the secular garden was a religious type, the Madonna of
the Rose Garden. Parenthetically, Schiavo's Madonna seated in a flowery
meadow abbreviates this type.

A critical revision of Van Marle's description is long overdue. Forty years
of intermittent scholarship have brought forth more examples of the Garden of
Love than Van Marle was aware of. Several of the Italian paintings that he
listed, on the other hand, do not represent the Garden of Love. Factual errors
of this sort appear everywhere: no garden for lovers, for example, can be
found in the second part of the *Roman de la Rose*. More serious than these
slips were Van Marle's fundamental assumptions. To make a rigid separation
of allegorical and naturalistic representations of love in late medieval art is
to make distinctions where none were intended. Nor does it always follow
that secular iconography must necessarily depend on religious types or that
a visual commonplace must derive from a single literary text. Most im-
portant, Van Marle's account was simply too short to give history its due.

We never learn how a French text could influence Italian paintings or if the Madonna of the Rose Garden actually preceded the Garden of Love in time. As a result, the "signification abstraite" of which Van Marle spoke never is apparent.[16]

If the delights of the Garden of Love abound in the *Realms of Love*, then the problems peculiar to that cassone panel ought to be resolved after the general type is properly understood. Left unresolved, however, are important issues, including the role of pictorial commonplaces, the uses of textual sources, and the relevance of religious themes. A tangled thicket surrounds the *Realms of Love*. Beyond that thicket lies a void awaiting exploration.

Perhaps the only way out of the thicket is to change metaphors. Once E. H. Gombrich casually noted that the Garden of Love belongs to "a broad stream of tradition."[17] His chance fluvial image yields useful analogies. A stream, after all, must begin in one place and end in another. Beginnings may be a single source or banks spongy with many springs. Streams run swiftly, and sometimes slowly. Frequently they meander and on occasion they dry up. Often streams mingle to form wider currents.

The history of the Garden of Love is truly like a flowing stream. Rather than a single broad stream of tradition, it represents the confluence of many currents. Perhaps the first in time is a tradition of literature, understood as poetry describing allegorical gardens dedicated to love, a tradition beginning with Latin texts from classical antiquity, continuing with allegories of the high Middle Ages, and concluding with Italian writings of the Trecento. From that current emerges a sense of the "signification abstraite" of the Garden of Love. Running parallel to the current of poetic tradition is the development of erotic art in western Europe during the thirteenth and fourteenth centuries. Here two distinct streams can be charted. One pertains to "les rapports entre les deux sexes," confined to small and useful objects, the medieval ancestors of Renaissance cassoni. Another has to do with immovable gardens, a common motif of palace decoration in medieval Florence. In both cases a pithy language of symbols rapidly develops. Yet another current, as Van Marle suspected, is the iconography of Christian art, where landscapes with figures denoting the powers of love did indeed flourish during the fourteenth century, but not necessarily in connection with the cult of the Virgin. Although all these streams run parallel with each other in the Trecento, they do not quite merge.

In the Quattrocento a broad stream suddenly forms. Gardens with lovers become a pervasive symbol of the nature of love, chiefly in painted furniture commissioned for marriages. The dominant type is the Garden of Love, the "pays du rêve d'Amour" that Van Marle described, at whose center lies a great marble fountain. Coinciding with this allegorical landscape are simpler gardens, usually verdant meadows, connoting the joys of love and the grace of Venus. Both simple gardens and elaborate ones crop up in unexpected places

as the symbolic setting of narratives based on classical authors such as Ovid, and on medieval writers such as Petrarch and Boccaccio, and the authors of Scripture. The Garden of Love could even adorn the sylvan realms of Diana herself.

When the stream of tradition forming the Garden of Love is thoroughly explored, we shall return to its most splendid embodiment, the *Realms of Love*. Its relationship with the *Myth of Callisto* and the conclusions made thus far hint at a paradox, that the garden of love here becomes a place where choices are made in favor of chastity. Accordingly, the *Realms of Love* may ultimately suggest why the Garden of Love disappeared in Tuscany.

2

Poets by a Fountain

BESIDE the fountain in the *Realms of Love* stand three men, dressed in long red robes, crowned with wreaths of laurel, and displaying books as attributes. Like saints in an altarpiece, they discourse on Cupid their god (pl. 3). The image brings to mind Ovid's defense of his art, "We poets are a band more fitted than the rest for love."[1] To us the poetic band also signals that any study of the Garden of Love must begin with studies of amorous literature. This is a field almost too luxuriant. A poetic association of the pleasures of making love with the charms of cultivated landscape surely goes back to the Song of Solomon and the *Iliad*, at least. Fortunately for historians of art, innumerable historians of literature have ably studied allegorical landscapes in ancient and medieval poetry. Chief among these are C. S. Lewis, Ernst Robert Curtius, and A. Bartlett Giammatti.[2] Thanks to that critical triad, we easily apprehend why the poetic one in the picture gathers by a fountain. Poets of love, more than others, naturally belong in a place fit for love. Cupid's garden corresponds to a poetic commonplace, or *topos*, that recurs perennially in amorous literature of classical antiquity and the Middle Ages.

An ornate allegorical landscape, shaped by the poetic conventions of the ancient world, adorns an *Epithalamium for the Emperor Honorius*, written by the Latin poet Claudian in 398. When Cupid hears the laments of Honorius, who has fallen in love, he flies eastward from Rome to pass on the news to his mother, who resides at Cyprus:

> A mountain casts its shadow over the western
> end of Cyprus: it faces Pharos and the mouths
> of the Nile; nothing can violate it. No man
> has ever climbed its slopes; it never has
> > frost; the winds and
> the clouds do not attack its cliffs. It was
> > made for

25

pleasure and is a shrine to Venus. The climate
never changes; the seasons are always the same;
it enjoys the grandeur of an eternal spring.
The slopes become a level plain surrounded by
a golden hedge which guards the meadows from
 the world. . . .
The enclosed land is bright with flowers,
though the only gardener is Zephyr; no bird
may enter its peaceful groves until the goddess
herself approves the quality of its singing.
Those which please her are admitted, the
 others leave.
The very leaves on the trees live only for love
and every tree comes to know the power of love.
Palm bends to mate with palm; poplar sighs for
 poplar;
plane whispers to plane; alder whispers to alder.
There are two fountains: one sweet, the other
 bitter.
One has honey mixed with its water, the other is
poisoned. It is in these two streams that Cupid
dips his arrows. Cupid's thousand brothers with
 their
quivers play on the banks of those streams. To-
 gether
they are like Cupid both in age and appearance.
They are the sons of nymphs while Cupid is the one
son of Venus. All things are subject to his bow.
From the stars of heaven to the lowest of men,
There is no one who cannot know the sting of
 love.
Other gods also live within this enclosure.
Unfettered Licence and mercurial Anger,
wine soaked Sleeplessness, innocent Fears, the
 Pallor
that is the lover's badge, trembling Audacity,
pleasant Fear, fickle Pleasure and the lovers'
 Vows
who play in every passing breeze. And among them
there is always Youth closing Age out of the grove.[3]

To one side of the meadow that Claudian describes stands the palace of
Venus, wrought of gold and many precious stones, where the Graces assist
the goddess at her toilet. Here Venus agrees to come to the emperor's aid.

Claudian gracefully weaves together standard amatory images of classical
Greek and Latin poetry. Cupid's thousand brothers, for example, recall the
myriad Erotes populating one of the fictive murals described by Philostratus
the Elder in the *Imagines*.[4] The twin fountains where Cupid dips his arrows
elaborate upon the arrows of gold and lead that Ovid gives the god of
love in the opening episodes of the *Metamorphoses*.[5]

A similar eclecticism shaped the topography of Claudian's garden in

Cyprus. That pleasant place recalls ideal landscapes from the age of Augustus. In Book 6 of the *Aeneid*, for example, Virgil depicts a landscape for lovers consigned to the Underworld:

> They came to the Fields of Mourning,
> So called, where those whom cruel love had
> wasted
> Hid in secluded pathways, under myrtle,
> And even in death were anxious.[6]

Virgil's anxious lovers were to become Claudian's "innocent Fears." The *lugentes campi* of Virgil's Underworld are symbolically controlled since myrtle belongs to the goddess of love. They almost become allegorical landscapes, in which dark secluded pathways accord with the perturbed spirits who dwell beside them, such as unhappy Dido. Virgil further contrasts the dismal place reserved for impassioned lovers with the Fields of Elysium, shaded by laurel: "happy places, the joyful dwelling, / The lovely greenery of the groves of the blessed."[7] Here dwell virtuous heroes, such as Achilles and Anchises, father of Aeneas. Four centuries after Virgil, however, Claudian made the realm of Venus into an Elysium, not a Field of Mourning. The transfer may be explained, as Curtius has suggested, by the commentaries that Servius wrote on the *Aeneid* in the fourth century. From Virgil's line "locos laetos et amoena virecta," Servius argued that Elysium is a *locus amoenus*, a pleasing place suitable for love, an association resting on a pun where "amoenus" follows "amor."[8] Perhaps Claudian remembered the enchanting verses of another poet of the age of Augustus, Tibullus:

> It will be Venus herself . . .
> who will lead me along the way to the Elysian
> fields
> where song and dance go on forever, and over-
> head, curving,
> and fluting and falling, song from the delicate
> throats of birds.
> The fields, untilled, will bear trees of a cinna-
> mon sweetness,
> and roses cover the earth and fill the air with
> their scent. . . .
> And here are those whom death robbed of both life
> and lover,
> Their mark a wreath of myrtle laid lightly on the
> hair.[9]

It was Tibullus who found a *locus amoenus* for lovers in the Underworld, a place where senses still find easy gratification. Like his contemporary Virgil, Tibullus carefully selected plants for this realm of love: roses were flowers proper to Venus, while in antiquity cinnamon pertained to her cult.[10]

Claudian's garden of Venus is much more than an artful mélange of Augustan images. His description establishes a convincing geography, wherein walls enclose plains, hills, groves, and fountains. That landscape, much more extensive than Elysium, is like the Underworld in epic poetry, a digression. The *Epithalamium* begins in Rome and in Rome it must conclude. The digressive garden becomes an enchanted place where extraordinary events habitually happen. Spring never ends. The garden gives perpetual refuge to the joys and sorrows that all lovers feel, here allegorized into pleasant Fear and fickle Pleasure. In painting an ideal landscape modeled upon Virgil and Tibullus, Claudian also established the prototype for gardens of love in medieval literature.[11]

From twelfth-century France comes an allegorical landscape imitating antique models, but in a highly unclassical way. It occurs as an instructive digression partway through an ironical treatise on love, *De arte honesta amandi* by Andreas Capellanus. A nobleman tells a lady with whom he wants to make love about a delightful place where every kind of fruitful and fragrant tree grows. This garden is circular in plan and concentric in organization. At its center lies Amoenitas, a fair country rich in trees, soft lawns, and singing birds. A spring full of fish and a tall tree bearing every sort of fruit mark the center of Amoenitas. Encircling that delightful place is Humiditas, a dreary swamp soggy from too many springs. A horrid desert, rich only in thorns, Ariditas, forms the outermost circle. Andreas Capellanus does not neglect to spell out the moral significance of the landscape. Amoenitas is the paradise of worthy lovers, meaning ladies who have observed the true rules of love and have been properly receptive to their suitors. To Humiditas go promiscuous ladies, too eager to disperse their favors. Only virgins may inhabit Ariditas. The key to Andreas's allegory lies in his Latin nomenclature. "Amoenitas" clearly derives from Virgil's "amoena virecta." Its elaboration into realms desirable and regrettable more closely follows the Christian afterworld of Heaven, Purgatory, and Hell. Similarly, the garden's concentric plan recalls both the medieval image of the universe and the circular labyrinths worked into the pavements of Romanesque and Gothic churches. Andreas Capellanus transforms classical landscapes into medieval gardens.[12]

Less dryly humorous is the setting of the first part of the *Roman de la Rose*, which Guillaume de Lorris composed around 1220 in northern France. At the beginning of the poem, the narrator says that he will recount events that happened to him in a dream when he was young. On a lovely morning in May the Dreamer rises from his bed, strays through a meadow beside a river, and comes upon a garden enclosed by high battlemented walls. "Pourtraictures" of ten enemies of love, among them Poverty, Envy, and Old Age, are painted on the curtain wall. Idleness, a lovely girl guarding the postern gate, admits the Dreamer into the garden:

> I thought the place
> Was truly a terrestrial paradise,
> For so delightful was the scenery
> That it looked heavenly; it seemed to me
> A better place than Eden for delight
> So much the orchard did my senses please.[13]

In a meadow bounded by a grove dance many lovers, such as Youth, Wealth, and Liberality, all vassals of Sir Mirth, or Deduit, whose garden this is. After the dance the Dreamer wanders to a more secret part of the garden, especially rich with flowers, deer, and rabbits. Here a tree shades the Well of Narcissus and in that crystal spring the Dreamer spies an image of a rose. As he stares enchanted into the Well, the God of Love shoots him. Ten arrows transform the Dreamer into a Lover.

The opening episodes of the *Roman de la Rose* make an allegory of the inception of love. A lack of serious business makes love possible, according to medieval poetic theory; hence Idleness lets the Dreamer into the garden. The pleasures of the senses, represented by the garden, then nurture love. Finally, the power of sight enflames passion, just as a man falls in love when he sees the beauty of a fair lady. The causal sequence implicit in the initial actions of the poem is spelled out later in the text, when the lover is chastised:

> For had not Idleness conducted you
> Into the Garden that is called Delight
> The God of Love had never seen you there.[14]

The speaker here is Reason, always a foe of Love.

Italian poetry of the thirteenth and fourteenth centuries followed French and Latin precedents in creating allegorical landscapes. French texts circulated widely: a translation of the first part of the *Roman de la Rose*, entitled *Il Fiore*, is sometimes attributed to Dante; Petrarch once owned a manuscript of the entire work in its original tongue.[15] Andreas Capellanus's realm of Amoenitas became "Dilettanza" in a Tuscan version of his treatise made during the thirteenth century.[16] In Italy, moreover, ancient authors remained as important as more recent writers. Virgil served as Dante's guide to the underworld, while Claudian was hailed as the first Florentine poet throughout the Trecento.[17]

Although Dante wrote on love, his *Divina Commedia* has little room for digressive gardens of delight. In Limbo virtuous pagans dwell in a noble castle enclosing a green meadow, an echo of Virgil's pleasant Elysium. The Earthly Paradise crowning Mount Purgatory combines traditional descriptions of the garden of Eden with elements of amorous imagery. The final image of Paradise is a Rose, once sacred to Venus. However, Dante's "love that moves the sun and all the other stars" has little to do with the passions allegorized by Guillaume de Lorris.[18] Indeed, Dante's contribution to an

Italian landscape of love is really much less than those made by his successors, Petrarch and Boccaccio, and by his predecessor, Brunetto Latini.

Shortly after 1262 Brunetto Latini began, but never completed, the *Tesoretto*, a poem in Tuscan in which he portrayed himself as embarked on a pilgrimage. Toward the end of the journey he enters a most puzzling country: "As it was in May time, after traversing vales and mounts, woods, groves, and bridges, I came to a fine meadow, sprinkled with flowers on every side. Now it seemed like a circle to me, now like a square; now its air was obscured, now clear and shining; now I saw great crowds, now I saw no one. . . . Thus on every side I saw both joy and sorrow."[19] The meadow Brunetto sees is ambiguous because it belongs to the God of Love, whom the poet follows Guillaume de Lorris in calling "Piacere" or Delight. Fear, Desire, Hope, and Love are this lord's henchmen. Brunetto's landscape initially seems like an allegory in the dry manner of Andreas Capellanus on Claudian's characterization of fickle Pleasure, "et non secura Voluptas." In fact, the poet claims later on that the condition of being in love, which means seeking out pleasure, implies constant mutability within the soul.

Even the narrative structure of the *Tesoretto* speaks of the joys and sorrows of love. The poem begins with the author's entry into the vast realm of "Natura" and a subsequent exploration of its appanages, including the fair land of Virtue. Along the way the narrator is told to stay away from "Piacere," but curiosity drives him on. After traversing Virtue's country, he stumbles into the mutable garden of Pleasure. Only after learning about the true nature of love from the fabled author of the *Art of Love*, "Ovidio maggiore," can Brunetto escape the garden. As soon as he extricates himself, he confesses and does penance for his sin. Not only is the garden of love a digression, then; it is also highly dangerous. Like many medieval authors, Brunetto simultaneously extols the power of love and warns of its dangers. Such moralizing attitudes rarely were absent thereafter in Tuscan poetry.

Love as joy mixed with sorrow is the theme of the *Trionfo d'Amore*, which Petrarch first wrote between 1338 and 1343, and then revised thirty years later toward the end of his life. In the first three cantos, the poet witnesses a lengthy procession of lovers, famed in mythology and history, who follow the triumphal chariot of Cupid. In the fourth canto, the god transports his prisoners to his mother's home beyond the Aegean sea:

> The softest and gentlest of all isles
> Warmed by the sun or watered by the sea;
> And hidden in the midst a shadowy hill
> With fragrances so sweet and streams so clear
> That from the heart they banish manly
> thoughts. . . .
> And the whole valley echoed with the songs
> Of waters and of birds, and all its swards
> Were white and green and red and yellow
> and perse.[20]

Petrarch reaches back nearly a millennium to recapture the enchanted island of Cyprus that Claudian described in the *Epithalamium for Honorius*. Like Brunetto Latini, however, Petrarch moralizes his allegorical landscape in a fashion utterly different from Claudian's gentle ironies. The garden becomes a snare: manly thoughts are banished, idleness casts an evil spell, and mad confusion finally reigns. Petrarch's garden demonstrates his conception of love as "certain sorrows and uncertain joys."[21]

Joy, however, seems to outweigh sorrow in the landscapes of love enlivening the works of Giovanni Boccaccio. In the *Decameron*, for example, the gardens where seven ladies and three men recount a hundred tales constitute a refuge from Florence, which was turned into a charnel house during the Black Death of 1348. First the company retreats to a delightful villa in the country; a second villa graced by a walled garden is the setting of the third day of storytelling; on the sixth day the company assembles in the spacious Valley of the Ladies. Boccaccio enumerates the features of the garden, setting the stage for the third day in such detail that he gives the game away. Its high walls enclose fragrant orchards, freshly cut lawns, and a marble fountain carved with reliefs. The storytellers wander into an enchanted place much like the garden that belongs to Sir Mirth in the *Roman de la Rose*. When they agree that "if Paradise were constructed here on earth, it was inconceivable that it would take another form,"[22] they recognize the garden as a *locus amoenus*. The framing gardens of the *Decameron* thus become appropriate symbols for a book ostensibly written to give aid and diversion to ladies in love.[23]

Other symbolic gardens enrich the romances and allegories in Tuscan that Boccaccio composed in the decade preceding the Black Death. His *Amorosa Visione*, for example, has two gardens, one fictive, the other real. Connecting them is a vision of love beheld in a dream. A lady guides the narrator to a noble castle whose great hall is painted with frescoes. One of these represents the Triumph of Cupid: the god sits at the center, surrounded by crowds of lovers; on either side unfold famous scenes of love, such as Apollo's pursuit of Daphne, or Dido's suicide. Defining the fresco's pictorial space is an extensive meadow, gay with flowers and trees. Boccaccio here looks back to the realm of Amoenitas that Andreas Capellanus explored. From the castle where art depicts gardens the narrator strolls to a real garden, small in scale and made verdant by a great fountain. This well is a multistoried construction of red marble culminating in three conjoined bronze figures, women bearing urns from which water splashes. In this second garden the poet meets fair women and gains his heart's desire. Amoenitas merges with the Garden of Sir Mirth, now Italianized, for the red fountain surely must be based on Nicola Pisano's ornate Fontana Maggiore at Perugia.[24]

Yet another garden, familiar to English readers as the model used by Chaucer for the setting of his *Parlement of Fowles*, is a digressive landscape from the *Teseida*, which Boccaccio wrote shortly before 1343. One of the

heroes of that epic, the knight Palemone, prays that his patron, Venus, may aid him in love. Instantly personified, his prayer soars to Mount Cithaeron and enters a garden "leafy and beautiful, full of the greenest plants, fresh lawns, and every new flower."[25] Myrtles and pines form groves sacred to Venus. Rabbits scamper here and there; bucks and hinds gracefully leap. Within the garden, which Loveliness guards, stroll Gentility, Courtesy, and Delight. To one side Idleness and Reverie observe Cupid and his daughter, Pleasure, tempering arrows in a fountain. Adorning the garden is the temple of Venus, made conspicuous by a statue of Priapus placed atop it. Within the shrine reclines the goddess herself, nude save for a thin purple veil. Bacchus and Ceres regale her. In Boccaccio's *Teseida* the amatory personifications enumerated by Guillaume de Lorris have now migrated to the enchanted landscape mapped by Claudian. Medieval and classical gardens here become one.

Boccaccio spelled out the "signification abstraite" of the garden at length in the commentary that he appended to the *Teseida*. We learn that the meadow, grove, and fountain symbolize the workings of the concupiscent appetite, which the poet personifies as the goddess of love:

> Venus is double, since by the first we say and ought to mean every proper and licit desire, such as the desire to acquire a wife in order to have children, and desires similar to this; and we do not speak of this Venus here. The second Venus is that by which every lasciviousness is desired, and who is commonly called the "goddess of love." And of this Venus the author depicts the temple and the other things surrounding it.[26]

Boccaccio thus agrees with Claudian's view that the garden is made for pleasure and is a shrine to Venus. He goes on to explain why this should be so. For example, myrtles belong to Venus not only because the ancient poets said so, but also because their odor naturally excites sexual desire. Similarly, pines must abound here because their fruit, when eaten, has a miraculous power to provoke sexual appetites.[27] Although Boccaccio modestly claims that he is repeating common medical lore, he undoubtedly recalled Ovid's praise of "the nuts that the sharp-leaved pine tree bears" as an aphrodisiac in the *Art of Love*.[28] More generally, a grove spurs love on for reasons both psychological and physiological. It provides a dark and private place in which to make love, while its coolness further tempers the blood to make the body fit for the service of Venus. In other words, the garden appeals to all the senses, preparing body and mind for the act of love.[29]

Boccaccio consistently follows his own poetic doctrines in the plot of the *Teseida*. The woman whom Palemone loves, Princess Emilia, attracts his love when he sees her on a morning in spring gathering roses in a pleasant garden.[30] Similarly, Palemone's rival in love, Arcita, from time to time retires to lament his passion in a grove watered by springs, fragrant with

young trees, and loud with the songs of birds—a sylvan garden that we learn is sacred to Priapus.[31] At the end of the epic Palemone finally wins Emilia. They marry, have a large, glittering wedding feast, and retreat to the nuptial bed. The next morning, the narrator notes:

> It was rumored that Venus, long before the day was bright, seven times had plunged into the amorous font, where only rarely does one become a good fisherman with profit.[32]

The gloss does not neglect to say that the image signifies that Palemone and Emilia made love seven times that night.[33]

Ribald images of this sort enliven a story from the *Comedia delle ninfe fiorentine*, a pastoral that Boccaccio wrote around 1341. The narrator is Agapes, a young and comely nymph forced by her parents to wed a hideous old man. This is how she describes her wedding night: "O nymphs, now have compassion for my travails. After he had drawn out the night with foolishness, he tried to cultivate the gardens of Venus, but in vain, attempting to till those fields (which did indeed desire gracious seed) with his old plowshare."[34] Venus takes pity on Agapes. Taking her to Mount Cithaeron, she leads the nymph to a fountain sacred to Cupid. As they bathe together in its cool waters, Agapes notices a youth watching them from the shelter of a myrtle grove. Venus then summons this timid observer, Apiros, from his hiding place, gives him Agapes' hand, and guides them both to a secret spot, "painted with many flowers."[35] Here Cupid transfixes them with golden arrows to predict that the fields of Venus will be properly tilled at last.

Agapes is one of seven nymphs dedicated to Venus in the *Comedia delle ninfe fiorentine* who conduct a symposium on the nature of love. They gather in a charming meadow, complete with trees, flowers, and a fountain, on the feast day of Venus in May. The nymphs tell of their loves to Ameto, a rude hunter who has never heard of Cupid and has no idea what love is. The stories the nymphs tell rapidly enlighten him. When Agapes and her companions have finished, swans suddenly fill the air, heralding the advent of Venus. Quickly the nymphs strip off Ameto's rough garb and plunge him into the fountain. From its waters he emerges cleansed and purified: "it seemed that he who once had the soul of a brute now became a man . . . the nymphs who had once appealed more to his eye than to his mind now pleased his mind more than his eye."[36] Boccaccio here draws on Christian imagery to show that love is noble. Ameto's immersion is like a catechumen's baptism, while the nymphs represent the seven virtues. Even Venus becomes like the triune god, because she no longer "is that Venus whom foolish folk call goddess of their disordered lusts, but that other Venus from whom true and just and holy loves descend to mortals."[37] The garden that in the *Teseida* symbolizes wanton desires becomes here, in the *Comedia delle ninfe*

fiorentine, the setting for allegories of noble love. In fact, Boccaccio's *Comedia* demonstrates the range of meaning that a garden could enjoy in medieval literature.

Enough has been said, for the time being, about the stream of literary tradition. The poets standing beside Cupid's fountain in the *Realms of Love* (pl. 3) clearly signal the importance of Trecento poetry for Quattrocento paintings. Like Petrarch and Boccaccio, Paolo Schiavo celebrates amorous passions with images drawn from nature. The very shape of his garden, a meadow painted with many flowers, interrupted by dark stands of trees, and ennobled by a marble well, closely follows the imagined landscapes of medieval poetry. Mather's intuitive assumption that the complicated narrative patterns of the *Realms of Love* depend ultimately on the bewildering sequences of Trecento allegory can easily find justification.

Nevertheless, the time is not quite right for a ransacking of texts to account for the iconography of Schiavo's panel. More than poems went into the making of the Garden of Love. Paintings such as the *Realms of Love* came from busy workshops whose proprietors habitually depended on pattern-drawings, model-books, and other visual stereotypes, to give form to ideas. Between Trecento texts and Quattrocento images intervened the customs of a craft tradition.[38]

3

Lovers without Gardens

A T the time when Petrarch and Boccaccio were writing about gardens symbolizing love, craftsmen in Italy were also creating lively images depicting the art of love. Their work adorned small objects designed for everyday use, such as combs and chests, as well as mirrors and manuscripts—all "portable property," as Mr. Micawber would say. This craft art constitutes a second stream of tradition flowing parallel to poetic developments. Its vocabulary substituted visual stereotypes for the prolix phrases of the poets. What lovers were to do in Quattrocento representations of the Garden of Love chiefly followed from the precedents established by Trecento erotic art.

Illustrated manuscripts of the texts discussed in the preceding chapter initially define the role of visual stereotypes in the fourteenth century. An instance is a codex of Brunetto Latini's *Tesoretto*, which an unknown Florentine draughtsman illustrated around 1310. A *bas-de-page* drawing shows how Brunetto discovered the realm of "Piacere" (pl. 11). Here the artist renders that ambiguous country as a void quite unlike the solid world of wood and mountain where the narrator stands. The draughtsman attains firmer ground in the next folio, where he indicates how Brunetto came upon the lord of Piacere himself (pl. 12). Closely following the text above, he represents Piacere as a nude, winged, and blindfolded Cupid.[1] There is, however, one striking departure from Brunetto's verses. According to the poet, Piacere stands upright in a "chaiere," the Old French word for a throne. The scribe copying the manuscript illustrated here corrupted this into "carriera," meaning that Piacere stands in a chariot or even rides on horseback.[2] The artist cuts through linguistic confusion by showing the god as standing upon a slender column. For the textual description he substitutes a stock image of medieval art, the convention for a pagan idol. Stereotype thus interferes with literal illustration. Yet the formula also endows the

drawing with an apposite significance in harmony with the purposes of the *Tesoretto*. By turning Piacere into a heathen idol, the artist emphasizes the poet's teaching that sensual indulgence is really a secular heresy.

A similar pattern of illustration and emendation governs the opening pages of a manuscript of Boccaccio's *Decameron*. The scribe was Giovanni d'Agnolo Capponi, a Florentine merchant and politician who died in 1392. The tightly fitting costumes worn by the young men in the frontispiece (pl. 13) suggest that Capponi had his manuscript illustrated about two decades before his death.[3] As one would expect from Florentine art during the 1370s, the drawings of the Capponi *Decameron* describe nature more fully than the illustrations to the *Tesoretto*. In the frontispiece a grassy lawn beside a villa forms a charming place for the *novellatori* to tell their tales. If we read Boccaccio's text, however, it becomes evident once more that the artist was not wholly committed to literal illustration. The conspicuous marble fountain, for example, appears in the symbolic garden Boccaccio described at the outset of the Third Day, well on in the *Decameron*, but not in the landscape setting of the Introduction. Furthermore, the artist embellishes the fountain with a tiny nude idol raised on a colonnette. This figure, of course, is Venus.[4] A tree beside her fountain and another shading the scepter-wielding queen presiding over the storytellers are both pines, whose fruit spurs the labors of Venus's servants. It is almost as if Capponi's illustrator had anticipated the findings of modern literary criticism. His intention, no doubt, simply was to present the general content of the *Decameron*, as stated in the Preface on the adjoining folio: "in these tales will be found a variety of cases of love, bitter as well as pleasing."[5]

Two more drawings enliven the Preface to Capponi's *Decameron* (pl. 14). In an initial Boccaccio himself reads from his book to an engaging congregation of ladies while Cupid aims his arrows above. The artist wittily paraphrases the text, in which the author announces that he once suffered from love and has written his hundred tales to "provide succour and diversion for the ladies, but only those who are in love."[6] The drawing inserted above the rubric seems less immediately related to the Preface. Among broccolilike trees ride two couples corresponding neither in number, rank, nor activity to the storytellers described in the text and depicted in the frontispiece opposite. Since they are plainly characterized as lovers, however, they must exemplify once more the general theme of the *Decameron*. Like the illustrator of the *Tesoretto*, Capponi's draughtsman makes his point by falling back on a familiar stereotype, here represented by a French ivory carving of the early fourteenth century (pl. 15). Like the cavaliers of the manuscript, a lady and a lord make love as they ride to the chase.[7]

The drawings of the *Decameron* and the *Tesoretto* indicate patterns of pictorial custom in the Trecento. Easily understood symbols count for more than painstakingly literal illustration. Some symbolic images clearly derive

from textual sources and traditions, such as the cupids in Plates 12 and 14. Others, such as the amorous riders, seem to enjoy an existence virtually independent of texts. Stereotyped imagery of this sort, however, dominates erotic art of the Trecento.

The French ivory showing lovers at a chase serves also to introduce the problems of amorous imagery in the Middle Ages. The ivory is called a stereotype because it is one of hundreds of such objects produced in Europe during the thirteenth and fourteenth centuries. Most have been conveniently assembled by Raimond Koechlin in his corpus of French Gothic ivories published over half a century ago.[8] Koechlin sorted out the principal themes of secular ivories, arguing that they illustrated no particular literary text. In his *Iconographie de l'art profane*, Van Marle went so far as to suggest that the ivory carving here illustrated and its cognates were intended simply as genre scenes based somehow on contemporary life.[9] Symbolic content was restored only recently by a historian of literature, D. W. Robertson. In his delightful *Preface to Chaucer* of 1962, he asserted that the riders in our ivory have nothing to do with everyday activities. Instead, they typify the very nature of love itself. Robertson justifies that claim in two ways, by demonstrating that the image has an internal logic, and also by adducing external evidence, chiefly manuscript illuminations and the commonplace utterances of theologians and poets.[10] In attempting to shed light on literary problems, Robertson adopts the methods of an art historian. Perhaps the time has come for art historians to reciprocate.

The drawings of Giovanni Capponi's *Decameron* suggest that the symbolic imagery Robertson decoded was an international one, as well understood in Florence as in London. We should now listen for Tuscan inflections of a medieval *lingua franca*. An instructive analogy lies in the *dolce stil novo*, lyric poetry of the thirteenth and fourteenth centuries, which developed in Italy under the influence of Provençal verse. Unlike the prolix allegories of Brunetto or Boccaccio, its imagery is tersely allusive. When the Duecento poet Guido Guinizelli sings "I wish to praise my lady and liken her to the rose and the lily,"[11] he condenses thereby the general image of a *locus amoenus*. Guido's synecdoche brings to mind a well-worn biblical image, "I am the rose of Sharon and the lily of the valleys" (Song of Solomon, 2:1). In similar fashion the drawing of lovers riding through a grove speaks a clipped symbolic language, which now awaits a more systematic exploration.

An ancestor of the amorous riders in the Capponi *Decameron* appears in the figural decorations of a chest made in Florence at the beginning of the Trecento (pl. 16). Its physical size and proportions help establish that early dating; a chest much like it, for example, was depicted by Giotto in the *Annunciation to St. Anne* in the Arena Chapel, painted around 1305. The long, loosely fitting costumes sported by the figures in its gessoed reliefs further suggest that it was made around the time of Giotto's Paduan activi-

ties.[12] Three scenes, once gay in red and blue, are repeated on the sides and top of the chest. On either side of a small fountain set in front of a leafy tree stand a man holding a falcon and a crowned woman who displays a flower. A second image shows the gentleman on horseback with his bird, while in the third the queenly lady brandishes a whip as she rides her steed. We are to imagine an amatory narrative in which the man and the lady are lovers who rendezvous in a garden, much like Tristan and Iseult in Arthurian legends, or the happy lovers who ride to the kingdom of Amoenitas in Andreas Capellanus's amatory parable. The gessoed reliefs seem also like primitive versions of the activities and landscapes of the Capponi *Decameron*.

The reliefs also take meaning from the commonplaces of Trecento art and literature. Elegantly dressed figures on horseback, for example, customarily denote nobility: a woman on a charger displaying a many-tailed whip represents "Magnificenza" in a Florentine illumination of the 1330s,[13] while in Boccaccio's *Decameron* riding with a hawk often serves as a sign of aristocratic aspirations.[14] A couple riding to the hunt typifies the month of May, as the carvings of Nicola Pisano's Fontana Maggiore of the late thirteenth century indicate. Here the association is particularly apt because springtime induces love-making; to cite one instance, the narrator of the *Tesoretto* enters the realm of Piacere in "Calendimaggio."[15] The general narrative pattern of lovers at the chase and in a garden alludes to one of the hoariest conceits in Western culture, namely, that the art of making love is like a chase. Andreas Capellanus calls love-making a kind of hunting, following Ovid, who, in the *Art of Love*, sings of "the gatherings of women, fit occasions for hunting."[16] In abbreviated form, then, the gesso reliefs demonstrate how the arts of venery are allied to the service of Venus.

Symbolic stereotypes invade all types of portable property during the Trecento. From the middle decades of the century comes a gittern, now in the Untermyer Collection of the Metropolitan Museum.[17] On the front a charming maiden crouching amid foliage shows how to use the instrument (pl. 17). On the back appears a couple standing beneath a tree (pl. 18), much like the amorous hunters of the early Trecento chest. In the wood carving, however, a bright-eyed Cupid appears in the greenery to proclaim an allegory of love. Accompanying animals further elucidate its content. As a dog sniffs at the lady's long gown, the gentleman displays a hawk, while a stag crouches at the lovers' feet. The woman's pet seems far too small for the exertions of the hunt. Its significance is explained by a Florentine miniature of the 1330s in which a dog and a mirror serve to identify a sumptuously clad woman as "Corporale Bellezza" (pl. 19). The accompanying text goes on to castigate beauty as a vain thing.[18] Both the illuminator and the wood-carver drew on a bawdy medieval tradition in which small furry beasts allude to female pudenda.[19] In similar fashion, birds represent the male organ.

"Uccello" meant the penis as well as a bird in medieval Italian, an association that goes back to ancient times and that also crops up in the *Decameron* in a charming story where the nightingale was made to sing.[20] The carver of the Untermyer gittern alludes to that virile tradition by making the gentleman hold his bird as he touches his purse, which is strategically placed.

The stag beneath our carnal lovers enjoys a more delicate significance than the bird and the dog. In poetry of the thirteenth and fourteenth centuries, a deer becomes a metaphor for the lover who submissively offers himself to his lady. A poet of the *dolce stil novo*, Lapo Gianni, likens the state of being in love to the outcome of a chase: "When I heard your noble spirit, then as the deer in truth towards the hunter turns, so do I in service to you, so that you may take pity on me."[21] Two familiar passages from the Bible further account for the stag's amorous credentials. "As the hart panteth after the water brooks, so panteth my soul after thee," sings King David (Psalms 42: 1). Even more to the point is Solomon's utterance: "The voice of my beloved! behold how he leapeth upon the mountains, skipping on the hills. My beloved is like a roe or a young hart" (Song of Solomon, 2: 8–9).[22] The stag in the gittern represents the inner state of the man, who becomes infatuated with the lady. As in most medieval writings on love, the woman clearly has the upper hand.

The images of the Untermyer instrument coincide with amatory stereotypes from the fourteenth century. The powerful allure of woman, for example, is amusingly set forth in an ivory carved in northern Italy during the last third of the Trecento. Under a spreading tree of vaguely beechlike species, a man kneels in submission to his lady (pl. 20). Diminutive servants, a squire and a maid, indicate that these must be high-born lovers. Above the gentleman hovers Cupid, who once held a bow, long since obliterated. Love's arrow penetrated the lady's breast; traces of its trajectory still remain. The carving allegorizes the inception of love. As the man, smitten by the lady's beauty, sinks to his knees, Cupid ensures that she will return his love. The nature of their amours we understand from the dogs, which whine and scratch at the tree-trunk, as if in frustration or anticipation.[23]

The Untermyer gittern brings together love and music. The same association appears in an Italian ivory comb from the early Trecento (pl. 21). Several couples here stand stiffly, to make an ungainly frieze, as they listen to musicians. One plays a stringed instrument much like the Untermyer gittern, while others make melody on an organ and a psaltery. Some of their listeners embrace each other with discretion. One young man, however, seems so affected by the music the woman plucking the psaltery makes that he emulates, or rather anticipates, the act of Chaucer's clerk Nicholas:

And prively he caughte hire by the queynte.
(Miller's Tale, 3276)

The notion that music is the food of love could not be more pungently expressed.[24]

The Italian comb belongs to a larger class of portable objects depicting typical acts of love. An elegant instance is a Parisian ivory from the early fourteenth century (pl. 22). In a garden reduced to clusters of trees gather three couples. On a bench at the right a youth armed with his bird chucks the chin of a girl who restrains yet another agitated lapdog. In the center a second youth kneels to receive a garland from his mistress. To the right a third maiden chucks the chin of her lover, who gracefully strokes her "quenyte." The ivory sets forth progressive stages of lovemaking, from a first proposal to its acceptance and subsequent mutual enjoyment.[25]

An Italian counterpart to the second motif of the Parisian ivory appears in a Tuscan drawing that can be dated to the early 1360s (pl. 23). At the upper right a maiden crowns her gallant with a chaplet; to the left a man crowns his lady. Below appears a most unerotic activity, a clash of mounted knights. The sheet of drawings belongs to a model-book, now in the Pierpont Morgan Library in New York. The book is given over entirely to secular themes—hunting scenes, labors of the months, putti at play, and acts of love, some of which are highly indelicate.[26] The model-book thus preserves invaluable evidence of iconographic patterns circulating in Italy at the time of Petrarch and Boccaccio. It also indicates which motifs were most popular, as well as suggesting how those motifs easily formed scenes and narratives.

The lovers crowning one another with garlands in the Morgan model-book could easily have been copied from an ivory like that shown in Plate 22. In the Trecento the motif would easily have been understood as a complicated amatory allegory, thanks to literary traditions. In a famous sonnet of the late Duecento, for example, Dante da Maiano posed a riddle to his poetic colleagues: "A fair woman, in gaining whose favor my heart takes pleasure, made me the gift of a green leafy garland; and charmingly did she so; and then I seemed to find myself clothed in a shift she had worn; then I made so bold as to embrace her. . . . I will not say what followed—she made me swear not to."[27] Dante Alighieri responded by arguing that: "the gift you first mentioned signified true desire, proceeding from merit or beauty, a desire that seldom comes to an end. As for the garment, be confident that this will be love."[28] The gift of the garland represented in the Morgan drawing symbolizes love's desire and love's consummation.

Sometimes the leaves of the Morgan model-book contain amatory motifs arranged in sequences, like the abbreviated narratives represented in contemporary ivories and chests. On folio 13, for example, the draughtsman depicts a dance where two couples follow music made by a youth playing a gittern; beneath the dancers a couple embraces (pl. 24). Overleaf a girl beats a tambourine to provide rhythms for the dance, which concludes with acrobatics (pl. 25). The next folio represents the lovers crowning one

another, whose meaning has just been deciphered. In other words, the gift of garlands follows after music and the dance in an amorous progression.

Narrative sequences sometimes follow in reverse order. On the reverse of folio 14 a young man kneels before a seated lady who has transfixed him with an arrow (pl. 26). Seen in isolation, the motif seems puzzling. Its significance becomes apparent, however, when the drawing is compared to a chest from Catalonia covered with leather reliefs (pl. 27). As in the Florentine chest showing lovers at the chase and by a fountain (pl. 16), three repeated images form a narrative: a knight kneels to receive a helmet from his lady; she crowns him with a garland; and she shoots her kneeling lover with an arrow. An inscription, MERCE SI VS PLAU or, in English, "Show mercy, if you please," presumably alludes to the knight's amorous plaints occasioned by his lady's archery but relieved by her gifts.[29] The Morgan drawing of the woman with transfixed lover can be read in an analogous way; first the man kneels in homage and then, overleaf, he gains his reward.

Another page from the Morgan model-book varies the motif of amorous archery (pl. 28). Here the draughtsman shows how a lady shoots her gallant who is characterized as charmingly diffident. This folio can be seen in conjunction with the drawing just analyzed, which depicts the consequences of the lady's act. An instructive analogue to it, however, is a German coffer from the early fourteenth century (pl. 29). On the left a woman armed with a bow punctures a complaisant youth with arrows, as in the Morgan drawing. To the right the man offers his heart pierced by love's arrows to his adversary. Inscriptions spell out the allegorical significance of this sequence: "Sent m . . . ov min herz ist wnt," cries the lover in the second panel, which is to say, "My heart is wounded."[30]

The motif of amorous archery becomes an allegory of the inception of love. We have seen that the chase alludes to courtship, and that Cupid is no mean archer. In the Morgan drawings and in craft objects, a woman usurps Cupid's role. The motif demonstrates the standard medieval theory about how love begins, namely that passion arises when a youth looks at a beautiful lady: "Love is a certain inborn suffering derived from the sight of and excessive meditation upon the beauty of the opposite sex," observes Andreas Capellanus.[31] More precisely, men fall in love when the rays from a lovely woman's fine eyes pierce the heart. A classic expression of the doctrine is the verse of a thirteenth-century Sicilian poet, Giacomo da Lentini:

> Love is a desire that comes from the heart
> from abundance of a great contentment; and
> first the eyes generate love, and the
> heart gives it nutriment.[32]

The penetrating rays of a lady's eyes can be likened to the swift arrows of

Cupid. Here is how Petrarch bemoans his amorous fate: "Amor found me when I was totally disarmed, with the way from my eyes to my heart quite open, for they are the doors and halls of tears. Hence to my mind, it did him no honor to wound me with his arrow when I was in that state."[33] In the Trecento, then, complicated theories on the genesis of love become easily epitomized by a simple visual motif.

The list of amatory motifs, or visual stereotypes, adorning portable property could go on seemingly without end. Enough has now been said to permit some preliminary conclusions. The drawings of the Morgan model-book prove that no distinction between naturalistic and allegorical images of love actually existed in the fourteenth century. Instead, the images all speak a pithy symbolic language. What we have just seen further demonstrates that manuscript illuminators, ivory carvers, and other craftsmen borrowed from each other indiscriminately, and that their stock images could be combined again and again in ever-changing sequences. Pictorial custom developed a logic of its own. In general, the imagery of love-making falls into three broad categories, all based on courtship. The first includes the inception of love, whether by Cupid's arrows or the rays of a lady's eyes. The second encompasses the progress of love, represented by the offering of garlands or flowers. Both overlap in the hunt of love, which involves inception and pursuit. The third category simply presents the state of being in love. In all instances we recognize that love involves conventional behavior of a courtly sort, which implies cheerfully sexual pleasures. Most of the motifs celebrate the allure of women, no doubt a gallant compliment to the fourteenth-century ladies who possessed chests, coffers, and combs.

To look forward once more to the *Realms of Love*: it now becomes obvious that several episodes of that cassone panel, such as the dance or the triumph of Cupid, have their ancestry in erotic art of the Trecento. Yet there remains one crucial difference between amatory images of the fifteenth and fourteenth centuries. Lovers in the Trecento pirouette on empty stages, except in a few manuscript illustrations. To find gardens like those Paolo Schiavo was to paint, we must jettison portable property for the moment and turn to frescoes in Trecento palaces and churches.

4

Frescoed Gardens in Florentine Palaces

WHEN the narrators of Boccaccio's *Decameron* first arrive at their villa outside Florence, they take delight in chambers decorated with joyous paintings, "liete dipinture."[1] The pictures they saw were probably of the type that Boccaccio's contemporary Franco Sacchetti describes in a story from his *Trecento Novelle*. Once Messer Piero Brunelleschi commissioned the painter Bartolo Gioggi to fresco a room in his palace, specifying that "among the trees above there should be many birds."[2] Bartolo, however, included only a handful of birds and wryly told his disgruntled patron that the rest had flown when Piero left the windows open! Bartolo Gioggi, incidentally, actually was a *dipintore di camera* recorded in Florence around 1330.[3]

A fresco from a chamber like those Boccaccio and Sacchetti describe still survives in the Museo di San Marco in Florence (pl. 30). It is one of several paintings salvaged from medieval palaces in Florence before their demolition in the late nineteenth century. The decorative pattern is very simple: pointed arches divide the wall space into bays large enough to shelter a leafy tree, a hedge bright with flowers, and several birds foraging for food.[4] This frescoed garden belongs to a very old tradition in the Mediterranean world, represented in the fourteenth century by the painted chambers of the Pope's palace at Avignon, in the twelfth by the mosaics of King Roger's Room at Palermo, and in the first by the garden landscapes of the House of Livia at Primaporta.[5]

This Florentine fresco and others of its type could also correspond to the symbolic groves and gardens prominent in allegorical poetry of the Trecento. These gardens without lovers served to symbolize the joys and perils of love. As such, they form a precedent for the Garden of Love.

Evidence for a symbolic reading of decorative landscapes can be found in the painted chambers of the Palazzo Davanzati, the only completely preserved

example of a medieval patrician's house to survive in Florence. The palace first belonged to the Davizzi family, which came into some prominence late in the Duecento, prospered in the Trecento, and finally died out in the Cinquecento. Though no documents exist to record the building's history, architectural historians agree that it belongs to the fourteenth century. Recently published opinions date it toward the middle of the century, or even as early as 1330.[6]

Inside the Palazzo Davanzati are four brightly decorated rooms, all painted during the fourteenth century. The Sala dei Papagalli, so called because of an avian motif adorning its walls (pl. 31), and the Sala delle Impannate, named after its fictive wall hangings (pl. 32), share the same pictorial formula. Slender colonnettes supporting an elaborate architrave divide the upper part of the wall into bays painted red and blue where trees grow. Supporting the colonnade is a marble wall covered by painted tapestries. A detail of the Sala delle Impannate (pl. 33) reveals that the colonnettes separating tree from tree are also fountains. From each capital sprout animal heads, somewhat lupine in appearance, that water pots of lilies. Behind the trees runs a hedge full of flowers. In the Sala dei Papagalli the hydraulic columns water bunches of white roses. In both chambers birds perch in the trees.

A slightly different garden brightens the Sala dei Pavoni (pl. 34). Here Gothic arches spring from corbels that have no visible means of support. As a consequence the hedge behind the arcade becomes continuous. As in the other rooms it is set behind verdant trees, from which now hang escutcheons. Once more, a fictive tapestry masks the wall. It stops, however, about six inches short of the floor to reveal the trunks of the shield-bearing trees and the flowery hedge. Like Shakespeare's Polonius, this garden lurks behind an arras. The room takes its name from the chief denizens of the garden, large peacocks pecking at the trees (pl. 35). Herons and songbirds add to the delights of the Sala dei Pavoni.

A fourth garden appears in the so-called Camera Nuziale, which I prefer to call the Sala della Donna del Verzù after the narrative that is its chief ornament. Here the arcade changes to a series of barrel vaults supported by pairs of Corinthian columns, all rendered in an elaborately illusionistic perspective (pl. 36). Clearly this was the most important room of the palace. Between the columns appear scenes from the amatory narrative that gives the chamber its name. Behind the figures enacting it unfolds the familiar configuration of garden and grove. Again the tapestry stops short of the floor to unveil a hidden garden. Particularly delightful is the fireplace corner where the garden extends well under the mantelpiece—surely a primrose path to a bonfire not quite everlasting.

Over sixty years ago Walter Bombe first published these frescoed gardens, identified the subject of the amatory scenes in the principal room, and pro-

posed a date for the palace's decoration.[7] Conspicuous in the building and its paintings are the coupled arms of the Davizzi and the Alberti, as Bombe observed. In Plate 36, for example, the Alberti escutcheon is carved on the left-hand corbel supporting the fireplace, while the Davizzi arms appear opposite. Davizzi and Alberti shields hang side by side in the Sala dei Pavoni (pl. 34). The blazonry denotes a marriage between an Alberti girl and a Davizzi youth. Using Passerini's genealogy of the Alberti family, Bombe discovered a wedding of 1395, when Catelana di Alberto degli Alberti married Francesco di Tommaso Davizzi.[8] Bombe concluded that the decorations of the Palazzo Davanzati must date from the end of the Trecento.

It cannot be denied that the frescoed gardens of the palace once celebrated a matrimonial union. The paintings themselves document that thesis in abundant detail. The heraldic decorations of the Sala dei Pavoni, for example, include the Alberti and Davizzi arms repeated four times. The shields of other Florentine families hang here, including those of the Strozzi, the Bardi, and the Capponi. It seems as if the Davizzi were celebrating not only a particular marriage but also all their matrimonial alliances that securely connected them with the patriciate of Trecento Florence.[9] Another matrimonial image involves the birds of the Sala dei Pavoni. Peacocks belong to Juno, the guardian of wedding vows, as Paolo Schiavo's *Myth of Callisto* was to demonstrate (pl. 10). We may safely presume that some male member of the Davizzi family had reread Ovid before summoning a *pittore di camera* to fresco the trees above with many birds.[10] It is not by accident that a peacock stands guard over the Alberti shield in the Sala dei Pavoni (pl. 34).

Renewed inspection of all the rooms in the Palazzo Davanzati indicates that its array of plants was not at all haphazardly chosen. In every room roses both white and red fill up the hedges. Lilies bloom in the Sala delle Impannate. As we know from Ovidian mythology, the Christian tradition, and the *dolce stil novo*, roses and lilies pertain to ladies especially well beloved. Schiavo's *Madonna of Humility* shows the ecclesiastical applications of a well-worn floral symbolism (pl. 5). Furthermore, the tiny fountains in two of the rooms make those lilies and roses blossom. What better augury for a new bride than an image of fertility?

Not only the flowers but the trees of the frescoed gardens live only for love as those of Claudian's Cyprus do. Although it would be rash to insist on the painter's botanical expertise, he did take care to distinguish tree from tree, varying the color of the fruit and sometimes altering the foliage. Some trees bear yellow fruit, some red, some orange. Odoriferous trees laden with lemons, apples, and oranges resemble those which give delight to the narrators of the *Decameron*. Several trees have shiny green leaves, sometimes short, sometimes long, resembling myrtles or laurel. Some clearly are pines, bristling with long needles and heavy with cones. In Plate 34, for example, the Davizzi arms hang from a tree bearing that fruit which spurs on the followers

of Venus. Fittingly enough, the pine is next to a myrtlelike tree bearing the Alberti arms and guarded, as we have seen, by Juno's peacock.

The frescoed gardens of the Palazzo Davanzati symbolize love but leave little room for lovers. An exception is the Sala della Donna del Verzù (pl. 36), where the garden forms the setting for a narrative cycle. Horses placidly amble through this locus amoenus, castles interrupt it, lovers rendezvous beside it. At first sight this fourth garden seems merely a pervasive decorative mannerism, almost in conflict with the human actors. It is, however, profoundly symbolic and thus necessary to our understanding of the frescoed tale.

The frescoes represent the romance of the Chateleine de Vergy. First appearing in France late in the thirteenth century, it was rendered into Tuscan verse as a popular ballad early in the fourteenth century. The paintings of the Palazzo Davanzati follow the turns and twists of the Tuscan ballad quite faithfully, as Bombe observed many years ago.[11] The protagonists are a French knight, Messer Guglielmo, who is in love with the fair Lady of Vergy, or the "Donna del Verzù" as the ballad-monger puts it. The lady, in turn, is a kinswoman of Guernieri, Duke of Burgundy, who is also Messer Guglielmo's feudal lord. The story begins with the amours of the knight and his lady at Vergy (pl. 37). Unfortunately, the Duchess of Burgundy conceives a passion for the knight, attempts to seduce him while he is playing chess, is rebuffed, and then denounces Guglielmo to her husband (pl. 38). The duke compels his vassal to reveal his clandestine affair. When word of Guglielmo's true love finally reaches the duchess, she confronts the Donna del Verzù with her knowledge. Chagrined, the lady promptly slays herself; her lover follows suit; Duke Guernieri hacks off his wife's head (pl. 39). What begins as a romantic idyll ends in murderous mayhem.

A playful logic connects the frescoed garden with the narrative. In Tuscan dialect the French place name "Vergy" becomes "Verzù," quite close to *verziere*, a meadow. Moreover, the castle of Verzù is itself set amid a pleasant lawn. When the action begins, the knight goes to the lady's castle to make love in secret. The lady's pet dog serves as a guardian, keeping an eye out for visitors to the castle and making sure that no spies hide inside it. If the coast is clear, Messer Guglielmo and the Lady meet in the castle garden:

> And here the lovers, now full of happiness, come together with all their desire; and lustful hot friendship makes each one cry "O my love!" as they kiss and further embrace.[12]

In other words, the garden fittingly symbolizes erotic longings. In the opening episodes of the fresco cycle (pl. 37), the knight on horseback appears to the lady, who indicates her castle in the next bay, which her dog defends. As in

the text, the elements of lovers, lapdog, and garden resemble the stock images of secular art (pls. 16, 18). If the story begins in this garden, to which the knight returns twice before he meets his end, it seems only proper to extend the garden throughout the fresco cycle. It becomes a continuous visual symbol for the passions animating the Donna del Verzù, the Duchess of Burgundy, and Messer Guglielmo.

As in the other painted chambers of the Palazzo Davanzati, the details of the garden reveal its true purpose. Oranges, apples, lemons, and pine cones are its customary fruits. Singing birds populate the trees, as well as more predatory ones snapping at dragonflies. Sometimes a large cock-pheasant accompanies the amorous knight. In short, the garden telegraphs a constant message, that this is a story of love, just as the fleurs-de-lis adorning the barrel vaults proclaim that the story unfolds in faraway "Borgogna."

And yet there remains something unsettling about the choice of this story as a decoration for a marriage. After all, the protagonists fornicate, attempt adultery, and come to a bloody end. Moreover, the unknown author of the Italian version warns us of the tale's grimness right at the very beginning:

> O glorious Virgin, o chaste maiden, I wish to bring your grace to me, and I wish to tell in verse a new story to give an example to whoever wants to love, of a knight and a lady, of noble lineage and of high deeds— and how because of love each one died, and the great damage that followed therefrom.[13]

Even when we take into account the unromantic views of marriage current in medieval Florence, the story of the Donna del Verzù still seems an excessively cheerless admonition.

To understand the significance of this frescoed narrative, and by extension, to grasp what its garden setting implied, we must turn to the problem of when the paintings were actually executed. But there seems to be no question about dating. Walter Bombe, we recall, used heraldic evidence to date the frescoes around 1395. Bombe did imply, however, a difficulty by attributing the narrative cycle to a follower of Andrea Orcagna, whose activity ran from the 1340s to 1368—a generation before the Davizzi-Alberti wedding he cited.[14] Quite recently, Luciano Berti shrewdly observed that the frescoes reflect the dominant styles of the middle years of the Trecento—even though he retained Bombe's late dating.[15]

One reason that the narrative scenes have been placed so late comes from a misunderstanding of the text they illustrate. The ballad of the Donna del Verzù survives in two manuscripts, both made in the Quattrocento. Following the philologist Emil Lorenz, Bombe assumed that the manuscripts were of the fourteenth century, and that the poem was written by the Florentine Antonio Pucci, who did not die until 1390.[16] This attribution still appears

in modern art-historical studies of the frescoes, even though historians of literature have long since dropped the poem from Pucci's works, as well as determining that the original text must date from the 1330s.[17]

Positive evidence for the correct dating of the Sala della Donna del Verzù lies in the frescoes themselves. Although the paintings are much too battered and overpainted to permit the methods of connoisseurship to work with exactitude, the actors' costumes suggest an approximate time of execution.[18] The heroine and her enemy, the Duchess of Burgundy, wear simple gowns, tightly cut and distinguished by low necklines, sometimes cut on a circular pattern, sometimes a square one (pls. 37, 39). These fashions appear also in documented paintings from the middle years of the Trecento, such as Ambrogio Lorenzetti's *Good Government in the City* of 1338–1340, here represented by a famous detail (pl. 40). Some of Ambrogio's dancing maidens wear parti-colored dresses, divided vertically down the front, and bound by a girdle at the hips. The ladies in the concluding episodes of the Donna del Verzù sport similar fashions (pl. 39). Identical costumes can be found in dated Florentine paintings of the 1340s and 1350s, particularly in the work of Bernardo Daddi and Nardo di Cione.[19] Bernardo Daddi's knightly saints, splendid in close-fitting tunics and elegantly draped mantles, went to the same tailor, so to speak, as Messer Guglielmo.[20] Nowhere in the fresco cycle do the fashions popular in the last third of the Trecento appear. None of our tragic lovers is as wasp-waisted, for example, as the storytellers from the Capponi *Decameron* (pl. 13) or the couples of ivory carvings (pl. 20).

A flood of evidence further sweeps the Davanzati frescoes back to the mid-Trecento. The diaper pattern of the fictive tapestry in the Sala della Donna del Verzù can be likened to textiles depicted in frescoes and panels made early in the century.[21] It was also a favored formula for the golden ground of altarpieces of that time.[22] The complicated method of hanging tapestries in this room and the Sala dei Pavoni is demonstrated also in the setting of Bernardo Daddi's *Birth of the Virgin* in the Uffizi.[23] Even the spindly columns and mosaic-enriched architrave of the architecture sheltering the narrative cycle have close counterparts in a Florentine panel from the first half of the Trecento, now in Paris.[24]

It might be argued that the playful illusionism of the Davanzati frescoes bespeaks a late and sophisticated phase of fresco decoration. The perspectival systems deployed in the palace existed fully formed around 1300, however, in the frescoes of the Upper Church of San Francesco at Assisi, where painted tapestries also appear. Furthermore, the cycle that Taddeo Gaddi painted in the Baroncelli Chapel in S. Croce during the 1330s was an ingenious Florentine response to the illusionism of Assisi. One scene from that chapel, the *Betrothal of the Virgin* (pl. 41), strikingly resembles the formulas of the Palazzo Davanzati: tapestries mask marble walls, trees grow behind a

garden wall, singing birds fill the air with melody.[25] It seems only a short step now to the heraldically conceived decorations of private palaces.

Examining the frescoes of the Sala della Donna del Verzù leads to two conclusions. The decorative patterns of that room all go back to formulas current in the first half of the Trecento. The figural scenes indicate an approximate date of execution around the middle of the century. Both conclusions, however, conflict with Bombe's date of 1395.[26]

But there was a wedding between the Davizzi and the Alberti that has been overlooked. In the year 1350 a Davizzi youth, Paolo di Gherardo, married an Alberti girl, Lisa di Albertozzo. Much documentary evidence survives to show that this particular wedding was crucial to the fortunes of the Davizzi family.[27]

Lisa degli Alberti must have been a wonderful catch in 1350. Her father, Albertozzo di Lapo, was a personage of considerable prestige and great wealth. He died suddenly of the Black Death in the summer of 1348. His testament of 9 July of that year stipulated that large sums of his fortune were to be spent on good works, such as building the choir of S. Croce. Each of Albertozzo's three daughters was to receive a dowry of a thousand florins, a staggering sum for the early Trecento. Another clause specified that if his sons Lapo and Giovanni died without issue, then the girls' dowries would be doubled.[28] When Lisa wed Paolo Davizzi in 1350, she brought with her a thousand florins, and when her last surviving brother died childless in 1352, her dowry leaped to two thousand. The marriage also opened up bright prospects of alliances with the great families of Florence. Lisa's mother, for example, was the daughter of Messer Ottavio Brunelleschi, and her sisters, Bice and Francesca, married into the Gianfigliazzi and Albizzi families respectively. After 1350, it should be noted, the Davizzi enjoyed a sudden spurt of prosperity. In 1362 the family erected a chapel for themselves in their parish church of S. Trinita, no mean enterprise, and in 1371 Francesco Davizzi even had a tomb built within it.[29] Marriage alliances continued apace: in 1388 the family gave a daughter to the powerful clan of the Strozzi and, as we have seen, the matrimonial alliance with the Alberti was renewed in 1395.

The Davizzi-Alberti wedding of 1350 was undoubtedly of great importance to Paolo di Gherardo and his family. That date also suits perfectly the visual evidence of the narrative cycle in the Sala della Donna del Verzù. We may conclude, then, that sometime around 1350 the house of the Davizzi decided to commemorate a particularly felicitous marriage by commissioning a program of fresco decorations.

If this hypothesis is correct, the frescoes of the Davanzati palace coincide with the aftermath of the Black Death of 1348 in Florence. They are also close in time to the *Decameron*, which begins with a description of that

plague. At the close of the Third Day, given over to quiet ribald tales of love, the company elects a new king to preside over the following day. Filostrato then announces that tomorrow's tales will tell of love that ends unhappily. The company remain in their enchanted garden while two young people sing of the love of Messer Guglielmo and the Donna del Verzù.[30] In the book and in the palace, then, the story serves as a newly minted instance of the unhappy consequences of love.

When the story of the Donna del Verzù first appeared on the walls of the Palazzo Davanzati, the horrors of the Black Death were still a vivid memory. Lisa degli Alberti herself had witnessed the terrifying deaths of her father and a brother in the summer of 1348. In a way the pleasant gardens frescoed for her wedding must have been a welcome refuge from recent experiences. Yet death is the conclusion of the story of the Donna del Verzù. We may now understand that its appearance at the Palazzo Davanzati pertains to the prevailing climate of guilt and penance, which Millard Meiss has so judiciously reconstructed. At a time when the commune of Siena could destroy an antique statue of Venus out of fear and distrust, paintings setting forth the perils of love seem a fitting theme for palace walls.[31]

The story of the Donna del Verzù was probably intended as an edifying moral tale. As we have noted, the frescoes adhere closely to the text. We read that this is a story of love in which the protagonists observe all the rules codified by Ovid and Andreas Capellanus: the knight and his lady are of noble rank, they keep their love hidden, they pledge faith to one another. But they make the wrong choices. The lady resists many good offers of marriage in order to continue her affair. The hero's cryptic self-satisfaction only encourages the evil duchess to fall in love with him. From a proper observance of the rules follow fornication, attempted adultery, and mayhem. That point is made clear by the placement of the frescoes in the Davanzati palace. The concluding episodes of violence are juxtaposed to the opening scenes of love; conclusion and beginning flow together without caesura, linked by a continuous garden.

The frescoes of the Palazzo Davanzati lay bare the fundamental ambivalence of love in a way that erotic images on a much smaller scale, on ivories and chests, could not do. One might almost imagine some crusty elder of the Davizzi family escorting a new bride through the palace: "Look at these blooming lilies and roses in the Sala delle Impannate and the Sala dei Papagalli, and think of fecundity; observe the peacock-studded garden of the Sala dei Pavoni and consider the benefits of family life; then look carefully at the groves and hedges of the Sala della Donna del Verzù, and shun this mode of love, for it is dangerous."[32] In their own elliptical fashion the contrasting landscapes of that Florentine house correspond to Boccaccio's two Venuses, one inspiring licit desires, the other inciting wanton lust.

Frescoed gardens in Florentine palaces of the Trecento symbolized the nature of love. Undoubtedly they constitute a precedent for the Quattrocento Garden of Love. Their greenery is certainly much more abundant than the places where lovers congregate in contemporary ivories and manuscripts. Yet this palace tradition remains a delightful meandering stream that never quite fertilizes broader meadows. The Garden of Love springs from monumental frescoes enjoining not love, but penitence.

5

Gardens of Vanity

ADDEO Gaddi's *Betrothal of the Virgin* (pl. 41) reminds us that no rigid distinction between religious and secular imagery existed during the late Middle Ages. The fresco also touches on a point that Raimond Van Marle made years ago, that gardens in religious art formed the source of the Quattrocento Garden of Love. That argument now deserves scrutiny. Landscapes very much like a secular garden of love did indeed flourish in ecclesiastical art of the Trecento, but not in connection with the cult of the Virgin, as Van Marle suggested. Rather, they appear in monumental frescoes warning of the horrors of death, urging repentance as a way to salvation, and condemning love as a vain enterprise.

A garden representing the perils of love brightens an immense fresco in the Camposanto of Pisa (pl. 42). Many disparate episodes of that painting elucidate a common theme, the grim equality imposed by death. At the extreme left a cavalcade of aristocrats stumbles upon the rotting corpses of a king, a magistrate, and a naked commoner. As they recoil in horror an aged hermit displaying a scroll urges them to repent. In the mountains above more recluses demonstrate where true salvation lies in a landscape of barrenness and quietude. To the right of the cavalcade lie the cadavers of merchants, scholars, friars, nuns, and fair ladies. Above, angels and demons struggle for the tiny souls of the dead. Through the sky swoops Death, a hideous crone armed with a scythe. Ironically, she turns away from a pack of beggars, who beg her to release them from this life, in order to assail another company of noblefolk, ensconced in a grove at the extreme right.

Before proceeding to explore this new garden, we need to weigh two important questions of iconography and dating. The fresco's conventional title, "The Triumph of Death," should be discarded. It is, after all, a nineteenth-century appellation borrowed from Petrarch's *Trionfo della Morte,* written shortly after the great plague of 1348. Petrarch briefly describes the

advent of Death, a fell woman dressed in black, whose vast army of the dead fills up a verdant plain; most of the allegory, however, treats of the demise of Laura, the poet's beloved. Little of this has much to do with what is represented at Pisa. Even more misleading is the concept of Triumph, which implies a processional order, as in Petrarch's poem, or a hieratic one, as in Boccaccio's *Amorosa Visione*. Neither ordering corresponds to the diffuse episodic structure of the Pisan fresco. To an observer of the Trecento, the painting would have presented an image of death itself, or rather an exposition of the nature of death—its universality, its horror, its capriciousness, and most important, the possibility of salvation from it. Perhaps the undramatic but comprehensive *Exposition of Death* may serve as an apt and descriptive title.

The second issue involves the dating and authorship of this *Exposition of Death*, together with its companion frescoes representing the *Last Judgment*, *Inferno*, and *Thebaid*. If this book had been written a decade ago, the frescoes would have been assigned to the Pisan master Francesco Traini with a date of execution shortly after the Black Death of 1348.[1] Yet scholarship in the past few years has overturned both assumptions. Joseph Polzer, for example, has argued that the frescoes date from 1327, thanks to extrinsic historical evidence.[2] A more complex chain of reasoning, forged chiefly by Miklos Boskovits, locates the Pisan paintings in the early 1340s.[3] Quite recently Luciano Bellosi has argued that the *Exposition of Death* was painted around 1340, according to the carefully weighed evidence of costume. Bellosi attributes this fresco and its pendants to a Florentine painter whose practical jokes enliven the *Decameron*, Buffalmacco.[4] An emerging scholarly consensus, then, places the frescoes well before the Black Death, and well before Petrarch's *Trionfo della Morte*. The consequences of this new chronology for the content of the *Exposition of Death* and for the garden that is its chief ornament now need to be considered.

The garden differs sharply from the scenes of suffering nearby (pl. 43). It consists of several leafy trees, their boughs abundant with orange fruit, and a soft lawn unbounded by walls. The ensemble seems oddly flattened, like a textile pattern, in comparison with the solid, stony world at the left.[5] On a bench draped with a rich cloth, a lady plucks a psaltery while a man standing close-by to the right bows a viol. Between the musicians stands another woman, hushing the viewer to silence. Music entrances a lord, so identified because he is the only man in the company wearing a hat; he bears a great falcon on his gloved hand. To the left putti inverting flaming torches hover above a couple seated on the bench. As the man strokes his hawk, the lady's dog playfully gnaws at her plump fingers.

The general significance of the garden scene is spelled out by a series of inscriptions set into the border beneath. Directly below the left-hand couple an angel unfolds a scroll inscribed with Tuscan verses:

Vain woman, why do you delight to go thus painted and adorned, so that you wish to please the world more than God? Ah, abandon it! What a judgment awaits you unless your heart incontinently turns to confess itself, often, of every sin.[6]

To the right of the angel a grinning skeleton foretells a grim fate: "O soul, why, why, do you not consider that Death will tear from you that vesture in which you feel corporeal delight through the power of the five senses?"[7] In the garden above, the revelers are in fact unaware of the advent of Death. Their garden is a sham refuge in contrast with the secure haven of the hermitage to the left.

These inscriptions signify that the company in the grove represents the sensual life, or corporeal delight (*corporal dilecto*). Singled out for special condemnation is the attractiveness of women. Both the particular instance and the general example are dangerous: pleasure is vain, transitory, and sinful. The company of revelers demonstrates the generic sin of *Cupiditas,* that willful love of the world which ignores the love owed to God.[8]

The first to study the garden was Giorgio Vasari in the sixteenth century. Aptly characterizing the landscape as a "bosco amenissimo," he saw that the people within it represent "all the degrees of temporal lords caught up in the pleasures of this world . . . seated in a flowery meadow beneath the shade of several orange trees."[9] Though Vasari may have overstressed the amatory aspects of the motif, as well as misreading some details, his description remains in sympathy with what his Trecento predecessor represented. It has rightly been accepted by most modern historians.[10]

Scholarship in the past century has focused on the classical sources of the garden scene. In 1881 Eduard Dobbert observed that the artist adapted the torch-bearing putti from a Roman sarcophagus that still remains in the Camposanto. He surmised that the borrowing implies both the power of love and the imminence of death.[11] Several years ago Erwin Panofsky presented a more sinister interpretation, in which the cupids become harbingers of Death who point out for her two likely victims, "an elegant young man and a handsome young lady unsuspectingly absorbed in one another."[12]

Rather less attention has been paid to the painter's use of contemporary secular art. To be sure, Dobbert recognized that the four noble persons seated on a bench correspond closely to the stereotypes of Gothic ivories, of which the comb illustrated in Plate 22 is an instructive instance.[13] It should now be pointed out that the demonstration of music's power, so subtly depicted here, belongs also to the erotic repertory of the early Trecento (pl. 21). The reliefs of the Untermyer gittern (pl. 18) explain the fresco painter's emphasis on falcons and a dog. Even the "bosco amenissimo" evokes the conventional landscapes of palace decoration. In particular, the way the painter at Pisa puts a tree directly behind the couple seated at the left in order to draw our attention to them is close to the narrative conventions in vogue at the Palazzo

Davanzati (pl. 38). Incidentally, a tree set behind the cavalcade at the left in the *Exposition of Death* has the same broad, flat, pneumatically rendered shape as the groves of the Sala delle Impannate (pl. 32).

The Trecento model-book in the Morgan Library further demonstrates the impact of secular art at Pisa. One of its drawings shows a woman seated on a bench playing a psaltery (pl. 44). She is remarkably like one of the musicians of the Pisan garden. The relationship does not necessarily mean that the frescoed figure was copied from the model-book, since the *Exposition of Death* precedes the drawing by two decades, at least. It also seems unlikely that the draughtsman directly copied the psaltery-playing lady at Pisa. In the drawing, the lady plays a duet with a seated man strumming a lute. On another folio appear two more pairs of sedentary musicians, one secular, one monastic (pl. 45). The drawings, then, suggest that the compiler of the model-book put together a generalized series of musical couples, no doubt adopted from some lost work of art. The master of the *Exposition of Death* probably drew on a similar source to characterize the vain and sensual folk of his fresco.

An array of images drawn from secular art shows that here at Pisa around 1340 a vital synthesis occurred. The fresco painter, who might well have been Buffalmacco of Florence, brought together the figural traditions of portable property, lovers without gardens, and the decorative landscapes of Tuscan palaces, gardens without lovers, to make a new image typifying sensual love.[14] The next step, then, is to consider who conceived of this garden and who devised the program of the *Exposition of Death*.

An author frequently linked to the Pisan fresco is none other than Giovanni Boccaccio. Eduard Dobbert was among the first to notice that in the grove are seven women and three men, exactly the same number as the narrators of the *Decameron*. The parallels become downright seductive: the fresco and the book both dwell on the terrors of death, from which a garden serves as a refuge.[15] The new dating of the frescoes must, alas, rule out Boccaccio as a source; the *Decameron* goes the way of Petrarch's *Trionfo della Morte*. Nevertheless, those tantalizing similarities Dobbert noted still remain. For a moment the parallel should be pursued, because it leads to new observations about the garden and its denizens.

The distribution of the sexes is the same in the fresco and in the framework of Boccaccio's book. The painter, however, clearly distinguishes two couples from the rest, who may be regarded as servants or vassals. In the *Decameron* all ten narrators are of the same class, and at the outset the men and the ladies agree to live chastely. If there is a relationship between the painting and the book, it must be more typical than literal.

Amatory symbolism of the late Middle Ages does account for one key point of resemblance, the number of persons assembled in the garden. Ten was a pregnant figure in allegorical literature. In the *Roman de la Rose*,

Guillaume de Lorris described the images of ten enemies of love on the walls enclosing the Garden of Sir Mirth. Ten are the arrows that the God of Love launches at the Dreamer, five of them joyous in their effects, five dolorous.[16] A Tuscan equivalent appears in the early Trecento illustrations of Brunetto Latini's *Tesoretto*. Piacere, the god of love, accepts the homage of his wounded victims, who number precisely ten (pl. 12). The illustrator's exactitude differs from the poet's vagueness. "Many saw I, some joyful and some sad,"[17] is how Brunetto sums up love's vassals. The painter at Pisa drew upon a well-established numerical symbolism to define his garden group, just as Boccaccio was to do shortly after 1348.[18]

Unlike Giovanni Boccaccio, however, the master of the *Exposition of Death* represented a moment of amorous intrigue in his pleasant garden. The clue is furnished by the putti hovering above the left-hand couple. The lady beneath them must be a bride, because she wears a wreath or *grillanda*, which none of the remaining six women do. A similar doughnut-shaped headdress is worn by a historical bride, Ilaria del Carretto, whose tomb effigy carved by Jacopo della Quercia around 1406 commemorates her marital virtues (pl. 46).[19] Although the sculptor gave Ilaria a dog to represent her fidelity to her bridal vows, the Trecento painter surely gave his bride a dog simply as a sign of lechery. *Pace* Panofsky, the couple at the left are not rapturously absorbed in one another. The pair incline their heads together, as if engaged in conversation. Though the bareheaded youth does gaze longingly at the bride, she glances sideways at the lord, who is distracted by the music-making woman. The ladies standing to the left of the nobleman pointedly direct our attention back to the garlanded bride. A pretty ambiguity arises, because we cannot be sure whom the bride is wedded to. If she is married to the bareheaded youth, then her attention seriously strays; if the lord is her husband, then she cuckolds him. In either case our bride is no shining exemplar of virtue. Those torch-bearing cupids single out for extinction a vain lady moved by adulterous passions.[20]

In the final analysis, the painter of the *Exposition of Death* used erotic imagery to make a theological point. The garden and its occupants do not appear in the fresco simply to show that Death strikes at the mighty as well as the wretched. Nor is the garden a sentimental allusion to the transience of youth and beauty, as many would have us believe. The garden instead symbolizes wanton vain love, stressed as a general sin, and as a vice peculiar to women. We observe that adulterous love will receive direct and devastating punishment.

An equally acerbic condemnation of love and womankind can be found in the writings of Bartolomeo da San Concordio, a Dominican theologian who died in Pisa during July of 1347. Particularly relevant to the *Exposition of Death* is one of the preacher's youthful works, the *Ammaestramenti degli antichi*, which Bartolomeo composed in Latin and translated into Tuscan

early in the Trecento.[21] This book treats of sin, death, and salvation by arranging brief maxims from the Bible, the Fathers, and selected pagan authors in a rigorously logical order. Frequently the author peppers the *Ammaestramenti* with his own pungent comments, sometimes in rhyming verse, much like the admonitory inscriptions accompanying the *Exposition of Death.*

Quoting Bernard of Clairvaux, Bartolomeo da San Concordio urges his readers to follow the Christian life: "You should never set aside from the inner eye of your heart the horror of death, the peril of judgment, and the fear of Hell."[22] That tripartite image is set forth for the external eye in the great frescoes of the Camposanto.

Bartolomeo frequently dwells on the vanity of worldly love. His doctrine finds expression in Plate 19, a folio from a manuscript of the *Ammaestramenti* made in Florence. Here a chapter on "Corporale bellezza" begins with the proposition that beauty is a vain thing. Supporting that are citations from Jerome, Gregory, and the Old Testament: "Solomon in the Proverbs: Favor is deceitful and beauty is vain (Proverbs 31, 30)."[23] The author goes on to assail women. He cites Boethius, "Your own nature does not make you beautiful; it is due to the weak eyesight of the people who see you,"[24] in order to hurl darts at one of the key doctrines of love. He ungallantly quotes Juvenal to the effect that only rarely may concord exist between beauty and honesty, and then embitters that pill with an epigram of his own: "Beauty often is the enemy of honesty" (*Bellezza spesse volte è nemica d'onestà*). The first of the maxims explains that "Corporale bellezza" is a mortal danger because it leads to the sin of Luxury. These attitudes are congruent with the imagery of the *Exposition of Death*, particularly the garden with lovers set so seductively within it.

Gardens of the Pisan sort appeared elsewhere in Tuscany during the fourteenth and early fifteenth centuries. The fragments that survive of Andrea Orcagna's *Death* and *Inferno* in the nave of S. Croce, painted perhaps as early as 1345, bear out Vasari's report that the Pisan and Florentine representations of the horrors of death were nearly identical. If so, a garden with foolish lovers probably appeared in Florence shortly before the Black Death.[25] That probability is strengthened by the iconography of a fresco, not illustrated here, painted in San Gimignano by the Florentine Cenni di Francesco di ser Cenni during 1413, in which a verdant garden given over to music-making ladies and playful dogs forms part of an exposition of death and the last judgment.[26] These frescoes depicting gardens give evidence for an iconographic type, or more properly a subtype, which may be called the Garden of Vanity. The rubric follows from the tituli of the Camposanto condemning the life of the senses and the foolishness of vain women.

Perhaps the last appearance of the Garden of Vanity was in the bizarre frescoes of the Palazzo Sclafani in Palermo around the middle years of the

Quattrocento. Here the "bosco amenissimo" first seen at Pisa includes an ornate fountain of Youth. But Death now directly violates the tranquillity of this late garden.[27]

A variant of the Garden of Vanity plays a major role in the *Way to Salvation* in the Spanish Chapel of S. Maria Novella in Florence (pl. 47). Painted by Andrea Bonaiuti in 1366–67, the fresco demonstrates that spiritual salvation depends on the sacerdotal structure of the Church and the preaching of the Dominican Order.[28] Midway in the painting, above a disputation between heretics and friars and beneath an image of Christ in glory, lies a charming flowery meadow (pl. 48). Four great figures occupy a wooden bench: a man plunged in melancholic thought, a woman feeding her dog, a bearded magnate displaying a falcon, and a lady garlanded with flowers who plays a viol. Behind them extends a grove where children scramble for food. Below, two groups of pretty blond maidens dance to the beat of a tambourine struck by a young girl, who also sings, and to the skirlings of a bagpipe inflated by a gigantic youth (pl. 49).

Vasari claimed that this garden represented "pleasures and vain delights, enacted by human figures," and, as at Pisa, there seems no reason to disagree.[29] To a Trecento observer the figures on the bench would have been recognizable types of worldliness, vanity, and sensuality. Once more a dog and a bird give the game away. Andrea Bonaiuti probably knew of the Garden of Vanity at Pisa, and undoubtedly drew on the stock images of secular art, represented once more by the Untermyer gittern (pl. 18) and the pages of the Morgan model-book (pls. 24, 25).

Andrea also expanded on the Pisan garden by including the dancing maidens, derived ultimately from Ambrogio Lorenzetti's frescoes of good government in Siena (pl. 40). In the Spanish Chapel the dance clearly signifies fleshly delights. Not only are the participants delightful to behold, but they dance to the music of a bagpipe, perhaps the most notorious phallic image (except for birds) current in the late Middle Ages and early Renaissance.[30]

Further enriching this garden of vanity are children who climb trees in search of nuts, cherries, and other food. This seeming parody of our first parents is less immediately understood than the motif of the dance. In Trecento art children frequently signified emotional indulgence untrammeled by reason; this general interpretation may hold true for the *Way to Salvation*. But in this particular garden, the greedy consumption of food becomes a ubiquitous occurrence. The lady's lapdog eagerly snaps up a tidbit, while the lord's falcon greedily downs a morsel. Gluttony, then, becomes an ally of lust. This partnership is further suggested by two youthful figures set in the grove immediately above the lady who feeds her furry beast. A boy invites a blond girl into the shrubbery, not to seek food as the other children do, but to make use of it in the ways recommended by Guillaume de Lorris

in the *Roman de la Rose* and Boccaccio in his gloss to the *Teseida*. The yonth's gesture echoes that of the Donna del Verzù in the Davanzati palace as she points out the palace where she will sleep with her lover (pl. 37).

An explanation of Andrea Bonaiuti's imagery can be found in the *Ammaestramenti degli antichi* by Bartolomeo da San Concordio. In discussing the seven deadly sins, this author places gluttony at the head of the list: "Since gluttony is the beginning of all vices, so it causes the destruction of all virtues."[31] Gluttony is also the immediate cause of lust. Bartolomeo proves that thesis by quoting Ambrose, who observes that hunger is the friend of virginity and the foe of vanity. Gregory the Great declares that when the belly swells out in satiety then the pricks of lust arouse themselves. Jerome argues that since the stomach and the organs of generation are physically near one another, they must also enjoy a causal relationship.[32] Andrea Bonaiuti's greedy children mime the adages of Bartolomeo's *Ammaestramenti*.

The theologian usually associated with the Spanish Chapel is Jacopo Passavanti, not Bartolomeo da San Concordio. The Pisan writer was, however, a distinguished member of the Dominican order. Moreover, he resided in Florence at the beginning of the century, writing the *Ammaestramenti degli antichi* within the convent of S. Maria Novella itself. Manuscripts of the book produced by the Dominicans themselves (pl. 19) show that it continued to be read in Florence well into the Trecento.[33]

Bartolomeo's crusty logic illuminates another motif in Andrea's garden. To the left of the lady who plays a viol, the bench suddenly turns into a confessional, where a Dominican friar absolves a kneeling penitent. In fact, this convert is the man clad in long green robes who sits at the far right in the garden. There he has no distinguishing attribute, such as a falcon, to indicate either noble rank or amorous proclivities. As his thoughtful posture indicates, he is a scholar. His costume resembles the academic robes worn by a grammarian, either Priscian or Donatus, who sits at the feet of Grammar in another fresco in the Spanish Chapel (pl. 50). This grammarian is busy; our garden scholar is idle. He should then be understood as one prone to the scholar's vice, *acidia*. Bartolomeo da San Concordio treats of *acidia* at some length in the *Ammaestramenti*, condemning it as mere sloth. *Acidia* is a danger because it is almost the same as idleness, which like gluttony leads ineluctably to lust. Bartolomeo quotes the usual array of clerics, concluding with a tag from Ovid's *Remedies of Love*: "Just as the plane tree rejoices in wine, and the poplar in water, and the reed of the mere in marshy ground, so does luxury love idleness."[34] Bartolomeo's borrowing from Ovid, incidentally, may account for the large bunches of grapes next to the lord displaying a falcon.

We understand now that Andrea Bonaiuti's garden of vanity sets forth the temptations of luxury, that is, sensual pleasure. More concisely than the

grove at Pisa, this landscape represents the workings of the five senses. The greedy children embody taste, the dancers touch, the musicians sound. The power of sight is indicated by the two boyish spectators observing the dancers, and by the hawk-bearing magnate who eyes his companion. Smell is represented by Andrea's oddly mixed grove of odoriferous trees, bearing pomegranates, grapes and roses. The workings of the senses lead to a life of pleasure as dangerous to good conduct as the teachings of the heretics who are so vigorously refuted below the garden.

Andrea Bonaiuti also uses the motif of the converted grammarian to show that penitence can defeat vanity. The way out of that sensuous garden lies through the narrow arched gate guarded by Saint Peter. Here children crowned with garlands gain entry to the barren reaches of Paradise.

Absolute contrasts govern the *Way to Salvation*: greedy children, child-like blessed; indulgence, repentance; a garden of vices, a desert of virtue.

Though embodying quite complicated theological ideas, the sequences of the *Way to Salvation* are not far removed from secular literature and art. In the *Tesoretto* of a century before, Brunetto Latini embarks on a pilgrim's progress in which the flowered land of pleasure becomes a trap that must be escaped. Confession follows incontinently thereafter. Even in the Morgan model-book, scenes of lovemaking alternate with penitential exercises (pls. 24, 25). These comparisons bring home once more the increasingly important contribution of secular culture to religious imagery in the late Trecento. Put the other way round, theological culture provided a systematic framework in which disparate ideas and images could be fused.

More than the decorative groves of palaces or the diminutive doings of ivories, monumental frescoes condemning the pleasures of the flesh give space for "boschi amenissimi" bringing together symbolic landscapes and erotic activities. When these pejorative landscapes of love were formed in Pisa and Florence, the separate streams of Trecento traditions began, slowly, to intermingle. During the century to follow, gardens of vanity were used as models for secular allegories of love. The truth of that generalization can be proved immediately by the *Realms of Love*. Paolo Schiavo's bright meadows, dancing maidens, and arched gate repeat the sequences that Andrea Bonaiuti set forth in the *Way to Salvation*. From the Garden of Vanity to the Garden of Love is only a short step.

6

The Garden of Love in Florence

NOT long after Andrea Bonaiuti completed the frescoes of the Spanish Chapel, the first work of art that we can properly call a Gorden of Love was painted in Florence. During the last decades of the Trecento, the disparate streams of tradition that I have charted—symbolic gardens sacred and profane, erotic scenes, literary allegories—finally coalesced to form a broader stream. The Garden of Love throve in Florence for over a century, both in its pure state as an allegory of love, the "pays du rêve d'Amour" of Van Marle's happy phrase, and as the symbolic setting of narratives both profane and sacred. It principally adorned furniture commissioned for weddings, bridal chests, and objects commemorating fertility, birth salvers. Its rather simple imagery embodied quite complex doctrines concerning the nature of love, set forth in admirably cohesive fashion. Equally important, the paintings representing the Garden of Love are delightful to see, sometimes amusing, always charming, and on occasion enchanting.

The earliest known example of the Garden of Love is a small painting now in Douai (pl. 51). Against a gold ground rises a single tree, springing up from a meadow softened by clumps of grassy plants and brightened by tiny flowers. Masking the tree trunk is an imposing marble fountain where several young men and women gather. Music fills the garden as a lady dreamily bows a viol and a youth strums a lute. Three lovers dance before the well, their capers mimicked by a prancing dog and a falcon-bearing dwarf. Each individual element is familiar enough; their combination is novel.

Richard Offner once suggested that the painter of this first Garden of Love was a Florentine close to Jacopo and Nardo di Cione.[1] In style the panel bears a close resemblance to the predella, now dispersed, of Jacopo's *Coronation of the Virgin*, completed in 1371 for S. Pier Maggiore in Florence.[2] The costumes resemble those displayed in paintings from the early 1370s by Giovanni del Biondo and Giovanni da Milano.[3] The *Garden*

of Love is, therefore, contemporary with the illustrations of Giovanni Capponi's *Decameron* (pls. 13, 14).

It is obvious that the painter was indebted to the traditions of craft art. His geometric sense of composition resembles the ordering of an earlier Florentine chest showing lovers at the chase and by a fountain (pl. 16). In fact, the gessoed relief showing a fountain in front of a tree may be considered a direct precedent for the central feature of the Douai panel. The translation from gesso, wood, and ivory into paint was also aided by the conventions developed by *pittori di camera*. The tree, spreading over the gold ground in symmetrical lobes, seems left over from the groves frescoed in the Davanzati palace a decade or so before (pls. 31, 32).

The painter's greatest debt was to religious art. The configuration of a tree, lovers, and a meadow abbreviates the chief elements of the Garden of Vanity, whether in its first appearance at Pisa (pl. 43) or in its elaboration by Andrea Bonaiuti (pl. 48). The impact of the Spanish Chapel cannot be denied. The pattern of the dance, for example, is copied from the triad of maidens in a meadow at the right of Andrea's fresco. The woman playing the viol echoes a musician seated above the dancers. Even the little dog comes from the Spanish Chapel, albeit from Andrea's *Pentecost* in the vault, and not illustrated here, rather than the *Way to Salvation*.

In devising the new Garden of Love, our unknown artist essentially detached the Garden of Vanity from its general religious context and wed it to other images derived more directly from secular art. In so doing, the painter altered its meaning. The garden no longer is a snare to be avoided; it becomes instead a delightful place to seek.

This celebration of love aligned the visual arts more closely to poetic traditions. The chief image of the painting is a garden made verdant by a fountain. The gold ground ensures that what we see is sacred and set apart from mundane experiences, exactly like the glittering panels of an altarpiece. The painter depicted a true *locus amoenus*, corresponding to those erotic Elysiums explored by poets of ancient and more modern times. A striking demonstration of the new importance of literary tradition is the frontispiece of the Capponi *Decameron* (pl. 13), done in the same decade as this panel. Its landscape of meadow, grove, and fountain now seems to be simply an extensive version of the Douai *Garden of Love*. So close are these in time, however, that the question of which influenced which must remain open.

The Douai panel and the Capponi drawings show that during the 1370s amatory images began to experience a renaissance, so to speak, after the bleak years following the Black Death. To be sure, works of amatory art never entirely disappeared at mid-century, as the frescoes of the Palazzo Davanzati demonstrate. But the negative portrayal of love in the Sala della Donna del Verzù, as well as its outright condemnation at the Pisan Campo-

santo and the Spanish Chapel, does indicate a climate best described as distrustful. That climate began slowly to thaw as the century waned.

An illuminating symptom of change is a poem, "Di loco in loco, per piani e per piagge," which an unknown Florentine composed toward the end of the Trecento. His work demonstrates the staying power of the *Roman de la Rose* and the *Amorosa Visione*. The author tells of searching the countryside for flowers to weave into a garland. Suddenly, by the banks of a river, he meets Love himself, enthroned amid a company of lovers, girls and ladies gracious and wise, men courteous and gentle. Amor invites the poet to enter his realm:

> This is my garden and this my grove is. . . . It has no wall to offer resistance nor a gate that may shut out a lover; instead it alone is made for their safekeeping.[4]

The lover, of course, accepts the invitation and finds the flower he sought. The point of this little poem is that allegory has been scaled down. Those within the garden are simply lovers, not "Beauty" or "Courtesy." The garden itself is unwalled. The literary images, then, run parallel to the *Garden of Love* at Douai. Furthermore, the author has none of the qualms and doubts besetting Giovanni Boccaccio and Guillaume de Lorris. He accepts the courtly view that sensual love implies moral virtue, or as he poetically puts it, faith and honor, courtesy and nobility, all work to create a garden for Love. A similar view must have animated those who commissioned the *Garden of Love* early in the 1370s.

The anonymous "Di loco in loco" yields a further analogy to the panel in Douai. The poem was an occasional piece. A textual anagram informs us that the river flowing by Love's kingdom is actually the Arno and that the lady the poet desires dwells in the Via dei Fondacci near Santo Spirito.[5] The poetic Garden of Love has finally migrated from Cyprus to Tuscany. The *Garden of Love* was also commissioned for a specific occasion as a compliment to a lady. This twelve-sided panel is a salver, or *desco di donna da parto* as Florentines would have called it six hundred years ago, used to bring food and gifts to mothers after childbirth. In fact, the *Garden of Love* may well be the earliest known birth salver.[6] How delightful to note that an image extolling the virtue of love decorates an object intended as an augury of fertility, and a commemoration of matrimonial virtues.

The Garden of Love continued well into the Quattrocento in Florence. From the new century is a desco da parto, formerly in the Figdor Collection in Vienna and now in Princeton (pl. 52). Though much overpainted and abraded, it still remains one of the most elegant versions of the Garden of Love. Most authorities have dated the panel between 1420 and 1440, agreeing that its author was Florentine.[7] Several direct borrowings from Masolino's

frescoes in the Brancacci Chapel, as well as a more generalized debt to the art of Lorenzo Monaco, serve to put the Princeton *Garden of Love* firmly into the 1430s.[8] Although sixty years separate the Princeton and Douai salvers, basic iconographic and even compositional patterns remain unaltered. Lovers continue to cluster by a fountain, listen to music, and dance. What does change is the setting. The gold ground of the Trecento gives way to a dark forest, and the garden now becomes as extensive and as flat as the surface of a *mille-fleurs* tapestry. Obviously contributing to the development of the Garden of Love is the decorative naturalism typical of International Gothic painting, the "gotico fiorito," as the Italians so aptly call it.

Close in time and related in style to the Princeton panel are several Florentine paintings. In a desco da parto, formerly at Wildenstein's in London and now in a private British collection, the garden serves as the stage for a feast and music-making (pl. 53). A garden full of roses decorates its back (pl. 54). Since the lovers bear a general resemblance to the figural types of Mariotto di Nardo, who was active until 1424, this panel should be put in the 1420s.[9] A cassone panel depicting the Garden of Love can be assigned to the shop of Giovanni di Marco, conventionally called "dal Ponte" (pl. 55). Giovanni supervised a *bottega* specializing in cassoni from the early 1420s until his death in 1437. The general influence of Masolino and Gentile da Fabriano, and a specific borrowing from a salver painted by Bartolomeo di Fruosino in 1428, serve to date Giovanni di Marco's *Garden of Love* with some precision. It belongs to the early 1430s.[10]

Later than these paintings are two more Gardens of Love. A salver formerly in the collection of Martin Le Roy in Paris is by a Florentine close to Pesellino, who died in 1457 (pl. 56). The painter had also studied several works of the early Renaissance, including Ghiberti's relief of *Jacob and Esau* from the Gates of Paradise, Fra Filippo Lippi's *Annunciation* in San Lorenzo, and the predella to Domenico Veneziano's St. Lucy altarpiece. This *Garden of Love* can be dated around 1450.[11] Two decades later appeared a small engraving (pl. 57), sometimes attributed to the Florentine goldsmith and printmaker Baccio Baldini. It belongs to a sizable group of erotic engravings, conventionally known as the "Otto prints," in which the imagery of Florentine and Netherlandish art coexists. Here, for example, a wreath of classic design frames a garden for lovers clad in the fashions of Gothic Burgundy.[12] With Baldini's print, the history of the Garden of Love in Florence, as we know it, comes to an end.

Nearly a century intervened between the desco in Douai and the Otto print. The history of the Garden of Love documents the persistence of Trecento formulas far into the Quattrocento. It is this very conservatism, however, that makes the Garden into a coherent and consistent visual symbol. It now awaits a systematic exposition.

The most obvious feature of the Garden of Love is its landscape. Usually a simple lawn with trees to one side defines the garden. In the Wildenstein panel (pl. 53) a villa entered by an arched door marks a limit to the meadow. In the late examples, walls completely girdle the garden, to which narrow gates give access. Historically, then, the Garden shifts from a *prato fiorito*, like the landscapes Trecento poets describe, to a *hortus conclusus*, like the realms delineated by Guillaume de Lorris and Claudian. This enclosure movement coincides with the appearance of walled gardens as the setting of the Annunciation in Florentine painting of the 1430s and 1440s.[13]

Within the garden no great variety of plants abounds. Tiny flowers, some red, some white, dot grassy meadows, enlivening pictorial surfaces but failing to provide specific botanical information. Groves are equally generalized: some paintings contain evergreens, some deciduous trees laden with fruit. On occasion, the grove is mixed (pl. 56). The landscape forms an image of nature that is bountiful, an appropriate decoration for panels commissioned at times of marriage and childbirth. The Garden of Love can be seen as a direct continuation of the blossoming groves of Trecento palace decoration.

The preternatural fertility of the garden becomes explicit in late Gardens of Love girdled by walls. Between the battlemented wall and the bower in Baccio Baldini's engraving (pl. 57) stretches a barren tract of earth. Outside the wall and to the left of the loggia in the Le Roy salver rises a solitary dead tree (pl. 56). Blasted tree and barren earth emphasize the fertility of the places where lovers dwell. To paraphrase Andreas Capellanus, Ariditas lies next to Amoenitas. Time and death lie outside the Garden of Love which, like Claudian's Cyprus, "enjoys the grandeur of an eternal spring."

In the earliest and latest examples of the Garden of Love appears a tree that never loses its foliage and that bears fruit in abundance. A pine rich with cones shades the lovers in the Douai salver (pl. 51). The artist refers to the traditional belief that pine nuts are an aphrodisiac, a belief shared by the illustrator of the Capponi *Decameron* (pl. 13) and the decorator of the Palazzo Davanzati (pl. 34). A century later Baccio Baldini took some pains to revive that pseudo-medicinal doctrine; clusters of pinecones adorn a garland-weaving woman's gown (pl. 57). Appropriately enough, this lady's sleeves bear an erotic admonition, AMES DROIT.[14]

Several trees in the grove pertain directly to the goddess of love. Trees sprouting shiny green leaves, like laurel or myrtle, dominate the Wildenstein panel (pl. 53). As an attribute of Venus, myrtle grows in Tibullus's erotic Elysium and in Boccaccio's Mount Cithaeron. Trees bearing red and yellow fruit enclose the gardens of the Princeton salver and Giovanni di Marco's cassone panel. The painters probably intended these to be apple trees, in remembrance of the golden apple of discord that Paris once awarded to

Venus. According to Boccaccio in the *Teseida*, the goddess herself displays that golden fruit, like an emperor who holds his orb, as an emblem of her sovereignty.[15]

Surprisingly few of the animals the poets describe, such as rabbits or deer, migrate to the Garden of Love in the Quattrocento. An exception is the cassone panel designed by Giovanni di Marco. Here singing birds curve and flute and fall, like the birds that sing in the poetry of Tibullus (pl. 55). The painter's songbirds also bear scrolls in their beaks as they tumble through a golden sky. This garden, like all the others, exists only as a symbol.

There are really too many lovers wandering through the Garden of Love to permit much wildlife to flourish. More than natural landscapes, human images define the meaning of the garden. Throughout the fifteenth century, lovers remain rich, aristocratic, and noble. Always they wear expensive garb: brocaded fabrics, long trailing sleeves, parti-colored hose, all surely in violation of Florentine sumptuary laws. In the Otto print, the garland-weaving lady wears a gown trimmed with regal ermine. Another badge of rank is the presence of servants and buffoons, a maid in the Wildenstein panel, a dwarf in the Douai salver. Such careful characterization goes back to craft traditions of the Trecento (pls. 16, 20). Poetry accounts for its logic. Among the ten enemies of love Guillaume de Lorris enumerates in the *Roman de la Rose* is Poverty, while Wealth and Liberality serve the God of Love. Nobility dwells with Venus atop Boccaccio's Mount Cithaeron. Only the wealthy and the wellborn, after all, have the leisure to indulge in love. Claudian excludes Old Age from the verdant plains of Venus on Cyprus, Guillaume de Lorris defames Age as a foe of Love, and Boccaccio puts Youth and her companions Beauty and Charm in the domain of Venus mapped in the *Teseida*. The painters all observe the same laws, except for the master of the Le Roy *Garden of Love* (pl. 56). Though he violates the rules by putting a little boy and an old woman in Cupid's realm, perhaps he intended to demonstrate that the proper time for love is the interval between infancy and senescence.

Sometimes the lovers bring with them familiar pets, the falcons and dogs whose significance we remember from Trecento art. The fauna of the Le Roy salver deserve special comment. Two spotted beasts, probably leopards, are chained to a trellis (pl. 56). The painter undoubtedly remembered those leopards accompanying the three kings to Jerusalem in Gentile da Fabriano's *Adoration of the Magi* of 1423. A chained leopard served also as the heraldic device of a famous lord, Duke Giangaleazzo Visconti of Milan.[16] The spotted beasts in the garden must then denote nobility, as dogs and hawks do. But they also connote amorous passion. The erotic credentials of the leopard derive from a cryptic passage in Dante's *Inferno*. At the outset the narrator finds his way blocked by three fierce animals, one of which is a "lonza" distinguished by a spotted hide.[17] By the end of the Trecento commentators on Dante and artists illustrating his verses generally agreed that the *lonza* was

a leopard and that it signified Luxury.[18] The rationale can be found in the lengthy commentary that Benvenuto da Imola wrote between 1378 and 1383. The glossator declares that any spotted beast may represent lust, thanks to his somewhat confused reading of the first book of Virgil's *Aeneid*, in which Venus speaks of her sister as a huntress who wears a spotted hide.[19] Ransacking the lore of bestiaries, Benvenuto proves that the leopard is an appropriate sexual symbol, thanks to its swiftness, its sanguinary appetite, and its cunning. He further argues that Dante's mysterious beast must in fact be a leopard, because when an actual leopard was once paraded through Florence children ran through the streets gleefully shrieking "Ecco la lonza!" Benvenuto credits this story to his learned Florentine colleague, Giovanni Boccaccio.[20] A gentler treatment of the beast is in a poetic allegory contemporary with the Le Roy *Garden of Love*, the romance *Nicolosa Bella* written by the Bolognese Gianotto Calogrosso around 1446. Several times a leopard that a lady has tamed serves as a metaphor of a lover caught in the chains of love.[21] Fittingly enough, one of the painted leopards gazes at the company of lovers dancing in the garden.

Lovers gathered in the Garden have remarkably little to do. Generally they make music, or join in the dance. On occasion they feast or play with garlands. Some may even gently embrace. Their activities continue the familiar erotic repertory of the late Middle Ages, except that chin-chucking disappears and seizing by the "queynte" almost never happens. Desultory though these activities seem, they are governed by a strict amatory logic.

Music-making is an activity reserved for highborn lovers, not the servants who wait on them. In all the Gardens of Love music fills the air. A single harpist entertains the lovers of the Princeton salver (pl. 52). More often than not, duets are played—viol against gittern in the Douai salver, lute and harp in Giovanni di Marco's cassone panel, the Otto print, and the Le Roy salver. The Wildenstein *Garden of Love* features a quartet of harp, organ, drums, and gittern. We recall that music can be the food of love. Boccaccio declares that "songs and instruments . . . have the power to chase away all melancholy, which is strongly adverse to the effects of Venus."[22] Less pedantically, Ovid observes that "zithers and flutes and lyres enervate the mind."[23] The painters make the same point. Observe how tenderly the members of the Wildenstein quartet eye each other, and how Giovanni di Marco's lutanist seems lost in sweet thought. More straightforward is the Douai *Garden of Love*. Two ladies touch a man plucking his gittern, one embracing him, the other plucking at his low-slung belt. We must remember that this master was not far from the craft tradition (pl. 21). Once more, Baccio Baldini seems to have remembered medieval lore when engraving the *Garden of Love* (pl. 57). While instruments sound in the bower, two lovers playfully tussle in the grass, as if to demonstrate "the lascivious pleasing of a lute."[24]

Food can also serve as the food of love. The table where the quartet of

the Wildenstein desco plays is set out for a feast, cluttered with cutlery and cups. A maid draws near bearing a *fiasco* of wine and a basket of victuals. Here after music comes food. A similar sequence is implied in the late engraving, where the lovers have provisioned themselves with a flagon of wine and a salver full of fruit. In neither instance should the motif be considered a reference to everyday life. The Garden of Vanity in the Spanish Chapel, for example, demonstrates an age-old alliance between gluttony and lust. On the secular side Boccaccio points out that eating and drinking are the obligatory fuels of love. A proverb common to classical Latin and medieval Tuscan puts the proposition more succinctly: "Without Bacchus and Ceres Venus lies shivering."[25] Grapes and wine appear in both the engraving and the desco. The basket borne by the servant may even be large enough for loaves of bread. Another reference to the powers of Bacchus is the grape arbor of the Le Roy *Garden of Love*, where couples prepare to dance. After all, "Wine gives courage and makes men apt for passion," as Ovid reminds us.[26]

The chief exercise of our idle lovers is the dance, which appears in all the Gardens except for the desco in London and the Otto print. Pictorial custom, instituted by Andrea Bonaiuti's Garden of Vanity, accords with poetic traditions from Tibullus to Boccaccio. A specific reference to the art of love lies in the very pattern of the dance itself. More often than not, a woman dances between two men. This corresponds reasonably well to actual dances of the early Renaissance, such as those which Guglielmo Ebreo describes in his *Trattato dell'arte del ballo*. Figures involving a lady and two men are provocatively titled "L'ingrata" or "Giove" because the participants interweave in patterns suggestive of courtship, coquetry, pursuit, and capture. A *bassa danza alle tre* can be read as equivalent to the medieval hunt of love.[27] In a more general way, any dance signifies lovemaking. Ovid claims that "constantly in the dance are lovers played,"[28] and even stately Petrarch calls the triumphal procession of Cupid a dance.[29] As usual, the master of the Douai *Garden of Love* exposes the erotic implications of the motif. Behind his dancers prances a dwarf armed with a hunting falcon, an absurdly over-scaled belt buckle parodying his virility. Leading them is a furry dog, alluding to the ultimate goal of love.

Pictorial custom provides a place for garlands in the Garden of Love. Adorning the reverse of the Wildenstein salver are the raw materials for a garland, roses white and red, flowers sacred to Venus; on the other side a drummer wears a chaplet of roses, while others prepare to pluck leaves from myrtle trees to make garlands, a motif here oddly reminiscent of the greedy children who pick fruit in the groves of the Spanish Chapel. Weaving garlands is a conspicuous pastime in the Otto print, and in the cassone panel given to Giovanni di Marco, two maidens reward their suitors with chaplets, a motif recalling the drawings of the Morgan Library's model-book. The

Trecento tradition ensures that garlands signify love's desires attained in the Garden of Love.

The denizens of the Garden regularly assemble in simple numerical configurations. A maidservant attends ten noble lovers in the *Garden of Love* at Wildenstein's (pl. 53), a gathering that at first sight seems remarkably like the introductory episodes of the *Decameron* (pl. 13). Here, however, are three ladies who wear low-necked gowns and seven gentlemen in high collars, exactly the reverse of Boccaccio's scheme. We may conclude that in this salver, as well as in the Douai panel and the Le Roy desco (where ten lovers prepare to dance), the numerical symbolism of the Trecento survives well into the Quattrocento.

Baccio Baldini divides the amatory number, ten, to produce five lovers in his engraved Garden. The sum befits love, since it corresponds to the number of the senses, as the tituli of the Pisan Camposanto remind us. The senses in their turn enjoy erotic connotations. According to the late-antique mythographer Fulgentius, when Apollo betrayed the adulterous love of Mars and Venus, the angry goddess "inflamed with love the five daughters of the Sun, that is, the five human senses devoted to love and truth and as if made dark by this corrupting of the sun's blood."[30] Boccaccio approvingly cites this allegory in his influential *Genealogy of the Gods*. A more light-hearted medieval tradition dwells on five modes of love: sight, conversation, touching, kissing, and coitus.[31] Once more Boccaccio continues a medieval doctrine when claiming in the gloss to the *Teseida* that "the works of pleasure-seeking persons do not merely consist of luxury but also of lewdness (*lascivia*), by which lewdness is meant kissing, touching, singing songs, whispering words of love, and other foolishness."[32] In his lectures on Dante, the same author contends that there are five modes of coitus.[33] A like fivefold path is followed in Baldini's *Garden of Love*.

Another persistent figural pattern is an amorous trinity. Three lovers usually participate in the dance, as we have just seen. Triads govern the figural composition of the earliest Garden of Love (pl. 51) in which three dance, and three stand to the left of the fountain, three to its right. Giovanni di Marco balances three dancers with three girls weaving garlands. Once more mythological and numerological traditions explain this configuration. Three is a number commonly linked to the goddess of love. She has three Graces, she governs the third heaven, and hers is the third, voluptuous, way of life offered to Paris, according to Fulgentius and Boccaccio.[34] More generally, three implies love itself. A medieval jingle asserts that "Three are the steps of love and triple is its grace: the first finds, the second nourishes, the third clinches the work."[35]

"There are three things that are never satisfied, nay four things say not, It is enough," says Solomon.[36] Lovers may assemble in fours as well as threes. We have observed the Wildenstein quartet (pl. 53). A like number

gathers on the steps of the fountain in the Princeton salver, and clusters at the right in Giovanni di Marco's cassone panel. Probably the configuration continues the four seated figures prominent in the Garden of Vanity (pls. 43, 48). From triplets and quartets comes the total sum of lovers in the Garden, twelve in the Princeton salver, sixteen in Giovanni di Marco's painting.

As important as number is the distribution of the sexes. Never in the Garden of Love is there equality. Men usually outnumber the ladies, sometimes greatly, as in the Wildenstein panel, sometimes only by one or two, as in the Douai and Princeton salvers. Giovanni di Marco and Baccio Baldini reverse the situation. A glance at all the Gardens suggests why the distribution must be uneven. In the pursuit of love somebody is doomed to lose. Not all suitors gain what they desire, nor can all ladies find suitors. Andreas Capellanus's ironic parable of Amoenitas and Ariditas expresses the same doctrine. Tuscan poets also observe incessantly that love brings joy and sorrow.

In most of the Gardens, the lovers gravitate to a fountain. This artifact is perhaps the most important single element of the Garden of Love. In early examples its size dominates the composition. It stands precisely at the center of the cassone panel from Giovanni di Marco's shop, for example. Only in the Le Roy salver does it find a subordinate site, while in the engraving it dwindles to a mere ornamental trough. It is the fountain that distinguishes these allegorical gardens from their Trecento predecessors. Take away the fountain and the Garden of Love is no more.

The poets account for the central importance of the fountain. We recall that a spring makes the realm of Amoenitas pleasantly verdant, according to Andreas Capellanus. Fountains ensure fecundity, a point also made by the decorations of the Palazzo Davanzati (pl. 33). They belong also to the god of love. Claudian's Cyprus has two fountains, one sweet, the other bitter, where Cupid dips his arrows. Boccaccio follows the Roman poet in assigning Cupid a fountain where he sits making his arrows, which his daughter Pleasure tempers in its waters. The gloss to the *Teseida* develops a complicated allegory from this image wherein pleasure, born from hope and love (alluding to the union of Psyche and Cupid), passionately inflames an eager heart.[37]

The powers of the fountain are made apparent in the Garden of Love. The master of the Le Roy desco placed a nude putto atop his fountain to show that it belongs to Cupid. He followed a precedent established by the illustrator of the Capponi *Decameron* eighty years before (pl. 13). Mimetic activities also demonstrate that divinity dwells by the well. Two lovers in the Princeton Garden of Love draw our attention to the golden column rising from a marble basin: a man touches it and gently gestures, as if in awe,[38]

while his mistress points to it as though it were an object of religious venera-
tion. Other figures demonstrate that the fountain inspires love, just as
Cupid's golden shafts do. To the left of the Princeton fountain, a lady points
to the well, like one of Alberti's figures who admonishes, while her gallant
plucks at her gown. On the other side a second couple more openly embraces.
Similar touchings and claspings enliven earlier salvers (pls. 51, 53).

Several lovers gaze as if hypnotized into the waters of Cupid's well.
Others touch its reflecting surface. Both activities appear at the center of
Giovanni di Marco's cassone panel, to cite only one example. These quiet
lovers repeat the fatal act of Narcissus, whom the gods punished by making
him fall fatally in love with his own image reflected in a clear pool. Endlessly
he gazed at his mirrored loveliness; sometimes he sought to embrace his
image, but in vain.[39] Medieval poets conflated the story of Narcissus with
the fountain sacred to Cupid. Guillaume de Lorris describes the well where
the Dreamer sees the fatal flower of the *Roman de la Rose* as the perilous
Well of Narcissus, by whose waters Love captures his prey. A sprightly
figure from Boccaccio's *Comedia delle ninfe fiorentine*, the nymph Agapes,
finds a potent lover only after bathing with Venus in the fountain of Nar-
cissus. The same author explains that the spring where Cupid makes his
arrows in the *Teseida* is really the fountain of our own false judgment, since
pleasure, conceived from hope and love, is that which makes us judge what-
ever we love to be more worthy than anything else terrestrial or celestial.[40]
In the painted allegories, the Fountain of Love, as we should now call it,
snares visitors to the Garden. So love makes prisoners of us all.

The architecture of the Fountain of Love remains remarkably consistent
through a century of development. Usually it is a hexagonal marble basin,
often tinted red or pink, mounted on two broad steps. Sometimes the basic
plan is elaborated to form a quatrolobe. Frequently a column, sometimes of
gold, rises from the center of the first basin to support a second smaller
bowl, from which water pours. This multi-tiered type echoes the red-marble
structure Boccaccio described in the *Amorosa Visione*. Counterparts exist,
however, in civic fountains of the late Trecento, such as a hexagonal "pozzo"
still in use in the Umbrian town of Bevagna.[41] More frequently encountered
are baptismal fonts that from the late Trecento onwards become hexagonal in
plan. A small marble font not unlike the fountain of the Douai salver was
installed in the Baptistery of Florence in 1371.[42] The ornate double-tiered
font of S. Giovanni in Siena, begun in 1417 and completed a decade later,
is close to the fountains painted by Giovanni di Marco and his contemporaries
(pl. 58).[43] If the painters deliberately made the erotic fountain resemble the
baptismal font, their intentions are in delightful accord with the meaning of
the Garden of Love. The rite of baptism begins a new life, just as falling
in love does. Moreover, references to baptism are superbly appropriate for

paintings commemorating childbirth and matrimony. The world must be peopled, as Shakespeare's Benedick says. Making love is still the best way to go about it.

The Fountain of Love must not be confused with the Fountain of Youth, as Raimond Van Marle tended to do.[44] The differences between the two fountains are demonstrated by an amusing fresco that a follower of the Piedmontese master Jaquerio painted in the great hall of the Castle of Manta around 1440 (pl. 59). To the left elderly people of various ranks descend a hillside to a leafy meadow. After awkwardly disrobing, they clamber into a fountain, bathe, and suddenly are rejuvenated. A statue of Cupid perched atop this well is launching arrows only to show that youth regained means flesh resurrected. Eager couples at the right of the fountain, not illustrated here, make the same point.[45] Surely the fountain at the center of the Garden of Love is not this wondrous contraption, because the poets agree that Old Age can never enter Cupid's realm in the first place, a rule that most of the Florentine painters scrupulously observe.

The meaning of this ensemble of fountain, lovers, and landscape now awaits definition. Briefly put, the Garden of Love presents an image of the nature of love, implying what love is, how it arises, how it progresses, and where it leads.

In the Garden are portrayed the workings of all five senses.. Flowers and trees gratify the sense of smell, music delights the ear, touching gladdens lovers. Food and drink stimulate taste. Lovers look into the green depths of Cupid's fountain. Here the senses find eternal gratification. The Garden, then, is an image of pleasure made perpetual. Here lies a subtle snare, for as Spenser observes, "pleasure does frail sense entice."[46] Sensual delights infallibly engender the desire to love, either through the accidental workings of nature, such as cone-laden pines, the magical artifacts of the gods, here represented by the fountain, or through human activities, such as song and music. We all must *fall* in love. Once entrapped, the lovers eternally enact a masque of love, which revolves once more around the fountain. The progression governs the cassone designed by Giovanni di Marco, as the eye moves rightwards, beginning with music and the dance, pausing by the fountain, and concluding with proposals made and accepted. The aim of love is pleasure's consummation.

The earthier aspects of love never disappear from love's elegant domain, as we have seen in the Douai salver and the late engraving. At the same time the courtiers of the Princeton panel or Giovanni di Marco's painting perform their roles with a dreamy gentleness that seems almost spiritual. As in poetic doctrine, love remains ambivalent. The poets tell us too that love means not only the desire to get pleasure but also the wish to give pleasure to the object of one's desires. Love at once gratifies and ennobles. Perhaps the ornate costumes all lovers wear indicate that the doctrine that one must be

noble to love may mean also that to love one must become noble. At the conclusion of the *Comedia delle ninfe fiorentine*, Boccaccio movingly evokes the nobility of the Garden of Love:

> Whoever truly perceives must become sad, and his heart embittered on leaving that gracious place. There beauty, nobility, and worth, charming words, the very mould of virtue, and highest happiness dwell with love; there a desire impelling man to his salvation, there so much of good and of delight as many could ever have; there fulfilled are worldly dreams, and their sweetness is seen, and felt. And where I go but melancholy and eternal sadness.[47]

Truly, the Garden of Love in Florentine art was a "loco grazioso."

During the first half of the Quattrocento the Garden of Love also appeared as the symbolic setting of several narrative paintings. An instance is a birth salver that Mariotto di Nardo painted around 1420 (pl. 60). A garden dense with flowers shelters a fountain, four ladies, a tiny stag, and a leaping hare. To one side two youths peep through the barred windows of a castle. In the distance a lady on horseback comes upon two armed soldiers fighting in a grove.[48] Thanks to its delightful setting, Mariotto's panel has been called a Garden of Love ever since Raimond Van Marle first published it nearly half a century ago, even though Guy de Tervarent has twice identified its subject as episodes from Boccaccio's *Teseida*.[49]

Tervarent perceived that the two scenes Mariotto painted form a continuous narrative linked by one of the ladies in the garden, clad in red, who also appears in the grove. She disrupts a duel fought by the same young men who are prisoners in the foreground dwelling. This narrative comes from the third and fifth books of the *Teseida*, better known to English readers, perhaps, as the story the Knight contributes to the Canterbury Tales. The prisoners are Palemone and Arcita, knights from Thebes immured in Athens on the orders of Duke Theseus. On a May morning they see Princess Emilia, the duke's sister-in-law, strolling in a garden beneath their window. Both knights fall precipitately in love. Both contrive to get out of prison, though at different times. They meet again in a grove just beyond Athens, quarrel, and then fight furiously over Emilia, invoking Mars and Venus with each blow. Their battle ceases when Theseus and Emilia, intent on the chase, come upon the knights by accident.

What Guy de Tervarent did not investigate was Mariotto di Nardo's reliance on symbolic landscape. The foreground scene is, after all, difficult to decipher because it resembles a Garden of Love. Mariotto took his cue from Boccaccio's verses. When the prisoners first see Emilia singing in her garden, they think that she must be Venus herself, and that she comes from paradise. The narrator also describes her landscape as a "giardino amoroso."[50] As we have noted before, Boccaccio is using a landscape of symbols to explain

narrative actions. In a way, Mariotto di Nardo follows suit by depicting an elaborate garden with a fountain, embellished further with a rabbit, that familiar beast of Venus, and a stag, traditional symbol of smitten lovers. Mariotto further underlines the moral by giving Emilia three attendants, playing Graces to her Venus. Moreover, he makes his imprisoned knights gaze intently at the Fountain of Love in order to show their state of mind. The painter turns the grove customarily shading the Garden of Love into the spot where Palemone and Arcita duel. Here he follows pictorial custom, rather than observing Boccaccio's distinction between urban garden and suburban copse. The landscape, however, actually suits the poet's intentions perfectly. This very grove spurs Arcita to thoughts of love when he retires to meditate in its depths, because the place is sacred to Priapus.[51] Mariotto di Nardo turns the Garden of Love into a setting for scenes of romantic yearning and clashing violence. He also uses that symbolic landscape to point out that the *Teseida* is a story about love, and to show why love is engendered and what its consequences are.

A similar reference to the Garden of Love appears in a delightfully mannered panel painted around 1447 by another Florentine, the Master of the Bargello Tondo (pl. 61). The salver represents the concluding episodes of the Old Testament legend of Susanna and the Elders.[52] In the middle distance a boyish prophet Daniel stands beside chaste Susanna, pointing out to her the just fate of her false accusers, two elderly judges whom young men stone to death in the foreground. Behind Daniel extends a familiar landscape —a lawn, groves, and an empty fountain suitable for bathing—the place where the story begins when the elders attempted to seduce Susanna as she bathed. The Vulgate text consistently calls that place a *pomarius*, meaning an orchard, and makes no mention of fountains.[53] The Master of the Bargello Tondo emends the text by depicting a Garden of Love devoid of lovers. The Garden thus denotes time past. It may also have been intended as a symbol of the erotic attractions of Susanna in the bath and as an allusion to the amorous thoughts of her accusers. Thus far the Garden of Love plays much the same role here as in the earlier representation of the *Teseida*. There is, however, a twist. The judges die for their sins : "Beauty has deceived you and lust has perverted your heart," thunders Daniel.[54] The center of attention is Susanna, who stands vindicated as a virtuous married woman. The Master of the Bargello Tondo contrasts the allure of chastity with the dangers of sensuality, an opposition in which the Garden of Love plays an ambiguous role.

Nearly a decade after the salver celebrating Susanna's virtue came a cassone panel in which the Garden of Love becomes the stage for Petrarch's Triumphs (pl. 62). The artist was a Florentine admirer of Pesellino, whose work closely resembles the *Garden of Love* in the Martin Le Roy Collection.[55] To the left a nude and blindfolded Cupid bestrides his flaming chariot; at the

right Chastity, discreetly clad in a long robe, conducts her gentle triumph. Between these two processions Cupid meets an unexpected fate. His white horses, fiery and fierce, quickly become mild when they enter a soft green garden, where apple trees frame a marble fountain surmounted by an amorino's statue. To a degree, the artist follows Petrarch, who sets Cupid's final triumph in a pleasant meadow. The poet's garden, however, flourishes amid high mountains on Cyprus, "The softest and gentlest of all isles / Warmed by the sun or watered by the sea." Setting aside the geography of the eastern Mediterranean, the cassone painter directs Cupid and his troop to a garden much like the setting of the Le Roy desco. His citation of the Garden of Love, however, becomes ironic, for here love is overthrown. Lady Chastity beats Cupid to the ground, smashing his arrow-stuffed quiver, and binding his wrists, right in front of his own fountain! To the right Love's garden continues as a carpet for Chastity's procession. The dog ambling along beside her triumphal chariot must now symbolize marital fidelity rather than sensual stirrings.[56]

The historical development that begins with the late Trecento *Garden of Love* in Douai and concludes with this mid-Quattrocento *Triumphs of Love and Chastity* yields several important iconographic conclusions. Two factors effectively define the content of an allegorical landscape, the topography of the site and the people depicted within it. Who the people are and what they do is almost as important as where they act. As a cohesive iconographic type, the Florentine Garden of Love depends on the spatial configuration of people in love, a meadow, a fountain, and a grove. That configuration represents an allegory of the nature of love. Take away the lovers and the meaning of the landscape changes slightly, becoming a particular symbol of love's sensual enticements and a general sign of the presence of love.

When Raimond Van Marle first assembled examples of the Garden of Love, he advanced Paolo Schiavo's cassone panel in New Haven (pl. 1) as the most important Italian instance of the type. If the historical development here charted is valid, then Van Marle was not quite accurate. In no Garden of Love do lovers dance in meadows unwatered by a fountain, nor is the fountain linked directly to Cupid's triumph. Although made possible by the Garden of Love, the *Realms of Love* depends also on other allegorical landscapes flourishing in Tuscany during the early Quattrocento. Gardens without fountains and fountains set in forests await exploration.

7

Gardens without Fountains:
The Grace of Venus

THE stream of tradition to which the Garden of Love belonged was a
very broad one. Contemporary with paintings depicting the nature of
love were several birth salvers, cassone panels, and coffers painted in Florence
and Siena before the middle years of the Quattrocento. Simple gardens adorn
these panels, sometimes a lawn bordered by a grove, sometimes merely a
meadow. Like the more elaborate garden with a fountain, these landscapes are
symbols of love whose precise significance depends on the figural activities
depicted therein. Indeed, simple groves and lawns should be considered as
variants of the Garden of Love, in which Tuscan painters developed aspects
of a familiar topography to make new allegories expressing the rewards of
love.

That fifteenth-century Gardens of Love, like twentieth-century atoms,
could be split up into their basic components, a salver from the 1430s proves
(pl. 63). The Master of the Bargello Tondo takes his name from this circular
panel in Florence, which represents the judgment of Paris.[1] In the back-
ground Paris and a companion observe Juno, Minerva, and Venus, who
quarrel over possession of the golden Apple of Discord. In the foreground
Paris awards the prize to the goddess of love. Cupid enlivens both episodes
of this continuous narrative: first he soars through the distant grove toward
the seated goddesses, and then he engages another putto in conversation as
Paris rewards his mother. Literally, this landscape represents Mount Ida,
not far from Troy, where Paris long lived in obscurity as a shepherd. The
stream trickling through the foreground plain must then represent the river
Xanthus.

During the 1430s the Master of the Bargello Tondo depicted the judg-
ment of Paris in a quite different fashion. A salver formerly in Paris, not

illustrated here, presents the story as a twofold narrative, as in the Bargello tondo, except that Paris has no companion and Cupid no brother amorino. Moreover, Cupid appears only in the background episode. Instead of cleaving the pictorial surface horizontally by separating grove from plain, the painter here devised a more naturalistic setting dominated by the wooded summit of Mount Ida, set against a distant view of Troy. A rude hut sheltering the factious goddesses and a tiny bagpiper peeping through a thicket suggest the site's rustic character.[2] The only feature of this landscape carried over to the Bargello *Judgment of Paris* is the simple stone wellhead that serves as the source of the river Xanthus. This was a common convention denoting pastoral nature, as Ghiberti's *Abraham* relief from the Gates of Paradise indicates.[3] In the Bargello tondo, however, the configuration of wellhead and spreading tree has a familiar secular look to it. In fact, it resembles primitive essays in symbolic landscape from the Trecento (pl. 16). Moreover, the grove where Paris and his friend sit looks like the background of the contemporary *Garden of Love* in Princeton (pl. 52). In depicting the legend of Paris, the Master of the Bargello Tondo did in fact fragment the Garden of Love, a symbolic landscape that he would use in more unified fashion for the *Susanna* of 1447 (pl. 61).

The textual sources for the judgment of Paris explain the disjunctive landscapes of the Bargello tondo. Rather than relying wholly on medieval versions of the legend of Paris popular at the turn of the fifteenth century, the painter and his unknown patron turned to accounts of the story from classical Latin poetry. Nothing but Epistle XVI of Ovid's *Epistulae* or *Heroides*, for example, accounts for the man who sits beside Paris in the grove. He is Mercury, messenger of the gods, sent by Jove to Mount Ida to urge Paris to decide which goddess is fairer than the other two. As Ovid specifies, Mercury comes equipped with a golden staff, the "aurea virga" depicted here.[4] Whoever ordered this painting must have been in touch with recent humanistic discoveries, because this section of the *Heroides* did not come to light until the early Quattrocento.[5] A second metrical epistle, *Heroides* V, accounts for the configuration of tree and wellhead in the foreground. Ovid makes Paris's first love, the fountain nymph Oenone, berate him for preferring Helen to her. She laments that Paris was wont to carve their names on Ida's trees:

> I know a poplar at the river's edge
> Where once you carved the letters of our pledge;
> Poplar beside the bank, live long, I pray
> And on your wrinkled bark these words display:
> "When Paris can Oenone leave and live,
> Back to his source Xanthus will waters give."[6]

These words drip with bitter irony, because Paris does in fact leave Oenone

for Helen, but he does not live, because the fountain nymph refuses to heal him after he suffers mortal wounds during the Trojan War. Although hardly poplarlike in form, the bushy tree at the river's edge in the Bargello tondo does display the disheveled fronds typical of symbolic evergreens in Florentine secular art (pls. 34, 51). Emphasizing this arboreal footnote are the diminutive figures standing beside the stream. One putto points to the tree while his mate, whose winglike epaulets identify him as the Cupid soaring through the grove, indicates the flowing river. We may easily imagine their conversation: as one reminds his brother that Paris is a fickle lover, the other demonstrates that Xanthus still runs in his course. If their conversations can be read as a dispute, as the debate of the goddesses above certainly is, then the wingless boy might well be the first Renaissance Anteros, frequently misconstrued during the fifteenth century as an opponent of Eros, the son of Venus.[7]

If the tree shading a spring recalls the love of Paris and Oenone, then the grove where Paris sits must indicate more amorous aspects of his story. In *Heroides* XVI, Ovid depicts Mount Ida as a *locus amoenus*, complete with dark groves and grassy lawns.[8] Following a now familiar pictorial method of textual emendation, the Master of the Bargello Tondo renders this locale as a stand of apple trees abundant with fruit sacred to Venus herself. Moreover, the painter indicates that Paris has made up his mind in this same shady place, because Cupid flies through the trees, not to wound anyone with his arrows but, like the Angel of the Annunciation, to bring momentous tidings—namely, who will win the Apple that all desire.[9] Paris has already decided in favor of Venus, thereby preferring love to wisdom and power, and the voluptuous life to all others.[10] Merely by sitting idly in a place habitually dedicated to Priapus, as Arcita did in Boccaccio's *Teseida*, Paris predisposes himself to vote for the goddess of love and thus sets in motion a momentous chain of events.

Contemporary with this allegorized narrative is a group of allegorical landscapes devised by Giovanni di Marco several years before his death in 1437. The finest of these, a panel preserved in Cracow, shows two amorous couples strolling through a meadow shaded by tall slender trees (pl. 64). To the left a youth gently urges his lady into this garden, while at the right a knight clasping the hand of his charming companion gazes intently into her eyes.[11] The Cracow allegory is a fragment from a larger panel, now destroyed, which would have closely resembled a cassone by Giovanni di Marco that is now in Paris (pl. 65). Here four pairs of lovers stroll side by side across a grassy plain bordered by hedges and punctuated by carefully trimmed trees. The garden spills into the cassone's frame as a lawn where two more lovers, a soldier and a lady, stand and serve as armorial supporters.[12] Two more fragments from cassone panels of this type once survived in private English collections.[13] In all instances the garden sparkles with tiny clusters of white

flowers; trees laden with golden fruit loom darkly against an ornamented gold ground. Like the Master of the Bargello Tondo, Giovanni di Marco reached back to the early Trecento to fabricate this landscape. His neatly arranged trees and hedges repeat the conventions of medieval palace decoration (pls. 34, 36).

In devising this distinctive iconographic type, Giovanni di Marco did not create a Garden of Love, as Paul Schubring and other authorities persistently maintain.[14] Here no fountain plays and here the sexes are evenly matched. Nor did Giovanni di Marco intend to paint scenes of genre, as Van Marle believed.[15] The golden sky, precisely aligned trees, and exact symmetry of figural composition ensure that these landscapes are remote from everyday experience. Numbers further determine that the garden is symbolic: only three trees grow in the Paris cassone, while ten lovers find shelter beneath their branches.

A further clue to the painter's intentions lies in the costumes the lovers wear, extravagant even by the cosmopolitan standards of the early Quattrocento. Wrapped in flowing mantles and covered by loosely draped turbans, the ladies seem outlandish by comparison with even the most aristocratic women frequenting the Garden of Love. Similarly, male civilian attire has little to do with conventional lovers' garb. Moreover, soldiers win admittance to this garden, wearing armor much more fanciful and conspicuously *all'antica* than the battle gear of the 1430s. Giovanni di Marco's costumes, in fact, anticipate the elaborate confections appearing in Renaissance visualizations of "history," cycles of *uomini famosi*. To cite a specific example, these lovers resemble the kings, warriors, and queens from the Florentine Picture Chronicle of the 1460s, now in the British Museum.[16] Giovanni di Marco's garden, then, is a place reserved for men and women famed in history of a sort.

Recently Jan Bialostocki has attempted to identify several of these famous lovers by name. Arguing from elements of Arthurian legend, he claims that the soldier at the right in the Cracow panel, wearing a crested helmet, was Tristram, with his lover, Iseult.[17] If the painter were well versed in chivalric lore, then he would have given that lady a queen's diadem. Moreover, he seems to have altered identifying attributes, such as crests and weapons, almost at will, as a glance at the Paris cassone will show. Giovanni di Marco seems to have used no consistent method of identifying his heroes, nor did he include inscriptions or *tituli* to aid the viewer. Probably the painter never intended to specify his cast of characters, presenting them instead as "famous lovers" in much the same way as he characterized the denizens of his *Garden of Love* (pl. 55) simply as "lovers." What matters, then, is the general assembly of amorous worthies and the verdant landscape where they gather.

A cycle of *uomini famosi* nearly contemporary with Giovanni di Marco's

cassone panels sheds some light on his invention. In the same Piedmontese castle where the Fountain of Youth appears (pl. 59), Jaquerio painted frescoes depicting the Nine Worthies of medieval legend and their feminine counterparts, the Nine Heroines.[18] Our illustration shows the masculine side of this gathering (pl. 66). As in Giovanni di Marco's panels, figures elaborately bedecked converse in a garden, limited to a flower-strewn lawn and tall trees whose leafy branches interlace. Here Jaquerio celebrates fame won by military valor. His worthies assemble in a garden set outside of time because fame itself is everlasting, as eternal as the laurel wreath worn by a conquering hero, or the greenery of Elysium where virtuous men dwell.[19] There can be, of course, no possibility of a direct connection between the frescoes at Manta and Giovanni di Marco's paintings; their strong visual similarities may be explained by a common heritage in medieval palace decoration. Nevertheless, the analogy remains instructive: like Jaquerio, Giovanni di Marco devised a garden denoting fame but here reserved for worthies whose amorous exploits have won them renown.

Giovanni di Marco also tapped a long-lived poetic tradition in Western literature. His couples parade in an erotic Elysium, a paradise for those worthy in love, like the laurel-shaded garden Tibullus described or the verdant realm of Amoenitas which Andreas Capellanus reserves for those most faithful to Love's commands. Even closer to the paintings is a passage from the Triumph of Cupid Boccaccio delineates in the *Amorosa Visione*. The setting of this fictive fresco is "a newly growing meadow, which I saw there turning all that part green, and in like manner full of flowers, adorned too with many trees newly growing; so that to be there seemed joyous and full of grace."[20] This garden, then, is in the tradition of Elysium, a paradise for those who love. Here appear Cupid and his followers, a great crowd of lovers, some sad, some elated, all full of hope. There follows a lengthy description of the amours of pagan deities, which concludes with a brief account of more recent amatory heroes who stroll through the garden. "There I saw Lancelot depicted with her who for so long was his glory. And there after him, on his right side, was Tristram, and she by whom he was made to fall in love, more than any other."[21] Like Boccaccio, Giovanni di Marco unites famous lovers and their companions in an erotic paradise, where happiness is forever attained. Boccaccio's *Amorosa Visione*, incidentally, inspired at least one other cassone painter of the early Trecento, an unknown Florentine close to Agnolo Gaddi who depicted a Triumph of Fame, not illustrated here, based on another fictive fresco preceding the Triumph of Cupid. Most authorities assign this panel, formerly in Munich, to the youthful Giovanni di Marco.[22]

In devising his paradise for legendary lovers, Giovanni di Marco might also have been influenced by earlier secular paintings in which followers of Venus gather in a garden. An example is a birth salver in the Louvre depicting the goddess of love with famous warriors (pl. 67). Resembling it in

composition and imagery is the circular lid of a coffer from the same museum, dated by inscription 1421 (pl. 68). Besides the dominating figure of Venus, attended by diminutive followers, the paintings share a garden that lacks a fountain.

Problems of style constitute a major stumbling block to understanding the content of these panels. Most scholars designate the salver as north Italian, putting it somewhere in the first half of the Quattrocento.[23] But the costumes of Venus's worshipers—tightly fitting tunics belted at the hips, fluttering capes cut short, peaked hats, and plate armor almost *cap-à-pie*—indicate that it should be placed in the declining years of the Trecento. The panel comes about a decade or so after the drawings illustrating the Capponi *Decameron* (pls. 13, 14) and the Douai *Garden of Love* (pl. 51). Given this early dating, there is no compelling reason to search for the artist in Lombardy, a region where painted birth salvers seem to have been unknown around 1400. Not surprisingly, the youthful blond knights have a Tuscan air to them, a cast of feature somewhere between the participants in the earliest Garden of Love and the immured gallants of Mariotto di Nardo's *Teseida* (pl. 60). Even more specific parallels can be found between the Venus salver and the early work of Mariotto (who began his career in the 1390s), paintings by Bicci di Lorenzo, and a panel by a follower of Giovanni del Biondo, who died in 1398.[24] The master of the Venus salver, then, was a Florentine who depended on the work of a rather cheerless generation of painters active at the turn of the century.

Most authorities consider the 1421 coffer to be Umbrian or Lombard.[25] Over thirty years ago, however, Millard Meiss suggested that it be given to Giovanni di Paolo of Siena.[26] Although that specific attribution has not won critical acceptance, his perception that a Sienese master was at work here is accurate. The smooth oval that is the face of Venus, made piquant by a small and slightly pouting mouth, appears frequently in the work of Paolo di Giovanni Fei, who died in 1410, and Andrea di Bartolo, who remained active until 1428.[27] Other mannerisms of drawing, figural type, and landscape securely locate the master of the Venus coffer in Siena during the 1420s. He seems to have been the city's counterpart to the Master of the Bargello Tondo, a Tuscan well versed in the graces of the International Gothic style.[28]

The salver and the coffer are close in time and space. They should now be considered as surviving examples of an iconographic type whose development is roughly contemporary with that of the Garden of Love. Each painting has heretofore received scholarly attention as a work of art in isolation, with emphasis on the iconography of Venus. The historical situation linking these works justifies a new approach stressing the gardens reserved for the followers of Venus. As much as the great goddess who hovers over her devotees, symbolic landscape defines the salver and the coffer as an erotic paradise promised by Venus.

More heavily populated than the Sienese coffer is the Florentine desco, where six warriors kneel in a garden, or more precisely a late medieval jungle. Inscriptions embroidered on their surcoats identify them as Achilles, Tristram, Lancelot, Samson, Paris, and Troilus. The hero of the *Iliad* is at the far left, the protagonist of Chaucer's *Troylus and Criseyde* at the extreme right. Trojan and Greek, Christian and Jew, become one in the adoration of Venus. Above them levitates the goddess of love, resplendent in an aureole of light, winged, crowned, and totally nude. From her "queynte" flow clusters of golden rays, which touch the parted lips of the knights below, truly a remarkable species of Holy Communion.

In a detailed study of this salver, Eugene Cantelupe has observed that the painter freely appropriated the conventional formulas of Christian art. The compositional pattern, for example, repeats that of the Assumption of the Virgin.[29] It may also be noted that bearded Samson emulates the attitude of doubting Thomas, who in Tuscan Assumptions sometimes spreads his hands to receive the Holy Girdle. Even more outrageous is the gesture Venus makes as she extends her shapely arms, imitating the Man of Sorrows who displays his wounds.[30] The desco thus becomes an *Ostentatio Veneris*.

Borrowings from Christian art do not necessarily mean that the painting must bear a Christian message, as Cantelupe claims, or even that we should strain to discern elevating spiritual content here. The early date of the Venus salver aligns it to a vast number of medieval works of art that play with sexual images. An instructive counterpart to this painting is a contemporary German coffer depicting a woman who plucks penises from a tree![31] Moreover, the rays linking Venus and the knights correspond to a long-lived motif in folklore; in a Florentine engraving from the middle years of the fifteenth century, for example, young men ignite their torches from the genitals of a Roman prostitute who had entrapped Virgil.[32] At least this Venus generates light as well as heat. Furthermore, Tuscan poets of the Trecento often sing of the provocations of nudity. Describing the wanton Venus who governs lust, Boccaccio says that she is unclothed because the sight of bare flesh spurs on the libidinous: "the naked part of Venus signifies the surface appearance of things, which attract the spirits of those who cannot pass on to reality."[33] The knights in the meadow undoubtedly are attracted to a specific aspect of the surface appearance of things. This painter, then, used Christian imagery to give emphasis to a secular doctrine, the power of sex. Although Venus may emulate the Man of Sorrows, she remains Our Lady of Pleasures.

The Cupids flanking Venus further demonstrate the power of love. Like their mistress, these putti are nude but unlike her they have clawed feet, resembling the talons of a bird. Amor's claws are a Trecento addition to Cupid's attributes, signifying the fierce, even demonic, tenacity of love, according to Panofsky's classic study of blind Cupid. Fully enunciating that

doctrine in the late fourteenth century is Boccaccio's mythographic encyclo-
pedia, the *Genealogy of the Gods*.[34] An earlier text not without relevance for
this painting comes from Boccaccio's *Filostrato*: "Love is a greedy spirit;
and when he seizes anything, he holds it in great strength and so firmly in
his talons, that in vain it thinks to free itself."[35] So Criseida of Troy castigates
Cupid as she lies in bed embracing her lover, Prince Troilus, who adores
Venus and her taloned attendants in the birth salver.

Numbers also reveal the power of Venus. Two Cupids accompany Venus
here to swell the number of amorous deities to three. Twice that sum gather
in the meadow below, neatly grouped in triads separated by an apple tree.
As in the Garden of Love, three signifies the workings of love in general and
the effects of Venus in particular. We recall that her planet is the morning
star, the third planet in the universe if you travel, like Dante, from the earth
upwards. Dante himself spells out Venus's power in the *Divina Commedia*:

> 'Twas once believed that the fair Cyprian, whirled
> Radiant in the third epicycle, shed
> Love's madness on the yet unransom'd world;
> By which old error men of old were led
> To honour her.[36]

Dante's characterization of the star that gazes amorous-eyed weds the sym-
bolism of numbers and the stars. Of particular importance for the salver is
the poetic notion that Venus sheds love's madness, "il folle amore / raggiasse."
Here the painted goddess of love sends out rays to men of old. Dante's
glossators dwell on the kind of love this Venus sheds, specifying that "folle
amore" means unbridled sexual desire.[37]

Observing that our nude goddess resembles many late medieval repre-
sentations of planetary Venus, Panofsky and Cantelupe have argued that
the whole panel is a species of *Planetenkinderbild*.[38] In astrological images
of this sort, a planet is personified as one of the Olympian deities set up in
the heavens to preside over the characteristic activities of mortals subject to
them on earth below. Hence the children of Mars make war, the children
of Mercury works of art. Two objections, however, can be raised to this
argument. If the Venus salver dates from the late Trecento, it is much
earlier than any known *Planetenkinderbild* from Italy. More important, the
knights depicted here do not do what the children of planetary Venus custo-
marily do, that is, sing, dance, make love, dally in courtship, and enjoy
mixed communal bathing.[39] These heroes lack their ladies, a serious impedi-
ment to love-making. If the master of the Venus salver actually borrowed
from astrological images, he did so selectively as a way to demonstrate the
power of Venus.

Overlooked in previous discussions of the salver is a small detail that
unlocks the meaning of the painting. The two claw-footed Cupids, equal in

every other respect, are mismatched in their weaponry. The putto at the left displays a bow and two arrows, his companion but one shaft. This trio of arrows complements the general numerical pattern governing the painting. A sonnet, "O tu, che porti nelli occhi sovente," which Guido Cavalcanti of Florence penned late in the Duecento, explains its deeper significance. Likening the experience of falling in love to the effects of the arrows Cupid launches, Guido claims that the god of love needs only three darts:

> The first gives pleasure (and discomfort) and the second desires the virtue of the great joy which the third brings.[40]

Cupid's three arrows, then, bring mortals under his dominion because of the immediacy of pleasure, and keeps them enthralled because of promised joys to come.

Present power and the promise of pleasure are also the key themes of the Venus salver. As in Dante's evocation of the amorous planet, men of old honor Venus by worshiping her. The putti accompanying her display the fatal weapons that once brought them, and that continue to bring all men, to this state. Yet adoring Venus is no dolorous rite. The knights are blithe; happily they partake of their communion. Tempering the fearful tenacity of passion is the desire for "gran gioia," represented by the claw-footed putto bearing the third of Cupid's arrows.

The garden where the knights honor Venus further connotes amorous power and pleasure. For this landscape Cantelupe offers a flurry of interpretations, suggesting that it pertains to Venus in her aspect as a planetary deity, that it alludes to her role as goddess of springtime, that it symbolizes fecundity (appropriately enough for a birth salver), and even that it is a Garden of Love.[41] Admittedly, a garden may mean virtually anything in late medieval art, but the "signification abstraite" of this place can be pinned down with some precision. First of all, clumps of fruitful trees heavy with apples establish the garden as sacred to Venus herself. It exists beyond the normal experience of time, since men from all periods of human history gather here. Moreover, these warriors have committed fornication, adultery, and rape, as well as martial feats, on behalf of the goddess of love. Paris, for example, is not the callow shepherd of the Bargello tondo but a seasoned soldier who abducted Helen and precipitated the Trojan War. Because of his devotion he has joined his Greek foes in a kingdom beyond time. The garden, then, is sacred to a deity but open to virtuous mortals. As such, it is like the Christian Paradise. It resembles also the Elysium for legendary lovers that Giovanni di Marco was to paint in the 1430s. Here, however, Venus ideally replaces these worthies' consorts. The garden symbolizes the potential delights of sexual love, established by the powers of Venus. Indeed, we look upon

the "orti di Venere" celebrated by Agapes in Boccaccio's *Comedia delle ninfe fiorentine.*

This Paradise of Venus set a precedent for the Sienese coffer of 1421 (pl. 68). Now sumptuously clad, the goddess once more appears in majesty above a garden reserved for her devotees. Here the garden is restricted to a grassy meadow while the worshipers have become contemporary ladies, not famous men of old. Yet the rules of number symbolism are precisely observed, three mortals adoring three amorous deities. Although no golden rays shower down upon them, the ladies adopt attitudes of reverence. At the center of the garden a woman in profile genuflects, her crossed arms repeating Troilus's reverent pose, as her companions praise the goddess with the music of tambourine and lute. Encircling this painting is an admonitory inscription that might well have embellished the earlier desco:

> Chi vole vivere felice ghuardi chostei
> che glie sugieto Amor e tutti gli altri dei.

("Whoever wishes to live happily should look on her to whom are subject Love and all the other gods.") This couplet spells out the coupling of present power and promised joy combined in sexual passion that the imagery of the Venus salver implies.[42]

The coffer of 1421 is seemingly a much more discreet celebration of Venus's might than its late Trecento predecessor. This change can be attributed to a general tendency of the early Quattrocento, a shift from earthy to elegant images observed previously, for example, in the development of the Garden of Love. The coffer's chaste presentation of Venus is also specifically appropriate to these worshipers, highborn ladies, not virile warriors. We can hardly expect ladies in 1421 to adore a "queynte." Nevertheless, the painting subtly implies sexual delights to follow. The genuflecting lady wears the same puffy turbanlike headdress as Venus, a covering worn also by the victor in the Bargello's *Judgment of Paris* (pl. 63). The principal worshiper literally imitates her deity. Like admonitory saints in an altarpiece, two blindfolded Cupids point to the goddess herself. She in turn hands over to them the weapons of love, delegating her powers to these mischievous imps. This courtly ritual demonstrates that even Amor becomes subject to Venus. It also means that in response to her subject's prayers Venus is about to inaugurate the hunt of love. On the sides of the coffer unfolds the chase (pl. 69). Hounds bound after stags, familiar symbols of love-stricken men entrapped by feminine wiles. The ladies adoring Venus await their men in a green meadow, a place where one might well live happily.

As its heraldic decoration suggests, this coffer was painted for an unmarried woman.[43] It is likely, in fact, that an unknown Sienese maiden was

shortly to change her status sometime in 1421. Small objects like this were often commissioned at the very beginning of marriage negotiations as containers for expensive presents, such as girdles, mirrors, and combs, which a prospective groom would send to his future bride at the time of betrothal. The coffer served symbolically as a token of love suddenly engendered by the charms of the bride-to-be.[44] This casket's images of Venus, cupids being armed, and stags hunted down, are appropriate for the inception of wedlock. Similarly, the more overt sexual imagery of the Venus salver commemorates the ineluctable outcome of sexual activity, childbirth. Whether the goddess of love be deliciously nude or splendidly gowned, her place is in the nuptial chamber.

> The ties of family bind even longer
> When Venus tightens them to make them stronger;

so Ovid cheerfully claims in the *Heroides*.[45]

If this Sienese painting shows a paradise ruled by Venus where joy may be attained, then another betrothal coffer from the same city indicates the proper way to enter paradise. Around 1438 Domenico di Bartolo depicted a rite of courtship held in a flowery meadow, a youth offering his heart to a lady (pl. 70). This is the circular lid of an exquisite casket destroyed, alas, during World War II. On the sides (not illustrated here) were inset medallions devoted to the chase. Two hounds attack a doe, a lion dispatches a stag, and an eagle assails an ox. Splendid in a golden collar, a leopard displays a scroll inscribed "Un puro amor vol fe." The general organization of Domenico's object follows that of the 1421 Venus salver. Moreover, the allegory adorning the lid looks as if the painter had removed Venus, slightly altered the cast of characters and retained the simple garden landscape. Instead of showing the might of Venus, Domenico di Bartolo set forth the perils of love relieved by the promise of everlasting joy.[46]

The motif of a young man offering his heart to his mistress was a commonplace of the late Middle Ages, as the decorations of a German coffer discussed three chapters ago indicate (pl. 29). Undoubtedly Domenico di Bartolo knew instances where this motif occurs in isolation, such as a French ivory of the early fourteenth century (pl. 71). Here a lover presents his gift with all the solemnity of a priest elevating the Host.[47] From northern Italy comes a much battered ivory of the late Trecento (pl. 72). Bawdiness now triumphs over grace; eagerly the lady thrusts herself forward to receive the heart as her suitor blatantly strokes his weapon.[48] Domenico di Bartolo restores something of Gothic grace while endowing an old subject with new content. The lady becomes tall, aloof, almost disdaining her companion, vividly clad in blue, who presents his heart with diffidence.

A syllabus of inscriptions elucidates this Sienese *istoria*. Between the

lovers curls a scroll, whose much abraded inscription records the young man's thoughts:

> Borea . . . v . u te piu degnia. dum tanto dono . . . quanto lo quore mio ti rend. dir ca lui sia beningnia.

A provisional paraphrase reads: "The north wind has made (my soul?) more worthy of you. Of such a gift . . . as my heart is I render to you. Say that you may be benign to it."[49] A second record of the lover's inner state is a device embroidered upon his sleeve; around a blasted tree winds a scroll inscribed "per la forza delli contrari venti." Running round the side of the lid, and consequently not visible in Plate 70, is an admonitory verse referring to this scene of courtship and addressed to all courting lovers. A transcription indicates that this exhortation is abbreviated nearly to the point of obscurity:

> S. glon degli och raggi ciascum core
> la dov alberg amore.
> Fair vidar lieto
> si chom consueto
> e di chi ben amar mostra colore.

Again, a paraphrase might read: "The rays of the eyes shine into every heart, there where love dwells. Decide then to be happy, as is the custom. And whoever wishes to love well, let him show his color."[50] Finally, the leopard indicates that a pure love requires faith.

These inscriptions derive their phrasing, and some of their imagery, from popular verse of the late Trecento, as Ezio Levi has demonstrated.[51] More directly explaining Domenico's exhortations, rhymes, and devices is the lyric verse of the great founders of Trecento poetry, Dante, Petrarch, and Boccaccio. The first-named poet, for example, often characterizes love's beginning as a lady's glance—"the rays of those beautiful eyes have entered into my enamoured ones."[52] He also defines the heart as the place where love dwells, "dove Amore alberga."[53] The opening couplet of the exhortation, then, is a conventional declaration of how love begins.

The closing verses of the exhortatory rhyme seem to be merely a light-hearted command to follow love's dictates. Poetic custom, however, shows that the injunction contains hidden ambiguities. The clause "e di chi ben amar mostra colore" may echo Dante's line "lo viso mostra lo color del core."[54] Nevertheless, it does not necessarily follow that showing the colors means displaying a ruddy countenance. In another lyric Dante likens the lover's true color to the hue of death.[55] Similarly, Claudian included "Pallor that is the lover's badge" among Venus's retinue on Cyprus, while Ovid enjoined "Let every lover be pale, for this is the color fit for lovers."[56] If the

young man Domenico di Bartolo painted be any indication, then the color lovers should display is a pallid one. Before you can enjoy love, you have to undergo suffering. Smitten by the lady's bright eyes, the youth has fallen painfully in love, trapped as tightly as the stag on the coffer's side. The lover's subsequent action is best explained by Petrarch: "O my sweet warrior, I have a thousand times offered you my heart just to make peace with your beautiful eyes."[57] Wan, diffident, dejected, the youth faithfully follows the well-worn rules of love.

"Dejected" seems too mild an adjective for a lover about to drown in despair. His emblem is a barren tree blasted by the force of adverse winds, hardly a hopeful device. In poetry of the *dolce stil novo*, a dry tree sometimes symbolizes the anxieties lovers must necessarily suffer, sometimes the vain hopes they harbor. In either case the tree loses its verdure because it is too heavily laden to begin with or because of the seasons' natural rhythm.[58] "Per la forza delli contrari venti," however, implies a more rigorous chastisement, like that meted out to the lustful whom Dante saw in the fifth circle of Hell, "se da contrari venti è combattuto."[59] The scroll recording the lover's petition also informs us what has blasted his tree, namely, the north wind, Boreas. Petrarch dwells on the rigors of this wind, associated with the most horrid days of winter when the sun almost disappears.[60] If the north wind is against you, then you have every reason to lose heart.

Once more the verses shelter ambiguities. Dante observes in the *Paradiso* that the fierce north wind has a gentler side:

> As when the dome of air more lovely grows,
> By Boreas serene and shining made,
> When from his milder cheek he softly blows,
> Purging and scattering the murky shade
> Wherewith the sky was stained until, made clean
> It smiles, with all its pageantry displayed.[61]

Thanks to these verses, we can now understand the lover's petition. Just as Boreas purges the sky, it will chasten the young man's soul, making it worthy of love. That love implies such chastisements, a sonnet by the Duecento poet Lapo Gianni demonstrates. Humbly he thanks Love for the tribulations he has suffered because they have made *him* worthy to be a lover and thus to be loved. After purgings come rewards.[62]

The amorous leopard displays a scroll foretelling that the lover's despair will not long endure. His motto, "Un puro amor vol fe," anticipates by at least thirty years a device made famous by Lorenzo the Magnificent, "Che vuol fede amore."[63] It also repeats an epigram penned by Boccaccio two generations before Domenico di Bartolo painted this coffer. His ballad, "Amor, che con sua forza e virtù regna," enumerates the rewards granted to lovers by their mighty sovereign:

Love, who reigns with force and virtue, lives forever in an exalted ardent heaven, and makes the noble soul worthy of him. He rules my life and that which my hand writes my devout heart displays to his divinity. . . . Love requires Faith and with him are bound Hope with Fear and Jealousy, and always Loyalty and Humanity.[64]

Boccaccio's terse "Amor vol fede" alludes to a relationship between Love and his subjects that is essentially feudal. On one level, then, the leopard's device refers to the might of love, an idea given visual form in the Paradise of Venus. If Love is granted Faith, so Boccaccio claims, then like a good over-lord he will reward faithful servitors with joyous hearts. His yoke is mild: "Trophies he does not seek, nor kingdoms nor high state, but only good-ness and an amorous desire, with pure faith."[65] Faith really means the bonds binding societies together, bringing lord and vassal, lover and lady, into a harmony sweetened by benefits mutually exchanged. Presiding over that peaceable kingdom is a pure, virtuous Love, not to be confused with love construed as lewd passions. The leopard's motto, "Un puro amor vol fe," states the condition necessary for entry into an amorous paradise.

By means other than literary, Domenico di Bartolo demonstrates that the young man's present despair will give way to joy. Despite her cool demeanor, his lady actually reaches for the heart with all the grace of Venus accepting the golden Apple of Discord from Paris in the Bargello Tondo (pl. 63). Her acquiescence accords with a well-established medieval tradition. In the French fourteenth-century ivory representing the offering of the heart (pl. 72), for example, the lady signals her acceptance of love by crowning her suitor with a garland. Here these reticent lovers indicate that love's true color will be sanguine, after all.

Contrasting with the dry tree stripped bare by adverse winds, the lover's emblem of despair, is the meadow, green, luxuriant, even unweeded, where the lover and his lady stand. As we have observed, this grassy lawn resembles the garden sacred to Venus where her servants await happiness in the coffer of 1421. Through admonitory inscriptions both Sienese paintings imply that the simple garden symbolizes joy: *fair vider lieto*; *chi vole vivere felice*. The juxtaposition of allegorical landscapes anticipates also the Martin Le Roy *Garden of Love*, where a barren tree stands outside a verdant meadow. If Domenico's simpler garden implies sensual joy, then it appropriately adorns an object associated with the initial stages of marriage.[66]

Analogous to Domenico di Bartolo's panel is a contemporary allegory of love from northern Italy (pl. 73). During the 1430s Bonifacio Bembo char-acterized the card "Amore" from the tarot deck as two lovers united in a meadow, illustrated here by an old engraving that brings out the painting's intricate detail better than most modern photographs.[67] Bembo's allegory represents a phase of love-making subsequent to Domenico's. Before a pavilion the lover and his lady join hands; above them a blindfolded Cupid displays

his darts, below a dog capers in the tufted grass. This image harks back to Trecento precedents, such as the loving couple of the Untermyer gittern (pl. 18). Some borrowings from classical art, most noticeably the couple's handclasp recalling the Roman ceremonial gesture of *dextrarum iunctio*, indicate that a wedding ceremony is enacted here. The shields encircling the pavilion alternate the cross of Savoy and the viper of Milan, a reference to the nuptials of Bianca of Savoy and Duke Filippo Maria Visconti of Milan in 1429. The device embroidered on the youth's extravagant hat, "A MON DROIT," securely identifies him as Duke Filippo. Another *impresa* shows that Cupid arranged this union, because the Duke wears on his sleeve a Fountain of Love. The little dog crouching at their feet must refer, then, to marital fidelity, like the beast crouching at the feet of Ilaria del Carretto (pl. 46). The meadow where this marriage takes place serves as a symbol of love consummated. It may also be an augury of fertility, like Duchess Bianca's gown, liberally strewn with flowers. Like Domenico di Bartolo's garden, Bembo's landscape alludes to the grace granted by the gods of love.

The panels from Tuscany here assembled, from the Master of the Bargello Tondo's *Judgment of Paris,* to Domenico di Bartolo's *Offering of the Heart*, are all distinguished by gardens without fountains, like the Garden of Love minus its central feature. Losing a fountain, however, implies no diminution of symbolic content. Depending on specific figural activities, the simple garden denotes love and connotes a specific aspect of love, joy. Pleasure may be awaited or it may already be attained. In either case, pleasure depends on the benevolence of Venus and her son.

The paintings also share a style that is remarkably archaizing, even for the general run of paintings by little-known masters from the early Quattrocento. The splendor of golden backgrounds, sometimes elaborately tooled, the confrontation of greenery and gold, an insistence on exact symmetry, all look back to pictorial styles and decorative patterns current in the last half of the Trecento. Giovanni di Marco remembers palace decoration, Domenico di Bartolo the conventions of ivories. The contemporary Garden of Love, by contrast, follows a more up-to-date phase of medieval art, the International Gothic style. Perhaps the archaisms were deliberate attempts to suggest the far-off splendor of an erotic paradise.[68]

The Bargello Tondo and the Visconti tarot card suggest yet another aspect of amatory imagery developed in the early Quattrocento. In both paintings the Fountain of Love exists essentially in isolation. Although bereft of a garden, the well still retains symbolic value. These paintings should now be linked to a larger group of panels, representing fountains set in forests, which, like simple gardens, vary the theme of the Garden of Love.

8

Hunting for a Fountain:
Venus versus Diana

CONTEMPORARY with the Florentine development of the Garden of Love are several coffers, chests, and salvers showing a fountain, which serves as the focus of a chase through a sylvan landscape. These objects fuse an amatory symbol, the Fountain of Love, with an erotic theme, the hunt of love. Hunting for the Fountain of Love becomes an allegory depicting how love begins, as opposed to simple gardens without fountains, symbols of how love may end. Unexpectedly the chase leads us, like Actaeon, to a fountain like love's font, which Diana defends. Love and chastity come into open conflict.

This serendipitous expedition may begin with a Florentine coffer produced during the late Trecento (pl. 74). Shaped like a cassone, or more precisely a reliquary chest, this small object is richly decorated with reliefs painted azure and gold.[1] On its front side runs a chase, entangled in graceful rinceaux of oak leaves. To the sides hunters blow horns and unleash hounds, while at the center more dogs pounce on fleeing stags. The curved sides of the lid display a mélange of chivalric events. At the left mounted knights joust, at the right more warriors escort several ladies to the tourney, and in the center two women guard a hexagonal fountain. These events recall the narrative sequence of a very early Florentine chest showing lovers at the chase and by a fountain (pl. 16). One of the vignettes from the hunt below, a stag looking back at a dog who claws its haunches, repeats almost line for line a drawing from the Morgan Library's model-book (pl. 75). Hoary Trecento patterns here receive a new configuration. A naturalistic motif from the model-book is associated with chivalric pursuits and with a fountain much like the central feature of the Douai *Garden of Love* (pl. 51). The well now becomes the goal of an amorous quest, possibly based on an Arthurian ro-

mance that has eluded identification.[2] The hunt after stags anticipates the ancillary decorations of the Venus coffer of 1421 (pl. 69). In a tortuous fashion the reliefs allude to the course of love in general and to feminine attractions in particular, an allusion suitable for a coffer probably intended as a betrothal gift.

A less inchoate reference to love in general and to one lovely lady in particular is an inscription carved upon the top surface of this casket's lid, "Onesta e bella." It is pleasant to note that such compliments to charm and virtue reconcile qualities long held to be mutually exclusive. At the beginning of the fourteenth century Bartolomeo da San Concordio, we recall, asserted that "Bellezza" more often than not was inimical to "Onestà." The epigraphic refutation of the *Ammaestramenti degli antichi* on a coffer at the end of the century depends upon the verses of the great Tuscan poets. Petrarch, for example, laments the departed Laura:

> Two great enemies, Bellezza and Onestà
> Had been brought together with so much concord
> That her holy soul felt rebellion no more.[3]

The union of opposites caused the poet to fall in love, first through the efficacy of "Bellezza," her fine eyes "whence so many amorous darts were wont to sally,"[4] and then through "Onestà," defined as an ideal of virtuous behavior: "Gentle deeds, and speech wise yet humble."[5] Of necessity the coffer's motto simplifies Petrarch's thought, endorsing more wholeheartedly than he the virtue of love.

A chase involving a fair lady, stags, and a fountain is the theme of a cassone panel fabricated during the 1430s, perhaps in Tuscany (pl. 76). Organizing the gilded plaster surface of the chest are two repeated decorative motifs, small tendrils of interlacing foliage and large pairs of addorsed deer, both framing figural scenes.[6] Although the scrolls anchored to the stags' antlers are no longer legible, the allegory can easily be read. To begin with the subsidiary scenes: to the left a hunter in a thicket aims his bow while at the right a beast expires beneath a tree. As in the Trecento coffer inscribed "Onesta e bella," we here observe a seemingly ordinary sylvan chase. The hunt continues in the larger scenes. At the extreme right an elegantly gowned lady directs her bow leftwards, as a dog roars after his prey in the background. At the far left, a young man staggers from a mortal wound, his breast pierced by an arrow, as a dog in the thicket behind bays at a porcine beast. The chase goes on, but now a hunter becomes the object of love's hunt. This sequence repeats familiar themes from erotic art of the Trecento (pls. 28, 29). The central pair of stags enclose a grove whose centerpiece is a polygonal fountain. Here stands the archeress, conversing with the young hunter, now safe and sound, who kneels at the fountain's base. This well presumably helps keep the young man ensnared by feminine charms. More

than the Trecento coffer, this Quattrocento panel integrates the Fountain of Love and the amorous chase to make a witty exposition of love's progress. Just as hunters shoot at hapless animals in the forest, so ladies may take aim at unsuspecting youths, piercing them with rays from their fine eyes, from which there used to issue amorous points. So ladies capture their lovers and receive their everlasting homage by Cupid's font.

Another cassone of the same period abounds with fountains (pl. 77). A hexagonal basin from which springs a twisted column spouting water at its top serves visually to organize this panel's molded surface. These repeated fountains also separate two amatory episodes. To one side an archeress confronts a falcon-bearing youth, and then on the other she prepares to crown her suitor. This narrative pattern follows familiar Trecento patterns (pls. 26, 27). Figuratively, the fountains serve as the goal of love's chase, an artifact set in a forest for hunters as docile as the inhabitants of the Garden of Love.[7]

Analogous to these mass-produced coffers and chests is a painted salver now in New Haven (pl. 78). It was executed in Florence during the 1420s by a master whose work resembles the Wildenstein *Garden of Love* (pl. 53).[8] This hunting scene includes a couple riding to the chase, huntresses armed with spears and bows, blond maidens guarding a rustic fountain like that of the Bargello tondo (pl. 63), and a great stag expiring at the center. Unlike the craftsmen working in wood and gesso, this painter was able to give his amorous chase an extensive spatial setting that implies temporal and causal relationships. The stage is now a rocky plain opened at the bottom of the salver by a dark pond and closed at the top by a grove. This landscape encompasses several venatic pursuits. By the pool a tiny fisherman casts a rod. One of the deerstalkers bears a falcon on her wrist, alert for prey smaller than stags. A hawking party enters at the right, a magnate and his lady astride delicate steeds, their retainers striding vigorously before them. One servant has already bagged a hare. His mate rushes forward to assist the huntresses, who finish off the deer. In the background a youth carries a girl toward the grove, surely a fine and pleasant place if the couple kissing within it be any indication. As in the contemporary *Teseida* by Mariotto di Nardo (pl. 60), the eye travels upwards through space and forward through time, moving from acts of venery to venereal activities. These events are distributed around the sylvan fountain, which irrigates a stony plain.

All the hunters seem moved only by tender passions, not bloodlust. The deerslayers go about their business with calm. The three huntresses supervising them exchange gentle glances, as do the girls seated by the spring. To the upper left stand two more huntresses: one observes the rape nearby with a gaze hardly expressive of disapproval; her companion, who embraces her, looks intently into her eyes. How much like the people tenanting the Garden of Love! Echoing this affectionate pair are the cavaliers, not the first loving pair to ride through the forests. Moreover, falcons and a hare suggest

that sexual games are here afoot. The cool grove bordering the plain recalls the well-populated shrubbery of Andrea Bonaiuti's Garden of Vanity in the Spanish Chapel (pl. 48). Truly, all the hunters have strayed into a place proper for love, "dignus amore locus" to use Petronius's happy phrase.[9]

The sequence depicted here corresponds to a popular poetic type, the *caccia*. Developed in Italy during the Trecento, this form appears chiefly as verse set to music. The meter of the poem, the sounds of instruments, and the human voice raised in song effectively mimic the hurly-burly of the hunt. More often than not, the *caccia* takes an erotic turn. An anonymous lyric, "Segugi a corta e can per la foresta," for example, describes how a man follows a hunting party through a forest, enjoying the clamor of hounds, horns, and hulloas. Suddenly he comes upon a country maid attracted by this harsh music:

> I embraced her, crushing her proud spirit,
> and carried her off into the woods.[10]

This poem is but one of many *cacce* in which men come out on top, so to speak, in the hunt of love. A classical precedent is the chase in Book IV of Virgil's *Aeneid*, where Dido and Aeneas set out to pursue wild beasts only to end up making love in a cave.[11]

Poetic traditions also account for the prominence of the stag. In representations of the erotic chase from the fourteenth and fifteenth centuries this animal usually plays a subordinate role; rarely is he so brutally treated as he is here. Virgil's *Aeneid* again begins to explain his fate. The poet likens Dido's burning passion for her Trojan guest to the way a deer, wounded by a shepherd, ranges the countryside with the shaft still clinging to the hurt side.[12] Elaborating Virgil's metaphor, Petrarch makes the wounded deer a symbol of masculine torments:

> And, like a stag wounded by an arrow,
> Its poisoned tip embedded in the flank,
> Who flees, and pains himself the more he hurries on,
> So I—with that arrow in my left side
> Which eats me up, and in part gives me joy.[13]

Three ladies in the salver put an end to the hart's tormented flight. In so doing, they also conclude his passion. That conclusion, however, must be a happy one, as the subsequent events depicted in the grove suggest. The slaying of the stag, accordingly, signifies that ladies are truly effective in the hunt of love, capturing men's hearts with ease. But then let the ladies beware, because passion can readily resurrect itself.

Seemingly unrelated to all this erotic venery is the fisherman crouched by the pond. We remember, however, that when Boccaccio concludes his

influential epic the *Teseida*, he slyly sings of the amorous font where only rarely does one become a good fisherman with profit. Explaining that the vagina is the font, the gloss continues: "Because of too much fishing in the amorous font there are those who get skinned by it."[14] Boccaccio derived his cryptic image from Andreas Capellanus, who begins *De arte honesta amandi* with the etymology of *amor*:

> Love gets its name from the word for hook which means "to capture" or "to be captured," for he who is in love is captured in the chains of desire and wishes to attract someone else with his hook. Just as a skilled fisherman tries to attract fishes by his bait and to capture them on his crooked hook, so the man who is a captive of love tries to attract another person by his allurements.[15]

These piscatorial metaphors explain the angler of the *Caccia amorosa* in New Haven. Far from being a mere genre note, this figure actually epitomizes the narrative enacted elsewhere. He becomes a symbol of sexual desires that others in the panel feel and some fulfill.

Boccaccio and Andreas Capellanus both rely on the master of those who would know love, Ovid. At the outset of the *Art of Love*, the Latin poet urges his masculine readers to get on with the business of love: "She will not come floating down to you through the tenuous air, she must be sought, the girl whom your glance approves. Well knows the hunter where to spread his nets for the stag, well knows he in what glen the boar with gnashing teeth abides; familiar are the copses to fowlers, and he who holds the hook is aware in what waters many fish are swimming; you too, who seek the object of a lasting passion, learn first what places the maidens haunt."[16] Ovid's extended metaphor might almost serve as an epigraph to this salver, so well does it correspond to the pictorial conjunction of fishing, falconry, fornication, and stag-hunting. Thanks to Ovid, we understand why men repair to this place haunted by maidens to pursue the chase. Just as ladies snare youths, men may seek the object of a lasting passion. Of special importance is the spatial character of Ovid's imagery. The hunter above all must know *where* to look. The painter accordingly substitutes elements of a medieval *locus amoenus* for the poet's copses and glens. A grove and a rude fountain become places of amorous entrapment.

Nearly two decades ago, Lionello Venturi perceived that the pictorial themes of this *Caccia amorosa* govern another Florentine salver, now in the Metropolitan Museum of Art (pl. 79). Common to both panels are stony landscapes, made unexpectedly pleasant by a fountain, in which huntresses pursue deer, hares, and other animals. Once more, frenetic activities alternate with moments of repose.[17] The New York salver precedes the New Haven one by nearly fifteen years, because it was painted in the shop of Lorenzo di Niccolò, and can be dated around 1410.[18] When Paul Schubring first pub-

lished the panel in 1927, he felt that it must represent the story of the Calydonian boar hunt, while in 1932 Raimond Van Marle included it among his examples of the Garden of Love.[19] Although neither identification is correct, Schubring was right to see that a narrative threaded its way through foreground and background scenes, and Van Marle did put his finger on the central feature of the panel, the flowery meadow and marble fountain around which those scenes rotate. These perceptions, together with Venturi's suggestions, prepare the way for an identification of the Metropolitan panel's true subject.

Like the master of the *Caccia amorosa*, Lorenzo di Niccolò deploys his actors in a temporal sequence beginning with the foreground episodes. Assembled by the lower left are several huntresses wearing the simple, loosely fitting gowns usually associated with Diana and her nymphs (compare pls. 8, 9, 10). Attracting the viewer's attention is an admonitory figure, a barefoot girl in a pink robe holding an arrow and a bow who stands beside her prey, two dead hares stretched out in the grass. Toward the huntresses marches a curly-headed, blond youth, dapper in a tight red tunic and green hose, who bears two more rabbits on a stick. He also wields a knotty club. Above and to the right the same youth appears again, peering over a ridge as if in search of something. The middle distance is given over to a hunt, where the young man has joined the ladies. Standing behind the ridge at the upper left, he cheers his companions on as they track down wild beasts. The salver, then, presents the story of a youth who seeks out a company of huntresses, approaches them as they rest, somehow finds acceptance, and thereafter joins them in their characteristic pursuit.

Lorenzo di Niccolò's continuous narrative corresponds exactly to the opening events of an allegory much quoted in this book, Boccaccio's *Comedia delle ninfe fiorentine*. Its hero is the rude hunter Ameto, whose only passion is to hunt. On a summer day of extraordinary heat, he pauses to rest in a cool grove on the way home from a successful chase. During that moment of idleness, an angelic but unfamiliar sound floats to his ears. Thinking that what he hears is the singing of the gods, he determines to see them with his own eyes. After tying his dogs to a tree, Ameto sets out, bearing some of his catch on a stick as an offering for the gods he seeks. Thanks to his tracking skills, Ameto comes upon a company of extremely beautiful nymphs resting beside a stream. The fairest of them all, whom Boccaccio calls Lia, sings the song that first moved the youth. Others rest on a grassy bank listening to Lia, while some wash themselves in the stream. These happenings Lorenzo di Niccolò depicts with some care. In the right middle distance we see Ameto, clad in red, peering over a ridge in search of the nymphs. His dogs sleep beneath a tree behind him. At the lower right, Ameto reappears, striding toward the stream and bearing his prey on a stick. The knotty club ("noderoso bastone") securely identifies him as the hero of the *Comedia delle ninfe*

fiorentine. On the other side of the stream several women listen to a song chanted by one of their company, who must be Lia. Two girls in the foreground awkwardly lave themselves in the greenish waters of the stream, as Boccaccio specifies.

Lorenzo di Niccolò also indicates how Lia and her ladies welcome Ameto. Behind the admonitory nymph one of the girls' dogs rouses himself from slumber, sniffing the air in Ameto's direction. On the far side of the stream more dogs yap and snarl at this youth, who stiffly attempts to ward them off with his club. Two barefoot huntresses dash across the river to quell their noisy hounds. Boccaccio says that when Ameto came in sight of the nymphs, their dogs caught his scent, roused themselves, and assailed the intruder. Just when Ameto was about to give himself up as lost, the nymphs hear the racket he and the dogs make, rush to his aid, quiet the beasts, and then invite him to join their company.[20]

The background chase corresponds to a later episode from Boccaccio's pastoral. After the nymphs put Ameto at ease, he occasionally joins them at the chase. As Boccaccio puts it, some mysterious power whose name Ameto does not know compels him to help the girls as much as he can, and to strive especially to please Lia. Lorenzo di Niccolò shows that nymph in the act of spearing a black boar while her rustic admirer looks on. What we witness is the budding of amorous passion within Ameto's soul, a passion born in idleness and nourished by music. Here the chase represents a key phase in Ameto's education in the ways of love.[21] And nearly a year after these events the nymphs gather to conduct their symposium on love, which ends with Ameto's transformation.

As Venturi surmised, love governs Lorenzo di Niccolò's narrative. A stag and several rabbits indicate to the viewer that Venus presides over this country place. The comely nymph seated on the grass who toys with a nibbling dog seems a direct borrowing from the Trecento Garden of Vanity (pls. 43, 48). The conventions of landscape, of course, give the game away. The river bank where the nymphs refresh themselves and sing of Cupid resembles the Garden of Love (pl. 51). To be more precise, it incorporates elements of that symbolic space, the flowery meadow and an imposing fountain. Like many painters of the early Quattrocento, Lorenzo at once adheres to Boccaccio's specifications and at the same time emends them. Although the poet makes the nymphs take their ease in a *locus amoenus,* "in the shade of pleasing little trees, amid flowers and very tall grass,"[22] he mentions no fountain. Indeed, this two-tiered artifact seems almost out of place in the painting's austere landscape. Moreover, the painter takes pains to draw our attention to it. A gray-gowned nymph peers upwards into its splashing waters as if to see rainbows shimmering there, while another touches its still surface with her hand. If the meadow is a conventional symbol of sensual joys, then the fountain must retain its meaning as a symbol of the allure of love, which

leads Ameto to a new life. It probably prefigures his ultimate fate, when at the end of the amatory symposium he is immersed in a fountain only to emerge from it transformed. In either instance a general symbolic type accords with specific literary purposes. Around the Fountain of Love gather nymphs who follow Venus and who pursue chases where love increases.[23]

Lorenzo di Niccolò also teases the viewer who looks too casually at his version of the *Comedia delle ninfe fiorentine*. The admonitory nymph standing in the meadow closely resembles the chaste followers of Diana. When Boccaccio's hero first catches sight of the company and is assailed by the dogs, he too assumes that these must be Diana's nymphs. Fearing that he must suffer the fate of Actaeon, he feels his forehead to see if the antlers have sprouted yet! The impact of the *Comedia* depends on our surprise, and Ameto's, at learning that these huntresses follow the goddess of love, not the defender of chastity. Another playful reference to Diana may be discerned in an important visual footnote, the girls bathing by the stream. The nymph at the left looks coyly out at us as she washes her feet. Her companion mirthfully splashes her with water, repeating the very act that transformed Actaeon from man to stag. An instructive comparison is offered by a Florentine cassone, also in the Metropolitan Museum of Art, where Ovid's myth appears in three acts (pl. 80). In the first panel, Actaeon and his companions set out on a chase, in the second Diana changes him into an antlered creature already menaced by a dog, and in the third panel Actaeon's companions search fruitlessly for him.[24] A glance at the second episode confirms that Lorenzo di Niccolò appropriates Diana's gesture as she warns Actaeon, "Now, if you can, you may tell how you saw me when I was undressed."[25] Lorenzo makes Diana's act playful and quite harmless.

Diana, however, is a dangerous goddess to mock. Although the master responsible for the Actaeon cassone did not show the hunter's fearful death, the third episode alludes poignantly enough to the consequences of the goddess's act. It is probable, too, that the painter intended to draw a stern moral from the myth. This cassone's companion chest, also in the Metropolitan Museum, bears three scenes (pl. 81). In the first a bearded man, wearing the same costume as Actaeon and his friends, converses with a seated woman who holds an infant. In the second picture two knights, sporting the short tunics fashionable during the early Quattrocento, clasp hands. The final panel presents a woman wearing a crown enthroned on a great marble bench. Surrounded by a great mandorla of light, she displays a scroll whose inscription begins "chi avin. . . ." Alas, the rest of her message can no longer be read, nor are the scrolls in the other panels legible. Her inscription, nevertheless, begins with the same exhortatory voice as the inscriptions of the 1421 Venus salver and Domenico di Bartolo's *Offering of the Heart* (pls. 68, 70). Moreover, this woman's mandorla ensures that she enjoys divine

status. She might well represent a virtue, though perhaps not one of the conventional seven. She comments on the preceding scenes, images of family and friendship, and, by extension, on the Actaeon cassone. The story of Actaeon is thus linked to a moralizing allegory.[26]

Usually we do not think that the myth of Actaeon would lend itself to moral judgments. Yet it was perceived in such a fashion frequently during the fourteenth and fifteenth centuries. A Florentine salver from the late Trecento, not illustrated here, presents the story as a continuous narrative, beginning with Diana and her troop at the bath and concluding with her transformation of Actaeon. On the back of the salver presides a figure of Justice, complete with sword and scales.[27] This painting addresses an ethical problem Ovid himself raises: "some thought that the goddess had been too cruel, others praised her and declared her act in keeping with her strict chastity."[28] The salver argues that Diana acted justly. A like moral may have been intended by the master of the Actaeon cassoni in New York. In both cases support for Diana's drastic act can be found in mythographic and poetic traditions. Although Ovid leaves the question of Diana's justice open, and Boccaccio consistently attributes Actaeon's end to bad luck,[29] other classical and medieval authors assert that Diana acted correctly. An influential mythographer from late antiquity, Hyginus, even claims that when Actaeon came across Diana and her nymphs, their nudity inflamed his lust and he desired to rape them.[30] More gently, Petrarch makes Actaeon a lover who follows his desire, which leads him to the agreeable sight of Diana at her bath, which he pauses to admire.[31] As in the Venus salver (pl. 67), the sight of a nude goddess at the center of the Actaeon cassone is highly provocative. But following erotic impulses now becomes a crime that Diana punishes with justice.

The cassone representing Actaeon's story (pl. 80) also shows a hunt that ends by a fountain. Diana and her band bathe in an object like the Fountain of Love standing at the center of Lorenzo di Niccolò's panel. In another salver from the 1440s Diana and her troop squeeze into an elaborate Gothic contraption much like the centerpiece of the Princeton Garden of Love (pl. 82). The painter was a Florentine familiar with the work of the Master of the Bargello Tondo and Domenico Veneziano.[32] He here deploys the events of Ovid's myth in quick succession. Actaeon wanders in at the right, gets splashed, and exits stag-headed at the left, pursued by his own dogs. The pacing of the narrative means that Diana's fountain dominates the picture.

In both these Tuscan mythologies Diana's bathing facilities have little to do with the elaborate setting Ovid describes, a dark grotto where nature seems to be imitating art. Here instead a work of art dominates the natural world. Two inferences follow from this deliberate borrowing from the

Garden of Love. Perhaps the painters intended to depict a sylvan *locus amoenus*, as if the nymphs had taken over a landscape more proper for Venus than them. This supposition points up the essential ambivalence of the Actaeon myth; naked nymphean bodies do provide a most amenable prospect. In the Actaeon salver, a nymph at the extreme right actually imitates the goddess of love, covering her private parts in the same way as the classical type of Venus *pudica*, represented here by the fountain figure from the Capponi *Decameron* (pl. 13). If this argument is correct, however, no one could fault Actaeon and only Fortune would bear the blame. But this conclusion runs counter to the ultimate justification Diana's act receives. Another chain of reasoning is that the painters borrowed conventional features only to modify them into a landscape suiting Diana. Its elements are stony mountains and dense groves, antipodal to the luxuriant greenery of the Garden of Love. Diana's fountain is deep and wide enough for nymphs to bathe in, unlike Love's font. These are in fact the chaste fonts that Statius celebrates.[33] Though they may look like Cupid's fountains, their waters bring only death to the lustful.[34]

Like the followers of Venus, nymphs dedicated to Diana assemble in fixed numbers. Seven huddle behind the goddess in one painting, three in another. Such gatherings do not happen by accident. According to Boccaccio's *Genealogy of the Gods*, the major nymphs number seven. Boccaccio's authority is Claudian's panegyric, *On the Consulship of Stilicho*, in which Diana summons seven lieutenants to marshal hundreds of nymphs to scour the corners of the earth looking for prey to adorn Stilicho's triumph.[35] Astrological lore assigns this same number to Diana. If you number the universe downwards from the Primum Mobile to the earth, then the moon, Diana's planet, becomes the seventh. Parenthetically, Venus shifts from third to fifth by this reckoning.[36] The ancient poets also link Diana to three. In the *Aeneid* Virgil calls her "tria virginis," alluding to her manifestation as Trivia, goddess of crossroads. Of her Horace sings: "Holy maiden, keeper of mountain and forest, / Virgin, to whom young women in labor / pray, who hear and save them from death, / triple goddess."[37] Diana's good offices in obstetrics would alone justify her appearance on birth salvers. Just as three and five pertain to Venus, three and seven belong to Diana.

A symbolism much more obvious than these poetic and astrological explanations of Diana's numbers suggests itself. Her virtuous nymphs equal the number of all the virtues, seven, and the sum of the theological virtues, three. The master of the Actaeon salver from the 1440s actually divides his septet according to the system reserved for the virtues. Behind Diana, four naked girls link arms to form a unit, leaving the remaining three sheltered in the fountain. The subdivisions recall the four temporal and three theological virtues. There can be little doubt that Diana and her nymphs represent a

standard of virtuous behavior antithetical to the conduct of Venus and her followers.[38]

Venus and Diana, then, war on one another in secular art of the early Quattrocento. If the hunt of love parodies Diana's characteristic activity, then Actaeon's story demonstrates that a stag belongs to the goddess of chastity as well as to the goddess of love. Moreover, the virgin goddess may offer a remedy for wanton love. Ovid himself prescribes such a cure: "Cultivate the pleasures of the chase; oftimes has Venus, vanquished by Phoebus' sister, beaten a base retreat."[39] More generally, we may understand the significance of Diana during the early Quattrocento as the embodiment of proper conduct, of *Onestà* as opposed to *Bellezza*. For a sizable number of patrons in Florence, love was beginning to be distrusted once more.

A distrust of love governs the subjects of a cassone made in Florence around 1430 (pl. 83). Three reliefs dimly recalling the youthful style of Ghiberti adorn its front panel.[40] At the right the young Egyptian bride of King Solomon compels him to adore a pagan idol, while at the left the prostitute Phyllis bestrides the philosopher Aristotle.[41] Thus the allure of women overthrows the mighty and the wise. The middle relief shows a familiar scene, a Fountain of Love that a lady and a hunter armed with arrows and a bow guard. Once more the hunt of love ends by a fountain. Given the flanking panels, however, we may be sure that love here has few positive connotations. Indeed, the scroll fluttering beside the archer identifies him as Actaeon.[42] Perhaps the craftsman intended to imply that he was always predisposed to amorous adventures and that he richly deserved his fate. Framing these harsh scenes is a generously scaled inscription:

> Sensa honesta perduta e la bellessa
> Et sensa amor non fu mai gentilessa.

Without honesty beauty is lost, and without love nobility can never be. An ambivalent motto this, affirming the chivalric faith that love can ennoble and yet agreeing with the theologians that beauty is not enough. How different from the uncomplicated compliment, "Onesta e bella," embellishing the coffer with which we began to trace the hunt of love that ends beside a fountain (pl. 74).

Inscriptions become double-edged and the images of Venus and Diana may overlap because love itself, finally, is ambiguous. "Amore" can mean anything and everything from cupidity to charity to chastity. Even the literary convention extolled by Tuscan poets and alluded to by most of the craftsmen discussed in this book is multivalent. Petrarch perpetually celebrates his passion for Laura while lamenting the misery of the lover's state. Boccaccio contrasts wanton and honest Venuses. A like ambivalence colors amatory

imagery of the early Quattrocento. Venus may be chastely clad or grossly nude, Cupid clearsighted or blindfolded. Hunting for a fountain may end in physical love or intellectual enlightenment; the Garden of Love may symbolize earthly delights or spiritual refreshment. Carnality might be an outward and visible sign of spiritual passion as well as an end in itself. Love's contradictions, ambiguities, and ambivalence finally receive their fullest exposition in a work long overdue for exploration, Paolo Schiavo's *Realms of Love*.

9

Diana versus Cupid: Exploring
the Realms of Love

WHITE stags draw the chariot of Diana away from the pleasant gardens of Cupid that adorn the *Realms of Love* in New Haven (pls. 1–4). The goddess of chastity actually enters the kingdom of love to win a victory over its lord. These events make Paolo Schiavo's panel the most complex amatory allegory to survive from the early Quattrocento in Tuscany. It becomes also the most elaborate of symbolic landscapes from that time. The *Realms of Love* not only grows out of a long secular tradition, it virtually anthologizes it, and in so doing brings that tradition to a logical conclusion.

A preliminary perusal of this cassone panel showed its subject to be an allegory of amorous experiences, set in two gardens separated by a narrow gate. The story begins with the arousal of love, which Cupid instigates, and continues with the stately triumph of the God of Love, only to conclude with the denial of love, which Diana effects. Further study of this particular panel was postponed in favor of a sustained examination of a more general theme, the Garden of Love and symbolic landscapes related to it. Only after a broad stream of tradition is charted do both the conventional aspects and the innovative features of the *Realms of Love* become evident. For all its abundant greenery, the painting cannot be classified simply as a Garden of Love, in the manner of Giovanni di Marco's contemporary cassone panel in New Haven (pl. 55). Paolo Schiavo instead used this well-established iconographic type as a point of departure, just as Giovanni di Marco devised variations on a horticultural theme (pls. 64, 65) and Domenico di Bartolo used landscape to form an allegory depicting amorous sorrow and joy (pl. 70). Executed around 1440, the *Realms of Love* comes only a few years after these pictures. In a sense, Paolo Schiavo fashioned a synthesis of gardens old and new. While enamored youths and ladies dance on a lawn and lovers

celebrated in legend assemble in a meadow to adore their god, one particular couple experiences the joys and sorrow love brings.

A key to understanding the *Realms of Love* is Paolo Schiavo's contemporary *Myth of Callisto* in Springfield (pls. 8–10). Earlier it was suggested that these panels may once have been companion pieces commissioned for a wedding. That assumption should now be tested. Serious objections to pairing these paintings readily suggest themselves: they do not share a common provenance, their dimensions differ, and their subjects do not seem to be logically related. The *Realms of Love* first turned up in Florence sometime before 1860, while the *Myth of Callisto* was in London by 1847. Nothing is known of their whereabouts between the early fifteenth and the early nineteenth centuries.[1] An argument based on provenance, however, can lead only to negative conclusions. Although the evidence now available does not prove that these panels were once paired, it does not absolutely rule out that possibility either. More difficult is the physical problem of measurements. The allegory is slightly longer than the mythology; neither appears to have been cut down or altered in size.[2] Not all paired cassone panels from the Quattrocento, however, share the same dimensions, even when all other factors are equal.[3]

Thematic incompatibility is the third objection to pairing Schiavo's secular pictures. Normally in cassone painting a narrative like the Callisto myth would have been depicted in two panels, or else be confined to one chest while its companion would be given over to an analogous narrative, such as Actaeon's story. But cassone painting is a field full of surprises. At least one mythological narrative of the early fifteenth century, the Metropolitan Museum's *Myth of Actaeon* (pl. 80), has for its pendant a moralizing allegory, baffling in precise subject to be sure but manifestly of different thematic character (pl. 81). Moreover, the material evidence of provenance and measurements and the historical evidence of heraldry firmly couple these chests.[4] To make a pair of the *Myth of Callisto* and the *Realms of Love*, then, would have been an unusual practice but not an unprecedented one. Given the paintings' closeness in style and date, it seems more than likely that they once formed a pair. The first step in deciphering the *Realms of Love*, therefore, must be to understand the significance of the *Myth of Callisto*.

As I have noted, Paolo Schiavo devised a narrative that closely follows the story Ovid tells. Indeed, the pictorial structure subtly enhances the poetic text. Schiavo sets the story of Callisto in a severe landscape of groves, crags, and mountains, warmed by a golden sun. Watering this land of Arcadia is a stream where the nymphs bathe, and where Callisto's pregnancy comes to light. From the center it flows to the left of the panel, running past Callisto's seduction and Diana's chase, the opening episodes of the story. Parallel to that stream flows the current of Ocean, forming the boundary of Arcadia

where the story ends. These two rivers set the stage for the twin catastrophes Ovid describes. The poet's verses also hint at their deeper significance. When Diana ousts Callisto, she cries "Off with you, do not defile this sacred spring!"[5] Similarly, Juno commands Oceanus, "Do not let my rival bathe in your pure tide."[6] Chaste streams from which Callisto is barred water Diana's landscape.

High above the pure tide of Ocean glitter the constellations of Ursa Major and Ursa Minor, connected by the Dragon (pl. 10). This configuration follows the description of the stars that Hyginus provides in the *Poeticon Astronomicum*.[7] Paolo Schiavo probably relied on an illustrated manuscript, such as a Trecento codex of Hyginus, now in Rome, that once belonged to the first humanist chancellor of Florence, Coluccio Salutati.[8] Paolo's display of astronomical erudition not only brings the narrative to a splendid close but it also recalls episodes appearing earlier in the panel. When Callisto wanders through the wilderness in shame after her seduction, she comes upon two bears, one of which is a cub (pl. 9). This endearing pair appears just above the grove where Callisto fell and just beneath her seducer, who flies through the sky above. These bears obviously prefigure the nymph's rough handling by Juno and her ultimate transformation by Jupiter.

Rabbits make another recurring image. The story begins when Diana and her company hunt after hares. On her own Callisto spears one of the beasts and carries it into the grove beside the sacred spring. Chasing after rabbits recalls a persistent motif of the *Caccia amorosa* in New Haven and Lorenzo di Niccolò's *Comedia delle ninfe fiorentine* (pls. 78, 79). In these works amorous hunters like Ameto presumably track rabbits to prove their devotion to Venus. But here Diana's nymphs pursue the same animals to show their enmity to love. What starts out as a hunt directed against love, however, ends up with a forcible act of love. Ovid's advice, that the exercise of the chase dampens love, is here contradicted. Moreover, at least one rabbit escapes Diana's vigilance. Perched safely on a crag, a bunny looks on as Diana angrily expels Callisto from her troop. Like Death, Venus might well boast, "Et in Arcadia ego."

Although love may triumph in the defloration of Callisto, chastity wins out in the end. Paolo Schiavo stresses the punishments meted out to his unhappy heroine. Diana's revenge, for example, takes place in two acts. First the goddess of chastity, one foot already immersed in her sacred spring, commands her nymphs to send Callisto away. In the foreground a maiden clad in pink expels her from Diana's stony Eden. Nude nymphs bathing in the stream scornfully splash Callisto as she is hurried past. They repeat the gesture Diana habitually makes when she dooms wanton Actaeon (pls. 80, 82). They also number three, a figure sacred to the virtue of chastity. Immediately thereafter Juno, garbed in gray, changes Callisto into a bear. These juxtaposed scenes of expulsion and metamorphosis occur at

the expense of narrative order. The painter relegates the nativity of Arcas which in Ovid follows almost directly after Callisto's expulsion to a background episode. This pictorial narrative weights events against the nymph. Seduced in a grove, she is harried from one stream to another by the outraged guardians of chastity and marriage vows.

Paolo Schiavo's treatment of Callisto's story derives from interpretations of the myth in Trecento literature. Usually the poets retell the story as an instance of the omnipotence of passion. Jupiter, after all, is the king of gods and of men who falls in love with a mere sylvan nymph. Boccaccio makes Callisto's bow a trophy of Venus's prowess, displaying it in the temple of that goddess described in the *Teseida*. Jupiter's violation of Callisto forms a lively episode in the frescoed Triumph of Cupid from the *Amorosa Visione*.[9] But Boccaccio never quite had the heart to tell the whole story of Callisto. Consistently he omits Juno's instructions to Oceanus, not to let the Bears ever find rest. Paolo Schiavo's panel is really much closer to Ovid's text and much harsher in its implications than Boccaccio's re-creation of the myth.

The other great Florentine poets did not gloss over the unpleasant aspects of Callisto's transformation. Petrarch, for example, calls the celestial Bear "the other who used to make Juno jealous."[10] More important is Dante's use of the myth. On the upper reaches of Mount Purgatory, Virgil and Dante observe how the lustful are purging themselves of their sin. First these spirits chant the hymn *Summae Deus Clementiae*:

> And they, when they had sung that hymn all
> through,
> Cried, *"Virum non cognosco"* loud and plain;
> Then softly they began the hymn anew,
> And soon as it was done they cried again:
> "Dian with the forest dwelt, and chased
> Helice forth, who'd drunk of Venus' bane."
> Then they resumed their singing; then they
> praised
> Husbands and wives who, faithful to the code
> Of virtue in the marriage bond, were chaste.[11]

The hymn they chant again and again is the Prayer of the Lustful in the medieval liturgy, while the Virgin cries *"Virum non cognosco"* during the Annunciation (Luke 1: 34). Helice, of course, is Callisto. Dante thus links the pagan goddess of chastity with instances of theological and social rectitude. Trecento glossators elaborated on the poet's usage of the Callisto myth. To Dante's son, Pietro, "Dian within the forest" resembled a Christian abbess protecting her nuns from the world.[12] An unknown Tuscan commentator at mid-century devised an astrological explanation of the story, making Diana the moon, "which with its coldness curbs the vice of luxury; Jupiter signifies fire, that is, the natural heat of man."[13] The learned Benve-

nuto of Imola fabricated elaborate parallels between the chanted *exempla* of Diana's wrath and wedded couples: men who in life had been lustful must laud chaste women, like Diana, just as lewd women were obliged to exalt virtuous men, such as husbands remaining true to their wives.[14]

Dante's use of Ovid's myth in the *Divina Commedia* explains its significance as a Quattrocento cassone painting. He made the story a famous antidote to lust as well as a more positive instance of proper conduct, applicable to sexual abstinence and to wedded love. It is not really a demonstration that love cannot be avoided as Boccoccio would have us believe, but an example of what happens when love is not resisted. In this Trecento interpretation attention necessarily shifts from Callisto's unending woes to Diana's just behavior. Like Actaeon, Callisto deserves her fate. Not by accident does Paolo Schiavo put Diana at the exact center of the Springfield panel. Wielding a great bow, she rides in a stag-drawn chariot. She gestures imperiously because Ovid characterizes her at this very moment as Diana the proud, "Dictynna . . . superba,"[15] returning in fine fettle from the chase. The same triumphant goddess abducts the heroine of the *Realms of Love*, taking her from Cupid's soft meadows to rough mountains, like those of Arcadia.

Although the *Myth of Callisto* sheds much light on the general content of the *Realms of Love*, it does not account for all the problems intrinsic to that allegory. One outstanding issue is the identity of Diana's rival, the woman clad in gold who accompanies her through the gardens. A second unresolved question is the identity of the poets by the fountain. At least this latter problem can readily be solved by external evidence. Identifying the writers by name also tells us something about the immediate intellectual context of the painting, as well as something about the logic that shaped its iconographic program. These discoveries further suggest ways to establish the identity of the mysterious guide. Once the cast of characters is complete, we can easily follow them on their progress through love's kingdom.

Scholars have offered conflicting views about the poets who adore Cupid (pl. 3). Generally it is believed that they are Dante, Petrarch, and Boccaccio. Recently, however, Charles Seymour cast doubt on that view, implying instead that they might well represent writers of ancient times.[16] Proximity to the mythological amours of Apollo and Mars, described by Ovid in the *Metamorphoses*, lends some credence to his argument. But if one of the three is Ovid, which one is he and who are the others? A further difficulty is that during the early Renaissance Italian authors habitually cited a quartet of classical love poets. Their number includes Ovid as a matter of course, as well as Tibullus, Propertius, and Catullus. Singling out these four in a stanza from the *Trionfo d'Amore*, Petrarch elaborated on his selection in an influential treatise, *De remediis utriusque fortunae*, and thereby established them as a fixed unit until the time of Lorenzo the Magnificent.[17] Paolo Schiavo, however, designated only three as Cupid's poets laureate.

A triad of poets immediately brings to mind the three great writers of the Trecento celebrated by poets, humanists, and artists throughout the Quattrocento. Dante, Petrarch, and Boccaccio do in fact appear as the crowns of Florence in the fresco cycle of famous men at the Villa Carducci, which Andrea del Castagno painted just a few years after the *Realms of Love*. Undoubtedly the number of poets here induced Jarves and other writers to identify them as the great Florentines. Only Frank Jewett Mather, however, actually tried to verify that opinion by comparing one of the writers, the poet standing to the right, with known portraits of Dante. Attempted more than fifty years ago, Mather's identification was not wholly convincing, if only because not enough portrait types were consulted. Nevertheless, his general perception that the painter intended to particularize the poets standing by the fountain remains accurate.[18]

In discussing the *Myth of Callisto*, it was observed that Paolo Schiavo relied upon manuscript illumination. Illustrated manuscripts serve also to identify the poets in the *Realms of Love*. The best preserved of these writers, the young, well-fed man standing at the left, closely resembles a portrait of Petrarch from a north Italian manuscript produced in 1379 (pl. 84). Both men gaze in profile, facing to the right. Each has a low forehead, a short thick nose rather flat at its base, and a pursed mouth distinguished by a short upper lip.[19] The poet who stands next to Petrarch has the same fleshy jowls and prominent curved nose as a profile portrait of Boccaccio made in Florence during 1451 (pl. 85).[20] The middle-aged author facing Boccaccio and Petrarch can now be identified as Dante, thanks to a beautiful drawing by Apollonio di Giovanni (pl. 86). This poet's open book, inscribed "Nel mezzo," securely establishes him as the author of the *Divina Commedia*. Apollonio's Dante and Paolo Schiavo's poet share a thin face, turned to the left, hollow cheeks, a slender aquiline nose, small mouth, and pointed chin. Both artists relied upon a preexisting portrait type of Dante much gentler than the craggy type made familiar by Andrea del Castagno.[21]

The image of the three poets in the *Realms of Love* anticipates by several years the triad Castagno painted at the Villa Carducci. In both instances, the group reflects the burgeoning cult of the three crowns of Florence, a cult fostered during the early Quattrocento by vernacular authors, civic-minded humanists, and the Signoria of Florence itself.[22] Unlike Castagno, however, Schiavo honors these Florentines specifically for their services to the cause of love. The situation parallels a nearly contemporary poem, "Nel paese d'Alfea un colle giace," which the notary Domenico da Prato composed around 1415. This work concludes with an evocation of a paradise established by Love in the third sphere of heaven, where among the famous servants of Venus are Dante, Petrarch, and Boccaccio, united with those ladies they honored, Beatrice, Laura, and Fiammetta.[23] Preceding this paradise is a lengthy catalogue of those whom Cupid has brought low;

Domenico's list includes Actaeon, Solomon (led astray by Pharaoh's daughter), Paris and Helen, and the heroes of the *Teseida*, Arcita and Palemone. Domenico da Prato, in other words, was an eclectic who drew on the resources of the Bible, medieval lore, and Trecento poetry, as well as the new classical erudition of humanism. Perhaps it is not too great an exaggeration to claim that his verses simply repeat, or rather collate, the imagery of Petrarch and Boccaccio. Domenico also celebrates the power of love with ironic restraint, at once extolling the might of Cupid and lamenting his sway. All these characteristics—veneration of the immediate past, eclecticism proudly upheld as a mark of scholarly virtue, and a distrust of passionate love—other poets of the early fifteenth century share.[24] The same features distinguish the program governing the *Realms of Love*.

A direct survival of medieval literary modes is the convention of guides who conduct pilgrims from realm to realm in the manner of Brunetto Latini's journey through the countries of Virtue and "Piacere" or Dante's ascent from Inferno to Paradise. One of those who guide the lovers through Paolo Schiavo's succession of gardens is undoubtedly Diana. But her companion is less easily identified. Throughout the *Realms of Love* she wears a simple gown and mantle woven of cloth-of-gold. She is the first to enter the garden where Cupid holds his triumph and is the only member of the party to remain in his realm. Moreover, when this guide passes through the gate, she acquires a laurel wreath, like those worn by Dante, Petrarch, and Boccaccio. The visual evidence indicates that the unknown lady is a learned cicerone in the service of love, almost a Muse consecrated to Cupid. Such a figure appears, in fact, in Boccaccio's *Amorosa Visione*. When the narrator first scans the fresco depicting the Triumph of Cupid, his eye lights on a noble lady, gracious and beautiful, who stands beside the god of love. She seems almost to be Cupid's *alter ego*:

> A noble lady, who seemed to me as if she were Amor, sweet of gaze, full of pity, and meek; though it is true that she was crowned with laurel, and in that way was unlike Amor. An angel she seemed to me, born in heaven, and inwardly at many times I thought she was the one who in Cyprus was once adored.[25]

Turning away from Cupid, this "donna gentile" seems to urge the narrator to look closely at the fresco, the God of Love, the flowery meadow, the crowd of lovers, and the amorous doings of the gods depicted nearby. Justifying love's ways to man, she serves as Cupid's emissary. When the narrator finishes with this triumph several cantos later, the lady returns as if to sum up the allegorical significance of the scenes he has witnessed. The precise identity of this lady in Boccaccio's poem is a question best left to historians of literature.[26] For present purposes it is sufficient to note that she corresponds to the golden-gowned guide of the *Realms of Love*. Like Boccaccio's

poetic cicerone, this figure is crowned with laurel and she also leads the pilgrims into the realm where Cupid holds his triumph. Moreover, she wears the same precious metal Cupid uses to fabricate his love-inducing arrows, gold.

Two other borrowings from the *Amorosa Visione* lend support to our identification. In Canto XV, where the "donna gentile" appears, Boccaccio also describes Cupid: "I saw a great lord of wonderful aspect seated on two eagles. . . . he kept his feet on two lion cubs, who made the green meadow their lair. . . . Without comparison his beauty was and he had two great wings of gold upon his shoulders, rising to their full height. In one hand he held an arrow of gold and another of lead . . . holding in his left hand a bow whose power many have felt, and for the worse."[27] Writing the first redaction of the allegory during the 1340s, Boccaccio visualizes the God of Love in the French fashion, endowing him with a crown, long blond hair, and a golden robe. Nearly a century later pictorial custom obliged Paolo Schiavo to make Cupid into a nude classical putto. No known visual tradition, however, accounts for this Cupid's animate throne of eagles and lions. The *Amorosa Visione* accounts specifically for the way in which Schiavo deployed the amours of the pagan gods. Among the medieval poets describing the triumph of love, only Boccaccio set the coupling of Mars and Venus right next to Apollo's embrace of Daphne. These juxtaposed events occur in Canto XIX of the allegory.[28]

Two preliminary conclusions about the *Realms of Love* can now be advanced. As Frank Jewett Mather suspected decades ago, the *Amorosa Visione* has much to do with this panel. It is not, of course, its direct literary source. Rather, its influence is at second hand, for several passages such as Cupid's triumph must have been incorporated into the program on which Schiavo's painting is directly based. Intervening between Boccaccio and Schiavo are two historical factors, the literary climate of which Domenico da Prato's "Nel paese d'Alfea, un colle giace" is an instructive example, and a century of pictorial tradition. An analogous instance of textual transformation is the garden Giovanni di Marco devised as a paradise for lovers from legend (pls. 64, 65), which is also ultimately derived from the *Amorosa Visione*.

Boccaccio's allegory permits us to complete the cast of characters who explore the realms of love. Henceforth, those whom Cupid wounds will be called the Lover and the Lady. Following Boccaccio's epithet, I shall name Diana's fellow guide the "Donna Gentile."

The journey begins with the inception of love in a garden (pl. 2). Flanked by the goddess of chastity and the Donna Gentile, the Lady sits in a lordly pavilion much like that dominating Filippo Maria Visconti's tarot card (pl. 73). As in the Lombard painting, blindfolded Cupid soars above the tent. Here, instead of displaying his weapons, he has put them to use.

After wounding the Lady, he has just transfixed her lover. Gestures characterize the beginning of love as a solemn moment. The Lover clasps his crossed hands to his breast in an attitude traditional for young men smitten by a lady's charm (pl. 20). The gesture also denotes reverence and even humility, as suggested by Troilus in the early *Paradise of Venus* (pl. 67). The Lady herself raises her left hand to touch her breast, an act shared by Achilles in the Venus salver and a gesture derived ultimately from the Annunciation.[29] Gently the Donna Gentile raises her hand, as if to bless the Lady's suitor.[30]

Despite such high seriousness, the Lover's suit must eventually fail. Cupid has wounded the young man with an arrow of gold, his beloved with a shaft of lead. According to the myth of Daphne that Ovid narrates in the *Metamorphoses* (an event depicted in the second garden), Cupid's golden arrow incites love but the leaden one rejects it.[31] The symbolism of color also indicates the outcome of this affair. Like Jupiter in the *Myth of Callisto*, the Lover is clad entirely in red, a hue proper to those possessed by passion. The Donna Gentile wears shoes of the same color. Opposing love's red and gold is the cool color once worn by the Lady and by Diana, silver. We recall that silver is the hue of Diana's planet, the moon, whose coldness curbs the vice of luxury.[32] Furthermore, Diana sits on the Lady's right hand, the place of honor in courtly ritual and the side reserved for the Blessed in the Last Judgment. One reason why the Lady will finally follow Diana might be her married state. Like Ilario del Carretto at Lucca (pl. 46), she wears the doughnut-shaped *grillanda* that brides in the Quattrocento favored.

Love begins in a place given over to worldly pleasures. The garden is simple enough: a grove of myrtles and a lawn spacious enough for the pavilion and a long wooden bench. On either side of the bench pairs of lovers embrace. Twelve young people in all, excluding the musicians, take delight here. Singing, listening to music, and dancing occupy these lovers. The dance becomes a figure more complex than those prominent in contemporary cassone paintings. Rather than three, five stand up to dance in the shade of myrtles, a pair to one side, a trio to the other. Paolo Schiavo might have intended to represent contemporary dances, such as the aptly named *La Mercantia,* where four men pursue a not unwilling lady.[33] It is more likely, however, that the painter remembered the erotic symbolism of the number five. Supporting that supposition is the witty characterization of the dancers themselves. At the center dances a young woman whose melting glance has captivated the men flanking her. Their female partners at the periphery, in turn, react in differing ways, one lady tight-lipped in disapproval, the other raising her voice in song to fan the flames of desire.

This first realm might almost pass for a Garden of Love. Like the nearly contemporary salver in Princeton (pl. 52), it is a dark, pleasant place sheltering a dozen idle people who enact the familiar course of love. Happily

for the men in Schiavo's garden, the ladies outnumber them two to one. Strategically placed details, such as the scarlet cloth draped over the bench and the little dog eyeing the dancers, ensure that passionate love must find nurture here. All that is lacking is the great fountain, symbolizing the source of Cupid's power. As if to compensate, Cupid himself invades this worldly garden, snaring the Lover with his arrow and starting the company on their pilgrimage through his realms.

A narrow, arched gate closes off the first garden (pl. 3). This we should understand as a pictorial synecdoche, representing a larger curtain wall. Within the second enclosed garden the landscape changes. The grove dwindles to a single luxuriant tree, set to one side. Filling up the lawn is a company of Cupid's worshipers, including the three poets of Florence, gathered around a multi-tiered fountain. A spur of rock closes off the space where the God of Love celebrates his might.

A key to understanding the significance of this new garden is the iconography of Cupid. He wears no blindfold. Normally in cassone painting of the early Quattrocento, Cupid's blindness or clearsightedness seems not to have been a major concern of the painters. Bright-eyed amorini accompany a quite wanton Venus, unseeing ones flank a more discreet goddess (pls. 67, 68). Paolo Schiavo, however, contrasts the busy blind archer fluttering through the first garden with the lordly and dignified putto presiding over the second. The *Realms of Love* thus becomes an unambiguous instance of the Renaissance distinction between capricious and noble aspects of love. Perhaps "noble" is too tame an adjective. If the *Amorosa Visione* is any indication, the Cupid whose triumph the "donna gentile" lauds is a benign and pure deity whose virtues are almost Christian.[34]

The second garden is a holy place, befitting its lord. When the Donna Gentile passes through the gate, she lacks the red shoes that she wore in the pavilion. Barefoot, she treads on sacred ground. Moreover, this guide shades her eyes when she enters the second garden, as though shielding them from bright light. Two men standing at the fountain also protect their eyes when they look upward at Cupid. The second garden, then, is no longer a place for pleasure but consecrated ground, subtly illuminated by an unearthly radiance.

In devising the *Realms of Love*, Paolo Schiavo clearly took a fresh look at Andrea Bonaiuti's *Way to Salvation*, itself a prime visual source of the Garden of Love (pl. 47). Both works share an arched gate separating terrestrial from celestial territory. The second realm in both paintings belongs to a deity who hovers above the faithful, displayed frontally and accompanied by symbolic beasts. Intervening between the *Way to Salvation* and the *Realms of Love* is a small panel by Fra Angelico, a *Last Judgment* installed in the Florentine hospital of S. Maria Nuova during 1431 (pl. 87). Angelico's painting gently revises Andrea Bonaiuti's fresco. To the left lies Paradise,

its forecourt now a flowery meadow where the blessed and the angels join in a round dance. At the upper left lies the narrow gate of Paradise, through which spills a golden light, which symbolizes life eternal. Past those rays two souls soar into heaven.[35] That Paolo Schiavo attentively studied this *Last Judgment* his *Myth of Callisto* proves, since the elegantly posturing nymphs of Diana's court are derived from Angelico's panel. Moreover, Schiavo's *Madonna of Humility* in Cambridge (pl. 5) reveals a strong dependence on the formal and iconographic inventions of Fra Angelico during the 1430s.

In addition to religious imagery, secular patterns determine that this second garden is a paradise founded by Cupid. In staging the triumph as a hieratic event, the god hovering above his worshippers marshaled in a flowery meadow, Schiavo undoubtedly adapted the formula developed for the Paradise of Venus earlier in the Quattrocento (pls. 67, 68). He must also have been aware of manuscript traditions, such as the illustrations of Brunetto Latini's *Tesoretto* from a century before, where the realm of "Piacere" dotted with pavilions gives way to the formalized triumph of its god (pls. 11, 12). Indeed, the second drawing from that Trecento manuscript is important not only for its symmetrical compositional pattern, with Cupid at the center, but also for the number of Cupid's vassals, a symbolic ten, unevenly distributed in groups of six and four on either side of the god.

Religious and secular borrowings both emphasize that Cupid is omnipotent. Supporting him are lions, familiar symbols of sovereignty to Quattrocento Florentines because they served as the heraldic emblems of their city, and eagles, symbols of empire in ancient and medieval times. Further stressing the might of Cupid is the Fountain of Love, whose placement gives the second garden a fortuitous resemblance to the *Adoration of the Mystic Lamb* from the Ghent Altarpiece by Jan and Hubert van Eyck. Here the fountain serves as the source of Cupid's power, the well where his arrows of gold and lead are tempered. It closely resembles the contemporary baptismal font of Siena in plan and scale, as well as in details of its superstructure (pl. 58). The second garden becomes a sanctuary made by the God of Love, who holds his distinguished followers in thrall.

Further demonstrating the universal sway of love are the ten worthies by the fountain. As has been demonstrated, Florentine poets of love discourse on their god. Their presence here follows from a venerable literary tradition. Ovid recommends that those who would learn the art of love should read amorous verses, preferably those of Propertius, Tibullus, and Ovid himself, and that those who would vanquish love should "touch not the poets of love."[36] Petrarch rewards all manner of authors, Greek, Latin, French, Provençal, Sicilian, and Tuscan, all "who sang fervently of love,"[37] by assigning them a prominent place in his Triumph of Cupid. The Florentine poets assemble in Cupid's garden too, because they are men of learning (as poets must be). This bookish triad represents scholarship and the contemplative

life. We recall from Andrea Bonaiuti's Garden of Vanity that scholars can be prone to love (pl. 48). An academic has also entered Giovanni di Marco's *Garden of Love* (pl. 55). On the other side of the fountain stand representatives of the active life, armor-clad warriors resembling the martial heroes from an earlier paradise of Venus (pl. 67). Here Cupid's vassals hold much higher rank than Venus's soldiers. One armoured man standing on the steps of the fountain wears a closed crown fitting for an emperor, while a man behind the fountain bears the open gold circlet of a king.[38] An emperor and a king, incidentally, are among the Blessed in Angelico's *Last Judgment* (pl. 87). Behind the emperor adoring Cupid stands a warrior wearing a laurel wreath, like those awarded triumphant generals in ancient Rome. Although none of these worthies can be securely identified, their presence can be attributed to well-established poetic customs: Petrarch, for example, lists Augustus and Nero among the emperors serving love, Agammemnon and David among the kings.[39] The monarchs prove that love governs even the noblest of men.

Among the three women attending Cupid's triumph stands a lady clad in a long sweeping gown. She holds a psaltery to her breast, singing as she plucks its strings. This musician visually balances the poets conversing on the opposite side. In the *Trionfo d'Amore*, Petrarch mentions "a young Greek maiden . . . singing with the noble poets there," Sappho of Lesbos.[40] One of the virtuous ladies whom Boccaccio eulogizes in *De Claris Mulieribus* is the same Greek maiden, whom he praises for the invention of lyric poetry: "This girl did not hesitate to strike the strings of the cythara and bring forth melody."[41] Boccaccio hastens to add that Sappho burned with love for young men. His interpretation was based on a too-literal reading of Ovid's *Art of Love*, where that Latin poet asks rhetorically "for who more wanton than she?",[42] as well as a misreading of *Heroides* XV, an epistle then believed to be by Sappho herself. The true direction of her affections was not suspected until late in the Quattrocento.[43] Sappho so misunderstood as a passionately heterosexual musician might well be she who sings Cupid's praises in the *Realms of Love*.

What makes this painting more interesting than its sources in allegorical literature of the Trecento is the way in which the painter depicts the adoration of Cupid. This event becomes a *profana conversazione*: Sappho sings, the soldiers stare, the scholars debate. Paolo Schiavo sets forth this latter exchange with his accustomed wit. Standing closest to Cupid is Dante, historically the first of the Florentine poets, who turns away from love's fountain to discourse *ex cathedra*, as it were, to his younger colleagues. Petrarch in turn stands close to Apollo, whose passion for Daphne this poet endlessly celebrates in his verses to Laura.[44]

The loves of the Olympian gods further demonstrate Cupid's omnipotence. Golden Apollo embraces Daphne, almost completely transformed into a laurel

tree, while on the mountainside above Mars clutches Venus amid the tangles of Vulcan's silver net. The selection of these two amours from the innumerable erotic exploits of the gods follows from Boccaccio's *Amorosa Visione*, as we have seen. The poet specifies that the first affair is sad, at least for Apollo, and that the second is merely risible. Boccaccio also follows Ovid in claiming that the adultery of Venus and Mars was infamous.[45] Apollo's passion for Daphne, by contrast, became the very badge of fame. From Daphne's foliage Apollo wove the first wreath of laurel, a garland that poets, generals, and emperors were to wear in future ages.[46]

Paolo Schiavo places Apollo and Daphne before Mars and Venus in his visual narrative, thereby reversing the order of Boccaccio's poetic account. Ultimately the painter must have relied on the logic of Boccaccio's source, the *Metamorphoses* of Ovid. Daphne's transformation is the first love story the Latin poet tells. Fittingly enough, Cupid's archery compelled Apollo to chase after Daphne. "Your dart," boasts Eros, "may pierce everything else, Phoebus, but mine will pierce you : and as all animals are inferior to the gods, your glory is to that extent less than mine."[47] Ironically, Apollo later told Vulcan of his wife's adultery with Mars, thus serving as the immediate cause of the hilarious predicament in which the goddess of love and the god of war find themselves.[48]

In presenting these amours Schiavo also relied on the resources of contemporary narrative painting. The love of Mars and Venus occasionally enlivened cassone painting from the early Quattrocento.[49] More popular was the myth of Daphne, here represented by a Florentine painting that can be dated to the middle of the century (pl. 88). Set in a flowery meadow bordered by mountains, the story unfolds in four episodes. Daphne converses with her sister nymphs, Cupid inspires Apollo to chase her, she quickly changes to a tree, and Apollo departs, crowning himself, Napoleon-like, with a laurel wreath.[50] Throughout, Daphne wears an outsized bridal *grillanda* of a style fashionable in Florence during the 1450s.[51]

From conventional representations of the Daphne legend Schiavo took only the penultimate act, Apollo's belated embrace, and placed it close to the embrace of Mars and Venus. These two acts—passion frustrated, passion consummated—amusingly complement one another. Further enriching the juxtaposition is a reversal of roles. Apollo wears a tightly fitting costume suitable for an athlete, but Mars makes love in mufti.[52] Cupid can make the god of poetry heroic, the lord of war gentle.

The final element in the logic of this Triumph of Cupid is the implicit connection between the gods on the mountainside and the worthies assembled in the meadow. The Florentine poets all bear wreaths woven from Daphne's branches. Balancing the scholars are lovers whose other occupation was war. In a sense, the figures by the fountain are the children of Apollo and Mars, repeating their servitude to love through all of recorded time. The

second garden in the *Realms of Love* thus gives form to Claudian's verses in praise of Cupid: "All things are subject to his bow. / From the stars of heaven to the lowest of men, / There is no one who cannot know the sting of love."

Although all must know the sting of love, some are able to resist it. Such is the meaning of the episodes concluding the *Realms of Love* (pl. 4). A narrow spur of rock closes off Cupid's triumph, leaving a narrow stretch of meadow. Here the Lady plucks the sting of love, Cupid's leaden arrow, from her breast. Close beside her stands radiant Diana, gazing tenderly into the Lady's eyes. Pivoting on one bared foot, the Donna Gentile turns as if to return to the fountain. Over the mountain rising above the meadow rides the Lady with Diana, who guides her stag-drawn chariot. Trapped in a cleft below, the Lover reaches in vain for his beloved. Finally the youth reclines alone in a rocky desert.

Landscape vividly symbolizes the outcome of the allegory. The barren ledge where the Lover reposes contrasts harshly with the greenery reserved for those more successful in love. Instead of flowers and myrtles, only a few prickly plants and dry trees grow here. The plants, in fact, resemble varieties of thistle, such as fuller's teasel or *cardo dei linaioli*, as the Italians call it.[53] These unpleasant prickles impede another Lover, the narrator of the *Roman de la Rose*: "But there so many briars and thistles were, / and bramble bushes, that I failed to pass / The barrier and the rose attain."[54] Another emblem of ill fortune in love is the dry tree, as we remember from Domenico di Bartolo's contemporary bridal coffer (pl. 70). More generally, any desert place may represent amatory difficulties. Propertius, for example, laments his unrequited passion:

Here of truth is a lonely and silent place where I may make my moan. . . .
This chill couch of rock is mine on this rugged track: and all that my plaintive cries can tell must be uttered in this waste place to shrill-voiced birds.[55]

Similarly, Ovid warns those who seek to master the art of love to expect difficulties: "oft you will lie cold on the bare ground."[56]

The poets all jauntily assume, however, that disappointments will constitute only temporary setbacks in the pursuit of love. Paolo Schiavo presents no such grounds for hope. The Lover ends up outside of the paradise made by Cupid, troubled by thorns and thistles just as Adam was after his expulsion from the Earthly Paradise.[57] Moreover, Schiavo's striking image of a barren tree set on a sloping ledge of rock repeats one of the most important landscapes in Trecento painting, the setting of Giotto's *Lamentation* in the Arena Chapel (pl. 89). Giotto uses the dry tree as a symbol of death, as if nature were in mourning for the Lord.[58] Paolo Schiavo's revival of his sym-

bolic landscape has its counterparts in Tuscan painting of the mid-Quattro-cento, such as Piero della Francesca's *Resurrection* at Borgo San Sepolcro, where dead and living trees appear,[59] and Apollonio di Giovanni's illustrations of Petrarch's *Trionfi*, where a dry tree belongs to Death.[60]

The language of gesture also stresses the hopelessness of the Lover's plight. When the Lady departs with Diana, her suitor reaches for her, re-peating the gesture of Apollo as he embraces Diana. The Lover's plight is even more pathetic than the god's for he grasps only empty air. This pattern of repeated motifs parallels the narrative structure of the companion *Myth of Callisto*. Here the reference back to Apollo reminds us that the myth of Daphne governs the narrative in the *Realms of Love*. At the beginning Cupid repeats the mythic act that drove Apollo to pursuit and Daphne to despair. When the lovers pass through Cupid's gate, they see the fruits of that archery. At the end the Lover, like Apollo, is reduced to frustration while his Lady plucks out the leaden arrow that was Daphne's bane. Moreover, Daphne herself can be considered as a type of the Lady. Since she appears sometimes as a bride in Renaissance painting (pl. 88), she becomes an impeccable model for the Lady, who is also a bride, to emulate. Daphne was also a nymph who followed Diana, as the Lady does. When she flees Apollo, she calls upon the chaste goddess to save her. In fact, Cupid's arrow of lead turns the nymph into an imitator of Diana's ways, "aemula Phoebes," as Ovid puts it.[61] It is wonderfully ironic that virginal Diana is Apollo's sister, and equally fitting that the first thing the Lady sees as she enters Cupid's second realm is Daphne's successful albeit drastic rebuff of Diana's brother. Like that nymph, the Lady is destined to become an *aemula Phoebes*.

The ending of the *Realms of Love* seems clear-cut. Diana wins out over Cupid, chastity quenches love, and passion dies. And yet the allegory con-cludes with images of great tenderness. When the Lady plucks out love's arrow, the Lover crosses his hands over his breast, repeating the same amorous act of reverence with which his passion began (pl. 2). Here we might interpret it as simply a gesture of respect, were it not for the other adjacent episodes. Reclining in his lonely and silent place, the youth seems oddly serene. When the Lady leaves with Diana, she looks back, not without tenderness, at her despairing suitor below.[62] Here Schiavo blurs the distinc-tions between love and chastity. Put another way, the *Realms of Love* concludes with scenes of love, never to be consummated, to be sure, but love nevertheless.

This continuation of love serves to explain a seemingly redundant act, the Lady's removal of her arrow. The lead shaft, after all, is intended to put love to flight and on the face of it there seems no need to pluck it out. But lead and gold arrows are the agents of Cupid's power, tempered in the great Fountain of Love. By removing the arrow (the only positive act she

performs in this allegory), the Lady puts away the dominion of Cupid once and forever. She rejects the kind of love Cupid symbolizes, and prepares to accept the love that Diana represents.

Diana appears as the foe of Cupid and Venus, and as the guardian of another sort of love, in several Tuscan poems written at the turn of the fifteenth century.[63] Closely resembling the scenario of the *Realms of Love* is the general plot of the *Fimerodia*, a lengthy allegory that a Sienese exile, Jacopo da Montepulciano, wrote in Florence around 1397. A manuscript of this work dates from 1434, just a few years before Paolo Schiavo painted the cassone panels now in Springfield and New Haven.[64] The *Fimerodia* expounds the nature of love for many cantos, only to find it wanting. Its author was a polished but eclectic poet, like his contemporary Domenico da Prato, author of the Triumph of Venus "Nel paese d'Alfea un colle giace." Jacopo's poetry is firmly based upon the precedents set by Dante's *Divina Commedia*, Petrarch's *Trionfi*, and all of Boccaccio's verse romances, including the *Amorosa Visione*.[65]

Jacopo da Montepulciano composed the *Fimerodia* as an occasional piece, a commentary on the passion of Luigi di Matteo Davanzati for a Florentine lady, a certain Alessandra of the Bardi family. The narrator calls himself "Niccologio," signifying reason victorious over unreason. His friend Luigi Davanzati is "Eritonio," meaning reason conquered by love. Throughout, Alessandra remains herself, a woman without a blotch. The action begins when Cupid arrives to launch his golden arrows. A truly bewildering, and prolix, sequence of dreams, visions, pageants, and debates follows. At one point an interminable triumphal procession wanders by, beginning with Nimrod from the Book of Genesis and continuing with worthies from more recent times, such as Tristram and the blond Iseult, and concluding with the advent of Florence, a lady clad in a robe covered with red lilies, accompanied by Dante, Petrarch, and Boccaccio. Niccologio and Eritonio then make their way to Cyprus to visit the kingdom of love, rich with green vales and dancing nymphs:

> Every fruit, every flower grew there, as well as those which nature never made, and sparkling water, and many sweet birds. There no heat, nor cold, nor sorrow, nor strife; there no anguish of arms nor bitter things; but full of idleness was all that place.[66]

There Cupid makes a second appearance, blindfolded to show that he is boyish and vain. In the nearby temple of Venus the friends view marble reliefs depicting the loves of the gods, including Apollo's pursuit of Daphne and Mars's adultery with Venus. The goddess herself comforts her servant Eritonio, boasting "No god have I found among so many in the heavens unwounded, save Diana."[67] Subsequent events demonstrate that her claim,

which anticipates the exhortation of the 1421 Venus coffer (pl. 68), is not wholly accurate.

The finale of the *Fimerodia* happens in Tuscany. Cupid attempts to wound Alessandra de' Bardi, whom Eritonio yearns for, with his arrows. She is determined to resist his onslaught, however, and calls on Diana for aid. Then Alessandra reappears in another triumphal procession, accompanied by a flock of feminine virtues, including "Onestà" and "Bellezza." Alessandra prays to the gods for deliverance from Cupid. When Venus and Diana subsequently dispute for possession of Alessandra, Jupiter steps in to resolve the question: "This Alessandra must be of Diana's band, to follow her; nor will Venus have dominion over her (or Eritonio her lover)."[68] With Alessandra's choice the *Fimerodia* ends.

Of particular importance for the *Realms of Love* is the significance Diana assumes in the *Fimerodia*. Jacopo da Montepulciano makes it plain that Diana's new nymph, Alessandra de' Bardi, rejects passionate love. Those who follow Cupid and Venus have been seduced by sensuality, defined as "shades, dreams, sad moans, rage, and sighs,"[69] a lugubrious version of the five genial ways of love. Choosing Diana over Venus means much more than an avoidance of lust. "Chase after virtue, where peace also dwells; flee from that blind and deadly viper,"[70] enjoins the poet in his peroration. The pursuit of virtue, in turn, may become a form of love. In the prefatory epistle, the author warns Luigi Davanzati that his poem will dampen the flames of love, not fan them, and that he ought to follow the love of the virtues that women possess, rather than their beauty, a blind and fleeting thing. When the heroine chooses Diana, Eritonio perceives the flames of a new love, chastened by virtue, kindling themselves within his breast. Both Alessandra and Eritonio choose "amore del virtù," represented by Diana, over that "amor falso" which Cupid and Venus champion.

Although the *Fimerodia* can by no means be considered as the direct literary source of the *Realms of Love*, its images and ideas do illuminate much of that panel's content. Like Eritonio and Alessandra, the Lover and his Lady explore the nature of sensual love, fittingly represented by the garden interrupted by the gate. Only after experiencing the full range of love can they accept the love of virtue. Like Alessandra, the Lady chooses to follow Diana as her Lover, like Eritonio, remains behind to contemplate the implications of her act. Furthermore, Diana fulfills the same moral function in Paolo Schiavo's allegory as she does in Jacopo da Montepulciano's poem. Riding in a chariot like a conquering general at his triumph, she leaves the realms of Cupid as a victor. Armed with a great bow, she becomes Diana the proud, the same superb figure who rides at the center of the *Myth of Callisto*. In that narrative, we recall, Diana serves as an example of rectitude, like the virtue of "Onestà" or the "Amore del virtù" lauded in the *Fimerodia*.

Unlike the *Fimerodia*, Paolo Schiavo's paintings were occasional pieces commissioned for a wedding. Their matrimonial significance is emphasized by the Lady's bridal wreath. The pictures become examples of conduct to avoid, just like the story of the Donna del Verzù painted for a Florentine marriage nearly a century before (pl. 36). Presumably the *Realms of Love* is directed to the groom, showing him that young men should not confuse marital love with wanton passion.[71] Similarly, the bride should carefully scan the story of Callisto to see what happens when one of Diana's nymphs breaks the rules. Linking both paintings is the goddess of chastity, who becomes a model to emulate. As a pair, the panels also present a choice. Opposing the mythology's central image, Diana triumphant, is the allegory's central feature, the gate opening to Cupid's paradise. Virtue lies on one side, love on the other. You may choose either *Onestà* or *Bellezza*. The alternatives are as crisply defined as the choices offered to Paris on Mount Ida.

The *Realms of Love* should now be seen in a context more comprehensive than cassone painting. Its elaborate program allies it to many Renaissance allegories of love and chastity, such as the first two of Petrarch's *Trionfi* (pl. 62). Anticipating the conclusion of Schiavo's panel is an amusing drawing by a Florentine draughtsman active during the 1420s (pl. 90). Here Cupid attempts to induce a lady to fall in love. The god of love literally burns with ardor, his shafts flame with passion, his clawed feet tenaciously seek to grasp their prey. Cupid needs only one arrow to finish off the courtly youth who submits to the lady, like the Lover in Schiavo's picture. But the girl he loves is made of adamantine stuff. Despite his arsenal, Cupid has no luck whatsoever with her. Harmlessly his blazing shafts bounce off the lady to lie broken and flickering at her feet. So firm is this woman that even Cupid's arrows bend into harmless toys! Like Schiavo's allegory, this drawing shows that women could be expected to resist amorous advances. Ironically, this early exhortation to feminine virtue forms the frontispiece to a manuscript of Ovid's *Heroides*, in which ladies such as Sappho, Oenone, and Helen offer no such resistance to Cupid's weapons.[72]

The *Realms of Love* anticipates later Renaissance allegories of love and virtue, such as Perugino's *Combat of Love and Chastity* of 1502–1505 (pl. 91). Following an iconographic program supplied by the Mantuan humanist Paride da Ceresea, Perugino turned the opposition of passion and restraint into a battle.[73] Venus pokes her flaming torch at Diana, who retaliates with her bow. Reason supports Chastity in the guise of Minerva, who suppresses a puerile Cupid. Two trees, an olive where an owl perches and a myrtle where an amorino finds refuge, serve as marshaling points for the rival armies. Enriching Perugino's allegory are the amours of the gods, relegated here to the middle distance. Once more Apollo embraces Daphne, to demonstrate that the sun god was a notorious enemy to chastity. It is amusing to

note that Perugino, for all his aspirations to classicism, depicts the goddess of love in much the same way as Boccaccio described her, as a nude woman whose private parts a veil barely conceals.[74] Like Schiavo's painting, Perugino's battlepiece was addressed to a feminine audience, in this case Isabella d'Este, the erudite Marchioness of Mantua, who might have devised its general program.

Perugino's *Combat of Love and Chastity* also puts the *Realms of Love* into a proper historical perspective. Separating these allegories are nearly seventy years of time that encompassed twin revolutions, Renaissance pictorial style and Renaissance humanism. These were just barely felt by Paolo Schiavo and the secular painters of his generation, the Master of the Bargello Tondo, Domenico di Bartolo, and Giovanni di Marco. Paolo Schiavo's gentle exposition of love, carefully set forth in hieratic compositions and enveloped in a symbolic garden, makes his *Realms of Love* almost the last flowering of a tradition essentially medieval.

10

Conclusion: Some Survivals of the Garden of Love

ONE question remains unanswered: why did the Garden of Love disappear in Tuscan art?

To understand the implications of this question, it is necessary to take into account all landscapes that symbolize love, not only the Garden of Love *per se*, but also such variations as the Paradise for Legendary Lovers Giovanni di Marco devised, the amorous chase centered around the Fountain of Love, and the specialized allegories painted by Domenico di Bartolo and Paolo Schiavo. Most of these landscapes appeared during the first half of the fifteenth century. Few can be dated after 1460. The evidence shows that a broad and lengthy stream of iconographical tradition came to an end or, more precisely, dried up, during the middle decades of the Quattrocento.

This situation is unlike the fate of the Garden of Love elsewhere in Europe. North of the Alps the Garden continued to be a popular subject, at least for printmakers, throughout the fifteenth century.[1] And in northeastern Italy the Garden of Love survived almost until the Cinquecento. A brief foray to Venice and the valley of the Adige, then, will serve two useful purposes, putting the development of the Garden of Love into a broad Italian context, and suggesting ways to understand why that symbolic landscape died out first in Tuscany.

A panel now in Australia, attributed to the Venetian master Antonio Vivarini and dated in the 1460s, seems at once familiar and strange (pl. 92). Lovers gather by a fountain of a design best described as proto-Victorian, the centerpiece of a garden defined by a stone wall inlaid with colored marbles in the Venetian manner and enclosed by a high trellis thick with roses.[2] The conspicuous absence of a flowery meadow immediately distinguishes Vivarini's garden from the Florentine type. It is possible, however,

that the painting has been cut, as the truncated gesture of the statue sur-
mounting the fountain would suggest. A second difference is of scale:
Vivarini's lovers are nearly life-size, since the panel measures nearly eight
feet across. Moreover, this painting forms part of a series of panels, now
dispersed, by the same master. One companion piece shows a couple standing
in a garden. Another depicts a rose arbor devoid of fountain and bereft of
figures.[3] This series was undoubtedly intended to adorn a Venetian palace.
When installed, the series must have recalled the sequence of gardens un-
peopled and peopled in the Florentine Palazzo Davanzati. If a narrative
sequence were intended, then Vivarini's paintings would have resembled the
series of symbolic gardens adorning Paolo Schiavo's *Realms of Love*. Like
that cassone panel, the series might have been derived from a prolix and
archaizing allegory not dissimilar to that bizarre Venetian exercise, the
Hypnerotomachia Poliphili, which was written during the 1460s.

The problems endemic to the panel preserved in Australia have been
recognized by Ursula Hoff, who has argued that the picture is not a con-
ventional Garden of Love but an allegory of Chastity.[4] The chief evidence
supporting her claim is the classically conceived but quite unattractive figure
crowning the fountain. Some contemporary paintings and engravings do de-
pict the virtue of Chastity in a manner similar to Vivarini's statue. One
example is a Florentine *Triumphs of Love and Chastity* analyzed several
chapters ago (pl. 62). Here Chastity appears as a young woman fully clothed
who displays a palm branch and a cluster of laurel as her attributes.
Vivarini's figure also bears leafy plants, which unfortunately defy precise
botanic identification.

The tradition to which this Venetian Garden of Love belongs indicates
that Antonio Vivarini did not really have chastity foremost in his thoughts.
The splendidly dressed persons assembled here number five, a figure rarely
connoting sexual restraint. At the left a lady strokes a bright-eyed dog, a
familiar erotic symbol; by no stretch of the imagination should this beast be
seen as an ermine, the traditional emblem of Chastity from Petrarch's
Trionfi onwards.[5] Moreover, this company is a playful one. A game of
blindman's buff seems about to begin on one side of the fountain while watery
high jinks soon will erupt on the other. This seems an odd way to celebrate
chaste love. Numerous iconographic details indicate that Vivarini's garden
is the preserve of an earthly love. The statue, for example, rests upon a
globe flanked by eagles, symbols of universal dominion commonly associated
with Love's sovereignty, as we recall from Schiavo's triumphant Cupid in
the *Realms of Love*. A garland heavy with spherical fruit, like apples,
carved on the fountain's main shaft, as well as more fruit of a curiously
scrotal shape adorning the basin, suggest references to Venus. The bulging
shaft of this fountain springs from a base of acanthus leaves and clustered

grapes, recalling that Bacchus often serves as an ally to Venus, or as Ovid puts it, "Venus in the wine has been fire in fire."[6]

A tentative explanation for the fountain figure can now be advanced. Its importance is signaled by one of the playful lovers, who directs the viewer's attention to it. The statue, in turn, gazes upward to the sky, where the gods customarily dwell. She should be regarded as an emissary of the gods of love who serves as an intermediary between them and their worshipers. She serves the same function, then, as the "Donna Gentile" in the *Realms of Love*. Perhaps we should consider Vivarini's figure more generally as embodying "love" in much the same way as the Germans of the thirteenth and four-teenth centuries personified the attractions of erotic passion as "Frau Minne."[7] This Teutonic lady, incidentally, was not unknown in Vivarini's city. As a winged figure clothed in a long gown and armed with a staff, Frau Minne holds lovers in her power on a mirror-frame carved in Venice early in the Quattrocento.[8]

This last example suggests that the minor arts of northern Italy may explain many of the peculiarities of Vivarini's *Garden of Love*. An instructive precedent for that painting is a small coffer produced during the early part of the fifteenth century (pl. 93). On its curved lid may be discerned three figures and a polygonal fountain; on its front side lovers engage in games amid stylized shrubbery.[9] These iconographic elements become spatially unified in an elegant cassone of the mid-Quattrocento (pl. 94). As Gilda Rosa has suggested, this chest was carved in the valley of the Adige.[10] Two scenes adorn its front panel: to one side young people in a meadow invite two girls in a nearby castle to come out and play; on the other side lovers meet in a garden of love. Dominating this scene are beautifully curving tendrils of foliage and a multi-tiered fountain of quite extravagant design. Admiring its architecture are ten lovers, some of whom toy with its gushing waters. This chest and the earlier coffer together suggest a visual context for Vivarini's painting, a specifically north Italian tradition emphasizing playful activities and aquatic pastimes for lovers who cavort in a world of ornamental vegetation and overbearing fountains, both symmetrically designed.

A cassone in Berlin demonstrates the continuation of the Garden of Love in the Adige Valley during the last third of the fifteenth century (pl. 95). Close examination of its low relief carvings shows that the Fountain of Love stands at the center of the main panel, while a chase unfolds in the rinceaux decorating the frame. Flanking the well are two identical baldachins where the God of Love holds his state. To the left he initiates a couple into his mysteries. Before him kneels a young woman, her breast pierced by an arrow. Love rises from his throne, reaching for another shaft from his quiver to finish off the lady's companion. At the extreme right the god accepts the homage of another kneeling couple. Between his pavilions more lovers gravitate to the fountain, some to wash in its waters, some to fill their

vessels.[11] Carved chests depicting the Garden of Love in this complicated fashion were a specialty of the Adige region throughout the Quattrocento.[12]

The imagery of the chest in Berlin betrays the influence of northern Europe. The God of Love is not at all like the classical putto found so frequently in Tuscan art. He is not nude but fully clad in a long gown, belted at the waist and covered by a sweeping mantle. On his temples he bears the open circlet of a king. In the right-hand scene of homage he also wields a scepter. This figure, of course, is the French Dieu d'Amours, who adorns countless ivories and other objects from the fourteenth century. A literary counterpart is the well-armed God of Love who snares the Dreamer in the *Roman de la Rose*.[13] This kingly god is joined by a consort in the right hand pavilion of the Berlin cassone, recalling perhaps the treatise on love Andreas Capellanus wrote some three centuries before, in which the King and Queen of Love preside over Amoenitas, a happy country watered by a crystal spring.

Side by side with archaisms and alien intrusions exist amatory images peculiar to Italy. The architecture of the fountain, for example, owes little to northern Gothic precedents. On it perch two spotted leopards, akin to the lecherous spotted beast that barred Dante's way in the *Inferno*. In the border more leopards stare at recumbent does. Behind the fountain courses an amorous chase in which a leopard pounces on a deer. This image brings to mind Petrarch's description of the battle between Cupid and Chastity: "So swiftly did Love move to strike her down . . . / That e'en a leopard, practiced in the hunt / or free to roam the forest, would have been / Less swift in hasting to an open place / Where he might leap upon a fleeing deer."[14] Presumably the image here means that chastity must succumb to love. A strange garden this, where Petrarchan leopards, Parisian Gods of Love, ladies clad in the fashions of Burgundy, and youths sporting the costumes of Verona, jostle one another—and in a garden where no blade of grass grows.

So ends the Garden of Love as an independent type in northern Italy. Looking at these panels sheds some new light on the Tuscan development. On both sides of the Apennines, the Garden of Love emerges from the craft traditions of the western Middle Ages and is shaped by the influence of classical and medieval literature. In Tuscany, however, the Garden became popular in panel paintings and as such afforded essays in landscape. By contrast, painted examples were rare in the north, carved ones abundant. Consequently, spacious meadows scarcely exist. In the Adige Valley and in Venice, the influence of transalpine iconography was strong. In Florence it was relatively weak, with the exception of Baccio Baldini's late engraving (pl. 57).

The Fountain of Love also survives as an autonomous symbol in northern Italian art. Perhaps the earliest instance of its emancipation from the

Garden of Love is the *impresa amorosa* the amorous Duke of Milan wears in Bonifacio Bembo's tarot card (pl. 73). During the last half of the fifteenth century fountains of florid design appear in graphic and craft art. Roughly contemporary with Vivarini's *Garden of Love*, for example, is an engraving made in Venice, not illustrated here. Dominating the print is a multi-tiered well in the north Italian taste; the presence of two lovers who make music confirm that this is indeed a fountain of love. Like Vivarini, the Venetian engraver drew upon the resources of the craft tradition.[15] Also from Venice comes a late Quattrocento goblet adorned with a simpler fountain populated now by cupids.[16] A Florentine variation on this Venetian theme is a niello print designed by Antonio Pollaiuolo of Florence, in which the Fountain of Love becames a multi-tiered stage for the athletic couplings of naked lovers! Like Baldini's engraved Garden of Love, this print should be regarded as an archaizing exercise by a Tuscan master familiar with the fashions of northern art.[17]

Conscious archaisms imply that a style or motif that has ceased to be current is for a moment revived. In other words, the Garden of Love hardly existed in Florence by 1460. This state of affairs is all the more surprising because the social and cultural factors that we remember were so important for the development of the Garden continued to flourish throughout the Quattrocento. There was no diminution in the number of chests, coffers, and salvers painted for marriages. In fact, the number of secular paintings actually increased as the century wore on. Similarly, Petrarch and Boccaccio continued to be read, although not always with favor. Moreover, the current of literary tradition continued unabated. To cite only one conspicuous instance from the late Quattrocento, Poliziano's *Stanze per la Giostra* takes the reader once more on a tour of Cyprus to see the realm of Venus. Here run streams of bitter and sweet water between flowery meadows, here play fountains richly carved. Poliziano borrowed much of his symbolic landscape directly from Claudian's seminal *Epithalamium*, but not without the assistance of his Trecento predecessors, Petrarch and Boccaccio.[18] Why, then, did the Garden of Love cease to be?

The history of Florentine cassone painting suggests one possible answer to this question. Replacing images of love as themes for marriage furniture were subjects drawn from ancient epic and history, the wanderings of Aeneas, the voyages of Ulysses, innumerable triumphs and battles of the ancient Greeks and Romans. Such was the repertory of the foremost cassone painter of the 1450s and 1460s, Apollonio di Giovanni, who painted no Gardens of Love. Amatory landscapes, then, became the victims of a major shift in fashion, a change from a "romantic" to an "epic" phase of imagery, as Paul Schubring perceived.[19] Like most upheavals in fashion, however, this change implies more than a mere whim on the part of Apollonio's patrons. For one

thing, the shift replaces allegory with narrative. The narrative, however, is of a particular type. Both E. H. Gombrich and Ellen Callmann have shown that Apollonio di Giovanni's *istorie* were taken more or less directly from classical authors, such as Virgil and Livy. Vernacular literature has only a minor role to play.[20] The demise of the Garden of Love can be linked to the triumph of Florentine humanism, which in its first Quattrocento phase was indifferent to soft tales of love.

Equally important is the general tone of the new narratives Apollonio and his contemporaries painted. Cassone panels now show heroic deeds and martial feats, in a word, manly virtue. Aeneas is usually celebrated first and foremost as the father of the Roman race, rather than as the sometime lover of Queen Dido. How different this world is from the early fifteenth century! The Garden of Love, the Paradise of Venus, the Judgment of Paris, and Boccaccio's *Teseida* all celebrate the virtue of love. Love prevails over violence, feminine allure vanquishes masculine force. Apollonio's themes now seem almost antithetical to these. It is as if that painter and his patrician patrons, like John Knox a century later, had grown distrustful of a potentially monstrous regiment of women.

A generation before Apollonio di Giovanni's activities, cassone painters began to shift away from the acceptance of love as a virtue and its corollary, the cult of feminine allure. Consider, for example, the career of the Master of the Bargello Tondo, who in the 1430s depicted the Judgment of Paris and in the 1440s painted the vindication of Susanna. The latter story, involving as it does a stern resistance to lust, could not be more different from the earlier legend. Within the same decade as the Master's *Susanna* appeared cassone panels depicting Petrarch's *Trionfi*, in which Love suffers by comparison with Chastity and Fame, as well as Paolo Schiavo's *Realms of Love*, where Cupid loses to Diana. Given such a change in attitudes toward love, the eventual demise of the Garden of Love now seems nearly inevitable.

The painters too might have had a role to play in the fate of the Garden of Love. As I have demonstrated, the visual components of this type were established by the last quarter of the Trecento and remained unchanged through the early Quattrocento. Its history roughly coincided with the infiltration and acceptance of the International Gothic Style in Tuscany. Once the formula was established, there were few ways to alter it, except in such details as the architecture of the fountain or the addition of enclosing walls. By the 1430s inventive craftsmen like Giovanni di Marco and Paolo Schiavo were attempting to vary the type, with differing degrees of complexity. This evidence suggests that the Garden of Love may have disappeared because its visual possibilities became too limiting.

Another factor shaping the fate of the Garden of Love in Florentine art was the slow acceptance of Renaissance pictorial inventions by the painters

of chests and salvers. By the late 1430s inklings of the innovations of Masaccio, Alberti, and Brunelleschi had begun to appear even in the Gothic Gardens where Love held his court: witness the abrupt perspective of the central gate in the *Realms of Love*. More sophisticated perspective systems puncture the Le Roy *Garden of Love* with all the famed impact of Cupid's arrows. (pl. 56). Put less poetically, a space delineated by the clear logic of Alberti's geometry seems ill-suited to an allegorical garden, which is, after all, a "pays du rêve d'amour." The introduction of perspective proved as fatal to the Garden as the Trojan horse did to Troy. Appropriately enough, the Garden of Love survives longest as a pictorial type in regions where Renaissance perspective was slow to arrive, such as Venice, or as a decoration for craft objects requiring no spatial imagery, such as the carved chests produced in the Adige.

A multitude of factors contributed to the disappearance of the Garden of Love: shifts in pictorial fashion, changes in literary interests, a growing distrust of love on the part of those who paid for cassoni, and a growing impatience with a stereotyped formula on the part of those who painted them. Perhaps all these factors are really symptomatic of a much larger issue. As its origins and development show, the Garden of Love was a medieval invention that survived into the early Renaissance, only to succumb eventually to it. Again, it is significant that the Garden of Love lingers on in places like the upper reaches of the Adige, rather remote from the centers of Renaissance invention but quite close to the northern Gothic world.

In Florence one broad stream of tradition abruptly ran dry. Yet the Garden of Love was never wholly forgotten. The Otto Prints by Baccio Baldini and other printmakers can be interpreted as a revival of cassone imagery of a generation before, a revival tempered by borrowings from northern Europe. In format, too, Baldini's engraved *Garden of Love* serves as a substitute for the lid of a betrothal coffer or the surface of a birth salver. His version of the Garden reminds us that the victory of humanism was by no means an absolute one during the Renaissance and that as long as it remained merely a conditional victory, images and ideas that were essentially medieval could easily be reborn.

Occasionally the Garden of Love appeared in monumental art during the last decades of the Quattrocento. Between 1492 and 1494 Bernardo Pinturicchio depicted the story of Susanna and the elders in the Vatican for the newly elected Pope Alexander VI (pl. 96). Two unjust judges assail Susanna in a charming garden, enclosed by a hedge of roses and masonry walls. Dominating the garden is a hexagonal fountain, adorned with statuary derived from the sculpture of Andrea del Verrocchio. Most students of this fresco have observed that the fountain is of questionable utility as far as the narrative goes, for no one could ever bathe in its basins.[21] But Pinturicchio

was interested in showing the symbolic rather than the literal meaning of this biblical story. Like the Master of the Bargello Tondo half a century before him, he transformed Susanna's orchard into a true Garden of Love, complete with a fountain little different from Cupid's traditional font (pls. 61, 55, 53). Lest anyone miss his point, Pinturicchio added the familiar beasts of love, a rabbit sacred to Venus and a stag symbolic of amorous desire, as well as an ape, alluding to insatiable lust.[22] Fittingly enough, Daniel vindicates Susanna, and her accusers meet their just end outside of this seductive space. We may be sure that Pinturicchio's symbolic landscape was not misread by his patron, Pope Alexander, himself no mean servant of Venus.[23]

Pinturicchio's fresco suggests that a symbolic landscape first developed in cassone painting early in the Quattrocento survived as a visual stereotype that could be employed at need—in much the same way as the fourteenth-century Garden of Vanity served as a source of the fifteenth-century Garden of Love. If this were the case, then at least one major Florentine painting from the late Quattrocento may represent a Garden of Love revived. The masque that Botticelli makes Venus and her troop enact in his *Primavera* unfolds in a clump of dark trees, whose boughs laden with golden apples interlace above a flowery meadow (pl. 97). A spray of myrtle frames Venus, who invites the spectator to enter her springtime realm.[24] To be sure, Botticelli was also entrusted with an intricate iconographic program, which three generations of scholars in this century have attempted to reconstruct. When confronted with his instructions, both oral and written, Botticelli must have turned to well-worn paradigms as the most cogent means of giving them intelligible shape. Like Perugino in the service of Isabella d'Este, he did not forget the recent medieval past. Botticelli's clothed Venus resembles the elegant goddess of love depicted in allegories of half a century before (pl. 68). Similarly, Venus's landscape recalls the setting of the Princeton *Garden of Love* minus the fountain (pl. 52), or the grove where Paris decides in favor of Venus in the Bargello Tondo, a stand of apple trees where Cupid soars (pl. 63). Botticelli's landscape proclaims that the allegory is enacted in a place sacred to Venus.[25]

Botticelli and Pinturicchio indicate that the Garden of Love could be revived on occasion throughout the Renaissance as an adjunct to allegory. Even in the Cinquecento, the Garden could play a significant, though visually modest, role. A pleasant, cultivated landscape, complete with rabbits, unfolds behind "Profane Love" in Titian's splendid allegory of love in the Galleria Borghese in Rome. Between Sacred and Profane Love Cupid stirs the waters of his familiar fountain.[26] One of Titian's numerous variants on the theme of Venus and a Musician, now in the Prado in Madrid, is graced by a soft green garden, bounded by high cypresses, watered by a cheerfully

splashing fountain, and enlivened by a stag. This background landscape enriches the erotic significance of the great foreground figures, nude Venus and her courtly admirer. In Titian's art the Garden of Love becomes an ancillary emblem of *voluptas*, a *paysage moralisé*.[27] From these sixteenth-century gardens, abbreviated survivors of a fifteenth-century landscape, it is only a step to the early seventeenth century, to Peter Paul Rubens, and the rebirth of the Garden of Love.

Notes

NOTES TO CHAPTER 1

1. James Jackson Jarves, *Descriptive Catalogue of "Old Masters"* (Cambridge, Mass.: H. O. Houghton, 1860), pp. 49–51.

2. Osvald Sirén, *A Descriptive Catalogue of the Pictures in the Jarves Collection* (New Haven, Conn.: Yale University Press, 1916), pp. 171–72. The panel was earlier called a "Garden of Love" by William Rankin, "Cassone Fronts in American Collections—V, Part 1," *Burlington Magazine* 11 (1907): 341.

3. Charles Seymour, Jr., *Early Italian Paintings in the Yale University Art Gallery* (New Haven, Conn.: Yale University Press, 1970), pp. 143–45.

4. Richard Offner, *Italian Primitives at Yale University* (New Haven, Conn.: Yale University Press, 1927), pp. 22–27.

5. Opinions up to 1970 are summarized by Seymour, *Early Italian Paintings*, pp. 143–45. Seymour himself denies Schiavo's participation in the panel.

6. Offner, *Italian Primitives*, p. 25.

7. Roberto Longhi, "Ricerche su Giovanni di Francesco," *Pinacotheca* 1 (1928): 36. Further references are in Frederick B. Robinson, "A Marriage Chest Frontal: The Story of Callisto," *Museum of Fine Arts Bulletin* 28, no. 3 (February and March 1962), unpaginated.

8. Seymour, *Early Italian Paintings*, pp. 143–44.

9. Ovid *Metamorphoses* 2. 431–501.

10. This figure was also identified as Diana by Raimond Van Marle, *Iconographie de l'art profane,* 2 vols. (The Hague: Martinus Nijhoff, 1931–1932), 2: 431.

11. I am indebted to Miss Elizabeth Chase, formerly Docent of the Yale University Art Gallery, who provided notes of Wind's unpublished lecture.

12. Mather's identification was reported by Rankin, "Cassine Fronts," p. 341.

13. Ezio Levi, *Botteghe e canzoni della vecchia Firenze* (Bologna: Nicola Zanichelli, 1928), p. 7. Levi calls the panel a "Trionfo d'amore e fontana di giovanezza."

14. Van Marle, *Iconographie*, 2: 426–31.

15. Ibid., 1: 451–525.

16. Van Marle's account has been accepted by Otto Brendel, "The Interpretation of the Holkham *Venus*," *Art Bulletin* 28 (1946): 73–74 and Eugene B. Cantelupe, "Titian's *Sacred and Profane Love* Re-examined," *Art Bulletin* 46 (1964): 225 and n. 47, to cite only two instances.

17. E. H. Gombrich, "Botticelli's Mythologies," *Journal of the Warburg and Courtauld Institutes* 8 (1945): 10, n. 2.

NOTES TO CHAPTER 2

1. "Hic chorus ante alios aptus amore sumus" (Ovid *Art of Love* 3. 534), trans. J. H. Mozley, *Ovid: The Art of Love and Other Poems* (Cambridge, Mass., and London: Loeb Classical Library, 1947), p. 157.

2. C. S. Lewis, *The Allegory of Love* (Oxford: Oxford University Press, 1936, reprinted. New York: Oxford University Press, 1958), pp. 73–197; Ernst Robert Curtius, *European Literature and the Latin Middle Ages*, trans. Willard R. Trask (New York: Pantheon, 1953), pp. 183–202; A. Bartlett Giamatti, *The Earthly Paradise and the Renaissance Epic* (Princeton, N. J.: Princeton University Press, 1966).

3. Mons latus Ionium Cypri praeruptus obumbrat,
 invius humano gressu, Phariumque cubile
 Proteos et septem despectat cornua Nili.
 hunc neque candentes audent vestire pruinae,
 hunc venti pulsare timent, hunc laedere nimbi.
 luxuriae Venerique vacat. pars acrior anni
 exulot; aeterni patet indulgentia veris.
 in campum se fundit apex; hunc aurea saepes
 circuit et fulvo defendit prata metallo. . . .
 intus rura micant, manibus quae subdita nullis
 perpetuum florent Zephyro cintenta colono,
 umbrosumque nemus, quo non admittitur ales,
 ni probet ante suos diva sub iudice cantus;
 quae placuit, fruitur ramis; quae victa, recedit.
 vivunt in Venerem frondes omnisque vicissim
 felix arbor amat; nutant ad mutua palmae
 foedera, populeo suspirat populus ictu
 et platani platanis alnoque adsibilat alnus.
 Labuntur gemini fontes, hic dulcis, amarus
 alter, et infusis corrumpunt mella venenis,
 unde Cupidineas armari fama sagittas.
 mille pharetrati ludunt in margine fratres,
 ore pares, aevo similes, gens mollis Amorum.
 hos Nymphae pariunt, illum Venus aurea solum
 edidit. ille deos caelumque et sidera cornu
 temperat et summos dignatur figere reges;
 hi plebem feriunt. nec cetera numina desunt:
 hic habitat nullo constricta Licentia nodo
 et flecti faciles Irae vinoque madentes
 Excubiae Lacrimaeque rudes et gratus amantum
 Pallor et, in primis titubans Audacia furtis
 iucundique Metus et non secura Voluptas;
 et lasciva volant levibus Periuria ventis.
 quos inter petulans alta cervice Iuventas
 excludit Senium luco.
 (Claudian *Epithalamium de nuptiis Honorii Augusti* 49–85)

The text used is *Claudian*, ed. M. Platnauer, 2 vols. (London and New York: Loeb Classical Library, 1922), 1: 246–48. The translation is by Harold Isbell, *The Last Poets of Imperial Rome* (Harmondsworth and Baltimore: Penguin Books, 1971), pp. 109–10.

4. Philostratus the Elder *Imagines* 1.6.

5. Ovid *Metamorphoses* 1. 468–71.

6. Nec procul hinc partem fusi monstrantur in omnem
 Lugentes Campi; sic illos nomine dicunt.
 hic, quos durus amor crudeli tabe peredit,
 secreti celant calles et myrtea circum
 silva tegit; curae non ipsa in morte reliquunt.
 (Virgil *Aeneid* 6. 440–44)

The text used is *Virgil*, ed. H. R. Fairclough, 2 vols. (London and New York: Loeb Classical Library, 1916), 1: 536. The translation is by Rolfe Humphries, *The Aeneid of Vergil* (New York, 1951), p. 159.

7. Devenere locos laetos et amoena virecta
 Fortunatorum Nemorum sedesque beatas.

(Virgil *Aeneid* 6. 638–39, trans. Humphries, *Aeneid*, p. 166)

8. *Servii grammatici qui ferunter in Vergilii Carmina commentarii*, ed. Georg Thilo and Hermann Hagen, 3 vols. (Leipzig and Berlin: Teubner, 1881–1923), 2: 89. The significance of Servius's comment is discussed by Curtius, *European Literature*, p. 192, and Giamatti, *Earthly Paradise*, pp. 26–27. See further Dagmar Thiss, *Studien zum Locus Amoenus im Mittelalter* (Vienna and Stuttgart: Wilhelm Braumüller, 1972).

9. Ipsa Venus campos ducet in Elysios.
 hic choreae cantusque vigent, passimque vagantes
 dulce sonant tenui gutture carmen aves;
 fert casiam non culta seges, totosque per agros
 floret odoratis terra benigna rosis. . .
 illic est, cuicumque rapax Mors venit amanti,
 et gerit insigni myrtea serta coma.
 (Tibullus 1. 3. 58–66)

The text used here is *Catullus, Tibullus and Pervigilium Veneris*, ed. F. W. Cornish, J. P. Postgate, and J. W. Mackail (London and New York: Loeb Classical Library, 1924), p. 208. The translation is by Constance Carrier, *The Poems of Tibullus*, ed. Edward M. Michael (Bloomington, Ind. and London: Indiana University Press, 1968), pp. 41–42. On the historical importance of this passage, see Giamatti, *Earthly Paradise*, pp. 36, n. 1, 150.

10. Ovid associates cinnamon with the cult of Venus and the beauty of Helen of Troy; see *Heroides* 16. 335.

11. Consult Lewis, *Allegory of Love*, pp. 74–76; Curtius, *European Literature*, p. 200 and n. 32, and Giamatti, *Earthly Paradise*, pp. 50–52.

12. Andreas Capellanus, *De Amore libri tres*, ed. E. Trojel (Copenhagen, 1892, reprint. Munich: Eidos Verlag, 1964), pp. 99–104. An English translation is in *The Art of Courtly Love*, trans. J. J. Parry (New York: F. Ungar, 1941, 1969), pp. 78–81. See further Lewis, *Allegory of Love*, pp. 38–39 and Giamatti, *Earthly Paradise*, p. 60, n. 66.

13. Je cuidai estre
 Por voir en parevis terrestre;
 Tant estoit li leus delitables
 Qu'il sembloit estre esperitables;
 Car, si come lors m'iert avis
 Il ne fait en nul parevis
 Si bon estre come il faisoit
 Ou vergier qui tant me plaisoit.
 (Guillaume de Lorris, *Roman de la Rose*, lines 635–42)

The text used is *Le Roman de la Rose*, ed. Ernest Langlois, 5 vols. (Paris: Firmin-Didot, 1914–1924), 2: 33. The translation is from *The Romance of the Rose*, trans. H. W. Robbins, ed. C. W. Dunn (New York: Dutton Paperback, 1962), p. 14. Consult the discussion of this passage by Giamatti, *Earthly Paradise*, pp. 61–63.

14. Amors ne t'eüst ja veü
 S'Oiseuse ne t'eüst conduit
 Ou bel vergier qui est Deduit.
(Guillamue de Lorris *Roman de la Rose*, lines 3008–10 trans. Robbins, *Romance*, p. 67)

In addition to Lewis, *Allegory of Love*, pp. 126–29 and 131–32, consult the discussions of this passage in Alan M. F. Gunn, *The Mirror of Love* (Lubbock, Texas: Texas

Tech Press, 1952), pp. 110, 113 and D. W. Robertson, Jr., *A Preface to Chaucer* (Princeton, N. J.: Princeton University Press, 1962), pp. 92–98.

15. A letter by Petrarch on the *Roman de la Rose* (*Epistolae metricae* 3. 30) is translated in David Thompson, ed., *Petrarch: A Humanist among Princes* (New York, Evanston, Ill., and London: Harper and Row, 1971), pp. 42–43. See also Luigi Foscolo Benedetto, *Il "Roman de la Rose" e la letteratura italiana* (Halle: M. Niemeyer, 1910).

16. Two Tuscan translations appear in *Andrea Capellano: Trattato d'amore*, ed. Salvatore Battaglia (Rome: Perrella, 1947).

17. For a fresco, now lost, depicting Claudian as a Florentine poet, see T. Hankey, "Salutati's Epigrams for the Palazzo Vecchio," *Journal of the Warburg and Courtauld Institutes* 22 (1959): 364. For Claudian's fame during the late Middle Ages, see Alan Cameron, *Claudian: Poetry and Propaganda at the Court of Honorius* (Oxford: Clarendon Press, 1970), pp. 425–26.

18. Giamatti, *Earthly Paradise*, pp. 94–119.

19. 　　　Come 'n calen di Maggio,
　　　　　passati valli e monti
　　　　　e bosche e selve e ponti,
　　　　　io giunsi in un bel prato
　　　　　fiorito d'ogni lato
　　　　　lo più ricco del mondo.
　　　　　Ma or parea ritondo,
　　　　　ora avea quadratura;
　　　　　ora avea l'aria scura.
　　　　　or veggio molta gente,
　　　　　or non veggio persone. . . .
　　　　　così da ogne canto
　　　　　veda gioco e piano.
　　　　　(Latini *Tesoretto* 2197–2218, my translation)

The text used is Gianfranco Contini, ed., *Poeti del duecento*, 2 vols. (Milan and Naples: Riccardo Ricciardi, 1960), 2: 252. Latini's "Piacere" is discussed by Giamatti, *Earthly Paradise*, pp. 57–58 and by Giulio Bertoni, *Il Duecento*, 3d ed. (Milan: F. Vallardi, 1939), pp. 338–41.

20. 　　　Un'isoletta delicata e molle
　　　　　più d'altra che 'l sol scalde o che 'l mar bagne;
　　　　　　nel mezzo è un ombroso e chiuso colle
　　　　　con sì soavi odor, con sì dolci acque,
　　　　　　ch'ogni maschio pensier de l'alma tolle. . . .
　　　　　　E rimbombava tutta quella valle
　　　　　d'acque e d'augelli, ed eran le sue rive
　　　　　bianche, verdi, vermiglie, perse e gialle.
　　　　　(Petrarch *Trionfo d'Amore* 4. 101–5, 121–23)

The edition I use is *Rime, Trionfi, e Poesie latine*, ed. Ferdinando Neri, Guido Martelotti, Enrico Bianchi, and Natalino Sapegno (Milan and Naples: Ricciardo Ricciardi, 1951), pp. 505–6. The translation is by Ernest Hatch Wilkins, *The Triumphs of Petrarch* (Chicago: University of Chicago Press, 1962), p. 31. For the dating of this passage, see Ernest Hatch Wilkins, *Life of Petrarch* (Chicago and London: University of Chicago Press, 1961), pp. 31–32, 245.

21. "Certe doglie e d'allegrezza incerte" (*Trionfo d'Amore* 4. 153), trans. Wilkins, *Triumphs*, p. 32. The historical significance of this landscape is discussed by Giamatti, *Earthly Paradise*, pp. 125–28.

22. "Se Paradiso si potesse in terra fare, non sapevano conoscere che altra forma, che quelle di quel giardino gli potesse dare" (Boccaccio *Decameron* 3. Intro.), my translation. The edition used is *Il Decameron*, ed. Vittore Branca, 3 vols. (Florence:

Sansoni, 1966), 1: 222–24. A useful account of Boccaccio's life and works is Carlo Muscetta, *Giovanni Boccaccio* (Bari: Laterza, 1972).

23. Edith G. Kern, "The Gardens in the *Decameron* Cornice," *Publications of the Modern Language Association* 66 (1951): 505–23.

24. The Triumph of Cupid appears in *Amorosa Visione* 15–29, the fountain in 38–39. All references are to Boccaccio's first redaction of the 1340s, "Testo A." The most recent edition of the poem is by Vittore Branca in *Tutte le opere di Giovanni Boccaccio*, gen. ed., Vittore Branca (Turin: Arnoldo Mondadori, 1967–), 3: 23–148. Branca's edition appeared in 1974. The frescoes Boccaccio describes were interpreted as reflections of lost works by Giotto by Julius von Schlosser, *La letteratura artistica*, trans. Filippo Rossi, 3d ed. (Florence and Vienna: La nuova Italia, 1964), p. 42. I have discussed the frescoes and the fountain in "Boccaccio and Medieval Italian Art," a paper read at the Tenth Medieval Studies Conference, Western Michigan University, Kalamazoo, Michigan, in May 1975.

25. Fronzuto e bello
 e di piante verdissime ripieno,
 d'erbette fresche e d'ogni fior novello.
 (Boccaccio *Teseida* 7.51.3–5, my translation)

The text used is Alberto Limentani's edition of 1964, published in *Tutte le opere di Giovanni Boccaccio*, 2:229–64. A recent English version is *The Book of Theseus*, trans. Bernadette Marie McCoy (New York: Medieval Text Association, 1974). All translations here from the *Teseida* are my own. Chaucer's debt to the *Teseida* is discussed by Lewis, *Allegory of Love*, pp. 174–76 and Herbert G. Wright, *Boccaccio in England* (London: University of London, Athlone Press, 1957), p. 44.

26. "Venere è doppia, perciò che l'una si può e dee intendere per ciascuno onesto e licito disiderio, sì come è disiderare d'avere moglie per avere figliuoli, e simili a questo; e di questa Venere non si parla qui. La seconda Venere è quella per la quale ogni lascivia è disiderata, e che volgarmente è chiamata dea d'amore; e di questa disegna qui l'autore il tempio e l'altre cose circustanti ad esso" (*Teseida* 7.50.1. gloss; Limentani ed., p. 463), my translation.

27. Boccaccio says: "il luogo era pieno di pini, il frutto de' quali, usandolo di mangiare, ha mirabilissime forze a provocare quello appetito, secondo che i fisici vogliono" (*Teseida*, ed. Limentani, p. 463).

28. "Quasque tulit folio pinus acuta nuces" (Ovid *Art of Love* 2.424), trans. Mozley, p. 95.

29. The entire gloss to *Teseida* 7.50.1 occupies pp. 462–72 of Limentani's edition. Boccaccio's physiological explanation of the garden rests on his assumption that Mount Cithaeron, reputed to be a temperate place, is the same as the island of Cythera, where Venus was said to have been born. See Giuseppe Velli, "Note di cultura Boccacciana," *Italia mediaevale e umanistica* 16 (1973): 330–35.

30. *Teseida* 3.10–19.

31. Ibid., 3.64–78 and 5.62.7. Appropriately enough, Arcita indulges in thoughts of love under a great pine tree.

32. S'argomenta
 che Venere, anzi che 'l dì fosse chiaro,
 sette volte raccesa e tante spenta
 fosse nel fonte amoroso, ove raro
 buon pescator con util si diventa.
 (*Teseida* 12.77.2–6)

33. *Teseida* 12.77.4. gloss: "giacque Palemone VII volte, la notte, con Emilia."

34. "O ninfe, abbiate ora compassione alle mie noie! Poi che egli ha gran parte della

notte tirata con . . . ciance, gli orti di Venere invano si fatica di cultivare; e cercante con vecchio bomere fendere la terra di quelli disiderante i graziosi sema, lavora indarno" (Boccaccio *Comedia delle ninfe fiorentine* 32. 15–16), my translation. The text here used was edited by Antonio Enzo Quaglio and was published in 1964 in *Tutte le opere di Giovanni Boccaccio*, gen. ed., Vittore Branca (Turin: Arnoldo Mondadori, 1967), 2: 679–835.

35. "Dipinti di molti fiori" (*Comedia ninfe* 32. 55), my translation.

36. "D'animale bruto, uomo divenuto essere li pare Le ninfe, le quali più all'occhio che allo 'ntelletto erano piaciute, e ora allo 'ntelletto piacciono più che all'occhio" (*Comedia ninfe* 46. 5, 3), my translation.

37. "Essere non quella Venere che gli stolti alle loro disordinate concupiscenzie chiamono dea, ma quella dalla quale i veri e giusti e santi amori discendono intra' mortali" (*Comedia ninfe* 42. 1), my translation. On the range of imagery in the *Comedia ninfe*, consult Quaglio's excellent introduction in *Tutte le opere di Giovanni Boccaccio*, 2: 667–77, as well as Natalino Sapegno, *Il Trecento*, 2d ed. (Milan: F. Vallardi, 1955), pp. 324–30 and Azzurra B. Givens, *La dottrina d'amore nel Boccaccio* (Messina and Florence: G. D'Anna, 1968), pp. 91–97.

38. I have discussed elsewhere some of the ways in which cassone painters treated literary texts, sometimes to such an extent that they become almost unidentifiable. See Paul F. Watson, "Boccaccio's *Ninfale Fiesolano* in Early Florentine Cassone Painting," *Journal of the Warburg and Courtauld Institutes* 34 (1971) : 331–33.

NOTES TO CHAPTER 3

1. For this manuscript, see Congrès international de linguistique romane, *Mostra di codici romanze delle biblioteche fiorentine* (Florence: Sansoni, 1957), p. 18 with full bibliography. For the date of its illustrations see Bernhard Degenhart and Annegritt Schmitt, *Corpus der italienische Zeichnungen* (Berlin: Mann, 1968–), 1:40–41.

2. Brunetto's description reads: "E'n una gran chaiera/ io vidi dritto stante/ ignudo unfresco fante" (*Tesoretto* 2260-62). Scribal corruptions are discussed by Contini, *Poeti del duecento*, 2: 254, note to line 2260. In medieval Tuscan, "carriera" meant a space set aside for horseraces, or a jousting place, or even a two-wheeled cart; see *Grande dizionario della lingua italiana*, 2: 801.

3. Degenhart and Schmitt, *Zeichnungen*, 1: 134–36, date the manuscript around 1370–1380. The illustrations are discussed also by Vittore Branca, *Boccaccio medievale*, 3d ed. (Florence: Sansoni, 1970), p. 220. For the copyist, see Vittore Branca, "Copisti per passione, tradizione caratterizzante, tradizione di memoria," in *Studi e problemi di critica testuale*, ed. Raffaele Spongano (Bologna: Commissione per i testi di lingua, 1961), p. 73; Lucia Nadin, "Giovanni d'Agnolo Capponi, copista del 'Decameron,' " *Studi sul Boccaccio* 3 (1965): 41–54; and Christian Bec, *Les Marchands écrivains* (Paris and The Hague: Mouton, 1967), p. 396.

4. Observed by Degenhart and Schmitt, *Zeichnungen*, 1: 134–36.

5. "Nelle quali novelle, piacevoli e aspri casi d'amore . . . si vedranno" (Boccaccio *Decameron* Proem), my translation.

6. Boccaccio says: "Adunque, acciò che per me in parte s'ammendi il peccato della Fortuna, la quale dove meno era di forza, sì come noi nelle dilicate donne veggiamo, quivi più avara fu di sostegno, in soccorso e rifugio di quelle che amano . . . intendo di raccontare cento novelle" (*Decameron* Proem).

7. See Raymond Koechlin, *Les Ivoires gothiques françaises*, 2 vols. (Paris: A Picard, 1924), 1: 384, 386 and Margaret L. Longhurst, *Catalogue of Carvings in Ivory*, 2 vols.

(London: Victoria and Albert Museum, 1929), 1: 46. Similar ivories appear in Van Marle, *Iconographie*, vol. 1, figs. 473–75 and in O. M. Dalton, *Catalogue of the Ivory Carvings of the Christian Era* (London: British Museum, 1909), pp. 122, pl. 82, and 129, pl. 88. The illustrator of this Boccaccio manuscript used religious stereotypes in a similar way; see Millard Meiss, "The First Fully Illustrated *Decameron*," in *Essays in the History of Art Presented to Rudolf Wittkower* (London: Phaidon, 1967), p. 57.

8. Koechlin, *Ivories*, 1:373–403.

9. Van Marle, *Iconographie*, 1:473.

10. D. W. Robertson, Jr., *A Preface to Chaucer* (Princeton, N. J.: Princeton University Press, 1962), pp. 203–4. The ivory illustrated in my plate 15 is analyzed in pp. 191–92.

11. Io voglio del ver la mia donna laudare
 ed asembrarli la rosa e lo giglio.
 (Contini, *Poeti del duecento*, 2: 472, my translation)

12. The chest is usually dated ca. 1400. See Paul Schubring, *Cassoni*, 2d ed., 2 vols. (Leipzig: K. W. Hiersemann, 1923), p. 222; Raimond Van Marle, *The Development of the Italian Schools of Painting*, 18 vols. (The Hague: Martinus Nijhoff, 1923–1937), 9: 95, and Frederick Antal, *Florentine Painting and its Social Background* (London: Kegan Paul, 1948), p. 364. In addition to the arguments advanced in the text, analogies with early Trecento textiles suggest an early dating for the chest. Some suggestive parallels appear in Walter Bombe, "Studi sulle tovaglie perugine—le figurazione ornamentale e simboliche," *Rassegna d'arte* 14 (1914): 110. Recently this chest has been dated around 1300 by the curatorial staff of the Victoria and Albert Museum.

13. Florence, Biblioteca Laurenziana, Laur. 42.19, fol. 47r, illustrated in Richard Offner, *A Critical and Historical Corpus of Florentine Painting* (New York: New York University Press, 1930–), sec. 3, vol. 7, pl. In.

14. *Decameron* 4. 3 tells of three daughters of a rich Provençal merchant who make off with their father's money, elope with their lovers, and live in Crete enjoying themselves with dogs and horses and birds ("con cani e con uccelli e con cavalli . . . a guisa di baroni comiciarono a vivere"). In *Decameron* 2. 9, Ginevra of Genoa's skill in riding on horseback and managing a bird is a symptom of her gentility ("cavalcare un cavallo, tenere uno uccello"). See also Robertson, *Preface to Chaucer*, p. 192.

15. For Nicola Pisano's relief, see Giusta Nicco Fasola, *La Fontana di Perugia* (Rome: Libreria dello Stato, 1951), pls. 56–57. The action of the *Roman de la Rose* also begins in May. See further Robertson, *Preface to Chaucer*, p. 257.

16. "Femineos coetus venatibus aptos" (Ovid *Art of Love* 1. 253), trans. Mozley, p. 31. For the hunt of love in medieval literature, see Robertson, *Preface to Chaucer*, pp. 265–64 and Michael J. B. Allen, "The Chase: The Development of a Renaissance Theme," *Comparative Literature* 20 (1968): 301–12. A Trecento equivalent to the epigrams of Ovid is a miniature from Bibl. Laurenziana, Laur. 42.19, fol. 57r, depicting *Diletto e Desiderio*; it represents a man riding on a white horse who looks reverently at a woman standing on a grassy lawn. The miniature is illustrated in Offner, *Corpus*, sec. 3, vol. 7, pl. Ie.

17. Carmen Gómez-Moreno, *Medieval Art from Private Collections* (New York: Metropolitan Museum of Art, The Cloisters, 1968), no. 216. See also Otto von Falke, gen. ed., *Die Sammlung Dr. Albert Figdor, Wien*, 5 vols. (Vienna and Berlin: Artaria, 1930), 4, pl. 67, no. 125.

18. The manuscript is the *Ammaestramenti degli antichi* by Bartolomeo da San Concordio, preserved in Florence, Ms. Cod. Palat. 600. See Offner, *Corpus*, sec. 3, vol. 2, p. 254.

19. Robertson, *Preface to Chaucer*, pp. 112–13, 195, 264.

20. *Decameron* 4. 4; also 7. 9, with reference to a sparrow-hawk, "Voi dovete sapere che questo uccello tutto il tempo da dover essere prestato dagli uomini al piacer delle donne." The phallic connotations of "uccello" are discussed learnedly by Arthur M. Hind, *Early Italian Engraving*, 4 vols. (London: B. Quaritch, 1938–1948; Nendeln and Liechtenstein: Kraus Reprint, 1970), 1: 260–61. Hind's discussion is provoked by E.III.30, a Quattrocento copper-engraving plate, which is illustrated in Jay A. Levenson, Konrad Oberhuber, and Jacquelyn L. Sheehan, *Early Italian Engravings from the National Gallery of Art* (Washington: National Gallery of Art, 1973), p. 527. More generally, the erotic significance of birds, dogs, and rabbits is treated by Claude T. Abraham, "Myth and Symbol: The Rabbit in Medieval France," *Studies in Philology* 60 (1963): 589–97.

21.
> Quando vostro alto intelletto l'udio,
> sì come il cervio inver' lo cacciodore,
> così a voi servidore
> tornò, che li degnaste perdonare.
>
> (Contini, *Poeti del duecento*, 2: 575, my translation)

22. For the impact of these passages on medieval and Renaissance literature, see Allen, "The Chase," p. 306. A specific Italian instance may be found in the *Proverbi* of the Duecento poet Garzo: "Cerbio corrente/ a fonte surgente" (*Proverbi* 31, in Contini, *Poeti del duecento*, 2: 298). For the amorous stag in general, consult Marcelle Thiébaux, *The Stag of Love: The Chase in Medieval Literature* (Ithaca and London: Cornell University Press, 1974).

23. Dalton, *Ivory Carvings*, p. 142.

24. Longhurst, *Carvings in Ivory*, 1: 68 and Van Marle, *Iconographie*, 1: 467. Other medieval instances of the power of music are discussed by Robertson, *Preface to Chaucer*, p. 129. To his list should be added a German casket of the fifteenth century, depicting a youth who kneels in a meadow adoring a reclining nude woman who plays an organ. See H. Kohlhaussen, *Minnekästchen im Mittelalter* (Berlin: Verlag für Kunstwissenschaft, 1928), p. 94, n. 88, text fig. 14.

25. Longhurst, *Carvings in Ivory*, 1: 68 and Koechlin, *Ivoires gothiques*, vol. 2, no. 1417.

26. The drawings were first published by C. Fairfax Murray, *Two Lombard Sketch Books in the Collection of C. Fairfax Murray* (London, 1910). More recent discussions include Philippe Verdier, ed., *The International Style* (Baltimore, Md.: Walters Art Gallery, 1962), pp. 14–15; R. W. Scheller, *A Survey of Medieval Model-Books* (Haarlem: F. Bohn, 1963), pp. 137–41; and Degenhart and Schmitt, *Zeichnungen*, 1: 166–72 with full bibliography. Murray and Verdier consider the drawings to be Lombard, dating them around 1400. Degenhart and Schmitt more plausibly put them around the mid-fourteenth century, assigning them to a follower of Giotto active in Naples. Their comparisons with Neapolitan painting, however, are not convincing. I agree with Scheller that the book was produced in Tuscany shortly before 1370.

27.
> Una donna di bella fazone,
> di cu' el meo cor gradir molto s'agenza,
> mi fé d'una ghirlanda donagione,
> verde, fronzuta, con bella accoglienza:
> appressio mi trovai per vestigione
> camicia di suo dosso, a mia parvenza.
> Allor di tanto, amico, mi francai,
> che dolcemente presila abbracciare. . . .
> del più non dico, ché mi fé giurare.
>
> (Dante da Maiano, *Rime* 1a. 3–10, 13)

The text is edited by K. Foster and P. Boyde, *Dante's Lyric Poetry*, 2 vols. (Oxford: Clarendon Press, 1967), 1:2, trans. Foster and Boyde, 1:3.

28. U' rado fin si pone,
 che mosse di valore o di bieltate . . .
 significasse il don che pria narrate.
 Lo vestimento, aggiate vera spena
 che fia . . . amore.

 (Dante *Rime* 1. 5–10, trans. Foster and Boyde, *Dante's Lyric Poetry*, 1: 3, 5) The two Dantes derive their imagery from older sources; Deduit, for example, wears a garland "Par druerie e par solaz" (*Roman de la Rose* 828). See further Robertson, *Preface to Chaucer*, p. 192.

29. Kohlhaussen, *Minnekästchen*, p. 88, no. 71 and Verdier, ed., *International Style*, pp. 102–3.

30. The left-hand inscription reads: "Genad Frov ich hed mich orgeben." See Kohlhaussen, *Minnekästchen*, p. 76, no. 31 and Falke, gen. ed., *Sammlung Figor*, vol. 5, pl. 120, no. 305.

31. "Amor est passio quaedam innata procedens ex visione et immoderata cogitatione formae alterius sexus" (Andreas Capellanus *De arte honesta amandi* 1. 1), trans. J. J. Parry.

32. Amor è un desio che ven da core
 per abondanza di gran piacimento;
 e li occhi in prima genera [n] l'amore
 e lo core li dà nutricamento.

 (Contini, *Poeti del duecento*, 1: 90, my translation) See further U. Mölk, "Le sonnet *Amor è un desio* de Giacomo da Lentini et le problème de la genèse de l'amour," *Cahiers de civilisation médiévale* 14 (1971): 334–39. Other discussions of the origin of love in sight include Gunn, *Mirror of Love*, pp. 110, 115 and, more elaborately, John V. Fleming, *The Roman de la Rose: A Study in Allegory and Iconography* (Princeton, N. J.: Princeton University Press, 1969), pp. 92–96.

33. Trovommi Amor del tutto disarmato
 Et aperta la via per gli occhi al core,
 Che di lagrime son fatti uscio e varco.
 Però, al mio parer, non li fu onore
 Ferir me de saetta in quello stato.

 (Petrarch *Rime* 3. 9–13) The edition I use is *Le Rime*, edited by Giosuè Carducci and Severino Ferrari, revised by Gianfranco Contini (Florence: Sansoni, 1965). An English translation is Petrarch, *Sonnets and Songs*, trans. Anna Maria Armi, intro. Theodor E. Mommsen (New York: Pantheon, 1946). In this and all succeeding instances, however, the translation is my own.

Notes to Chapter 4

1. Boccaccio *Decameron* 1. Intro.

2. "Tra gli alberi di sopra dipignessi molti uccelli" (Sacchetti *Novelle* 170), my translation. The text used is *Il trecento novelle*, ed. Vincenzo Pernicone (Florence: Sansoni, 1946), p. 420.

3. Consult Sir Dominic Ellis Colnaghi, A *Dictionary of Florentine Painters*, ed. P. G. Konody and Selwyn Brinton (London: John Lane, 1928), p. 33.

4. See Guido Carocci, *Il Museo di Firenze antica annesso al R. Museo di San*

Marco (Florence, 1906), pp. 21–24 and Attilio Schiaparelli, *La casa fiorentina ed i suoi arredi nei secoli XIV e XV* (Florence: Sansoni, 1908), pp. 141–59.

5. Consult Eva Börsch-Supan, *Garten-, Landschafts-, und Paradiesmotive in Innen-raum* (Berlin: Hessling, 1967).

6. The palace is dated around the mid-fourteenth century by John White, *Art and Architecture in Italy 1250–1400* (Harmondsworth and Baltimore: Penguin, 1966), p. 172 and, more generally to the Trecento, by M. Jacorosso, *I palazzi fiorentini: Quartiere di San Giovanni* (Florence: Comitato per l'estetica cittadina, 1972), p. 70. A dating around 1330 is proposed by Giovanni Fanelli, *Firenze, architettura e città* (Florence: Vallecchi, 1973), p. 141.

7. Walter Bombe, "Die Novelle der Kastellanin von Vergi in einer Freskenfolge des Palazzo Davizzi-Davanzati zu Florenz," *Mitteilungen des Kunsthistorischen Institutes in Florenz* 2 (1912): 1–25. See also Bombe, "Un roman français dans un palais florentin," *Gazette des beaux arts*, 4th ser. 6 (1911): 231–42.

8. Luigi Passerini, *Gli Alberti di Firenze*, 2 vols. (Florence: M. Cellini, 1869), vol. 1, table 3, facing p. 107. Bombe, "Novelle der Kastellanin von Vergi," pp. 2–3.

9. Suggested by Guido Carocci, *Palazzo Davanzati* (Florence: Tipografia Cenniniana, 1910), p. 10 and Luciano Berti, *Il Museo di Palazzo Davanzati a Firenze* (Florence: Electa Editrice, 1972), p. 14.

10. Ovid *Metamorphoses* 1. 722–23. An early Trecento miniature depicting Juno clad in a gown embroidered with peacocks is in the British Museum, Royal Ms. 6.E.IX, fol. 22r, illustrated in Offner, *Corpus*, vol. 6, sec. 3, pl. XLIc.

11. Bombe, "Novelle der Kastellanin von Vergi," pp. 5–19. The Italian text is in *Poeti minori del trecento*, ed. Natalino Sapegno (Milan and Naples: Riccardo Ricciardi, 1962), pp. 824–42. For the original French poem and a discussion of northern illustrations of it, see René Ernst Victor Stuip, ed., *La chastelaine de Vergi* (The Hague, Paris, and London: Mouton, 1970).

12. E qui gli amador pieni di letizia
si congiungean con tutto il lor disio:
la disiosa e celata amicizia
facìe chiamar l'un l'altro:—Amore mio—;
di baci e d'abbracciar facean dovizia.
(*Donna del Vergiù* 81–85, my translation)

13. O gloriosa, o Vergine pulzella,
io vo' la grazia tua addimandare
e dir per rima una storia novella
per dare essemplo a chi intende d'amare,
d'un cavaliere e d'una damigella
di nobile legnaggio e d'alto affare,
sì come per amore ognun morie
e 'l gran dannaggio che poi ne seguie.
(*Donna del Vergiù* 1–8, my translation)

14. Bombe, "Novelle der Kastellanin von Vergi," p. 25.

15. Berti, *Palazzo Davanzati*, p. 14.

16. Bombe, "Novelle der Kastellanin von Vergi," pp. 4, 19 citing Emil Lorenz, "Die Kastellanin von Vergi" (Ph.D. diss., Halle, 1909). Lorenz and Bombe used the text preserved in Biblioteca Riccardiana, Ms. 2733, fols. 112–22, assuming it to date from the late Trecento. This manuscript, however, was produced in 1481.

17. Using two Quattrocento texts, Riccardiana MS 2733 and Biblioteca Moreniana Cod. Bigazzi 213, Ezio Levi established a reliable version of the poem in *Fiore di leggende, Cantari antichi* (Bari: Giuseppe Laterza, 1914), pp. 123–42. Levi did not associate the poem with Antonio Pucci and on p. 334 his editors argue that the work probably dates from before 1350. Sapegno, *Poeti minori*, p. 824, now suggests that the

poem was written around 1330. The older attribution of the *Donna del Vergiù* to Pucci is maintained, however, by Berti, *Palazzo Davanzati*, p. 14.

18. To be sure, dating paintings by costume can be treacherous. A judicious and sensitive use of the history of fashion, archival testimony, and literary records appears in Luciano Bellosi, *Buffalmacco e il Trionfo della Morte* (Turin: Einaudi, 1974), pp. 41–49.

19. Parti-colored gowns appear in Nardo di Cione's *Paradise* in the Strozzi Chapel, S. Maria Novella, dated around 1357, and in Andrea Bonaiuti's frescoes in the Spanish Chapel in the same church, illustrated in my plates 47–50. Even closer to the Davanzati Palace frescoes are two panels from the shop of Bernardo Daddi. A woman wearing a tightly fitting gown with a low neckline cut square across the shoulders is in *Michele Dogomari Receives His Bride*, Galleria Communale, Prato, illustrated in Offner, *Corpus*, sec. 3, vol. 3, pl. XI[3]. A similar costume appears in pl. XIV[15] of the same volume. Parti-colored gowns and scooped-out necklines are in Bernardo's *Wedding Feast of St. Cecelia*, Folkwang Museum, Essen, illustrated in Offner, *Corpus*, sec. 3, vol. 8, pl. II[b].

20. See the man's costume in *Michele Dagomari Receives His Bride*, cited in n. 19. A counterpart to the Duke of Burgundy's costume is worn by a male donor in a Daddesque *St. Catherine* in Florence Cathedral, illustrated in Offner, *Corpus*, sec. 3, vol. 5, pl. XVIII. Another instance of aristocratic male costume appears in *The Meeting of the Quick and the Dead* by a follower of Daddi, Accademia, Florence, illustrated in Offner, *Corpus*, sec. 3, vol. 5, pls. XVI, XVI[3]. In fact, this panel offers some close stylistic parallels to the Davanzati frescoes: a rather flat type of drawing, a fondness for grandly swinging draperies, and an exaggeratedly pantomimic mode of narrative. If the Palazzo Davanzati frescoes were to be cleaned, the *pittore di camera* who did them might well turn out to be a follower of Bernardo Daddi (d. 1348). Certainly, Bernardo's influence accounts for the resemblances to Orcagna that Bombe perceived and for the generically mid-Trecento style Berti noted.

21. Examples include the Virgin's gown in a Daddesque triptych in Altenburg, illustrated in Offner, *Corpus*, sec. 3, vol. 3, pl. XII[1]; the Virgin's cloth-of-honor in a triptych by a follower of Daddi, Pinacoteca Vaticana, Rome, illustrated in Offner, *Corpus*, sec. 3, vol. 4, pl. IV; and a *Coronation of the Virgin* by a Daddi follower in Berlin, illustrated in Offner, *Corpus*, sec. 3, vol. 4, pls. XXXV, XXXV[2]. Of course, this pattern is not confined to the early Trecento; see an *Annunciation* by Spinello Aretino, illustrated in Bernard Berenson, *Italian Pictures of the Renaissance: Florentine School*, 2 vols. (London: Phaidon, 1963), vol. 1, pl. 401. In general, however, geometric patterns of the Davanzati frescoes' type predominate before 1350; see further Brigitte Klesse, *Seidenstoffe in der italienische Malerei des 14. Jahrhunderts* (Berne: Stämpfli, 1967), pp. 34–49, 165–217.

22. Examples include a Riminese *Crucifixion*, Louvre, Paris, illustrated by Bellosi, *Buffalmacco*, pl. 161, and the gold ground of the St. Cecilia altarpiece in the Uffizi, illustrated in Offner, *Corpus*, sec. 3, vol. 1, pls. V, V[8], V[9], and V[10].

23. This is a predella panel to Bernardo's San Pancrazio altarpiece of the late 1330s, illustrated in Offner, *Corpus*, sec. 3, vol. 3, pl. XIV[26]. Later representations of this method appear in two panels by Giovanni del Biondo: *Annunciation*, Poggio di Croce di Preci, Capella dell'Annunziata, illustrated in Offner, *Corpus*, sec. 4, vol. 4, pl. XXIII; and an *Annunciation*, Museo dell'Ospedale degli Innocenti, Florence, illustrated in Offner, *Corpus*, sec. 4, vol. 4, pl. XXIV. Both works are dated in the early 1380s.

24. *Madonna and Child with SS. Magdalen and Margaret*, attributed to the

Vicchio-Paris Master, very early Trecento, illustrated in Offner, *Corpus*, sec. 3, vol. 6, pl. XL.

25. See Julian Gardner, "The Decoration of the Baroncelli Chapel in Santa Croce," *Zeitschrift für Kunstgeschichte* 34 (1971): 89–98.

26. Another point of conflict is raised by recent discoveries in the history of Tuscan palace decoration. The gardens of the Palazzo Davanzati are strikingly dissimilar to the landscapes in the office of the Palazzo Datini in Prato, painted in 1391, and firmly documented; see Bruce Cole, "The Interior Decoration of the Palazzo Datini in Prato," *Mitteilungen des Kunsthistorischen Institutes in Florenz* 13 (1967): 61–82. The Datini frescoes, incidentally, have no epithalamic connotations. The dissimilarities between these cycles might be plausibly explained by a difference in date. It is worth noting that the landscape conventions of the Davanzati frescoes also appear in paintings of the mid-Trecento, such as a Daddesque *St. John the Baptist*, Gangalandi, S. Martino, illustrated in Offner, *Corpus*, sec. 3, vol. 5, pl. XX and dated 30 April 1346. See also the trees shown in my plates 42, 47, 48.

27. Passerini, *Alberti*, vols. 1, table 5, facing p. 155, and 2: 97.

28. For Albertozzo, see Passerini, *Alberti*, 1: 156–57 and for Albertozzo's will, 2: 137–42.

29. Carlo Botti, "Note e documenti sulla chiesa di S. Trinita in Firenze," *Rivista d'arte* 20 (1938): 14, 16–17.

30. Boccaccio *Decameron* 3. Conclusion. Other references to the story in later Italian literature are summarized in Bombe, "Novelle der Kastellanin von Vergi," pp. 19–20.

31. Millard Meiss, *Painting in Florence and Siena after the Black Death* (Princeton, N. J.: Princeton University Press, 1951), p. 71. For related mid-century views on women and sexual pleasure, see pp. 51–53 and for Boccaccio's own feelings of guilt, pp. 158–64.

32. This homily is not so far-fetched as it may initially seem. In *Della Famiglia*, Leon Battista Alberti makes an elderly relative, Giannozzo, tell how he managed his young bride at the outset of their marriage, putting her in her place with little sermons embellished by "visual aids" such as cassoni. See Leon Battista Alberti, *Opere volgari*, ed. Cecil Grayson (Bari: Giuseppe Laterza, 1960 –), 1: 157–261.

NOTES TO CHAPTER 5

1. Opinion on dating, authorship, and program is summarized in Mario Bucci and Licia Bertolini, *Camposanto monumentale di Pisa* (Pisa: Opera della Primaziale pisana, 1960), pp. 46–50. See also White, *Art and Architecture*, pp. 366–67, with further references.

2. Joseph Polzer, "Aristotle, Mohammed and Nicholas V in Hell," *Art Bulletin* 46 (1964): 467 and n. 33.

3. Miklos Boskovits, "Orcagna in 1357—And In Other Times," *Burlington Magazine* 113 (1971): 244 and n. 22. See also Millard Meiss, "Notable Disturbances in the Classification of Tuscan Trecento Paintings," *Burlington Magazine* 113 (1971): 186.

4. Bellosi, *Buffalmacco*, p. 54. In addition to attempting an attribution based on stylistic evidence, Bellosi dates the frescoes before 1338 on the basis of costume, thereby putting them close in time to Buffalmacco's documented presence in Pisa (1336).

5. The sinopia drawings now displayed beside the fresco in the Camposanto show that the painter intended to continue a foreground rocky ledge, prominent at the left side of the picture, to the right, in front of the garden. Beneath the revelers' feet were

dogs, balancing those in the cavalcade at the left. In the completed fresco, however, the flowery meadow flattens pictorial space and isolates the garden. This effect is noted by Bellosi, *Buffalmacco*, p. 5, following Roberto Longhi. The painter probably did rely on an actual textile pattern for the flowery meadow, perhaps a pomegranate figure popular in Lucchese silks of that time. An instructive example appears in Adèle C. Weibel, *Two Thousand Years of Textiles* (New York: Pantheon, 1952), pl. 194.

6.　　　　　Femina vana, perchè ti dilecti
　　　　　D'andar così dipinta et adorna
　　　　　Che voi piacer al mondo più che a Dio?
　　　　　Ai lasscia! che sententia tu ne aspecti
　　　　　Sè incontente il tuo cor non torna
　　　　　A confessarsi spesso d'ogni rio.
　　　　　　　　　(*L'Arte* 2 [1899]: 56, my translation)

Since the actual inscriptions are badly abraded, I use the text established by Salomone Morpurgo, "Le epigrafi volgari in rime . . . nel camposanto di Pisa."

7.　　　　　O anima, perchè perchè non pensi
　　　　　Che Morte ti torrà quel vestimento
　　　　　In che tu senti corporal dilecto
　　　　　Per la vertù de suoi cinque sensi.
　　　　　　　　　(Morpurgo, "Epigrafi," p. 56, my translation)

8. Augustine *On Christian Doctrine* 3. 10. 15. See further D. W. Robertson, Jr., "The Doctrine of Charity in Medieval Literary Gardens: A Topical Approach Through Symbolism and Allegory," *Speculum* 26 (1951): 24–49.

9. "Tutti i gradi de' signori temporali involti nei piaceri di questo mondo . . . sedere sopra un prato fiorito e sotto l'ombra di molti melaranci" (Giorgio Vasari, *Le vite de' più eccellenti pittori scultori e architettori*, ed. Rosanna Bettarini and Paola Barocchi (Florence: Sansoni, 1966–), 2:218, my translation.

10. Hermann Hettner, *Italienische Studien* (Brunswick: Vieweg, 1879), p. 103, claimed that the garden represented Paradise. This view was ably refuted by Eduard Dobbert, "Der Triumph des Todes im Campo Santo zu Pisa," *Repertorium für Kunstwissenschaft* 4 (1881): 16–33 and Millard Meiss, "The Problem of Francesco Traini," *Art Bulletin* 15 (1933): 169–72.

11. Dobbert, "Triumph des Todes," pp. 16–21.

12. Erwin Panofsky, *Renaissance and Renascences in Western Art* (Stockholm: Almquist and Wiksell, 1960), p. 149.

13. Dobbert, "Triumph des Todes," p. 33.

14. It is intriguing to note that Buffalmacco, to whom Bellosi attributes the Pisan frescoes, is recorded by Boccaccio as a *pittore di camera*, that is, as a painter specializing in secular palace decoration resembling the frescoes of the Palazzo Davanzati; see *Decameron* 8. 9.

15. Dobbert, "Triumph des Todes," p. 32. More recent references include White, *Art and Architecture*, p. 366 and Frederick Hartt, *History of Italian Renaissance Art* (Englewood Cliffs, N. J., and New York: Prentice-Hall, 1970), p. 101. It is worth stressing that the *Decameron* did not begin to circulate in Tuscany until the early 1360s; see Vittore Branca, "La prima diffusione del *Decameron*," *Studi di filologia italiana* 8 (1950): 134.

16. For Love's ten arrows, see *Roman de la Rose*, lines 923–69 and for his ten enemies, lines 129–462. In the same poem, the God of Love recites ten commandments. Consult *The Romance of the Rose*, trans. Charles Dahlberg (Princeton, N. J.: Princeton University Press, 1971), p. 363, note to line 923.

17. "E vidi molte genti, / cu' liete e cui dolente" (Latini *Tesoretto* 2257–58), my translation.

18. For Boccaccio's numerical symbolism, see M. Marti, "Interpretazione del

'Decamerone,' " *Convivium*, n.s. 25 (1957): 280 and Joan M. Ferrante, "The Frame Characters of the *Decameron*: A Progression of Virtues," *Romance Philology* 19 (1965): 212–16. An important recent discussion of Boccaccio's interest in numerology and its expression in festive companies gathered in gardens is Victoria Kirkham, "Reckoning with Boccaccio's *Questioni d'Amore*," *Modern Language Notes* 89 (1974): 47–59.

19. See Luigi Biagi, *Jacopo della Quercia* (Florence: Arnaud, 1946), p. 60.

20. My thanks to my colleague, Malcolm Campbell, for his observations on this narrative. The general character of the scene is shrewdly characterized by Bellosi, *Buffalmacco*, pp. 7–8.

21. First suggested by I. B. Supino, *Arte Pisana* (Florence, 1904), cited by Bellosi, *Buffalmacco*, pp. 20–21, n. 19. For Bartolomeo, see Cesare Segre, "Bartolomeo da San Concordio," *Dizionario biografico degli italiani* 6 (1961): 768–70. The aims and methods of the *Ammaestramenti* are discussed by E. Teza, "Versi rimati negli 'Ammaestramenti degli antichi'," *Rassegna bibliografica della letteratura italiana* 5 (1897): 220–23.

22. "L'orrore della morte, lo pericolo del giudicio, la paura dell' inferno mai dagli occhi del cuor tuo non lasciare dilungare" (*Ammaestramenti degli antichi* 23. 1. 9), my translation. The edition used is *Ammaestramenti degli antichi*, ed. Domenico Maria Manni (Milan: Silvestri, 1829).

23. "Salomone ne' Proverbj. Fallace grazia e vana è bellezza" (*Ammaestramenti* 1. 1. 2), my translation.

24. "Dunque lo parere bello non è per propria natura, ma per debilezza del vedere degli occhi" (*Ammaestramenti* 1. 1. 8), my translation. Bartolomeo's source is Boethius *Consolation of Philosophy* 3. 8.

25. I follow the reconstructions given by Offner, *Corpus*, sec. 4, vol. 1: 42–48, and the dating proposed by Miklos Boskovits, "Orcagna in 1357—And In Other Times," *Burlington Magazine* 113 (1971), 239–51.

26. A photograph is in the Kunsthistorisches Institute in Florence. See also Giovanni Cecchini and Enzo Carli, *San Gimignano* (Milan: Electa editrice, 1962), p. 86; Offner, *Corpus*, sec. 4, vol. 1: 45, n. 14, and Miklos Boskovits, "Ein Vorläufer der spätgotischen Malerei in Florenz: Cenni di Francesco di ser Cenni," *Zeitschrift für Kunstgeschichte* 31 (1968): 280–83.

27. The most recent discussion is by M. Burleigh, "The *Triumph of Death* in Palermo," *Marsyas* 15 (1970–1972): 46–57. For the general sequence of frescoes from Pisa to Palermo, consult Liliane Guerry, *Le thème du 'Triomphe de la Mort' dans la peinture italienne*, (Paris: G. P. Maisonneuve, 1950).

28. Millard Meiss, *Painting in Florence and Siena After the Black Death* (Princeton, N. J.: Princeton University Press, 1951), pp. 97–99.

29. "I piaceri e' diletti vani in figure umane" (Vasari *Vite* 2, 195), my translation. In the 1550 edition, Vasari described the motif as "i piaceri e' diletti vani in figure che seggono." Disagreeing with Vasari were Hermann Hettner, *Italienische Studien* (Brunswick: Vieweg, 1879), p. 103, who believed the garden to be the *hortus conclusus* of the Canticle of Canticles, and C. Chiappelli, "Arte domenica del Trecento," *Nuova antologia* 131 (1907): 193, who thought it was the "orto cattolico" described by Dante, *Paradiso* 20. 69–102. Both views were refuted in my plate 19 as supporting evidence. by Dante, *Paradiso* 20. 69–102. Both views were refuted by Meiss, *Black Death*, pp. 98–99, who cited the miniature illustrated in my plate 19 as supporting evidence.

30. The pejorative connotations of dancing are stressed in a fresco painted in Pisa in 1377 by Antonio Veneziano, *The Conversion of S. Ranieri*, illustrated by Bucci and Bertolini, *Camposanto*, pp. 72–73. A graphic illustration of the bagpipe's phallic significance is in Hind, *Early Italian Engraving*, E.III. 29, the obverse of the copper

plate discussed in note 20 to chapter 3. Medieval precedents are discussed by G. F. Jones, "Wittenwiler's *Becki* and the Medieval Bagpipe," *Journal of English and Germanic Philology* 48 (1949): 209–28 and Robertson, *Preface to Chaucer*, pp. 128, 130–33.

31. "E siccomè la gola è cominciamento di tutti i vizi, così è distruzione di tutte le virtù" (*Ammaestramenti* 24. 1. 4), my translation.

32. *Ammaestramenti* 24. 3. 2–4.

33. Bartolomeo taught logic, philosophy, and canon law at S. Maria Novella from 1297 to 1304. His treatise is dedicated to the Florentine Geri Spini, head of the Neri faction of the Guelfs from 1302 to 1308. See Segre, "Bartolomeo," pp. 768–69. The manuscript reproduced in plate 19, Ms. Palat. 600, is by the Master of the Domenican Effigies, a Florentine taking his name from a panel from S. Maria Novella. Another codex of the *Ammaestramenti*, Florence, Biblioteca Nazionale, MS. II.II.319, was illuminated by the same master in 1342; see Offner, *Corpus*, sec. 3, vol. 2, pt. 2, Add. pl. XVIII. Manni, ed. *Ammaestramenti*, p. x, cites another manuscript (now lost) produced in 1368.

34. "Siccomè l'arbore plantano si gode di rivo, e come il pioppo gode dell'acqua, e come la canna salvatica nel limaccio, così la lussuria ama ozio" (*Ammaestramenti* 34.2. 13), my translation. Bartolomeo's source is Ovid *Remedia amoris* 141–43. The condemnation of secular learning in Andrea's fresco has a precedent in the Pisan *Exposition of Death*, where the inscriptions warn that learning and wealth cannot ward off death.

NOTES TO CHAPTER 6

1. According to the files of the Frick Art Reference Library, Offner verbally assigned the panel to a follower of the Cioni. Published opinion, however, has usually given it to a fourteenth-century follower of Giotto. See *Catalogue des ouvrages de peinture et de sculpture, des objets d'art et de curiosité legués au Musée de Douai par M. Amadée Foucques de Wagonville* (Douai, 1877), p. 7; Umberto Gnoli, "L'arte italiana in alcune gallerie francesi di provincia. Note di viaggio, 1," *Rassegna d'arte* 8 (1908): 157; Pierre Bautier, "Le opere d'arte italiana nella Francia invasa," *Rassegna d'arte* 19 (1919): 157–58; Stéphane Leroy, *Catalogue des peintures, sculptures, dessins et gravures exposés dans les galéries du Musée de Douai* (Douai, 1937), p. 9; Antonio Viscardi and Gianluigi Barni, *L'Italia nell'età comunale* (Turin: Unione Tipografico-Editrice Torinese, 1966), p. 368; and A. P. de Mirimonde, "Là musique dans les allégories de l'amour," *Gazette des beaux arts*, 6th ser. 69 (1967): 346, n. 43.

2. The components of the S. Pier Maggiore altarpiece appear in Offner, *Corpus*, sec. 4 vol. 3. Compare the Douai salver's conventions of landscape, figure, and composition with the *Resurrection*, National Gallery, London, pl. III[18]. A tree like that in the salver appears in *St. Peter Raising the Son of the King of Antioch*, Pinacoteca Vaticana, Rome, pl. III[27]. The punch-mark used in the salver, a circle surrounded by five lobes, appears also in *SS. Jerome, Matthew, and Mary Magdalen*, assigned by Offner to Jacopo's shop, pl. III[32].

3. Compare the men's costumes to the followers of the Magi in Jacopo's *Epiphany*, National Gallery, London, illustrated in Offner, *Corpus*, sec. 4, vol. 3, pl. III[17]. See also Giovanni del Biondo, *Scenes from the Life of S. Giovanni Gualberto*, S. Croce, illustrated in Offner, *Corpus*, sec. 4, vol. 5, pl. 1[3].

4. Quest'è il mio giardino, quest'è il mio orto. . .
 nè a di mura alcuna resistenza
 nè porta che si chiuda alcuno amante
 ma solo è fatto per la lor salute.
 (*Di loco in loco* 25, 31–33, my translation).

The poem occupies the last two folios of Florence, Biblioteca Riccardiana, MS 1086, following Boccaccio's *Filostrato*. The edition used here is Guido Biagi, ed., *Il giardino d'amore* (Florence: Nozze Bianche-Isnard, 1892).

5. The poem concludes with a sonnet claiming that the garden was made by *Fede, Onestà, Nobiltà, Dimestichezza, Cortesia, Costume, Industria,* and *Onore,* that is to say, FONDACCIO. The medieval Via del Fondaccio is now the Via di S. Spirito; see Antonio Manetti, *The Life of Brunelleschi,* ed. Howard Saalman, trans. Catherine Engass (University Park, Pa., and London: Pennsylvania State University Press, 1970), pp. 124–25 and 152, n. 176.

6. Schubring, *Cassoni,* records no Trecento salvers. Roughly contemporary with the Douai *Garden of Love* is a panel in the Pinacoteca Vaticana, Rome, depicting scenes from the life of S. Barnabas, Alinari photo #38175. See Bernard Berenson, *Italian Pictures of the Renaissance: Florentine School,* 2 vols. (London: Phaidon, 1963), 1: 161. The salver is attributed to Niccolò di Pietro Gerini. An early *Diana and Actaeon* is discussed in chapter 8.

7. All authorities agree that the salver is Florentine. Among those favoring a date around 1440 are Schubring, *Cassoni,* 1: 329; Raimond Van Marle, *The Development of the Italian Schools of Painting,* 18 vols. (The Hague: Martinus Nijhof, 1923–1937), 9: 105–6; and Frederick Antal, *Florentine Painting and its Social Background* (London: Kegan Paul, 1948), p. 366. A dating near 1420 is advocated by Max J. Friedlaender in *Sammlung Figdor,* vol. 3, pl. III; and Alfred Scharf, "Die italienische Gemälde der Sammlung Figdor," *Der Cicerone* 22 (1930): 418–19.

8. I accept the observations of Mario Salmi, "Aggiunte al Tre-e al Quattrocento fiorentino," *Rivista d'arte* 16 (1934): 178, n. 1, namely, that the painter was close to Lorenzo Monaco and his panel should be dated around 1430. The influence of Masolino's Brancacci Chapel frescoes, however, should be stressed. This painter's stylistic position, passing from Lorenzo Monaco to Masolino, is analogous to Paolo Schiavo's development during the early 1430s.

9. Adrian Bury, "A Florentine Desco," *Connoisseur* 160 (1965): 254, gives the panel to Mariotto di Nardo. A glance at Mariotto's work, such as the salver illustrated in my plate 60, shows that the Wildenstein desco is by a rather gentle follower, perhaps influenced by Francesco d'Antonio, and certainly active late in the 1420s. The coats-of-arms have not been identified.

10. Throughout this book I refer to this master by his patronymic rather than his nickname, "Giovanni dal Ponte," which results from and perpetuates Vasari's errors; see F. Guidi, "Per una nuova cronologia di Giovanni di Marco," *Paragone* 19, no. 223 (September 1968): 27–46. The panel in New Haven was first published as Giovanni's in *International Studio* 90, no. 375 (August 1928): 66, and was accepted as his by Bernard Berenson, *Italian Pictures of the Renaissance* (Oxford: Oxford University Press, 1930), p. 250. A recent cleaning has raised the issue of authorship; Seymour, *Early Italian Paintings,* pp. 152–54. Nevertheless, the picture before its recent treatment was reasonably close to Giovanni's mannerisms; compare plate 55 with plates 64 and 65. A dating toward 1430 is suggested by the woman seated and facing the viewer at the right, derived from Gentile da Fabriano and Masolino (the topmost angel in the Uffizi's *Madonna and Child with St. Anne*). Moreover, the harpist at the right resembles a musician from a salver in the New-York Historical Society dated 1428; see Paul F. Watson, "A *Desco da Parto* by Bartolomeo da Fruosino," *Art Bulletin* 66 (1974): 4–9.

11. On the reverse two nude *amorini* on a hillock tussle with a swan, the bird of Venus. The panel was first published by Eugene Müntz, "Les plateaux d'accouchées et la peinture sur meubles," *Monuments et mémoires* 1 (1894): 225–26. Andre Pérate

in *Catalogue raisonné de la collection Martin Le Roy*, 5 vols. (Paris, 1909), 5: 25–28, 32, calls it Florentine, noting relationships with Fra Angelico, Pisanello, and Milanese painting. Schubring, *Cassoni*, 1: 237–38 dates it around 1450. The painter should be considered as a follower of Pesellino, indebted also to Domenico Veneziano.

12. For the attribution to Baldini, see Levenson, Oberhuber, and Sheehan, *Early Italian Engravings*, p. 15. For the Otto prints in general, see Hind, *Early Italian Engraving*, 1: 85–96 with bibliography and Aby Warburg, "Delle 'Imprese amorose' nelle più antiche incisione fiorentine," *Gesammelte Schriften*, 2 vols. (Leipzig: Teubner, 1932), 1: 79–88.

13. Examples include the altarpiece by Fra Filippo Lippi cited in the text, the central predella panel to Domenico Veneziano's St. Lucy Altarpiece, now Fitzwilliam Museum, Cambridge, and Fra Angelico's fresco in the Convent of S. Marco, Florence, corridor, dormitory floor. This state of affairs differs sharply from the late Trecento when the Annunciation usually occurs in the Virgin's bedchamber; see the examples listed in note 23 to chapter 6. Although the change can be explained by textual sources, some weight should be given to a growing acceptance of secular imagery in religious art; see Luciano Berti, *Fra Angelico* (Florence: Sadea/Sansoni, 1967), p. 12.

14. Not "LAUS DEO" as reported by Hind, *Early Italian Engraving*, 1: 92. The inscriptions adorning a woman's gown in the Douai *Garden of Love* (pl. 51) are less easily identified, although the letters "A," "M," and "O" can be discerned.

15. *Teseida* 7. 66. 5, and gloss to 7. 50. 1.

16. Millard Meiss and Edith W. Kirsch, *The Visconti Hours* (New York: George Braziller, 1972), fol. BR 2v and Commentary, also p. 260, n. 6.

17. *Inferno* 1. 32–33: "Una lonza leggiera e presta molto,/ che di pel maculato era coverta."

18. See Holkham Hall, Norfolk, MS 514, fol. 1r, illuminated in the third quarter of the Trecento. Here the *lonza* appears as a leopardlike beast, and is labeled *luxuria*. See Peter Brieger, Millard Meiss, and Charles S. Singleton, *Illuminated Manuscripts of the Divine Comedy*, 2 vols. (Princeton, N. J.: Princeton University Press, Bollingen Foundation, 1969), 2, pl. 42b. See also pls. 41b, 43a.

19. Benvenuto da Imola, *Commentum super Dantis Aldigherij Comoediam*, ed. J. F. Lacaita, 5 vols. (Florence: G. Barbera, 1887), 1: 34–35. Benvenuto's analysis is based on *Aeneid* 1. 323: "Succinctam pharetra et maculosae tegmine lyncis." For this commentator, see L. Paoletti, "Benvenuto da Imola," *Dizionario biografico degli italiani* 7 (1966): 692–93.

20. Boccaccio's own remarks on the *lonza* are in *Esposizioni sopra la Comedia di Dante*, ed. Giorgio Padoan in *Tutte le opere*, ed. Branca, 60, pp. 72–78. Boccaccio concludes that the *lonza* signifies "il vizio della lussuria."

21. Gianotto Calogrosso, *Nicolosa bella*, ed. Franco Gaeta and Raffaele Spongano (Bologna: Commissione per i testi della lingua, 1959), pp. 11, 46, 113. A medieval precedent for Calogrosso as well as Dante and his commentators is the anonymous *Mare Amoroso* of the thirteenth century: "e più d'olor portate infra la gente che non ha la pantera infra le bestie, / e più di grazia non ha il leopardo" (pp. 144–46). See Contini, *Poeti del duecento*, 1: 492.

22. "Canti e istrumenti . . . hanno forze da cacciare via ogni malinconia, la quale . . . è forte avversa agli effetti di Venere" (*Teseida* 7. 50, 1. gloss), my translation.

23. "Enervant animos citharae lotosque lyraeque" (Ovid *Remedia amoris* 753), trans. Mozley.

24. Shakespeare *Richard III* 1. 1. 13.

25. "Sine Cerere et Libero friget Venus" (Terence *Eunuchus* 732), my translation. On the transmission of this maxim to the Middle Ages, see Leslie George Whitbread,

ed., *Fulgentius the Mythographer* (Colombus, Ohio: Ohio State University Press, 1971), p. 67. Alberti quotes the tag in *Della famiglia*, ed. Grayson, 1: 137. In the gloss to *Teseida* 7. 50. 1, Boccaccio explains that Bacchus and Ceres sit with Venus to signify that the lustful are also greedy and gluttonous, and also to show that consuming fine food and dainty wines often revives the libidinous appetite.

26. "Vina parant animos faciuntque caloribus aptos" (Ovid *Art of Love* 1. 237), trans. Mozley. On the reverse of the salver illustrated in my plate 61 is a demonstration of the combination of love and wine. Through a grove strides a youth, probably Cupid because the device AMOR adorns his sleeve, who nibbles at a bunch of grapes. See *Mostra dei tesori segreti delle case fiorentine* (Florence: Circolo Borghese e della Stampa, 1960), pl. 15.

27. Guglielmo Ebreo, *Trattato dell'arte del ballo*, ed. Francesco Zambrini (Bologna: Commissione per i testi della lingua, 1873, reprint ed. 1968), pp. 82, 90. The dance depicted in the Princeton *Garden of Love* (pl. 51) was compared to illuminations of Guglielmo's treatise by Scharf, "Sammlung Figdor," p. 419. The general importance of the dance for Quattrocento art has recently been treated by Michael Baxandall, *Painting and Experience in Fifteenth Century Italy* (Oxford: Oxford University Press, 1972), pp. 77–81.

28. "Illic adsidue ficti saltantur amantes" (Ovid *Remedia amoris* 755), trans. Mozley.

29. Petrarch *Trionfo d'Amore* 2. 70. In the gloss to *Teseida* 7. 50, 1, Boccaccio claims that the sight of women dancing inflames the lustful. See also Robertson, *Preface to Chaucer*, pp. 126–31. The connection between the dance and love is demonstrated by a coffer produced in Florence during the 1430s: Cupid appears on its circular lid, while a *bassa danza* unfolds on the sides. See Schubring, *Cassoni*, p. 230 and Friedländer, *Sammlung Figdor*, vol. 5, pl. CXLI.

30. "Haec itaque quinque Solias filias, id est quinque humanos sensus luci ac veritati deditos quasi solis fetus hac corruptela fuscatos" (Fabius Planciades Fulgentius *Mitologiae* 2. 7), trans. Whitbread, *Fulgentius the Mythographer*, p. 73.

31. Curtius, *European Literature*, pp. 512–13.

32. "L'opere de' voluttuosi non solamente in lussuria consistere, ma ancora in lascivia; la quale lascivia intende essere il basciare, il toccare e il cianciare e 'l motteggiare e l'altre sciocchezze che intorno a ciò si fanno" (Boccaccio *Teseida* 7. 50. 1. gloss), my translation.

33. Boccaccio, *Esposizioni*, ed. Padoan, pp. 339–43. The modes are fornication, incest, unions between lay and clerical persons, adultery, and sodomy. Boccaccio's comments pertain to his general allegorical explanation of Canto 5 of the *Inferno*, where the punishment of the lustful is described.

34. Fulgentius observes that three is the number of the Graces, and that Venus herself represents a third way of life, the voluptuous, offered to Paris. See *Mitologiae* 2. 1. Boccaccio's comments on Fulgentius's numerology are in *Genealogy of the Gods*, 6. 23.

35. "Sunt in amore gradus tres, triplex gratia; fundat / Prima, secunda fovet, tertia firmat opus," cited by Curtius, *European Literature*, p. 511.

36. Prov. 30:15, cited by Curtius, *European Literature*, p. 510. Equally relevant is Prov. 30:18–19: "There be three things which are too wonderful for me, yea, four which I know not: The way of an eagle in the air; the way of a serpent upon a rock; the way of a ship in the midst of the sea; and the way of a man with a maid."

37. *Teseida* 7. 54. 1–5. See also 7. 50. 1. gloss.

38. This gesture is derived from Masolino's *Raising of Tabitha* in the Brancacci Chapel; the source is an Oriental gesticulating with surprise at the miracle that St. Peter performs.

39. Ovid *Metamorphoses* 3. 407–510.

40. In *Teseida* 7. 50. 1. gloss, Boccaccio says: "E temperale nella fonte della nostra falsa estimazione, quando per questa dillettazione, nata d'amore e di speranza, giudichiamo che la cosa piaciuta sia da preporre ad ogni altra cosa o temporale o divina."

41. Illustrated in Arduino Colasanti, *Le fontane d'Italia* (Milan: Bestetti and Tumminelli, 1926), pl. 35.

42. Illustrated in Adolfo Venturi, *Storia dell'arte italiana*, 22 vols. (Milan: U. Hoepli, 1901–1940), 4: 785, fig. 652.

43. Most recently discussed by Charles Seymour, Jr., *Jacopo della Quercia* (New Haven, Conn.: Yale University Press, 1973), pp. 61–65.

44. Van Marle, *Iconographie*, 2: 432.

45. See Andreina Griseri, *Jaquerio e il realismo gotico in Piemonte* (Turin: Fratelli Pozzo, 1966), pp. 68–70.

46. Spenser *Faerie Queene* 4. 9. 22. 8.

47.
Ma pensi chi ben vide, se penoso
esser dovei e con amaro core,
quel loco abandonando grazioso.
Quivi biltà, gentilezza e valore,
leggiadri motti, essemplo di virtute,
somma piacevolezza è con amore;
 quivi disio movente omo a salute,
quivi tanto di bene e d'allegrezza
quant'om ci pote aver, quivi compiute
 le delizie mondane, e lor dolcezza
si vedeva e sentiva; e ov'io vado
malinconia e etterna grammezza
(Boccaccio *Comedia ninfe* 49. 64–75, my translation)

48. The panel was first published and attributed to Mariotto by Van Marle, *Development of the Italian Schools*, 9: 216.

49. Guy de Tervarent, *Les énigmes de l'art au moyen âge* (Paris: Éditions d'art et d'histoire, 1938), pp. 51–53; also Tervarent, *L'héritage antique* (Paris: Éditions d'art et d'histoire, 1946), p. 28, n. 3. Van Marle identified the panel as a Garden of Love, making it a conspicuous instance of the type in *Iconographie*, 2: 431. More recently, it is entitled a "Liebesgarten" in *Jahrbuch der staatlichen Kunstsammlungen in Baden-Wurtemburg* 2 (1965): 319.

50. *Teseida* 3. 11. 3.

51. Ibid., 5. 62. 7.

52. The panel was first assigned to the Master of the Bargello Tondo by L. Ragghianti Collobi in *Lorenzo il Magnifico e le arti* (Florence: Museo Mediceo, 1949), p. 35. On the reverse of the salver, mentioned in note 61 to this chapter, appear the arms of the Aldobrandini and the Alberti, which Ragghianti Collobi links to a marriage of 1446; see Passerini, *Alberti*, 2: 100. The compilers of the 1960 *Mostra dei tesori segreti* give the panel to Cecchino da Verona, whom Roberto Longhi attempted to identify as the Master of the Bargello Tondo (see further note 1 to chapter 7), and they date it around 1430–1435. A dating in the 1440s, however, is justified by the conventions of landscape as well as an extensive pictorial space, both resembling the predella panels of Domenico Veneziano's St. Lucy altarpiece.

53. Sus. 4, 7, 15, 17.

54. Ibid., 56. The Vulgate reads: "Species decepit te, et concupiscentia subvertit cor tuum." The Serristori salver is lacking from a recent consideration of Susanna's story in Quattrocento art; Everett Fahy, "The 'Master of Apollo and Daphne'," *Museum Studies* 3 (1968): 21–41.

55. The painting was first given to Andrea di Giusto by Tancred Borenius, "Un-

published Cassone Panels—V," *Burlington Magazine* 41 (1922): 104–9. See also Schubring, *Cassoni*, p. 421 and Van Marle, *Development of the Italian Schools*, 9:253. According to the files of the Frick Art Reference Library, Federico Zeri has verbally suggested that the panel is by a follower of Pesellino, an observation sustained by comparisons with Pesellino's beautiful paintings of the *Trionfi* in the Isabella Stewart Gardner Museum, Boston. The panel was sold several years ago at Sotheby's in London; its present location is unknown.

56. The overthrow of Cupid is recounted in *Trionfo della Pudicizia* 91–114. Usually in cassone painting, the first three *Trionfi* (Love, Chastity, Death) appear together, as in Pesellino's panels cited above. In addition to my plate 62, Love and Chastity appear on a cassone panel in Edinburgh attributed to Apollonio di Giovanni; see Ellen Callmann, *Apollonio di Giovanni* (Oxford: Clarendon Press, 1974), p. 60, pl. 111. Here, however, Cupid's downfall does not appear, and it is likely, as Callmann suggests, that the picture has been cut down at the right so that an accompanying Triumph of Death has been lost.

NOTES TO CHAPTER 7

1. First published by U. Rossi, "I deschi da parto," *Archivio storico dell'arte* 3 (1890): 78–79; the most recent discussion is Liana Castelfranchi Vegas, *Die internationale Gotik in Italien*, trans. Brigitte Schönert (Dresden: VEB Verlag der Kunst, 1966), pp. 61–62 and 179, with further bibliography. Most authorities put the panel in the 1430s. I agree with Schubring, *Cassoni*, p. 238 and Van Marle, *Development of the Italian Schools*, 9: 452, n. 2, that the painter should be considered a Florentine influenced by Fra Angelico, not a transplanted Sienese, Bolognese, or even Veronese master. The identification proposed by Roberti Longhi, "Fatti di Masolino e di Masaccio," *Critica d'arte* 5 (1940): 186, n. 23, namely, that the painter was Cecchino da Verona, active in Siena in 1430–1432, is not convincing.

2. Illustrated in Georg Pudelko, "The Minor Masters of the Chiostro Ver⟩," *Art Bulletin* 17 (1935): 71–89, fig. 10. The panel was formerly in the collection of Marquet de Vasselot, Neuilly-sur-Seine.

3. Richard Krautheimer in collaboration with Trude Krautheimer-Hess, *Lorenzo Ghiberti*, 2d ed., 2 vols. (Princeton, N. J.: Princeton University Press, 1970), 2: pl. 93.

4. Ovid *Heroides* 16. 64.

5. The passage is *Heroides* 16. 39–142. See Remigio Sabbadini, *Le scoperte dei codici latini e greci ne' secoli XIV e XV*, 2d rev. ed. Eugenio Garin, 2 vols. (Florence: G. C. Sansoni, 1967), 1: 124.

6.
 Populus est, memini, fluviali consita rivo,
 est in qua nostri littera scripta memor.
 Popule, vive, precor, quae consita margine ripae
 hoc in rugoso cortice carmen habes:
 'Cum Paris Oenone poterit spirare relicta,
 ad fontem Xanthi versa recurret aqua!
 (Ovid *Heroides* 5 . 25–30)
The edition used is *Epistulae Heroidum*, ed. Heinrich Dorrie (Berlin and New York: Walter de Gruyter, 1971). The translation is by Harold C. Cannon, *Ovid's Heroides* (New York: E. P. Dutton, 1971), p. 42. It is worth noting that Oenone herself is a river nymph; see *Heroides* 5. 10.

7. Erwin Panofsky, *Studies in Iconology*, 2d ed., (New York: Oxford University Press, 1939, 1962), p. 126.

8. *Heroides* 16. 53–56.

9. An example is a contemporary *Annunciation* by a follower of Fra Angelico, illustrated in Seymour, *Early Italian Paintings*, p. 133.

10. Boccaccio *Genealogy of the Gods* 6. 22. For more traditional representations of the judgment of Paris, consult Edward S. King, "The Legend of Paris and Helen," *Journal of the Walters Art Gallery* 2 (1939): 55–72.

11. First attributed to Giovanni by Mary Logan Berenson, "Dipinti italiani a Cracovia," *Rassegna d'arte* 15 (1915): 1–2. See also Schubring, *Cassoni*, 1: 236.

12. First attributed to Giovanni by Schubring, *Cassoni*, 1: 226.

13. One panel, formerly in the collection of Lady Ashburnham, London, shows a soldier and a lady striding to the left; see Berenson, *Italian Pictures; Florentine School*. vol. 1, pl. 486. A second panel shows a lady wearing an elaborate garland walking with a youth dressed in a long trailing robe; a photograph is in the Frick Art Reference Library. Both panels were attributed to Giovanni by Berenson, *Italian Pictures; Florentine School*, 1: 90, 91.

14. Schubring, *Cassoni*, 1: 126; Roberto Salvini, "Lo sviluppo artistico di Giovanni dal Ponte," *Atti e memorie della R. Accademia Petrarca di lettere, arti, e scienze*, n.s. 16–17 (1934): 42, n. 3.

15. Van Marle, *Iconographie*, 1: 457–58.

16. Compare Giovanni di Marco's armor to the costumes of Nimrod and Saturn in *A Florentine Picture-Chronicle*, ed. Sir Sidney Colvin (London: B. Quaritch, 1898), pp. 6, 30. Giovanni's costumes also resemble nearly contemporary drawings of *uomini famosi* recently ascribed to Leonardo da Besozzo as copies of lost frescoes by Masolino; see Robert L. Mode, "Masolino, Uccello, and the Orsini 'Uomini famosi,'" *Burlington Magazine* 114 (1972), fig. 20.

17. Jan Bialostocki, *La peinture italienne des XIVe et XVe siècles* (Cracow: National Museum, 1961), pp. 56–57.

18. See Griseri, *Jaquerio*, pp. 61–71.

19. On the eternal greenness of fame, see Boccaccio, *Esposizioni*, ed. Padoan, pp. 275–76. Boccaccio comments on *Inferno* 4. 106–11.

20. "Un giovane prato / tutta la parte vidi verdeggiare, / similemente fiorito e adornato / d'alberi molti e di nuove maniere, / e l'esservi parea gioioso e grato" (Boccaccio *Amorosa Visione* 15. 8–12), my translation.

21. "Vi vidi Lancilotto effigiato / con quella che sì lunga fu sua gloria. / Lì dopo lui, dal suo destro lato, / era Tristano e quella di cui elli / fu più che d'altra mai innamorato" (*Amorosa Visione* 29. 38–42), my translation.

22. The panel was formerly in the collection of Dr. Mog, Munich, and was first published by Paul Schubring, "New Cassone Panels," *Apollo* 5 (1927): 155–56. The influence of *Amorosa Visione* 6–12 was demonstrated by Dorothy Shorr, "Some Notes on the Iconography of Petrarch's Triumph of Fame," *Art Bulletin* 20 (1938): 102. Schubring gave the panel to Giovanni di Marco, dating it around 1420–1430; his attribution is retained, with reservations, by Ellen Callmann, *Apollonio di Giovanni* (Oxford: Oxford University Press, 1974), p. 12, n. 34.

23. Full bibliography is in Eugene B. Cantelupe, "The Anonymous *Triumph of Venus* in the Louvre: An Early Renaissance Example of Mythological Disguise," *Art Bulletin* 44 (1962): 238, nn. 1–2. The most recent discussion is Phyllis Williams Lehmann and Karl Lehmann, *Samothracian Reflections* (Princeton, N. J.: Princeton University Press, 1973), pp. 156, 159, nn. 199–200. Cantelupe and Phyllis Lehmann both consider the salver to be north Italian.

24. To cite a few examples: the knight who kneels second from the right, identified as Paris, resembles a saint in an altarpiece by a follower of Giovanni del Biondo,

formerly in a private collection, New York, illustrated in Berenson, *Italian Pictures: Florentine School*, vol. 1, pl. 299; Tristan and Lancelot, two knights kneeling second and third from the right, look like the angel Gabriel in an *Annunciation* by Bicci di Lorenzo in S. Maria Assunta, Stia, dated 1414 and illustrated in Berenson, *Italian Pictures: Florentine School*, vol. 1, pl. 498. An instructive instance of the youthful Mariotto di Nardo's work is a *Crucifixion* in Amherst, Mass., illustrated in Fern Rusk Shapley, *Paintings From the Samuel H. Kress Collection: Italian Schools XIII–XV Century* (London: Phaidon, 1966), p. 46, fig. 118. Mariotto's Roman centurions resemble the bearded knights in the salver in physical type and costume; his St. John the Evangelist is like the beardless heroes. In both panels the mannerism of a fluttering cape plays a persistent role.

25. First fully described by Frank J. Mather, Jr., "A Quattrocento Toilet Box in the Louvre," *Art in America* 11, no. 1 (December 1922): 45–51, who thought the piece was Umbrian. John Pope-Hennessy, *Giovanni di Paolo* (New York: Oxford University Press, 1938), p. 23, n. 50, considered it Lombard.

26. Millard Meiss, "The Earliest Work of Giovanni di Paolo," *Art in America* 24 (1936): 137–43. Recently Meiss withdrew his earlier attribution to Giovanni di Paolo, but still maintained that the piece was Sienese, perhaps by a follower of Paolo di Giovanni Fei; see Millard Meiss, *The Limbourgs and their Contemporaries* (New York: George Braziller and the Pierpont Morgan Library, 1974), 1: 26.

27. Compare the goddess with the diminutive Virgin and the teenage girls in a *Presentation of the Virgin* by Paolo di Giovanni Fei, National Gallery of Art, Washington, illustrated in Shapley, *Kress Collection*, p. 62, fig. 159. The women kneeling beneath Venus look like the participants in an *Assumption of the Virgin* by Andrea di Bartolo in Richmond, Va., discussed by H. W. van Os, "Andrea di Bartolo's Assumption of the Virgin," *Arts in Virginia* 11 (1970–1971): 1–11. The amorini beside Venus are close in drawing and proportions to the nude children of Andrea's *Massacre of the Innocents*, Walters Art Gallery, Baltimore, discussed in Philippe Verdier, ed., *The International Style* (Baltimore, Md.: Walters Art Gallery, 1962), pp. 1–2 and pl. XI, there attributed to Bartolo di Fredi. For conventions of landscape, compare an *Assumption of the Virgin* by Paolo di Giovanni Fei in the National Gallery, illustrated in Shapley, *Kress Collection*, fig. 160.

28. The painter responsible for the 1421 casket might well have executed some iconographically puzzling frescoes in the portico of the parish church of Lecceto, near Siena. One of the cupids seems identical with a putto hovering above a hay wain in the fresco. See Cesare Brandi, *Quattrocentisti senesi* (Milan: Hoepli, 1949), p. 252, pl. 42. Brandi dates the frescoes between 1420 and 1425. Federico Zeri, "Inedito del supposto 'Cecchino da Verona,'" *Paragone* 17 (May 1951): 31–32, suggests that the frescoes be given to Cecchino da Verona, whom he identifies as the Master of the Bargello Tondo, with a dating in the 1430s.

29. Cantelupe, *"Triumph of Venus,"* p. 239.

30. A doubting Thomas gesturing in much the same fashion as Samson appears in a *Madonna della cintola* attributed to Maso di Banco, now in Berlin; see Berenson, *Italian Pictures: Florentine School*, vol. 1, pl. 133. For the gesture of Venus, see a *Man of Sorrows* in Berlin by Giovanni del Biondo, illustrated in Offner, *Corpus*, sec. 4, vol. 5, pl. XXXII[1].

31. Kohlhaussen, *Minnekästchen*, p. 92, pl. 59.

32. Hind, *Early Italian Engraving*, A. 1. 47, 1: 43–44, illustrated vol. 2, pl. 46.

33. "La parte ignuda di Venere intende l'apparenza delle cose, le quali attraggono gli animi di coloro la cui estimazione non può passare all'essistenza" (*Teseida* 7. 50. 1. gloss.), my translation. Later counterparts to Boccaccio's nude Venus and to the nude

goddess of this salver include a drawing by Pisanello in the Albertina, Vienna, in which Luxury appears as a nude woman reclining beside a rabbit, illustrated in Maria Fossi Todorov, *I disegni del Pisanello e della sua cerchia* (Florence: Leo S. Olschki, 1966), p. 57, pl. 1; and a nude Venus in a Florentine cassone panel of the 1420s, now in Brunswick, Me., discussed by Watson, "Boccaccio's *Ninfale Fiesolano*," p. 332, n. 11 and pls. 55a, 55b.

34. Boccaccio *Genealogy of the Gods* 9. 4. See further Panofsky, *Studies in Iconology*, pp. viii, 115–20. The clawed feet are noted without comment by Cantelupe, "*Triumph of Venus*," p. 239 and with a query by Phyllis Lehmann in *Samothracian Reflections*, p. 156, n. 199.

35. Amore è uno spirito avaro, e quando
 alcuna cosa prende, sì la tene
 serrata forte e stretta con gli artigli,
 ch'a liberarla invan si dan consigli.
 (Boccaccio *Filostrato* 3. 48. 5–8), my translation.
The text used is *Filostrato*, ed. Vittore Branca, in *Tutte le opere*, 2.

36. Solea creder lo mondo in suo periclo
 che la bella Ciprigna il folle amore
 raggiasse, volta nel terzo epiciclo;
 per che non pur a lei faceano onore
 . . . le genti antiche.
 (*Paradiso* 8. 1–6).
Translation by Dorothy L. Sayers and Barbara Reynolds, *The Divine Comedy, 3. Paradise* (Harmondsworth and Baltimore: Penguin Books, 1962), p. 115. The Italian text used is *La Divina Commedia*, ed. C. H. Grandgent, rev. Charles S. Singleton (Cambridge, Mass.: Harvard University Press, 1972).

37. Benvenuto of Imola, *Commentum*, 4: 480, defines Dante's "folle amore" as "amor concupiscentiae lascivus" in opposition to "amor amicitiae." In so doing, Benvenuto echoes earlier commentators, such as Pietro di Dante, the poet's son, who defines "la bella Ciprigna" as "alia Venus est impudica et turpis amoris, per quem inclinamur ad turpia." See Pietro Alighieri, *Commentarium super Dantis ipsius genitoris Comoediam*, ed. Lord Vernon (Florence: Angelo Garineo, 1846), pp. 604–5. See also *L'Ottimo commento alla Divina Commedia*, ed. Alessandro Torri, 3 vols. (Pisa: Niccolò Capurro, 1827–1829), 3: 197–98 and *Chiose sopra Dante*, ed. Lord Vernon (Florence: Piatti, 1846), p. 549. Four of the knights in the salver, Achilles, Paris, Tristan, and Lancelot, are mentioned by Dante in *Inferno* 5, the circle of Hell reserved for the lustful.

38. Panofsky, *Studies in Iconology*, p. 115, n. 65 and Cantelupe, "*Triumph of Venus*," p. 241.

39. A. Hauber, *Planetenkinderbilder und Sternbilder* (Strasbourg, 1915), pls. XXV, XXVI, XXVII.

40. La prima dà piacere e disconforta,
 e la seconda disia la vertute
 della gran gioia che la terza porta.
 (Contini, *Poeti del duecento*, 2: 514, my translation)
Contini, note to line 2, traces the three arrows back to a Provençal poet, Guirant de Calanso; but see also the verses quoted in note 35 of chapter 6.

41. Cantelupe, "*Triumph of Venus*," p. 240.

42. Meiss, "Earliest Work of Giovanni di Paolo," p. 138, suggests that the panel is a *Planetenkinderbild* and that the worshipers of Venus may represent the three Graces. This clothed Venus also resembles a Trecento Venus in Ambrogio Lorenzetti's *Franciscan Martyrdom*, armed with an arrow and a bow, illustrated in Panofsky, *Renaissance and Renascences*, pl. 112. Furthermore, the inscription recalls Venus's

boast in Boccaccio's *Ninfale Fiesolano* 46. 4–8: "I' son colei che sì ben ho saputo / adoperar con questa mia scienza, / che, non ch'altri, ma Giove ho vinto e preso / con molti iddii, che niun non s'è difeso."

43. The arms have been identified as those of the Ranieri family: see Mather, "Quattrocento Toilet Box," p. 46.

44. Coffers like the objects depicted in my plates 68, 69, and 70 and diminutive chests like that shown in plate 74 usually are called vanity cases, toilet boxes, cake boxes, and the like. Their shape and size, however, make them ideal containers for such finery as jewelry and belts sent to newly affianced brides on the occasion of their betrothal. Some useful observations on the matrimonial significance of these objects appear in Georg Swarzenski, "A Marriage Casket and Its Moral," *Bulletin of the Museum of Fine Arts* 45 (1948): 55–62. More work, however, remains to be done. A promising line of inquiry is archival research, including inventories, account books, and sumptuary laws of the period. Published references to betrothal coffers include Carlo Carnessecchi, "Spese matrimoniali nel 1461," *Rivista d'arte* 5 (1907): 36–37; Daniel Herlihy, *Medieval and Renaissance Pistoia* (New Haven, Conn.: Yale University Press, 1967), pp. 288–89, reproducing accounts for a wedding of 1415; and P. Fanfani, "Legge suntuaria fatta dal Comune di Firenze l'anno 1355 e volgarizzata nel 1356 da Andrea Lancia," *Etruria* 1 (1851): 376–77. I have presented some observations on these materials in "Italian Wedding Furniture," a paper read at the College Art Association Annual Meeting, New York, 1973. My thanks to Professors Rab Hatfield and Julius Kirshner for criticism and helpful suggestions.

45. Illa coit firma generis iunctura catena,
 imposuit nodos cui Venus ipsa suos.
 (Ovid *Heroides* 4. 135–36, trans. Cannon)

46. A complete photographic record of the coffer's exterior paintings and inscriptions appears in *Sammlung Figdor*, vol. 4, pls. CXXXVIII–CXL. The attribution to Domenico di Bartolo was first proposed by Pietro Toesca, "Una scatola dipinta da Domenico di Bartolo," *Rassegna d'arte senese* 13 (1920): 107–8, and has been accepted by most authorities, including most recently Brandi, *Quattrocentisti senesi*, p. 264. An exception is Alfred Scharf, "Die Brautschachtel der Sammlung Figdor," *Der Cicerone*, 13 (1930): 5–8, who gives it to a north Italian painter close to Pisanello.

47. Longhurst, *Catalogue of Carvings*, 2: 44–45, and Philippe Verdier, Peter Brieger, and Margaret F. Montpetit, *Art and the Courts*, 2 vols. (Ottawa: National Gallery of Canada, 1972), 1: 156–57. Similar ivories are in Dalton, *Ivory Carvings*, p. 131, pls. XC, XCI.

48. Longhurst, *Catalogue of Carvings*, 2: 49.

49. The most complete attempt at transcription is Levi, *Botteghe e canzoni*, pp. 8–9. Levi, however, reads the first five letters of the inscribed scroll as "Por te."

50. This transcription is made from the photographs in *Sammlung Figdor*, vol. 4, cited in n. 46. The most difficult passage is the introductory verb *S.glon*, which most authorities render as "Soglon," expanded to *sogliono* from *solere*, to be accustomed. If this be the case, then the verb is an incomplete auxiliary construction. My paraphrase of the verb as "shine" follows Ital. *sole, soleggiare*, and is at least consistent with the substantives *raggi* and *occhi*. Werner Weisbach, *Francesco Pesellino* (Berlin: B. Cassirer, 1901), p. 77, translates *Soglon* as "Pflegen," to caress. The third line does not read *Far viver*, as Levi, Toesca, and others maintain. The wording seems close to Fr. *faire vider*.

51. Levi, *Botteghe e canzoni*, pp. 16–18.

52. "Entrano i raggi di questi occhi belli / ne' miei innamorati" (Dante *Rime* 68. 17–18), trans. Foster and Boyde, *Dante's Lyric Poetry*.

53. Dante, *Rime* 58. 13. Compare Boccaccio, *Ninfale fiesolano* 1. 1–2: "Amor mi fa parlar, che m'è nel core / gran tempo stato e fatto n'ha su' albergo."

54. Dante *Rime* 28. 5.

55. Ibid., 40. 21–22: "Elli era tale a veder mio colore, / che facea ragionar di morte altrui."

56. "Palleat omnis amans: hic est color aptus amanti" (Ovid *Art of Love* 1. 729), trans. Mozley.

57.
> Mille fiate, o dolce mia guerrera,
> per aver co' begli occhi vostri pace
> v'aggio proferto il cor.

(Petrarch *Rime* 21. 1–3, my translation)

Thus far, the coffer resembles other late medieval representations of the inception of love. Scharf, "Brautschachtel," pp. 5–8 likens it to a drawing in the Lugt Collection, Paris, showing a youth who genuflects before his lady; accompanying them is a verse beginning "O nobilissima donna ornata da ogni bellezza." For the drawing, see Adolfo Venturi, "Per il Pisanello," *L'arte* 28 (1925): 36–39 and Fossi Todorow, *Disegni del Pisanello*, pp. 176–77. Analogous craft objects include a German book cover inscribed "Das herze din muoss leiden pin," illustrated in Kohlhaussen, *Minnekästchen*, pp. 81–82, pl. 51; and a French coffer from the late fourteenth century inscribed MON ♡ AVES, discussed by Robert G. Calkins, *A Medieval Treasury* (Ithaca, N. Y.: Office of University Publications, Cornell University, 1968), p. 155.

58. See the anonymous *Mare Amoroso* 69–74, "Ch'io voglio far la dritta somiglianza / de l'albero che per troppo incarcare / scavezza e perde foglie e fiori e frutto, / e poi si secca infino a le radici; / così mi voglio d'amoroso afanno / e di pensier carcar tanto ch'i'mora," in Contini, *Poeti del duecento*, 1: 489. The vanity of lovers' hopes is sung by Pucciandone Martelli: "L'albor' e 'l vento siete veramente, / ché faite 'l fror: potetelo granare; / poi faitelo fallare / e vana divenir la mia speransa," in Contini, *Poeti del duecento*, 1: 336. Images of reflowering are treated by Gerhard B. Ladner, "Vegetation Symbolism and the Concept of Renaissance," *De Artibus Opuscula XL: Essays in Honor of Erwin Panofsky*, ed. Millard Meiss, 2 vols. (New York: New York University Press, 1961), 1: 316–18.

59. Dante *Inferno* 5. 30. See also Boccaccio, *Esposizioni*, pp. 343–44, on how cold winds curb and chastise luxury.

60. *Rime* 100. 3–4: "E quella dove l'aere freddo suona / Ne' brevi giorni, quando borrea 'l fiede." The rigors of the north wind are linked with the pains and joys of love remembered. Boccaccio *Comedia Ninfe* 30. 4, calls this wind "freddissimo Borea canuto."

61.
> Come rimane splendido e sereno
> l'emisperio de l'aere, quando soffia
> Borea da quella guancia ond' è più leno,
> per che si purga e risolve la roffia
> che pria turbava, sì che 'l ciel ne ride
> con le bellezze d'ogne sua paroffia.

(Dante *Paradiso* 28. 79–84, trans. Dorothy Sayers and Barbara Reynolds)

The image refers to the poet's new understanding of his lady Beatrice's explanation of the light of God, which is reflected in her eyes. Benvenuto da Imola, *Commentum*, 5: 415–16, defines this gentle Boreas as "tramontana lucida, quae diriget homines ad portam salutis."

62. Contini, *Poeti del duecento*, 2: 579–80. Especially pertinent are lines 21–24: "Ella mi fe' tanta di cortesia, / che no sdegnò mio soave parlare, / ond' i' voglio Amor dolce dingraziare, / che mi fe' degno di cotanto onore."

63. Luca Pulci, *Ciriffo Calvaneo, con la Giostra del Magnifico Lorenzo de' Medici*

(Florence: Giunti, 1572), p. 76. The same motto appears in the Otto Prints of the 1470s; see Hind, *Early Italian Engraving*, 1: 88–89 (A. IV. 8, 9, 11, 12).

64. Amor, che con sua forza e virtù regna,
 Nel sommo cielo ardendo sempre vive
 E l'anima gentil di lui fa degna;
 Regge mia vita e quel che la man scrive,
 Dimostra el cuor divoto a sua deitate. . .
 Amor vol fede e con lui son legate
 Speranza con timor e gelosia
 E sempre con leanza umanitate.

 (Boccaccio *Rime* 22. 1–9, my translation)

The edition here used is Giovanni Boccaccio, *Opere minori*, ed. Enrico Bianchi (Florence: Salani, 1974), pp. 546–48.

65. Premio non cerca, regni o alto stato,
 Ma sol bontate e un disio amoroso,
 Con pura fede, l'uno e l'altro amato.

 (Boccaccio *Rime* 22. 34–36, my translation)

66. Joy of a less courtly but more graphic sort may have been the content, so to speak, of this coffer; according to Brandi, *Quattrocentisti senesi*, p. 264, the interior was decorated with lewd paintings.

67. The blazonry was correctly identified by R. Steele, "A Notice of the *Ludes Triumphorum* and Some Early Italian Card Games: With Some Remarks on the Origin of the Game of Cards," *Archaeologia* 57 (1900): 190. For the attribution to Bembo, see Pietro Toesca, *La pittura e la miniatura nella Lombardia*, 2d ed., (Turin: Einaudi, 1966), pp. 217–19. See also Gertrude Moakley, *The Tarot Cards Painted by Bonifacio Bembo for the Visconti-Sforza Family* (New York: New York Public Library, 1966), p. 77.

68. No discussion of gardens without fountains would be complete without reference to two remarkable panels by Giovanni Toscani, a Florentine active in the 1420s. A painting in East Berlin, illustrated in Schubring, *Cassoni*, vol. 2, pl. C, depicts many couples and several children disporting themselves in an extensive landscape of meadows, shrubbery, and brooks; usually it is interpreted as genre. A second panel, now in Madison, Wis., depicts a company of youths, ladies, elderly men, and tiny children in a leafy bower; see Schubring, *Cassoni*, vol. 2, pl. C, and Shapley, *Kress Collection*, pp. 99–100, who assumes that it is based on the *Decameron*. For the attribution, see Luciano Bellosi, "Il Maestro della Crocifissione Griggs: Giovanni Toscani," *Paragone* 19, no. 193 (March 1966): 52–53. Although both paintings are related in a general way to the works described in this chapter, their iconography raises issues that digress from this book. The panels will be interpreted in a forthcoming study.

NOTES TO CHAPTER 8

1. Frida Schottmüller, *Furniture and Interior Decoration of the Italian Renaissance*, 2d. ed. (Stuttgart: J. Hoffmann, 1928), pp. 66, 165, describes it as north Italian, fourteenth century. The staff of the Victoria and Albert Museum believe it to be Florentine, around 1400.

2. A similar coffer, produced around 1400, is in the Museo dell'Opera del Duomo, Orvieto; its motifs include a fountain guarded by two women, a cavalcade of famous men, and an inscription reading PALAMIDESE PER LO VO' AMORE L'AEIE MORTO. See Raimond Van Marle, "Zwei italienische Minnekästchen des 14. Jahrhunderts," *Pantheon* 15 (1935): 173, and Pietro Toesca, *Il Trecento* (Turin: Unione Tipografico Editrice Torinese, 1951), p. 939. A fountain approached by hunters appears

in an ivory comb carved in northern Italy late in the Trecento; see Longhurst, *Carvings in Ivory*, p. 68, pl. LVI.

3. Due gran nemiche inseme erano aggiunte,
 Bellezza et Onestá, con pace tanta
 Che mai rebellion l'anima santa
 Non senti poi.

 (Petrarch *Rime* 297. 1–4, my translation).

Like Bartolomeo da San Concordio in *Ammaestramenti* 1. 1. 10, 10, Petrarch derived his imagery from Juvenal *Satires* 10, 297–98: "Rara est adeo concordia formae / atque pudicitiae."

4. "Onde uscîr giá tant'amorose punte" (Petrarch *Rime* 297. 8), my translation.

5. "L'atto soave, e 'l parlar saggio umíle" (Petrarch *Rime* 297. 9–10), my translation.

6. The staff of the Victoria and Albert Museum believe this panel to be north Italian, from the first half of the Quattrocento. The costumes and figural style, however, are generally similar to the Princeton *Garden of Love* (pl. 52). Moreover, the decorative pattern recalls textile patterns popular in central Italian painting of the late Trecento. See Klesse, *Seidenstoffe*, p. 316, Cat. 238; p. 341, Cat. 279; and p. 352, Cat. 353.

7. Augusto Pedrini, *Il Mobilio*, 2d ed. (Florence: Azienda Libraria Editoriale Fiorentina, 1948), fig. 200. Compare also the motif of spouting fountains with the Sala delle Impannate in the Palazzo Davanzati, my plate 33.

8. Most authorities agree that the panel is Florentine, dating it to the 1420s. Lionello Venturi, *The Rabinowitz Collection* (New York: Twin Editions, 1954), pp. 19–20, calls it an allegory of love and death. Charles Seymour, Jr., *The Rabinowitz Collection of European Paintings* (New Haven, Conn.: Yale University Press, 1961), pp. 20–21, assumes that the huntresses are Diana and her nymphs. In *Early Italian Paintings*, pp. 135–37, Seymour merely refers to its general allegorical subject matter. Luisa Vertova, "The New Yale Catalogue," *Burlington Magazine* 115 (1973): 159, calls it "the Killing of the Stag by the Fountain of Love."

9. Petronius *Carm.* 131, cited by Curtius, *European Literature*, p. 196.

10. "Pur l'abbracciai, che non le valse argoglio, e porta' la nel bosco," from Giuseppe Corsi, ed., *Poesie musicali del trecento* (Bologna: Commissione per i testi di lingua, 1970), p. 359; translated by William Thomas Marrocco, *Fourteenth-Century Italian Cacce*, 2d ed. (Cambridge, Mass.: Mediaeval Academy of America, 1961), p. xii. In addition to these works, a good introduction to the *Caccia* is Giosuè Carducci, *Cacce in rima dei secoli XIV e XV* (Bologna: Ganichelli, 1896). A medieval Latin poem similar in theme to "Segugi a corta" is discussed by Thiébaux, *Stag of Love*, pp. 106–8.

11. Virgil *Aeneid* 4. 160–70. This passage is directly alluded to in the *caccia* "Con bracchi assai e con molti sparveri," in Corsi, *Poesie musicali*, p. 9. The importance of Virgil for the medieval hunt of love is stressed by Thiébaux, *Stag of Love*, pp. 93–95.

12. *Aeneid* 4. 66–73.

13. E, qual cervo ferito di saetta,
 Co'l ferro avelenato dentr'al fianco,
 Fugge, e più duolsi quanto più s'affretta,
 Tal io con quello stral dal lato manco,
 Che mi consuma, e parte mi diletta.

 (Petrarch *Rime* 209. 9–14), my translation.

14. "Perciò che per troppo pescare nell'amoroso fonte sono di tali che se ne scorticano" (Boccaccio *Teseida* 12. 77. 5. gloss), my translation.

15. "Dicitur autem amor ad amo verbo, quod significat capere vel capi. Nam qui amat, captus est cupidinis vinculis aliumque desiderat suo capere hamo. Sicut enim piscator astutus suis conatur cibiculis attrahere pisces et ipsos sui hami capere unco, ita vero captus amore suis nititur alium attrahere" (Andreas Capellanus, *De arte*

honesta amandi 1. 3), trans. Parry. In this etymology, Andreas follows Isidore of Seville. Both Andreas and Boccaccio undoubtedly knew Ovid *Art of Love* 3. 425, "semper tibi pendeat humus," as well as *Remedia Amoris* 448, "Nec satis est liquidis unicus hamus aquis."

16. Haec tibi non tenues veniet delapsa per auras:
 Quarenda est oculis apta puella tuis.
 Scit bene venator cervis ubi retia tendat,
 Scit bene qua frendens valle moretur aper;
 Aucupibus noti frutices; qui sustinet hamos,
 Novit quae molto pisce natentur aquae:
 Tu quoque, materiam longo qui quaeris amori,
 Ante frequens quo sit disce puella loco.
 (Ovid *Art of Love* 1. 43–50), trans. Mozley.

17. Venturi, *Rabinowitz Collection*, pp. 19–20. Full bibliography is in Federico Zeri, with the assistance of Elizabeth E. Gardner, *Italian Paintings: A Catalogue From the Collection of the Metropolitan Museum of Art: Florentine School* (New York: Metropolitan Museum of Art, 1971), pp. 54–56.

18. This attribution is proposed by Zeri and Gardner, *Florentine School*, p. 54.

19. Paul Schubring, "Two New 'Deschi' in the Metropolitan Museum," *Apollo* 6 (1927): 105–7; Van Marle, *Iconographie*, 2: 431. Most authorities, however, term the salver a hunting scene; see the summary of opinon in Zeri and Gardner, *Florentine School*, p. 56.

20. *Comedia Ninfe* 3.

21. Ibid., 6.

22. "All'ombra di piacevoli albuscelli, fra' fiori e l'erba altissima" (Boccaccio *Comedia Ninfe* 3. 13), my translation.

23. The problems raised by the identification of this panel and its companion piece, also in the Metropolitan Museum, are treated at greater length by Paul F. Watson and Victoria Kirkham, "*Amore e virtù*: Two Salvers Depicting Boccaccio's 'Comedia delle Ninfe Fiorentine' in the Metropolitan Museum," *Metropolitan Museum Journal* 10 (1975): 35–50.

24. Zeri and Gardner, *Florentine School*, pp. 73–75. Zeri is tentative about assigning the panel to Florence. This master's generally slapdash manner is comparable, however, to several Florentine works, including a cassone panel from the 1420s formerly in Honolulu, discussed in Watson, "Boccaccio's *Ninfale Fiesolano*," pp. 331–33, and a coffer depicting hunting scenes, discussed by Georg Swarzenski, "A Marriage Casket and Its Moral," *Bulletin of the Museum of Fine Arts* 45 (1948): 55–62.

25. "Nunc tibi me posito visam velamine narres, / si poteris narrare, licet!" (Ovid *Metamorphoses* 3. 192–93). The text used is *Metamorphoses*, ed. and trans. Frank Justus Miller, 2 vols. (Cambridge, Mass., and London: Loeb Classical Library, 1944). Translation by Mary M. Innes, *The Metamorphoses of Ovid* (Harmondsworth: Penguin, 1955), p. 79.

26. Zeri and Gardner, *Florentine School*, pp. 73–75.

27. Photographs of both sides of this salver are in the Frick Art Reference Library. The obverse appears in Marie Tanner, "Chance and Coincidence in Titian's *Diana and Actaeon*," *Art Bulletin* 66 (1974): 538, fig. 5. The panel appears to be by a Florentine close to Niccolò di Pietro Gerini and Lorenzo di Niccolò. Whoever he was, he seems guilty of iconographic inexactitude, since two men witness Diana at her bath. Another puzzling variant on the Actaeon myth is a Florentine cassone panel from the 1420s, now in Warsaw: see A. Spychalska-Boczkowska, "Diana with Meleagros and Actaeon: Some Remarks on a 15th Century Italian Cassone," *Bulletin du musée national de Varsovie* 9 (1968): 29–36.

28. "Aliis violentior aequo / visa dea est, alii laudant dignamque severa / virginitate vocant" (Ovid *Metamorphoses* 3. 253–55), trans. Innes.
29. *Teseida* 5. 57. 6. gloss, and 7. 79. 5; also *Genealogy of the Gods* 5. 14.
30. Hyginus, *Fabulae*, ed. Maurice Schmidt (Jena: Hermann Dufft, 1872), p. 36: "Actaeon Aristei et Autonones filius pastor Dianam laventem speculatus est et eam violare voluit."
31. Petrarch *Rime* 23. 141–60.
32. A mid-century dating was proposed by Van Marle, *Development of the Italian Schools*, 10: 572. Schubring, *Cassoni*, p. 239, suggested a date around 1400; Mario Salmi, "Aggiunte al Tre- e al Quattrocento fiorentino," *Rivista d'arte* 16 (1934): 175–76, suggested ca. 1430.
33. Statius, *Thebaid* 3. 201–2. Statius alludes to Actaeon, who profaned Diana's bath.
34. Not all early representations of the Actaeon myth depict a fountain. In the salver cited in note 27 above, Diana and her nymphs bathe in a pool; to one side is a flowery meadow where rabbits play! For the myth in general, see Tanner, "Chance and Coincidence," pp. 535–50 and Ellis K. Waterhouse, *Titian's Diana and Actaeon* (London, New York, and Toronto; Oxford University Press, 1952), pp. 8–12.
35. *Genealogy of the Gods* 7.14. In *Genealogy* 5. 1, Boccaccio quotes Claudian, *De Consulatu Stilichonis* 3. 237, "He septem venere duces." See Giovanni Boccaccio, *Genealogie deorum gentilium libri xiv*, ed. Vincenzo Romano, 2 vols. (Bari: Guiseppe Laterza, 1951), 1: 234–35.
36. Hans Liebeschütz, ed., *Fulgentius metaforalis* (Leipzig: Teubner, 1926), p. 119: "Diana . . . ultima inter planetas, propter quod septima ponitur in numero fictorum deorum."
37. "Montium custos nemorumque Virgo, / Quae laborantis utero puellas / Ter vocata audis adimisque leto, / Diva triformis" (Horace *Odes* 3. 22. 1–4). The text used is Horace, *Odes and Epodes*, ed. Paul Shorey, rev, by Paul Shorey and Gordon J. Laing (Chicago, New York and London, 1919). Translated by Joseph P. Clancy, *The Odes and Epodes of Horace* (Chicago: University of Chicago Press, Phoenix Books, 1960), p. 140. See also Catullus, 34. 13–14. Important for the late Middle Ages and early Renaissance is Virgil *Aeneid* 4. 511: "Tergeminamque Hecaten, tria virginis ora Dianae" and the commentary by Servius, 1: 557. Diana, as the moon, becomes Trivia in Dante *Paradiso* 23. 25–27; see also Benvenuto da Imola, *Commentum*, 5: 316 and Boccaccio, *Genealogy of the Gods*, 4.16. Further instances are listed in Edgar Wind, *Pagan Mysteries in the Renaissance*, 2d. ed. (Harmondsworth: Penguin Books, 1967), p. 249. It should be remembered that Ovid says that *ten* nymphs assisted Diana at her bath; *Metamorphoses* 3. 165–72.
38. Strengthening the association of Diana with virtue is Horace's *Centennial Hymn*, directed to Apollo and Diana, in which the goddess is praised as the patron of childbirth, guide to the young, and protector of the laws of marriage: *Carmen saeculare* 17–20: "Diva, producas subolem patrumque / Prosperes decreta super iugandis / Feminis prolisque novae feraci / Lege marita." Boccaccio cites this ode in *Genealogy of the Gods* 4. 16. The visual evidence suggests that Diana became a major figure in early Renaissance mythology, who awaits further study. A good introduction to her fortunes is Leopold Ettlinger, "Diana," *Reallexikon zür deutschen Kunstgeschichte* vol. 3, cols. 1429–37.
39. "Tu venandi studium cole: saepe recessit / Turpiter a Phoebi victa sorore Venus" (Ovid *Remedia amoris* 199–200), trans. Mozley. The influence of these verses in the Middle Ages is discussed by Thiébaux, *Stag of Love*, p. 98.

40. Alfredo Lensi, *Il Museo Stibbert*, 2 vols. (Florence, 1918), 1: 163. Also Schubıing, *Cassoni*, 1: 231.

41. Solomon's idolatry is in 1 Kings 11: 1–8. For representations of the medieval fable of Aristotle made foolish by love in Italian art and literature, see Raffaello da Cesare, "Di nuovo sulla leggenda di Aristotele cavalcato," *Miscellanea del Centro di Studi Medievali*, n.s. 57 (1956): 181–247. A Tuscan precedent for this relief is a Trecento fresco in the Palazzo Communale in San Gimignano; see Ettore Li Gotti, "Gli affreschi della stanza delle Torre nel Palazzo del Podestà in San Gimignano," *Rivista d'arte* 20 (1938): 379–91.

42. The scroll above the hunter reads: ATTEON. Unfortunately, his partner's scroll can be only partly deciphered to read IOLA . . T . ANT . . . , perhaps a reference to Actaeon's mother, Autononis.

NOTES TO CHAPTER 9

1. James Jackson Jarves acquired the *Realms of Love* from a Prince Conti in Florence before 1860. The *Myth of Callisto* first appeared in the Ottley Sale, 30 June 1847, in London.

2. The *Realms of Love* measures 15⅜ x 57⅝", the *Myth of Callisto*, 15½ x 59".

3. Examples are listed in Callmann, *Apollonio di Giovanni*, pp. 56–57, Cat. 8–9; pp. 64–65, Cat. 24–25; and p. 68, Cat. 35. The differences, admittedly, are generally less than the disparity between the *Realms of Love* and the *Myth of Callisto*.

4: Zeri and Gardner, *Florentine School*, p. 75. Another oddly matched pair is Giovanni Toscani's cassone panel in Madison, Wis., discussed in note 68 to chapter 7, and a *Judith*, present location unknown. Both measure 54.1 x 121.8 cm., and were in the collection of Artaud de Montor, Paris, in 1843: see Artaud de Montor, *Peintres primitifs* (Paris, 1843), pp. 43–44, pl. 41.

5. "I procul hinc nec sacros pollue fontis" (Ovid *Metamorphoses*, 2. 464), trans. Innes.

6. "Ne puro tingatur in aequore paelex" (Ovid *Metamorphoses* 2. 530), trans. Innes.

7. C. Julius Hyginus. *De imaginibus coeli*, ed. L. W. Hasper (Leipzig: Teubner, 1861), pp. 11–12.

8. Salutati's copy of Hyginus is Rome, Bibl. Vaticana, Ms. Vat. Lat. 3110. Its illustrations are discussed in Degenhart and Schmitt, *Zeichnungen*, 1: 75–76. The Bears appear in vol. 3, pl. 54ᵃ.

9. *Teseida* 7. 61. 3–4 and gloss; *Amorosa Visione* 19. 44–75.

10. "L'altra che Giunone / Suol far gelosia" (Petrarch *Rime* 33. 2–3), my translation.

11. Appresso il fine ch'a quell'inno fassi,
gridavano alto: "*Virum non cognosco*";
indi ricominciavan l'inno bassi.
 Finitolo, anco gridavano: "Al bosco
si tenne Diana, ed Elice caccionne
che di Venere avea sentito il tosco."
 Indi al cantar tornavano;; indi donne
gridavano e mariti che fuor casti
come virtute e matrimonio imponne.
 (Dante *Purgatorio* 25. 127–35)

Translation by Dorothy L. Sayers, *The Divine Comedy, 2. Purgatory* (Harmondsworth and Baltimore, 1955), p. 266. On Dante's substitution of Helice for Callisto, see C. A. Robson, "Dante's Use in the *Divina Commedia* of the Medieval Allegories on Ovid," *Centenary Essays on Dante by Members of the Oxford Dante Society* (Oxford: Oxford University Press, 1965), pp. 14–15.

12. Pietro di Dante, *Super Dantis Comoediam Commentarium*, p. 482.

13. "Chollasu frigidità raffrena il vizio della lussuria. Jupiter significha il fuoco cioè il chalore naturale delluomo" (*Chiose sopra Dante*, pp. 458–59), my translation.

14. Benvenuto da Imola, *Commentum*, 4: 115–17. On the historical significance of *Purg*. 25. 131–32, see also Ettlinger, "Diana," col. 1431.

15. Ovid *Metamorphoses* 2. 441–43.

16. Seymour, *Early Italian Paintings*, p. 44.

17. See Petrarch *Trionfo d'Amore* 4. 22–24; *De remediis utriusque fortunae* 1. 69; and *Fam*. 9. 4. 10–16. Consult Marianne Shapiro, "Petrarch, Lorenzo il Magnifico, and the Latin Elegiaic Poets," *Romance Notes* 15 (1973): 172–77.

18. Frank Jewett Mather, Jr., "Dante Portraits," *The Romanic Review* 3 (1912): 121 and *The Portraits of Dante* (Princeton, N. J.: Princeton University Press, 1921), pp. 46–47.

19. Licisco Magagnato, *Da Altichiero a Pisanello* (Venice: N. Pozza, 1958), p. 14, with full bibliography. See also P. de Nolhac, *Pétrarque et l'humanisme*, 2d ed. (Paris: Bouillon, 1907), p. 250 and Theodor Ernst Mommsen, "An Early Representation of Petrarch as Poet Laureate," *Medieval and Renaissance Studies*, ed. Eugene F. Rice, Jr. (Ithaca, N. Y.: Cornell University Press, 1959), pp. 103–4 and n. 12.

20. T. Nurmela, "Physionomie de Boccacce," *Neuphilologische Mitteilungen* 60 (1959), pp. 321–34.

21. Callmann, *Apollonio di Giovanni*, pp. 23, 36, 58. Apollonio's drawing and Schiavo's panel both depend upon a Florentine drawing of ca. 1380–90 (Vienna, National-bibliothek, MS 2600, fol. 1r), reproduced in Degenhart and Schmitt, *Zeichnungen*, 3: pl. 145ª and a Trecento drawing (Florence, Biblioteca Nazionale, MS Palat. 320, fol. IIr), reproduced in Brieger, Singleton, and Meiss, *Illuminated Manuscripts of the Divine Comedy*, 1: 41, fig. 14.

22. Gene Brucker, *Renaissance Florence* (New York: John Wiley and Sons, Inc., 1966), pp 225–26, 295, with further references. An instance of the Signoria's interest is a fresco cycle, now lost, in the Palazzo della Signoria; see T. Hankey, "Salutati's Epigrams for the Palazzo Vecchio," *Journal of the Warburg and Courtauld Institutes* 22 (1959): 364–65. Related to this Florentine cult and analogous to Schiavo's *Realms of Love* is a panel by Giovanni di Marco in Cambridge, Mass., depicting two poets in conversation in a flowery meadow. F. Mason Perkins, "A Florentine Double Portrait in the Fogg Museum," *Art in America* 9 (June 1921): 137–48, identifies them as Dante and Virgil. E. K. Rand, "Dante and Petrarch in a Painting by Giovanni dal Ponte," *Fogg Art Museum Notes* 1, no. 3 (January 1923): 25–33, suggested that they were Florentine poets, and that the Fogg panel once belonged to the same ensemble as Giovanni di Marco's *Seven Liberal Arts* in the Prado, Madrid, illustrated in Schubring, *Cassoni*, vol 2, pl. IV. I shall treat the iconographic problems raised by these pictures in a forthcoming study.

23. The text is in Carlo del Balzo, *Poesie di mille autori intorno a Dante Alighieri*, 12 vols. (Rome: Forzani, 1889–1906), 3: 275–80.

24. See Sapegno, *Trecento*, pp. 134–35 and Benedetto, *Roman de la Rose e la letteratura italiana*, pp. 182–87. A useful introduction to vernacular literature of the early Quattrocento is Francesco Flamini, *La lirica toscana del rinascimento anteriore al tempo del Magnifico* (Pisa: Nistri, 1891).

25. Una donna gentile,
 la qual pareva sì com'elli Amore,
 vaga nelli occhi, piatosa ed umile,
 ver è ch'era d'alloro coronata,
 ed in tanto era ad Amor dissimile.
 Angiola mi pareva nel ciel nata,
 e in me più volte pensai ch'ella fosse
 quella che in Cipri già fu adorata.
 (Boccaccio *Amorosa Visione* 15. 47–54, my translation.

26. See Vittore Branca's commentary to this edition of the *Amorosa Visione*, pp. 644–45, and to an earlier version, *Amorosa Visione* (Florence: Sansoni, 1944), pp. 497–500. Most critics say that the "Donna gentile" represents Boccaccio's love, Fiammetta. Branca stresses a literary tradition, present as early as Dante's *Vita nuova*, of personifying the abstract nature of love as a beautiful woman.

27. "Un gran signor di mirabile aspetto / vid'io sopra due aquile sedere . . . / sopra due lioncelli i piè tenea / ch'avean del verde prato fatto letto. / ed aveva due grandi ali d'oro / alle sue spalle, stese inver l'altezza. / In man tenea una saetta d'oro / ed un'altra di piombo. . . . / un arco nella man sinestra, / la cui virtù sentir già molti male" (Boccaccio *Amorosa Visione* 15. 14–33), my translation. Panofsky, *Studies in Iconology*, p. 102, n. 9, suggests that Boccaccio's source was Ovid.

28. *Amorosa Visione* 19. 7–54. In his *Trionfo d'Amore*, Petrarch lists Venus and Mars, as well as Apollo, but between Mars and Apollo come Pluto, Proserpina, and Juno (1. 151–56). Domenico da Prato, "Nel paese d'Alfea," places Jason, Medea, Solomon, Pyramus, Thisbe, Arcita, Demophon, and Phyllis between Mars and Apollo (Balzo, *Poesie*, 3: 276).

29. An example is the Virgin Annunciate in a panel from the 1430s in the Yale University Art Gallery; Seymour, *Early Italian Paintings*, p. 133.

30. A similar gesture of benediction is made by the Virgin in the *Miracle of the Snow* by Masolino, Museo di Capodimonte, Naples. See Berenson, *Italian Pictures: Florentine School*, vol. 1, pl. 565.

31. Ovid *Metamorphoses* 1. 466–71.

32. On silver and white as Diana's colors, see Boccaccio, *Genealogy of the Gods* 4. 16 and 5. 2.

33. Guglielmo Ebreo, *Trattato dell'arte del ballo*, pp. 95–96. A similar dance entitled *La gelosia* is described in C. Mazzi, "Il 'Libro dell'arte del danzare' di Antonio Cornazano," *La Bibliofilia* 17 (1915): 16.

34. *Amorosa Visione* 16. 16–27 and 29. 52–88.

35. For the dating and purpose of this panel, see Stefano Orlandi, *Beato Angelico* (Florence: Leo S. Olschki, 1964), pp. 27–28 and John Pope-Hennessy, *Fra Angelico*, 2d ed. (Ithaca, N. Y.: Cornell University Press, 1974), pp. 13, 192. The significance of Fra Angelico's light-filled gate is explained by a miniature from his shop, illustrated by Renzo Chiarelli, *I codici miniati del Museo di San Marco a Firenze* (Florence: Bonechi, 1968), pp. 21–24, pl. XXXIV. Representing souls released from Purgatory who ascend to Paradise, the painting illustrates the Mass for the Dead: "Requiem eterna dona eis, Domine, et lux perpetua luceat eis." The miniature is Biblioteca di San Marco, Missale ss. Inv. 558, fol. 86ᵛ.

36. "Teneros ne tange poetas!" (Ovid *Remedia Amoris* 757), trans. Mozley. See also *Art of Love* 3. 329–48.

37. "Che d'amor cantaro / fervidamente" (Petrarch *Trionfo d'Amore* 4. 23–24), my translation. For the poets of love, see 4. 13–60.

38. Observed by Seymour, *Early Italian Paintings*, p. 44. See further P. Grierson, "The Origins of the English Sovereign and the Symbolism of the Closed Crown," *British Numismatic Journal* 33 (1964): 118–34.

39. Petrarch *Trionfo d'Amore* 1. 88–101 and 3. 16–72.

40. "Una giovane Greca . . . coi nobili poeti ivi cantando" (Petrarch *Trionfo d'Amore* 4. 25–27), my translation.

41. "Sonore cithare fides tangere et expromere modulos" (Boccaccio *De mulieribus claris* 47). The text used is that edited by V. Zaccaria in *Tutte le opere*, 10:192. English translation by Guido A. Guarino, *Concerning Famous Women* (London: Allen, 1963). Sappho's musical instruments during the Renaissance are discussed by Emmanuel

Winternitz, *Musical Instruments and their Symbolism in Western Art* (London: Faber, 1967), p. 196.

42. "Quid enim lascivius illa" (Ovid *Art of Love* 3. 331), trans. Mozley.

43. Remigio Sabbadini, "Spigolature latine," *Studi italiani di filologia classica* 5 (1897): 370. See also Horst Rüdiger, *Sappho: ihr Ruf und Ruhm bei der Nachwelt* (Leipzig: Dieterich, 1933), pp. 11–18.

44. See Petrarch *Rime* 22.32–39 and 34.1–8. Consult also U. Dotti, "Petrarca: il mito dafneo," *Convivium* 37 (1969): 9–23 and Yves F.–A. Giraud, *La fable de Daphné* (Geneva: Droz, 1969), pp. 141–49.

45. For Boccaccio's views on the sad passion of Apollo, see *Amorosa Visione* 19. 53–54: "si dolesse di tal mutazione, / e ne' sembianti sen ramaricava." The risibility and shame of Mars's predicament are stressed in 19. 28–30: "Hai! come poi ciascuno apertamente / faceva il suo piacer, però che avieno / vergogna ricevuta interamente." Boccaccio here follows Ovid, *Metamorphoses* 4. 187–89.

46. Ovid *Metamorphoses* 1. 557–59.

47. Figat tuus omnia, Phoebe,
 te meus arcus . . . quantoque animalia cedunt
 cuncta deo, tanto minor est tua gloria nostra.
 (Ovid *Metamorphoses* 1. 463–65, trans. Innes)

48. *Metamorphoses* 4. 170–89 and *Art of Love* 2. 561–86; compare Homer *Odyssey* 8. 266–369.

49. Paul Schubring, "Aphrodites und Ares' Liebe: ein sieneser Cassonebild aus dem 14. Jahrhundert," *Pantheon* 10 (1932): 298–300. This panel is by a follower of Giovanni di Paolo working around 1450, not by a Sienese active about 1375, as Schubring believed.

50. Schubring, *Cassoni*, 1: 433. See also Giraud, *Daphné*, p. 245 and Wolfgang Stechow, *Apollo und Daphne* (Leipzig and Berlin: Teubner, 1932), p. 18. Stechow correctly dates the panel around 1450. A related cassone panel in the Museo Stibbert, Florence, shows the opening episodes of the story, Apollo's victory over Python and his subsequent debate with Cupid, who has clawed feet. See Lensi, *Museo Stibbert*, vol. 1, no. 4097; a good photograph is in the Frick Art Reference Library.

51. The bride whose wedding is the subject of the so-called Adimari Cassone in the Accademia, Florence, wears an extravagant garland like Daphne's. See Schiaparelli, *Casa fiorentina*, pp. 271–72; Schubring, *Cassoni*, pp. 227–28; and Luisa Marcucci, *Cassone Adimari* (Florence, 1962).

52. During the early Quattrocento, Mars usually appears in armor, while Apollo customarily wears a dandy's costume, as in my plate 88, or the flowing robes of a scholar. For Apollo and Mars conventionally clad in a fresco of 1414 by Taddeo di Bartolo, see Jean Seznec, *The Survival of the Pagan Gods*, trans. Barbara F. Sessions (New York: Pantheon Books, 1953), p. 129. In Schiavo's *Realms of Love*, Apollo wears a tight-fitting costume, much like that of Donatello's marble *David* of 1408–1409, reworked in 1416, in the Bargello; see further Colin Eisler, "The Athlete of Virtue: The Iconography of Asceticism," *De artibus opuscula* XL, 1: 86.

53. A. Béguinot, "Cardo dei lanaioli," *Enciclopedia italiana* 8: 993, with illustrations.

54. "Espines trenchaz et agues, / Orties et ronces crochues / Ne me laissoient avant traire, / Car je ne cremoie mal faire" (*Roman de la Rose* 1677–1680), trans. Robbins. An embroidery produced during the fifteenth century in Germany shows a lady with a unicorn protected by a hedge of thistles; see Lottlisa Behling, *Die Pflanzenwelt der mittelalterlichen Kathedralen* (Cologne and Graz: Bohlau, 1964), pp. 108–11, pl. CXIII.

55. "Haec certe deserta loca et taciturna querenti / et frigida rupes / et datur inculto tramite dura quies; / et quodcumque meae possunt narrare querelae, /

cogor ad argutus dicere solus aves" (Propertius. 1. 18. 1, 27–30), trans. and ed. H. E. Butler, *Propertius* (Cambridge, Mass., and London: Loeb Classical Library, 1958), pp. 46–47. Possibly echoing Propertius is Petrarch *Rime* 64. 9–10: "Ché gentil pianta in arido terreno / Par ché si disconvenga." A Trecento manuscript of Propertius is in the Biblioteca Laurenziana, Laur. Plut. 36, 46.

56. "Frigidus et nuda saepe iacebis humo" (Ovid *Art of Love* 2. 238), trans. Mozley.

57. Gen. 3: 17–18. Contemporary with the *Realms of Love* is Ghiberti's *Genesis* relief for the Gates of Paradise, which shows Adam and Eve being driven out into an arid waste where a few spiky plants grow; see Krautheimer, *Ghiberti*, vol. 2, pl. 84. A Trecento precedent is a fresco of 1389–1392 in the Camposanto, Pisa, depicting the Creation and Fall by Piero di Puccio, discussed by Bucci and Bertolini, *Camposanto*, pp. 103–6. Piero shows Adam delving in a wasteland of weedy and spiky plants; the Earthly Paradise, by contrast, is a verdant garden enclosed by battlemented walls and watered by a polygonal marble fountain. On the influence of Piero's frescoes in the Camposanto on Quattrocento Florence, see Krautheimer, *Ghiberti*, 1: 222 and Seymour, *Quercia*, pp. 72, 85–86.

58. R. J. Peebles, "The Dry Tree: Symbol of Death," *Vassar Mediaeval Studies*, ed. C. F. Fiske (New Haven, Conn.: Yale University Press, 1923), pp. 57–79.

59. Charles de Tolnay, "La *Résurrection du Christ* par Piero della Francesca: essai d' interprétation," *Gazette des beaux arts*, 6th ser. 43 (1954): 39–40.

60. Callmann, *Apollonio di Giovanni*, p. 58, pl. 96. The miniature, depicting the Triumph of Death, is in Florence, Biblioteca Riccardiana, MS 1129, fol. 21ᵛ.

61. Ovid *Metamorphoses* 1. 476.

62. The relationship between the Lady and her Lover resembles that of Lady Poverty as she departs from her mystic spouse, St. Francis, in a panel of 1437–54 by Sassetta now in Chantilly. See Van Marle, *Development of the Italian Schools*, 9: 335, fig. 223.

63. An example is the *Storia d'una fanciulla tradita da un suo amante* written by Simone Serdini of Siena before 1419, which tells of a nymph who falls in love beside the fountain of Narcissus; see *Storia d'una fanciulla*, ed. Francesco Zambrini (Bologna: G. Romagnoli, 1862; reprinted. Bologna: Commissione per i testi di lingua, 1968). Diana appears in two occasional pieces of the 1450s by the poet Ilicino, the *Visione di Giovan Battista Santi* and the *Somnium*; see G. Corso, "L'Ilicino (Bernardo Lapini)," *Bulletino senese di storia patria* 64 (1957): 80–85. Diana becomes a model to emulate in Calogrosso's *Niccolosa bella*, pp. 66–67.

64. Florence, Biblioteca nazionale, Magl. VII, 98, described by Balzo, *Poesie*, 3: 6–7, n. 1.

65. The text is in Balzo, *Poesie*, 3: 6–199. In addition to Balzo's commentary, consult Rodolfo Renier, "Una poema sconosciuta degli ultimi anni del secolo XIV," *Propugnatore* 15, no. 1 (1882): 176–87, 325–79; no. 2 (1882): 42–75. See also Sapegno, *Trecento*, pp. 134–35 and Benedetto, *Roman de da Rose e la letteratura italiana*, pp. 182–85.

66. Ogni frutto, ogni fiore era tra quelli
 Qual fu mai da natura qui prodotto,
 Con lucenti acque e pien di vaghi uccelli.
 Quivi non caldo, o freddo, o doglia, o lutto,
 Quivi non d'arme affanno o cosa amara,
 Ma d'ozio pieno era quel loco tutto.
 (Balzo, *Poesie*, 3: 155, my translation)

67. Nullo iddio troverai, fra cotanti,
 Nel cielo, se non Diana, non ferito.
 (Balzo, *Poesie*, 3: 136, my translation)

68.　Questa Alessandra di Dïana sia
　　　E segua lei e Eritonio amante,
　　　Nè Vener di costei abbia balìa.
　　　　　　　(Balzo, *Poesie*, 3: 193, my translation)
69.　L'ombre e i sogni e i tristi pianti,
　　　. . . l'ire e 'l sospirar.
　　　　　　　(Balzo, *Poesie*, 3: 198, my translation)
70.　Corrette alle virtù, dov'è la pace;
　　　Fuggite del mortal cieco veleno
　　　　　　　(Balzo, *Poesie*, 3: 198, my translation)

71. The *Fimerodia* was not the only early Renaissance work addressed to young men warning them of the dangers of love. See also Calogrosso, *Niccolosa bella*, p. 15 and Book 2 of Alberti's *Della Famiglia*, ed Grayson, 1: 87–97. It is perhaps not by accident that the supine Lover in Schiavo's panel resembles the reclining youths frequently painted on the inner lids of cassoni. See Schubring, *Cassoni*, 1: 257, pl. XXX and 1: 229, pl. LXIX; Seymour, *Early Italian Paintings*, p. 141; and Wind, *Pagan Mysteries*, p. 143 and n. 7, p. 243. Although some of these figures are famous lovers (Schubring, *Cassoni*, 1: 264–65, pl. LXIX, is labeled PARIS), most were probably intended as surrogates for grooms and their brides.

72. Renata Cipriani, *Codici miniati dell Ambrosiana* (Vicenza: N. Pozza, 1968), p. 74 gives the miniature to an unknown Florentine. Degenhart and Schmitt, *Zeichnungen*, 2: 287–88, argue that the manuscript is Florentine, dating it in the first quarter of the Quattrocento.

73. Egon Verheyen, *The Paintings in the Studiolo of Isabella d'Este at Mantua* (New York: College Art Association Monographs, 1971), pp. 25–27 and 44–47.

74. Boccaccio *Teseida* 7. 65. 5–8 and 50. 1. gloss; also *Comedia Ninfe* 32. 36–39.

Notes to Chapter 10

1. Two Netherlandish engravings of the early fifteenth century are in Max Lehrs, *Geschichte und kritischer Katalog des deutschen, niederländischen und französischen Kupferstichs im XV. Jahrhundert*, 10 vols. (Vienna, 1908–1934; reprint ed. New York: Collectors Editions, n.d.), 1: 323–25 and 10: 39–40, nos. 101–2. Their historical significance is discussed by G. Glück, "Rubens' Liebesgarten," *Jahrbuch der kunsthistorischen Sammlungen in Wien* 35 (1920–1921): 49–58. Their iconography is treated by Roberta Smith Favis, "The Garden of Love in Fifteenth Century Netherlandish and German Engraving" (Ph.D. diss., University of Pennsylvania, 1974).

2. Ursula Hoff, *Catalogue of European Paintings Before 1800* (Melbourne: National Gallery of Victoria, 1961), pp. 135–37. See also Michael Levey, *Early Renaissance* (Harmondsworth: Penguin, 1967), p. 127.

3. A photograph of the untenanted garden is in the Frick Art Reference Library; it was sold at Sotheby's on 7 July 1954. The third panel was sold at Christie's on 9 June 1939. The group was first assembled by Edward S. King, "The Legend of Paris and Helen," *Journal of the Walters Art Gallery* 2 (1939): 67–68.

4. Hoff, *European Paintings*, pp. 135–36. Hoff suggests that a *Lady with a Unicorn* by Antonio Vivarini, now in Esztergom, was also a companion to the *Garden of Love* in Australia; if this is true, then the series becomes an allegory of chastity. But the Esztergom painting measures only 3′ 6⅜″ x 2′ 11½″, much smaller than the Australian picture (4′ 10½″ x 7′ 10″) and its companions (4′ 11″ x 7′ 7″, 5′ x 7′ 7½″).

5. Hoff, *European Paintings*, p. 136, identifies the beast as an ermine. Ermines, however, are long weasel-like creatures; for a Quattrocento representation, see *The*

Florentine Fior di Virtù of 1491, trans. Nicholas Fersin (Washington: Library of Congress, 1953), p. 108.

6. "Venus in vinis ignis in igne fuit" (Ovid *Art of Love* 1. 244), trans. Mozley.

7. Frau Minne is probably the archeress depicted in my plate 29. See further Panofsky, *Studies in Iconology*, pp. 103, 113–14.

8. *Kunstgewerbemuseum: ausgewählte Werke* (Berlin: Kunstgewerbemuseum, 1963), no. K9164. In a Lucchese silk of the late Trecento, Frau Minne sits on eagles, brandishing arrows and a bow, as lovers kneel on either side. See Otto von Falke, *Kunstgeschichte der Seidenweberei* 2 vols. (Berlin: Wasmuth, 1963), 2: 88, fig. 461.

9. See Kohlhaussen, *Minnekästchen*, p. 89; *L'art européen vers 1400* (Vienna: The Council of Europe, 1962), pp. 354–55; and *Kunstgewerbemuseum: Ausgewählte Werke*, pl. 32. Similar to this coffer is a Venetian casket from the late Quattrocento with a relief showing a couple standing on either side of a tree; see *Sammlung Figdor*, vol. 5, no. 337, pl. CXXXVI.

10. Gilda Rosa, "Un cassone quattrocentesco al Castello Sforzesco di Milano," *Art Veneta* 5 (1951): 98–100. See also Gilda Rosa, *I mobili nelle civiche raccolte artistiche di Milano* (Milan: Aldo Martello, 1963), pp. 20–21.

11. Schubring, *Cassoni*, 1: 388.

12. A similar chest is in the Cluny Museum, Paris; see Schubring, *Cassoni*, 1: 388. Other examples are cited by Rosa, *Mobili di Milano*, pp. 20–21. Somewhat earlier than the chest in Berlin is a cassone showing four couples flanking an ornate fountain, beneath a frieze of hunting scenes; see Giuseppe Morazzoni, *Il mobile genovese* (Milan: Alfieri, 1949), p. 93, pl. III, fig. 8. Four pairs of lovers stand beside a fountain in the carvings of a north Italian chair of the early fifteenth century: see *Sammlung Figdor*, vol. 2, no. 643, pl. CXXVII.

13. Panofsky, *Studies in Iconology*, pp. 101–3, with further references. See also Fleming, *Roman de la Rose*, fig. 12.

14. "Non corse mai sì levemente al varco / d'una fugace cerva un leopardo / libero in selva o di catene scarco, / . . . tanto Amor pronto venne a lei ferire" (Petrarch *Trionfo della Pudicizia* 37–41), trans. Wilkins.

15. Hind, *Early Italian Engraving*, 1: 250; vol. 2, pl. 395, no. E.III.2. Hind dates the print around 1470. Affinities with French tapestries are suggested by Mirimonde, "La musique dans les allégories de l'amour," p. 340.

16. Levey, *Early Renaissance*, pp. 94–96, 210, fig. 51.

17. The print is in the Museo Malaspina, Pavia. See Arthur M. Hind, *Nielli* (London: The British Museum, 1938), p. 13 and Alberto Busignani, *Pollaiolo* (Florence: Edizioni d'Arte il Fiorino, 1970), pp. lxxxii–lxxxiii, pl. 61.

18. See Poliziano, *Rime*, ed. Natalino Sapegno (Rome: Edizione dell'Ateneo, 1965), pp. 46–80. For discussions of Poliziano's realm of Venus and its sources, see Giamatti, *Earthly Paradise*, pp. 129–34 and P. M. J. McNair, "The Bed of Venus: Key to Poliziano's *Stanze*," *Italian Studies* 25 (1970): 40–48.

19. Schubring, *Cassoni*, 1: 19–35, 101–14.

20. E. H. Gombrich, "Apollonio di Giovanni," *Journal of the Warburg and Courtauld Institutes* 18 (1955): 16–34; Callmann, *Apollonio di Giovanni*, pp. 39–51.

21. Federico Hermanin, *L'Appartamento Borgia in Vaticano* (Rome: Danesi, 1934), pp. 66–70, and Enzo Carli, *Il Pintoricchio* (Milan: Electa editrice, 1960), pl. 70.

22. H. W. Janson, *Apes and Ape Lore* (London: University of London, The Warburg Institute: 1952), pp. 115–16 and p. 141, n. 35.

23. The conventional rather than naturalistic form of Pinturicchio's landscape was observed by Sir Frank Crisp, *Mediaeval Gardens*, ed. Catherine C. Paterson, 2 vols. (New York: Brentano, 1924), vol. 1, fig. 75. It is amusing to note that by the

end of the Quattrocento Susanna's garden became a model for actual gardens. Around 1497 Giovanni Sabbadini degli Arienti describes the gardens of the Castello in Ferrara as follows: "Quando dentro in quello entrai, subito alla mia mente me corse la vera fama del bel zardino . . . la donde andava al fonte Susanna." See Werner L. Gundersheimer, *Art and Life at the Court of Ercole I d'Este* (Geneva: Droz, 1972), p. 52.

24. Recent discussions have raised doubts about the flora of Botticelli's garden. Charles Dempsey, *"Mercurius Ver: The Sources of Botticelli's Primavera," Journal of the Warburg and Courtauld Institutes* 31 (1968): 255 and n. 19, says that the trees shading Venus are apple trees and that the spray immediately behind her is myrtle, and that both establish her securely as the goddess of love. But Hartt, *Italian Renaissance Art*, pp. 288, 290, says that the trees bear oranges, and that the spray is laurel, references to the *palle* of the Medici family and to Lorenzo di Pierfrancesco, Botticelli's patron. Webster Smith, "On the Original Location of the *Primavera*," *Art Bulletin* 57 (1975): 36 and n. 33, inclines toward myrtle on morphological grounds. It would seem that botanical exactitude influences iconographic certitude.

25. The question of Botticelli's debt to pictorial tradition is debated by Gombrich, "Botticelli's Mythologies," pp. 40–42.

26. Panofsky, *Studies in Iconology*, pp. 150–51.

27. Erwin Panofsky, *Problems in Titian: Mostly Iconographic* (New York: New York University Press, 1969), pl. 136. See also Otto Brendel, "The Interpretation of the Holkham *Venus*," *Art Bulletin* 28 (1946): 73–74. Titian's occasional use of the Garden of Love should be distinguished from his reliance on classical texts describing allegorical landscapes of love; an instance is his *Worship of Venus*, also in the Prado, where he follows Philostratus *Imagines* 1. 6 in depicting an extensive garden with apple trees as the bower of Venus. See above, note 4 to chapter 2.

Bibliography

Abraham, Claude T. "Myth and Symbol: The Rabbit in Medieval France." *Studies in Philology* 60 (1963): 589–97.

Alberti, Leon Battista. *Opere volgari*. Vol. 1. Edited by Cecil Grayson. Bari: Giuseppe Laterza, 1960.

Alighieri, Pietro. *Petri Allegherii super Dantis ipsius genitoris Comoediam commentarium*. Edited by Lord Vernon. Florence: Garineo, 1846.

Allen, Michael J. B. "The Chase: The Development of a Renaissance Theme." *Comparative Literature* 20 (1968), 301–12.

Andreas Capellanus. *De Amore libri tres*. Edited by E. Trojel. Copenhagen, 1892; reprint ed., Munich: Eidos, 1964.

———. *Andrea Capellano: Trattato d'amore*. Edited by Salvatore Battaglia. Rome: Perrella, 1947.

———. *The Art of Courtly Love*. Translated by J. J. Parry. New York: F. Ungar, 1941.

Antal, Frederick. *Florentine Painting and its Social Background*. London: Kegan Paul, 1948.

Balzo, Carlo del. *Poesie di mille autori intorno a Dante Alighieri*. 12 vols. Rome: Forzani, 1889–1906.

Bartolomeo da San Concordio. *Ammaestramenti degli antichi*. Edited by Domenico Maria Manni. Milan: Silvestri, 1829.

Bautier, Pierre. "Le opere d'arte italiana nella Francia invasa." *Rassegna d'arte* 19 (1919): 157–67.

Baxandall, Michael. *Painting and Experience in Fifteenth Century Italy*. Oxford: Oxford University Press, 1972.

Bec, Christian. *Les marchands écrivains*. Paris and The Hague: Mouton, 1967.

Behling, Lottlisa. *Die Pflanzenwelt der mittelalterlichen Kathedralen*. Cologne and Graz: Bohlau, 1964.

Bellosi, Luciano. *Buffalmacco e il Trionfo della Morte*. Turin: Einaudi, 1974.

———. "Il Maestro della Crocifissione Griggs: Giovanni Toscani." *Paragone* 17, no. 193 (March 1966): 44–58.

Benedetto, Luigi Foscolo. *Il "Roman de la Rose" e la letteratura italiana*. Halle: M. Niemeyer, 1910.

168

Benvenuto da Imola. *Commentum super Dantis Aldigherij Comoediam.* Edited by J. F. Lacaita. 5 vols. Florence: G. Barbera, 1887.

Berenson, Bernard. *Italian Pictures of the Renaissance.* Oxford: Oxford University Press, 1932.

————. *Italian Pictures of the Renaissance: Florentine School.* 2 vols. London: Phaidon, 1963.

Berti, Luciano. *Angelico.* Florence: Sadea/Sansoni, 1967.

————. *Il Museo di Palazzo Davanzati a Firenze.* Florence: Electa Editrice, 1972.

Bertoni, Giulio. *Il Duecento.* 3d ed. Milan: F. Vallardi, 1939.

Biagi, Guido, ed. *Il Giardino d'amore.* Florence: Nozze Bianche-Isnard, 1892.

Biagi, Luigi. *Jacopo della Quercia.* Florence: Arnaud, 1946.

Bialostocki, Jan. *La peinture italienne des XIV^e et XV^e siècles.* Cracow: National Museum, 1961.

Boccaccio, Giovanni. *Amorosa Visione.* Edited by Vittore Branca. Florence: Sansoni, 1944.

————. *The Book of Theseus.* Translated by Bernadette Marie McCoy. New York: Medieval Text Association, 1974.

————. *Concerning Famous Women.* Translated by Guido A. Guarino. London: Allen, 1963.

————. *Decameron.* Edited by Vittore Branca. 3 vols. Florence: Sansoni, 1966.

————. *Genealogie deorum gentilium libri XIV.* Edited by Vincenzo Romano. 2 vols. Bari: Giuseppe Laterza, 1951.

————. *Opere minori.* Edited by Enrico Bianchi. Florence: Salani, 1964.

————. *Tutte le opere di Giovanni Boccaccio.* Edited by Vittore Branca. 12 vols. Turin: Arnoldo Mondadori. 1967–.

Börsch-Supan, Eva. *Garten-, Landschafts- und Paradies-motive in Innenraum.* Berlin: Hessling, 1967.

Bombe, Walter. "Die Novelle der Kastellanin von Vergi in einer Freskofolge des Palazzo Davazzi-Davanzati zu Florenz." *Mitteilungen des Kunsthistorisches Institutes in Florenz* 2 (1912): 1–25.

————. "Studi sulle tovaglie perugine—le figurazione ornamentale e simboliche," *Rassegna d'arte* 14 (1914): 108–20.

————. "Un roman français dans un palais florentin." *Gazette des beaux arts,* 4th ser. 6 (1911): 231–42.

Borenius, Tancred. "Unpublished Cassone Panels—V." *Burlington Magazine* 41 (1922): 104–9.

Boskovits, Miklos. "Ein Vorläufer der spätgotischen Malerei in Florenz: Cenni di Francesco di ser Cenni." *Zeitschrift für Kunstgeschichte* 31 (1968): 273–92.

————. "Orcagna in 1357—And in Other Times." *Burlington Magazine* 103 (1971): 239–51.

Botti, Carlo. "Note e documenti sulla chiesa di S. Trinita in Firenze." *Rivista d'arte* 20 (1938) : 1–22.

Branca, Vittore. *Boccaccio medievale.* 3d ed. Florence : Sansoni, 1970.

————. "Copisti per passione, tradizione caratterizante, tradizione di memoria." In *Studi e problemi di critica testuale.* Edited by Raffaele Spongano. Bologna : Commissione per i testi di lingua, 1961.

————. "La prima diffusione del *Decameron.*" *Studi di filologia italiana* 8 (1950) : 29–143.

Brandi, Cesare. *Quattrocentisti senesi.* Milan : Hoepli, 1949.

Brendel, Otto. "The Interpretation of the Holkham *Venus.*" *Art Bulletin* 28 (1946) : 65–75.

Brieger, Peter ; Meiss, Millard ; and Singleton, Charles S. *Illuminated Manuscripts of the Divine Comedy.* 2 vols. Princeton, N. J.: Princeton University Press, Bollingen Foundation, 1969.

Brucker, Gene. *Renaissance Florence.* New York : John Wiley and Sons, Inc., 1966.

Bucci, Mario, and Bertolini, Licia. *Camposanto monumentale di Pisa.* Pisa : Opera della Primaziale pisana, 1960.

Burleigh, M. "The *Triumph of Death* in Palermo." *Marsyas* 15 (1970–1972) : 46–57.

Bury, Adrian. "A Florentine Desco." *Connoisseur* 160 (1965) : 254.

Busignani, Alberto. *Pollaiolo.* Florence : Edizioni d'Arte il Fiorino, 1970.

Calkins, Robert G. *A Medieval Treasury.* Ithaca, N. Y.: Office of University Publications, Cornell University, 1968.

Callmann, Ellen. *Apollonio di Giovanni.* Oxford : Clarendon Press, 1974.

Calogrosso, Giannotto. *Niccolosa bella.* Edited by Franco Gaeta and Raffaele Spongano. Bologna : Commissione per i testi di lingua, 1959.

Cameron, Alan. *Claudian: Poetry and Propaganda at the Court of Honorius.* Oxford : Clarendon Press, 1970.

Cantelupe, Eugene B. "The Anonymous *Triumph of Venus* in the Louvre: An Early Italian Renaissance Example of Mythological Disguise." *Art Bulletin* 44 (1962) : 238–42.

————. "Titian's *Sacred and Profane Love* Re-examined." *Art Bulletin* 46 (1964) : 218–26.

Carducci, Giosuè. *Cacce in rima dei secoli XIV e XV.* Bologna : Ganichelli, 1896.

Carli, Enzo. *Il Pintoricchio.* Milan : Electa Editrice, 1960.

Carnessecchi, Carlo. "Spese matrimoniali nel 1461." *Rivista d'Arte* 5 (1907) : 36–37.

Carocci, Guido. *Il Museo di Firenze antica annesso al R. Museo di San Marco.* Florence, 1906.

————. *Palazzo Davanzati.* Florence : Tipografia Cenniniana, 1910.

Castelfranchi Vegas, Liana. *Die internationale Gotik in Italien.* Translated by Brigitte Schönert. Dresden: VEB Verlag der Kunst, 1966.

Catalogue des ouvrages de peinture et de la sculpture, des objets d'art et de curiosité légués au Musée de Douai par M. Adadée Foucques de Wagonville. Douai, 1877.

Cecchini, Giovanni, and Carli, Enzo. *San Gimignano.* Milan: Electa Editrice, 1962.

Chiappelli, C. "Arte domenicana del Trecento." *Nuova antologia* 131 (1907): 176–95.

Chiarelli, Renzo. *I codici miniati del Museo di San Marco a Firenze.* Florence: Bonechi, 1968.

Chiose sopra Dante. Edited by Lord Vernon. Florence: Piatti, 1846.

Cipriani, Renata. *Codici miniati dell'Ambrosiana.* Vicenza: N. Pozza, 1968.

Claudian. *Claudian.* Edited and translated by M. Platnauer. 2 vols. London and New York: Loeb Classical Library, 1922.

Colasanti, Arduino. *Le fontane d'Italia.* Milan: Bestetti and Tumminelli, 1926.

Cole, Bruce. "The Interior Decoration of the Palazzo Datini in Prato." *Mitteilungen des kunsthistorischen Institutes in Florenz* 13 (1967): 61–82.

Colnaghi, Sir Dominic Ellis. *A Dictionary of Florentine Painters from the 13th to the 17th Centuries.* Edited by P. G. Konody and Selwyn Brinton. London: John Lane, 1928.

Colvin, Sir Sidney, ed. *A Florentine Picture-Chronicle.* London: B. Quaritch, 1898.

Congrès international de linguistique romane. *Mostra di codici romanze delle bibliotheche fiorentine.* Florence: Sansoni, 1957.

Contini, Gianfranco, ed. *Poeti del Duecento.* 2 vols. Milan and Naples: Riccardo Ricciardi, 1960.

Cornish, F. W.; Postgate, J. P.; and Mackail, J. W., eds. *Catullus, Tibullus, and Pervigilium Veneris.* London and New York: Loeb Classical Library, 1924.

Corsi, Giuseppe, ed. *Poesie musicali del Trecento.* Bologna: Commissione per i testi di lingua, 1970.

Corso, C. "L'Ilicino (Bernardo Lapini)." *Bulletino senese di storia patria* 64 (1957): 3–108.

Crisp, Sir Frank. *Medieval Gardens.* Edited by Catherine C. Paterson. 2 vols. New York: Brentano, 1924.

Curtius, Ernst Robert. *European Literature and the Latin Middle Ages.* Translated by Willard R. Trask. New York: Pantheon Books, 1953.

Da Cesare, Raffaello. "Di nuovo sulla leggenda di Aristotele cavalcato." *Miscellanea del Centro di Studi Medievali,* n.s. 57 (1956): 181–247.

Dalton, O. M. *Catalogue of the Ivory Carvings of the Christian Era.* London: British Museum, 1909.

Dante. *Dante's Lyric Poetry*. Edited and translated by K. Foster and P. Boyde. 2 vols. Oxford: Clarendon Press, 1967.

―――. *La Divina Commedia*. Edited by C. H. Grandgent, revised by Charles S. Singleton. Cambridge, Mass.: Harvard University Press, 1972.

. *The Divine Comedy, 2. Purgatory*. Translated by Dorothy L. Sayers. Harmondsworth and Baltimore: Penguin, 1955.

―――. *The Divine Comedy, 3. Paradise*. Translated by Dorothy L. Sayers and Barbara Reynolds. Harmondsworth and Baltimore: Penguin, 1962.

Degenhart, Bernhard, and Schmitt, Annegritt. *Corpus der italienischen Zeichnungen 1300–1450*. 4 vols. Berlin: Mann, 1968.

Dempsey, Charles. "*Mercurius Ver*: The Sources of Botticelli's *Primavera*." *Journal of the Warburg and Courtauld Institutes* 31 (1968): 251–73.

Dobbert, Eduard. "Der Triumph des Todes im Campo Santo zu Pisa." *Repertorium für Kunstwissenschaft* 4 (1881): 1–45.

Dotti, U. "Petrarca: il mito dafneo." *Convivium* 37 (1969): 9–23.

Eisler, Colin. "The Athlete of Virtue: The Iconography of Asceticism." In *De Artibus opuscula XL: Essays in Honor of Erwin Panofsky*. Edited by Millard Meiss. 2 vols. New York: New York University Press, 1961.

Ettlinger, Leopold D. "Diana." *Reallexikon zur deutschen Kunstgeschichte* 3, cols. 1429–37.

Fahy, Everett. "The 'Master of Apollo and Daphne.'" *Museum Studies* 3 (1968): 21–41.

Falke, Otto von. *Die Sammlung Dr. Albert Figdor, Wien*. 5 vols. Vienna and Berlin: Artaria, 1930.

―――. *Kunstgeschichte der Seidenweberei*. 2 vols. Berlin: Wasmuth, 1963.

Fanelli. Giovanni. *Firenze, architettura e città*. Florence: Vallecchi, 1973.

Fanfani, P. "Legge suntuaria fatta dal Comune di Firenze l'anno 1355 e volgarizzata nel 1356 da Andrea Lancia." *Etruria* 1 (1851): 366–81.

Favis, Roberta Smith. "The Garden of Love in Fifteenth Century Netherlandish and German Engraving." Ph.D. dissertation, University of Pennsylvania, 1974.

Ferrante, Joan M. "The Frame Characters of the *Decameron*; A Progression of Virtues." *Romance Philology* 19 (1965): 212–26.

Fersin, Nicholas, trans. *The Florentine Fior di Virtù of 1491*. Washington: Library of Congress, 1953.

Flamini, Francesco. *La lirica toscana del rinascimento anteriore al tempo del Magnifico*. Pisa: Nistri, 1891.

Fleming, John V. *The Roman de la Rose: a Study in Allegory and Iconography*. Princeton, N. J.: Princeton University Press, 1969.

Fossi Todorow, Maria. *I disegni del Pisanello e della sua cerchia*. Florence: Leo S. Olschki, 1966.

Fulgentius. *Fabii Planciadis Fulgentii V. C. Opera*. Edited by Rudolf Helm. Leipzig: Teubner, 1898.

———. *Fulgentius the Mythographer*. Edited and translated by Leslie George Whitbread. Columbus, Ohio: Ohio State University Press, 1971.

Gardner, Julian. "The Decoration of the Baroncelli Chapel in Santa Croce." *Zeitschrift für Kunstgeschichte* 34 (1971). 89–114.

Giamatti, A. Bartlett. *The Earthly Paradise and the Renaissance Epic*. Princeton, N. J.: Princeton University Press, 1966.

Giraud, Yves F.-A. *La fable de Daphné*. Geneva: Droz, 1969.

Givens, Azzurra B. *La dottrina d'amore nel Boccaccio*. Messina and Florence: G. D'Anna, 1968.

Glück, G. "Rubens' Liebesgarten." *Jahrbuch der Kunsthistorischen Sammlungen in Wien* 35 (1920–1921): 49–98.

Gnoli, Umberto. "L'arte italiana in alcune gallerie francesi di provincia. Note di viaggio." *Rassegna d'arte* 8 (1908): 155–59.

Gombrich, Ernst H. "Apollonio di Giovanni." *Journal of the Warburg and Courtauld Institutes* 18 (1955): 16–34.

———. "Botticelli's Mythologies." *Journal of the Warburg and Courtauld Institutes* 8 (1945): 7–60.

Gómez-Moreno, Carmen. *Medieval Art From Private Collections*. New York: Metropolitan Museum of Art, The Cloisters, 1968.

Grierson, P. "The Origins of the English Sovereign and the Symbolism of the Closed Crown." *British Numismatic Journal* 33 (1964): 118–34.

Griseri, Andreina. *Jaquerio e i realismo gotico in Piemonte*. Turin: Fratelli Pozzo, 1966.

Guerry, Liliane. *Le thème du "Triomphe de la Mort" dans la peinture italienne*. Paris: G. P. Maisonneuve, 1950.

Guglielmo Ebreo. *Trattato dell'arte del ballo di Guglielmo Ebro Pesarese*. Edited by Francesco Zambrini. Bologna, 1873; reprint ed. Bologna: Commissione per i testi di lingua, 1968.

Guidi, F. "Per una nuova cronologia di Giovanni di Marco." *Paragone* 19, no. 223 (September 1968): 27–46.

Guillaume de Lorris and Jean de Meun. *Le Roman de la Rose*. Edited by Ernest Langlois. 5 vols. Paris; Firmin-Didot, 1914–1924.

———. *The Romance of the Rose*. Translated by H. W. Robbins, edited by C. W. Dunn. New York: Dutton Paperback, 1962.

———. *The Romance of the Rose*. Translated by Charles Dahlberg. Princeton, N. J.: Princeton University Press, 1971.

Gundersheimer, Werner L. *Art and Life at the Court of Ercole I d'Este*. Geneva: Droz, 1972.

Gunn, Alan M. F. *The Mirror of Love*. Lubbock, Texas: Texas Tech Press, 1952.

Hankey, T. "Salutati's Epigrams for the Palazzo Vecchio." *Journal of the Warburg and Courtauld Institutes* 22 (1959): 363–65.

Hartt, Frederick. *History of Italian Renaissance Art*. Englewood Cliffs, N. J., and New York: Prentice-Hall, 1970.

Hauber, A. *Planetenkinderbilder und Sternbilder*. Strasbourg, 1915.

Herlihy, David. *Medieval and Renaissance Pistoia*. New Haven, Conn.: Yale University Press, 1967.

Hermanin, Federico. *L'appartamento Borgia in Vaticano*. Rome: Danesi, 1934.

Hettner, Hermann. *Italienische Studien*. Brunswick: Vieweg, 1879.

Hind, Arthur M. *Early Italian Engraving*. 4 vols. London: B. Quaritch, 1938–1948; reprint ed. Nendeln and Liechtenstein: Kraus Reprint, 1970.

———. *Nielli*. London: British Museum, 1936.

Hoff, Ursula. *Catalogue of European Paintings Before 1800*. Melbourne: National Gallery of Victoria, 1961.

Horace. *Odes and Epodes*. Edited by Paul Shorey, revised by Paul Shorey and Gordon J. Laing. Chicago, New York and London: Benjamin H. Sanborn and Co., 1919.

———. *The Odes and Epodes of Horace*. Translated by Joseph P. Clancy. Chicago: University of Chicago Press, Phoenix Books, 1960.

Hyginus. *De imaginibus coeli*. Edited by L. W. Hasper. Leipzig: Teubner, 1861.

———. *Fabulae*. Edited by Maurice Schmidt. Jena: Hermann Dufft, 1872.

Isbell, Harold, trans. *The Last Poets of Imperial Rome*. Harmondsworth and Baltimore: Penguin, 1971.

Jacorosso, M. *I palazzi fiorentini: Quartiere di San Giovanni*. Florence: Comitato per l'estetica cittadina, 1972.

Janson, H. W. *Apes and Ape Lore*. London: The Warburg Institute, University of London, 1952.

Jarves, James Jackson. *Descriptive Catalogue of "Old Masters."* Cambridge, Mass.: H. O. Houghton, 1860.

Jones, G. F. "Wittenweiler's *Becki* and the Medieval Bagpipe." *Journal of English and Germanic Philology* 48 (1949): 209–28.

Kern, Edith G. "The Gardens in the *Decameron* Cornice." *Publications of the Modern Language Association* 66 (1951): 505–23.

King, Edward S. "The Legend of Paris and Helen." *Journal of the Walters Art Gallery* 2 (1939): 55–72.

Kirkham, Victoria. "Reckoning with Boccaccio's *Questioni d'Amore*." *Modern Language Notes* 89 (1974): 47–59.

Klesse, Brigitte. *Seidenstoffe in der italienischen Malerei des 14. Jahrhunderts*. Berne: Stämpfli, 1967.

Koechlin, Raymond. *Les ivoires gothiques françaises*. 3 vols. Paris: A. Picard, 1924.

Kohlhaussen, H. *Minnekästchen im Mittelalter.* Berlin: Verlag für Kunstwissenschaft, 1928.

Krautheimer, Richard, in collaboration with Krautheimer-Hess, Trude. *Lorenzo Ghiberti.* 2d ed. 2 vols. Princeton, N. J.: Princeton University Press, 1970.

Kunstgewerbemuseum: Ausgewählte Werke. Berlin: Kunstgewerbemuseum, 1963.

Ladner, Gerhard B. "Vegetation Symbolism and the Concept of Renaissance." In *De Artibus opuscula XL: Essays in Honor of Erwin Panofsky.* Edited by Millard Meiss. 2 vols. New York: New York University Press, 1961.

L'Art européen vers 1400. Vienna: The Council of Europe, 1962.

Lehmann, Phyllis Williams, and Lehmann, Karl. *Samothracian Reflections.* Princeton, N. J.: Princeton University Press, 1973.

Lehrs, Max. *Geschichte und kritische Katalog des deutschen, niederländischen und französischen Kupferstichs im XV. Jahrhundert.* 10 vols. Vienna, 1908–1934; reprint ed. New York: Collectors Editions, n.d.

Lensi, Alfredo. *Il Museo Stibbert.* 2 vols. Florence, 1918.

Le Prieur, P.; Pérate, André; and Lemoisne, A. *Catalogue raisonné de la collection Martin Le Roy.* 5 vols. Paris, 1909.

Leroy, Stéphane. *Catalogue des peintures, sculptures, dessins et gravures exposés dans les galeries du Musée de Douai.* Douai, 1937.

Levenson, Jay A.; Oberhuber, Konrad; and Sheehan, Jacquelyn L. *Early Italian Engravings From the National Gallery of Art.* Washington: National Gallery of Art, 1973.

Levey, Michael. *Early Renaissance.* Harmondsworth: Penguin Books, 1967.

Levi, Ezio. *Botteghe e canzoni della vecchia Firenze.* Bologna: Nicola Zanichelli, 1928.

―――. *Fiore di leggende. Cantari antichi.* Bari: Giuseppe Laterza, 1914.

Lewis, C. S. *The Allegory of Love.* Oxford: Oxford University Press, 1936; reprint ed. New York: Oxford University Press, 1958.

Liebeschütz, Hans, ed. *Fulgentius metaforalis.* Leipzig: Teubner, 1926.

Li Gotti, Ettore. "Gli affreschi della stanza della Torre nel Palazzo del Podestà di San Gimignano." *Rivista d'arte* 20 (1938): 379–91.

Logan Berenson, Mary: "Dipinti italiani a Cracovia—1." *Rassegna d'arte* 15 (1915): 1–4.

Longhi, Roberto. "Fatti di Masolino e di Masaccio." *Critica d'arte* 5 (1940): 145–91.

―――. "Ricerche su Giovanni di Francesco." *Pinacotheca* 1 (1928): 34–38.

Longhurst, Margaret L. *Catalogue of Carvings in Ivory.* London: Victoria and Albert Museum, 1929.

McNair, P. M. J. "The Bed of Venus: Key to Poliziano's Stanze." *Italian Studies* 25 (1970): 40–48.

Maganato, Licisco. *Da Altichiero a Pisanello.* Venice: N. Pozza, 1958.

Manetti, Antonio. *The Life of Brunelleschi.* Translated by Catherine Engass, edited by Howard Saalman. University Park, Pa., and London: Pennsylvania State University Press, 1970.

Marcucci, Luisa. *Cassone Adimari.* Florence, 1962.

Marrocco, William Thomas. *Fourteenth-Century Italian Cacce.* 2d ed. Cambridge, Mass.; Medieval Academy of America, 1961.

Marti, M. "Interpretazione del 'Decameron.'" *Convivium,* n.s. 25 (1957): 276–89.

Mather, Frank Jewett, Jr. "A Quattrocento Toilet Box in the Louvre." *Art in America* 11, no. 1 (December 1922): 45–51.

———. "Dante Portraits." *The Romanic Review* 3 (1912): 117–22.

———. *The Portraits of Dante.* Princeton, N. J.: Princeton University Press, 1921.

Mazzi, C. "Il 'Libro dell'arte del danzare' di Antonio Cornazano." *La bibliofilia* 17 (1915): 1–30.

Meiss, Millard. "Notable Disturbances in the Classification of Tuscan Trecento Paintings." *Burlington Magazine* 113 (1971): 178–86.

———. *Painting in Florence and Siena After the Black Death.* Princeton, N. J.: Princeton University Press, 1951.

———. "The Earliest Work of Giovanni di Paolo." *Art in America* 24 (1936): 137–43.

———. "The First Fully Illustrated *Decameron.*" In *Essays in the History of Art Presented to Rudolf Wittkower.* London: Phaidon, 1967.

———. *The Limbourgs and their Contemporaries.* 2 vols. New York: George Braziller and the Pierpont Morgan Library, 1974.

———. "The Problem of Francesco Traini." *Art Bulletin* 15 (1933): 97–173.

———, and Edith W. Kirsch. *The Visconti Hours.* New York: George Braziller, 1972.

Mirimonde, A. P. de. "La musique dans les allégories de l'amour." *Gazette des beaux arts,* 6th ser. 68 (1966): 265–90; 69 (1967): 318–46.

Moakley, Gertrude. *The Tarot Cards Painted by Bonifacio Bembo for the Visconti Family.* New York: New York Public Library, 1966.

Mode, Robert L. "Masolino, Uccello, and the Orsini 'Uomini famosi.'" *Burlington Magazine* 114 (1972): 369–78.

Mölk, U. "Le sonnet *Amor è un desio* de Giacomo da Lentini et le problème de la genèse de l'amour." *Cahiers de civilisation médiévale* 14 (1971): 329–39.

Mommsen, Theodor Ernst. *Medieval and Renaissance Studies.* Edited by Eugene F. Rice, Jr. Ithaca, N. Y.: Cornell University Press, 1959.

Montor, Artaud de. *Peintres primitifs.* Paris, 1843.

Morazzoni, Giuseppe. *Il mobilio genovese.* Milan: Alfieri, 1949.

Morpurgo, S. "Le epigrafi volgari in rime . . . nel camposanto di Pisa." *L'Arte* 2 (1899) : 51–87.

Mostra dei tesori segreti delle case fiorentine. Florence: Circolo Borghese e della Stampa, 1960.

Müntz, Eugène. "Les plateaux d'accouchées et la peinture sur meubles." *Monuments et mémoires* 1 (1894) : 202–32.

Murray, C. Fairfax. *Two Lombard Sketch Books in the Collection of C. Fairfax Murray*. London, 1910.

Muscetta, Carlo. *Giovanni Boccaccio*. Bari: Laterza, 1972.

Nadin, Lucia. "Giovanni d'Agnolo Capponi, copista del 'Decameron.'" *Studi sul Boccaccio* 3 (1965) : 41–54.

Nicco Fasola, Giusta. *La fontana di Perugia*. Rome: Libreria dello Stato, 1951.

Nolhac, Pierre de. *Pétrarque et l'humanisme*. 2d ed. Paris: Bouillon, 1907.

Nurmela, T. "Physionomie de Boccacce." *Neuphilologische Mitteilungen* 60 (1959) : 321–34.

Offner, Richard. *Italian Primitives at Yale University*. New Haven, Conn.: Yale University Press, 1927.

————, and Steinweg, Klara. *A Critical and Historical Corpus of Florentine Painting*. New York: New York University Press, 1930–.

Orlandi, Stefano. *Beato Angelico*. Florence: Leo S. Olschki, 1964.

Ovid. *Epistulae Heroidum*. Edited by Heinrich Dorrie. Berlin and New York: Walter de Gruyter, 1971.

————. *Metamorphoses*. Edited and translated by Frank Justus Miller. 2 vols. Cambridge, Mass., and London: Loeb Classical Library, 1944.

————. *Ovid: The Art of Love and Other Poems*. Edited and translated by J. H. Mozley. Cambridge, Mass., and London: Loeb Classical Library, 1947.

————. *Ovid's Heroides*. Translated by Harold E. Cannon. New York: E. P. Dutton, 1971.

————. *The Metamorphoses of Ovid*. Translated by Mary M. Innes. Harmondsworth: Penguin, 1955.

Panofsky, Erwin. *Problems in Titian: Mostly Iconographic*. New York: New York University Press, 1969.

————. *Renaissance and Renascences in Western Art*. Stockholm: Almquist and Wiksell, 1960.

————. *Studies in Iconology*. New York: Oxford University Press, 1939, 1962.

Paoletti, L. "Benvenuto da Imola." *Dizionario biografico degli italiani* 7 (1966) : 692–93.

Passerini, Luigi. *Gli Alberti di Firenze*. 2 vols. Florence: M. Cellini, 1869.

Pedrini, Augusto. *Il mobilio*. 2d ed. Florence: Azienda Libraria Editoriale Fiorentina, 1948.

Peebles, R. J. "The Dry Tree: Symbol of Death." In *Vassar Mediaeval Studies*. Edited by C. F. Fiske. New Haven, Conn.: Yale University Press, 1923.

Perkins, F. Mason. "A Florentine Double Portrait at the Fogg Museum." *Art in America* 9 (1921): 137–48.

Petrarch. *Le Rime*. Edited by Giosuè Carducci and Severino Ferrari, revised by Gianfranco Contini. Florence: Sansoni, 1965.

————. *Petrarch: A Humanist Among Princes*. Edited by David Thompson. New York, Evanston, Ill., and London: Harper and Row, 1971.

————. *Petrarch: Sonnets and Songs*. Edited and translated by Anna Maria Armi. New York: Pantheon, 1946.

————. *Rime, Trionfi e Poesie latine*. Edited by Ferdinando Neri, Guido Martellotti, Enrico Bianchi, and Natalino Sapegno. Milan and Naples: Ricciardo Ricciardi, 1951.

————. *The Triumphs of Petrarch*. Translated by Ernest Hatch Wilkins. Chicago: University of Chicago Press, 1962.

Poliziano, Angelo. *Rime*. Edited by Natalino Sapegno. Rome: Edizione dell'Ateneo, 1965.

Polzer, Joseph. "Aristotle, Mohammed and Nicholas V in Hell." *Art Bulletin* 46 (1964): 457–69.

Pope-Hennessy, John. *Fra Angelico*. 2d ed. Ithaca, N. Y.: Cornell University Press, 1974.

————. *Giovanni di Paolo*. New York: Oxford University Press, 1938.

Propertius. *Propertius*. Edited and translated by H. E. Butler. Cambridge, Mass., and London: Loeb Classical Library, 1958.

Pudelko, Georg. "The Minor Masters of the Chiostro Verde." *Art Bulletin* 17 (1935): 71–89.

Pulci, Luca. *Ciriffo Calvaneo, con la Giostra del Magnifico Lorenzo de' Medici*. Florence: Giunti, 1572.

Ragghianti Collobi, L. *Lorenzo il Magnifico e le arti*. Florence: Museo Mediceo, 1949.

Rand, E. K. "Dante and Petrarch in a Painting by Giovanni dal Ponte." *Fogg Art Museum Notes* 1, no. 3 (January 1923): 25–33.

Rankin, William. "Cassone Fronts in American Collections—V, Part 1." *Burlington Magazine* 11 (1907): 339–41.

Renier, Rodolfo. "Una poema sconosciuta degli ultimi anni del secolo XIV." *Propugnatore* 15, no. 1 (1882): 176–87, 325–79; 15, no. 2 (1882): 42–75.

Robertson, D. W., Jr. *A Preface to Chaucer*. Princeton, N. J.: Princeton University Press, 1962.

———. "The Doctrine of Charity in Medieval Literary Gardens: A Topical Approach Through Symbolism and Allegory." *Speculum* 26 (1951): 24–49.

Robinson, F. B. "A Marriage Chest Frontal: The Story of Callisto." *Museum of Fine Arts Bulletin* 28, no. 3 (February and March 1962): unpaginated.

Robson, C. A. "Dante's Use in the *Divina Comedia* of the Medieval Allegories on Ovid." In *Centenary Essays on Dante by Members of the Oxford Dante Society*. Oxford: Oxford University Press, 1965.

Rosa, Gilda. *I mobili nelle civiche raccolte artistiche di Milano*. Milan: Aldo Martello, 1963.

———. "Un cassone quattrocentesco al Castello Sforzesco di Milano." *Arte Veneta* 5 (1951): 98–100.

Rossi, U. "I deschi da parto." *Archivio storico dell'arte* 3 (1890): 78–79.

Rüdiger, Horst. *Sappho: ihr Ruf und Ruhm bei der Nachwelt*. Leipzig: Dieterich, 1933.

Sabbadini, Remigio. *La scoperta dei codici latini e greci ne' secoli XIV e XV*. 2d ed. Revised by Eugenio Garin. Florence: G. C. Sansoni, 1967.

———. "Spigolature latine." *Studi italiani di filologia classica* 5 (1897): 369–93.

Sacchetti, Franco. *Il trecento novelle*. Edited by Vincenzo Pernicone. Florence: Sansoni, 1946.

Salmi, Mario. "Aggiunte al Tre-e al Quattrocento fiorentino." *Rivista d'arte* 16 (1934): 65–76, 168–86.

Salvini, Roberto. "Lo sviluppo artistico di Giovanni dal Ponte." *Atti e memorie della R. Accademia Petrarca di lettere, arti, e scienze*, n.s. 16–17 (1934): 17–44.

Sapegno, Natalino. *Il Trecento*. 2d ed. Milan: F. Vallardi, 1955.

———, ed. *Poeti minori del Trecento*. Milan and Naples: Riccardo Ricciardi, 1962.

Scharf, Alfred. "Die Brautschachtel der Sammlung Figdor." *Der Cicerone* 13 (1930): 5–8.

———. "Die italienische Gemälde der Sammlung Figdor." *Der Cicerone* 22 (1930): 418–25.

Scheller, R. W. *A Survey of Medieval Model-Books*. Haarlem: F. Bohn, 1963.

Schiaparelli, Attilio. *La casa fiorentina ed i suoi arredi nei secoli XIV e XV*. Florence: Sansoni, 1908.

Schlosser, Julius von. *La letteratura artistica*. Translated by Filippo Rossi. 3d ed. Florence and Vienna: La Nuova Italia, 1964.

Schottmüller, Frida. *Furniture and Interior Decoration of the Italian Renaissance*. 2d ed. Stuttgart: J. Hoffmann, 1928.

Schubring, Paul. "Aphrodites und Ares' Liebe; ein sieneser Cassonebild aus dem 14. Jahrhundert." *Pantheon* 10 (1932): 298–300.

———. *Cassoni.* 2 vols. 2d ed. Leipzig: K. W. Hiersemann, 1923.

———. "New Cassone Panels." *Apollo* 5 (1927): 155–56.

———. "Two New 'Deschi' in the Metropolitan Museum." *Apollo* 6 (1927): 105–7.

Segre, Cesare. "Bartolomeo da San Concordio." *Dizionario biografico degli italiani* 6 (1961): 768–70.

Serdini, Simone. *Storia d'una fanciulla tradita da un suo amante.* Edited by Francesco Zambrini. Bologna: G. Romagnoli, 1862; reprint ed. Bologna: Commissione per i testi di lingua, 1967.

Servius. *Servii grammatici qui ferunter in Vergilii carmina commentarii.* Edited by Georg Thilo and Hermann Hagen. 3 vols. Leipzig and Berlin: Teubner, 1881–1923.

Seymour, Charles, Jr. *Early Italian Paintings in the Yale University Art Gallery.* New Haven, Conn.: Yale University Press, 1970.

———. *Jacopo della Quercia.* New Haven, Conn.: Yale University Press, 1973.

———. *The Rabinowitz Collection of European Paintings.* New Haven, Conn.: Yale University Press, 1961.

Seznec, Jean. *The Survival of the Pagan Gods.* Translated by Barbara F. Sessions. New York: Pantheon Books, 1953.

Shapiro, Marianne. "Petrarch, Lorenzo il Magnifico and the Latin Elegiac Poets." *Romantic Notes* 15 (1973): 172–77.

Shapley, Fern Rusk. *Paintings From the Samuel H. Kress Collection: Italian Schools XIII–XV Century.* London: Phaidon, 1966.

Shorr, Dorothy C. "Some Notes on the Iconography of Petrarch's Triumph of Fame." *Art Bulletin* 20 (1938): 100–107.

Sirén, Osvald. *A Descriptive Catalogue of the Pictures in the Jarves Collection.* New Haven, Conn.: Yale University Press, 1916.

Smith, Webster. "On the Original Location of the *Primavera*." *Art Bulletin* 57 (1975): 31–40.

Spychalska-Boczkowska, A. "Diana with Meleagros and Actaeon." *Bulletin du musée national de Varsovie* 9 (1968): 29–36.

Stechow, Wolfgang. *Apollo und Daphne.* Leipzig and Berlin: Teubner, 1932.

Steele, R. "A Notice of the *Ludes Triumphorum* and Some Early Italian Card Games; with some Remarks on the Origin of the Game of Cards." *Archaeologia* 57 (1900): 185–200.

Stuip, René Ernst Victor, ed. *La chastelaine de Vergi.* The Hague, Paris and London: Mouton, 1970.

Swarzenski, Georg. "A Marriage Casket and its Moral." *Bulletin of the Museum of Fine Arts* 45 (1948): 55–62.

Tanner, Marie. "Chance and Coincidence in Titian's *Diana and Actaeon*." *Art Bulletin* 56 (1974): 535–50.

Tervarent, Guy de. *Les énigmes de l'art au moyen âge.* Paris: Éditions d'art et d'histoire, 1938.

———. *L'héritage antique.* Paris: Éditions d'art et d'histoire, 1946.

Teza, E. "Versi rimati negli 'Ammaestramenti degli antichi.'" *Rassegna bibliografica della letteratura italiana* 5 (1897): 220–23.

Thiébaux, Marcelle. *The Stag of Love: The Chase in Medieval Literature.* Ithaca, N. Y., and London: Cornell University Press, 1974.

Thoss, Dagmar. *Studien zum Locus Amoenus im Mittelalter.* Vienna and Stuttgart: Wilhelm Braumüller, 1972.

Tibullus. *The Poems of Tibullus.* Translated by Constance Carrier, edited by Edward M. Michael. Bloomington, Ind., and London: Indiana University Press, 1968.

Toesca, Pietro. *Il Trecento.* Turin: Unione Tipografico Editrice Torinese, 1951.

———. *La pittura e la miniatura nella Lombardia.* 2d ed. Turin: Einaudi, 1966.

———. "Una scatola dipinta da Domenico di Bartolo." *Rassegna d'arte senese* 13 (1920): 107–8.

Tolnay, Charles de. "La *Résurrection du Christ* par Piero della Francesca: essai d'interprétation." *Gazette des beaux arts,* 6th ser. 43 (1954): 35–40.

Torri, Alessandro, ed. *L'Ottimo commento della Divina Commedia.* 3 vols. Pisa: Niccolo Capurro, 1827–1829.

Toscana. 3d ed. Milan: Touring Club Italiano, 1959.

Van Marle, Raimond. *Iconographie de l'art profane.* 2 vols. The Hague: Martinus Nijhoff, 1931–1932.

———. *The Development of the Italian Schools of Painting.* 18 vols. The Hague: Martinus Nijhoff, 1923–1937.

———. "Zwei italienische Minnekästchen des 14. Jahrhunderts." *Pantheon* 15 (1935): 171–73.

Van Os, H. W. "Andrea di Bartolo's Assumption of the Virgin." *Arts in Virginia* 11 (1970–1971): 1–11.

Vasari, Giorgio. *Le vite de' più eccellenti pittori scultori e architettori.* Edited by Rosanna Bettarini and Paola Barocchi. Florence: Sansoni, 1966–.

Velli, Giuseppe. "Note di cultura Boccacciana." *Italia medioevale e umanistica* 16 (1973): 327–35.

Venturi, Adolfo. "Per il Pisanello." *L'Arte* 28 (1925): 36–39.

———. *Storia dell'arte italiana.* 22 vols. Milan: Hoepli, 1901–1940.

Venturi, Leonello. *The Rabinowitz Collection.* New York: Twin Editions, 1945.

Verdier, Philippe, ed. *The International Style.* Baltimore: Walters Art Gallery, 1962.

———; Brieger, Peter; and Montpetit, Margaret F. *Art and the Courts.* 2 vols. Ottawa: National Gallery of Canada, 1972.

Verheyen, Egon. *The Paintings in the Studiolo of Isabella d'Este at Mantua.* New York: College Art Association Monographs, 1971.

Vertova, Luisa. "The New Yale Catalogue." *Burlington Magazine* 104 (1973): 159–63.

Virgil. *Virgil.* Edited and translated by H. R. Fairclough. 2 vols. London and New York: Loeb Classical Library, 1916.

———. *The Aeneid of Vergil.* Translated by Rolfe Humphries. New York, 1951.

Viscardi, Antonio, and Barni, Gianluigi. *L'Italia nell'età comunale.* Turin: Unione Tipografico Editrice Torinese, 1966.

Warburg, Aby. *Gesammelte Schriften.* 2 vols. Leipzig: Teubner, 1932.

Waterhouse, Ellis K. *Titian's Diana and Actaeon.* London, New York and Toronto: Oxford University Press, 1952.

Watson, Paul F. "A *Desco da Parto* by Bartolomeo di Fruosino." *Art Bulletin* 56 (1974): 4–9.

———. "Boccoccio's *Ninfale Fiesolano* in Early Florentine Cassone Painting." *Journal of the Warburg and Courtauld Institutes* 34 (1971): 331–33.

———, and Victoria Kirkham. "*Amore e Virtù*: Two Salvers Depicting Boccaccio's 'Comedia della Ninfe Fiorentine' in the Metropolitan Museum." *Metropolitan Museum Journal* 10 (1975): 35–50.

Weibel, Adèle. *Two Thousand Years of Textiles.* New York: Pantheon, 1952.

Weisbach, Werner. *Francesco Pesellino.* Berlin: B. Cassirer, 1901.

White, John. *Art and Architecture in Italy 1250–1400.* Harmondsworth and Baltimore: Penguin, 1966.

Wilkins, Ernest Hatch. *Life of Petrarch.* Chicago and London: University of Chicago Press, 1961.

Wind, Edgar. *Pagan Mysteries in the Renaissance.* 2d ed. Harmondsworth: Penguin, 1967.

Winternitz, Emmanuel. *Musical Instruments and their Symbolism in Western Art.* London: Faber, 1967.

Wright, Herbert G. *Boccaccio in England.* London: University of London, Athlone Press, 1957.

Zeri, Federico. "Inedito del supposto 'Cecchino da Verona.'" *Paragone* 17 (May 1951): 29–32.

———, with the assistance of Elizabeth E. Gardner. *Italian Paintings: A Catalogue From the Collection of the Metropolitan Museum of Art: Florentine School.* New York: The Metropolitan Museum of Art, 1971.

Index

Index

185

Illustrations

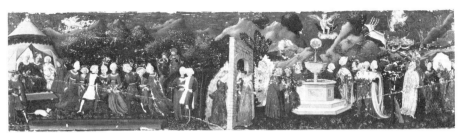

PLATE 1. Paolo Schiavo, *The Realms of Love*. Yale University Art Gallery, New Haven. James Jackson Jarves Collection. PHOTO: YALE UNIVERSITY ART GALLERY.

PLATE 2. Paolo Schiavo, *Realms of Love*, detail. PHOTO: YALE UNIVERSITY ART GALLERY.

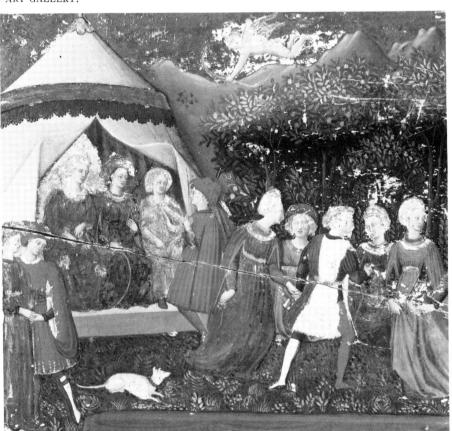

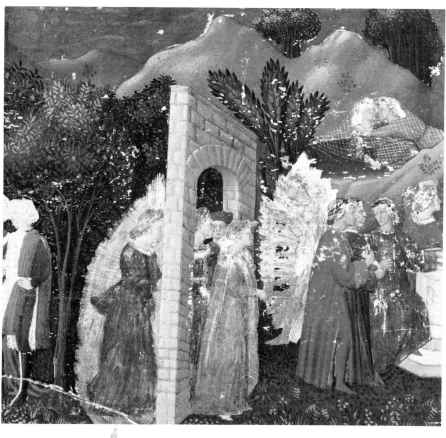

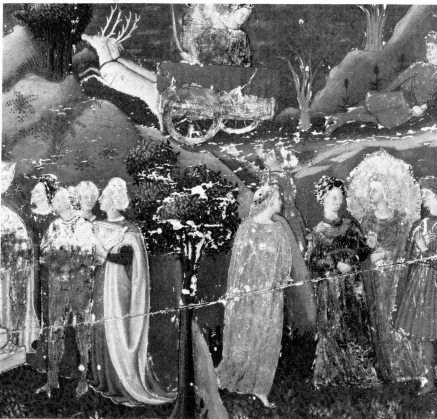

PLATE 3. Paolo Schiavo, *Realms of Love*, detail. PHOTO: YALE UNIVERSITY
ART GALLERY.

PLATE 5. Paolo Schiavo, *Madonna of Humility*. Fitzwilliam Museum, Cam-
bridge. PHOTO: FITZWILLIAM MUSEUM.

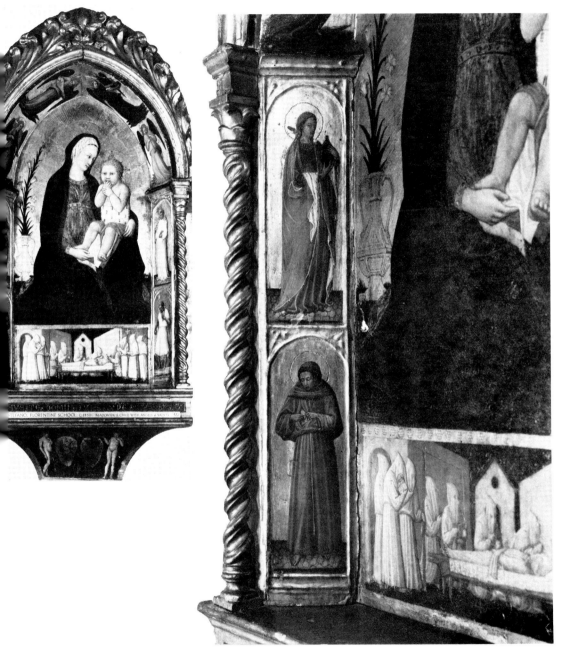

PLATE 6. Paolo Schiavo, *Madonna*, detail. PHOTO: FITZWILLIAM MUSEUM.

E 4. Paolo Schiavo, *Realms of Love*, detail. PHOTO: YALE UNIVERSITY
GALLERY.

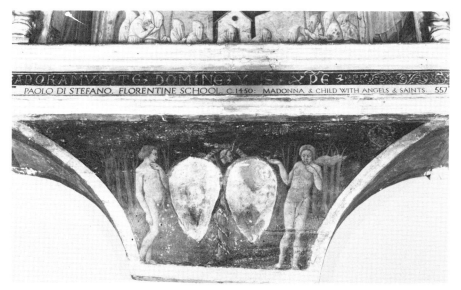

PLATE 7. Paolo Schiavo, *Madonna*, detail. PHOTO: FITZWILLIAM MUSEUM.

PLATE 8. Paolo Schiavo, *The Myth of Callisto*. Museum of Fine Arts, Springfield, Massachusetts. The James Philip Grey Collection. PHOTO: YALE UNIVERSITY ART GALLERY.

PLATE 9. Paolo Schiavo, *Myth of Callisto*, detail. PHOTO: MUSEUM OF FINE ARTS, SPRINGFIELD.

PLATE 10. Paolo Schiavo, *Myth of Callisto,* detail. PHOTO: MUSEUM OF FINE ARTS, SPRINGFIELD.

PLATE 11. Unknown Florentine, Illustration of the *Tesoretto.* Florence, Biblioteca Laurenziana, Ms. Strozz. 146, fol. 20ᵛ. PHOTO: PINEIDER, FLORENCE.

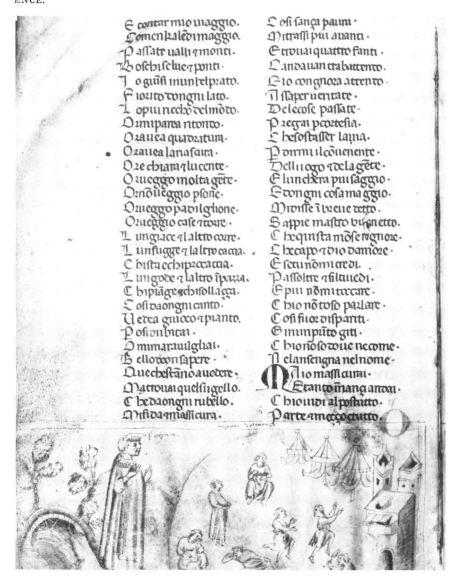

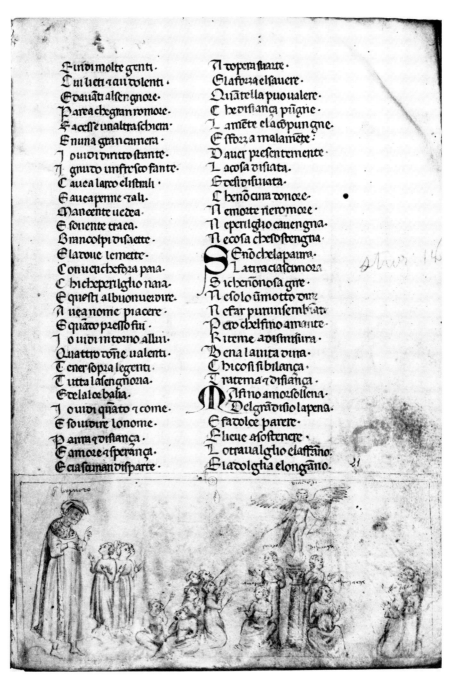

PLATE 12. Unknown Florentine, Illustration of the *Tesoretto*. Florence, Biblioteca Laurenziana, Ms. Strozz. 146, fol. 21ʳ. PHOTO: PINEIDER, FLORENCE.

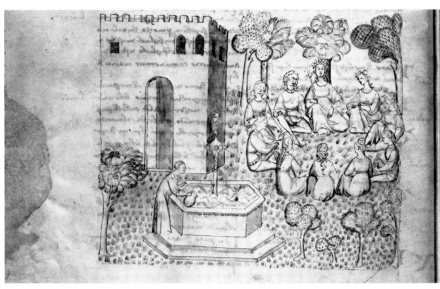

PLATE 13. Unknown Florentine, Illustration of the *Decameron*. Paris, Bibliothèque nationale, Ms. Italien 482, fol. 4ᵛ. PHOTO: BIBLIOTHÈQUE NATIONALE.

PLATE 14. Unknown Florentine, Illustrations to the *Decameron*. Paris, Bibliothèque nationale, Ms. Italien 482, fol. 5ʳ. PHOTO: BIBLIOTHÈQUE NATIONALE.

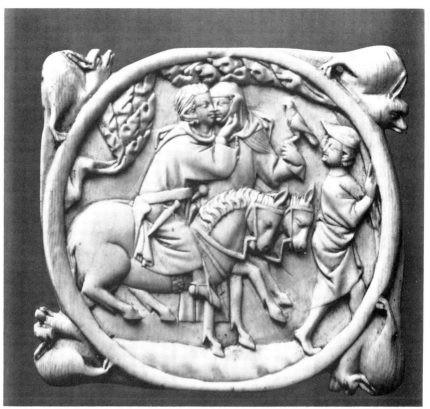

PLATE 15. Unknown French, Ivory mirror-case. Victoria and Albert Museum, London. PHOTO: VICTORIA AND ALBERT MUSEUM.

PLATE 16. Unknown Florentine, Chest. Victoria and Albert Museum, London. PHOTO: VICTORIA AND ALBERT MUSEUM.

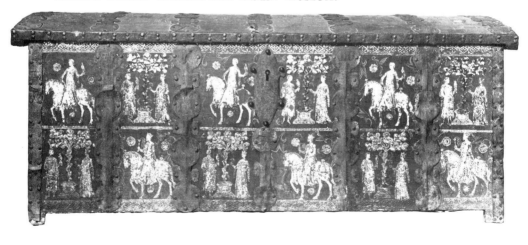

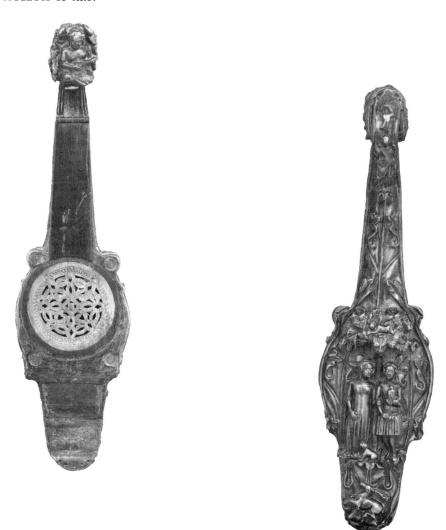

PLATE 19. The Master of the Dominican Effigies, *Corporale Bellezza*. Florence, Biblioteca Nazionale, MS. Palat. 600, fol 6ᵛ. PHOTO: PINEIDER, FLORENCE.

PLATE 21. Unknown North Italian, Ivory comb, Victoria and Albert Museum, London. PHOTO: VICTORIA AND ALBERT MUSEUM.

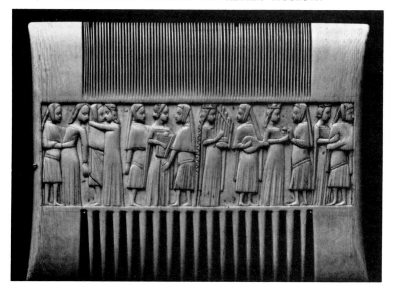

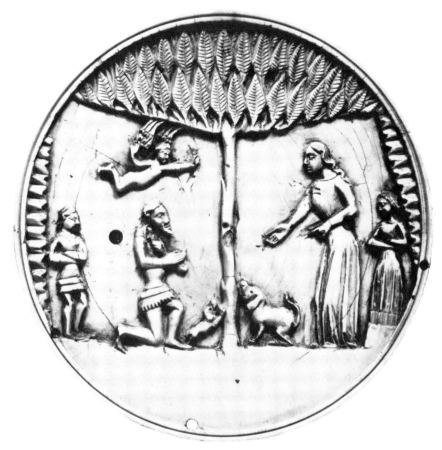

PLATE 20. Unknown North Italian, Ivory mirror-case. British Museum, London. PHOTO reproduced by courtesy of the Trustees of the BRITISH MUSEUM.

PLATE 22. Unknown French, Ivory comb. Victoria and Albert Museum, London. PHOTO: VICTORIA AND ALBERT MUSEUM.

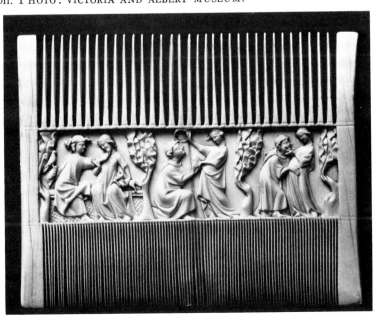

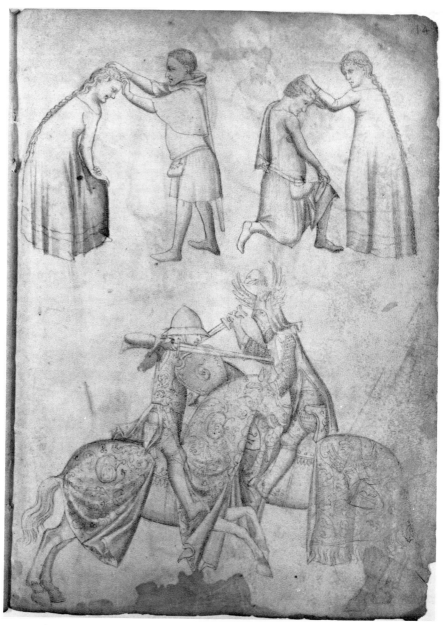

PLATE 23. Unknown Tuscan, Page from a Model-Book. The Pierpont Morgan Library, New York, Drawing II, fol. 14ʳ. PHOTO: THE PIERPONT MORGAN LIBRARY.

PLATE 24. Unknown Tuscan, Page from a Model-Book. The Pierpont Morgan Library, New York, Drawing II, fol. 13ʳ. PHOTO: THE PIERPONT MORGAN LIBRARY.

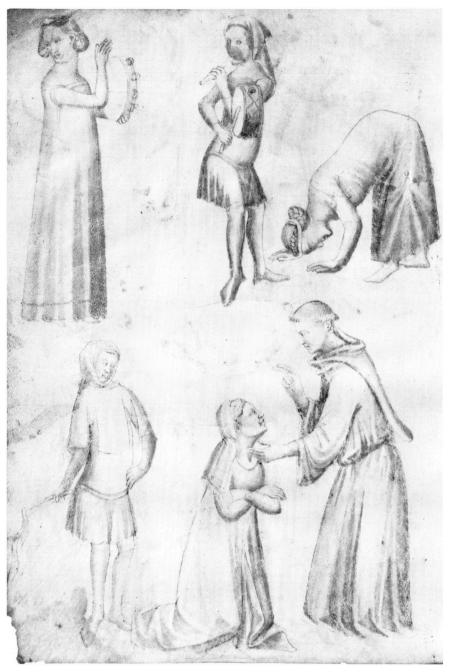

PLATE 25. Unknown Tuscan, Page from a Model-Book. The Pierpont Morgan Library, New York, Drawing II, fol. 13ᵛ. PHOTO: THE PIERPONT MORGAN LIBRARY.

PLATE 27. Unknown Catalan, Casket. The Walters Art Gallery, Baltimo PHOTO: WALTERS ART GALLERY, BALTIMORE.

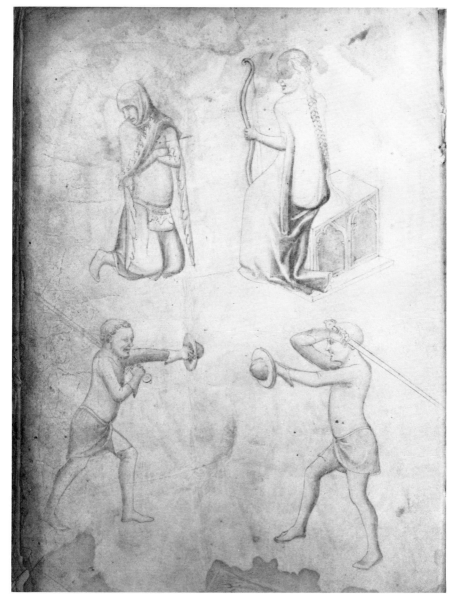

PLATE 26. Unknown Tuscan, Page from a Model-Book. The Pierpont Morgan Library, New York, Drawing II, fol. 14ᵛ. PHOTO: THE PIERPONT MORGAN LIBRARY.

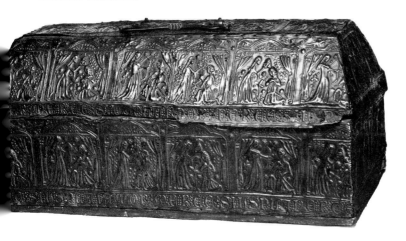

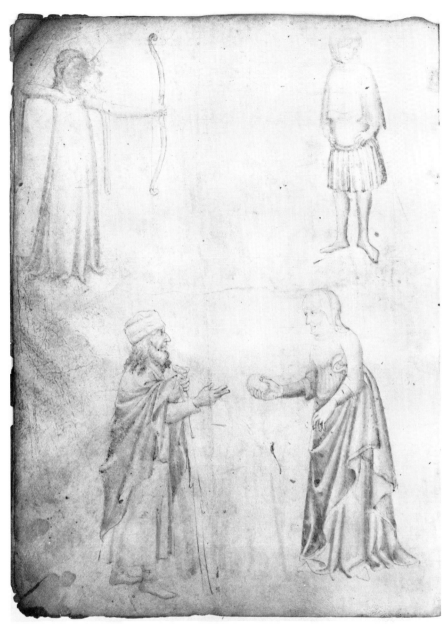

PLATE 28. Unknown Tuscan, Page from a Model-Book. The Pierpont Morgan Library, New York, Drawing II, fol. 4ᵛ. PHOTO: THE PIERPONT MORGAN LIBRARY.

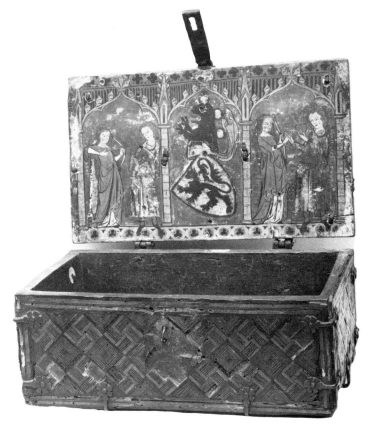

PLATE 29. Unknown German, Coffer. The Cloisters, New York. PHOTO: THE METROPOLITAN MUSEUM OF ART.

PLATE 30. Unknown Florentine, Fragments of fresco decoration. Museo di San Marco, Florence. PHOTO: ALINARI, FLORENCE.

PLATE 31. Palazzo Davanzati, Florence. Sala dei Pappagalli. PHOTO: ALI-NARI, FLORENCE.

PLATE 32. Palazzo Davanzati, Sala delle Impannate. PHOTO: ALINARI, FLORENCE.

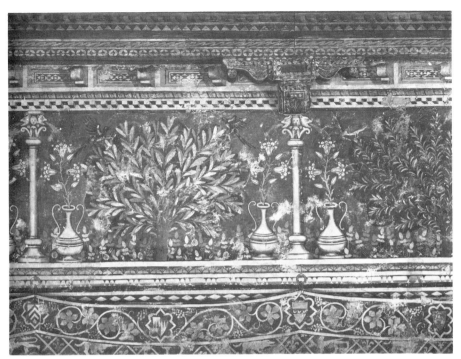

PLATE 33. Palazzo Davanzati, Sala delle Impannate, detail. PHOTO: ALI-
NARI, FLORENCE.

PLATE 34. Palazzo Davanzati, Sala dei Pavoni. PHOTO: ALINARI, FLORENCE.

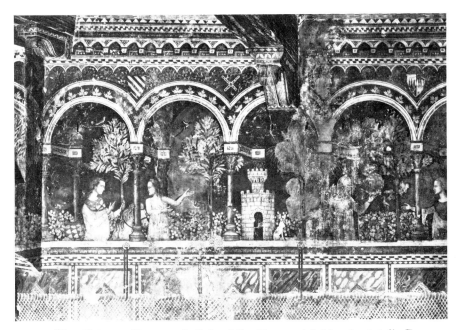

PLATE 37. Palazzo Davanzati, Sala della Donna del Verzù, detail. PHOTO:
ALINARI, FLORENCE.

PLATE 38. Palazzo Davanzati, Sala della Donna del Verzù, detail. PHOTO:
ALINARI, FLORENCE.

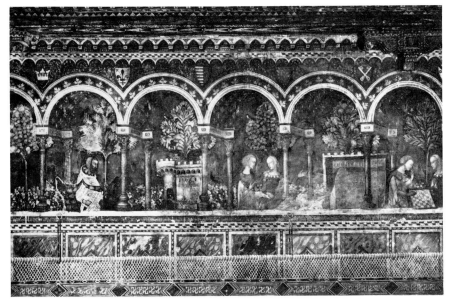

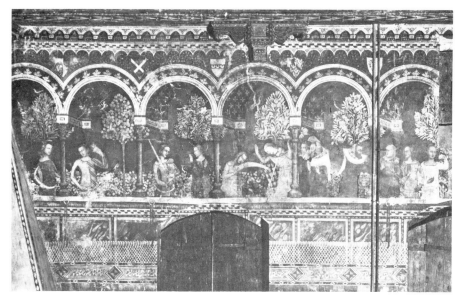

PLATE 39. Palazzo Davanzati, Sala della Donna del Verzù, detail. PHOTO: ALINARI, FLORENCE.

PLATE 40. Ambrogio Lorenzetti, *Allegory of Good Government in the City*, detail. Palazzo Pubblico, Siena, 1338. PHOTO: ALINARI, FLORENCE.

PLATE 41. Taddeo Gaddi, *Betrothal of the Virgin*. Baroncelli Chapel, S Croce, Florence. PHOTO: ALINARI, FLORENCE.

PLATE 42. Unknown Tuscan, *The Exposition of Death*. Camposanto, Pisa PHOTO: ALINARI, FLORENCE.

PLATE 43. Unknown Tuscan, *Exposition of Death*, detail showing Garde of Vanity. PHOTO: ALINARI, FLORENCE.

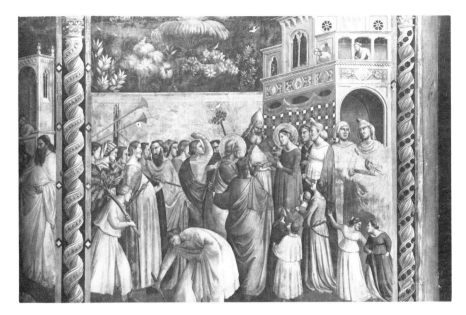

PLATE 44. Unknown Tuscan, Page from a Model-Book. The Pierpont Morgan Library, New York, Drawing II, fol. 12ᵛ. PHOTO: THE PIERPONT MORGAN LIBRARY.

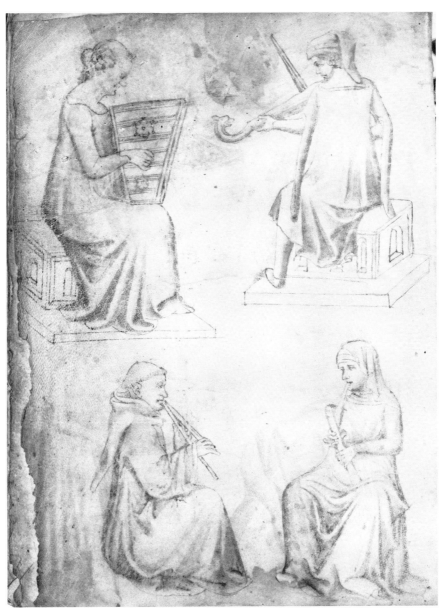

PLATE 45. Unknown Tuscan, Page from a Model-Book. The Pierpont Morgan Library, New York, Drawing II, fol. 15ᵛ. PHOTO: THE PIERPONT MORGAN LIBRARY.

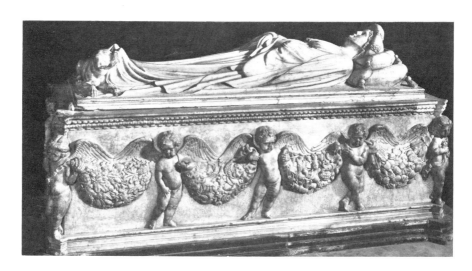

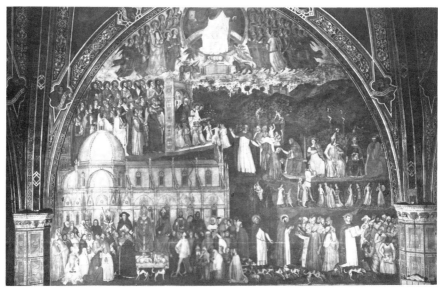

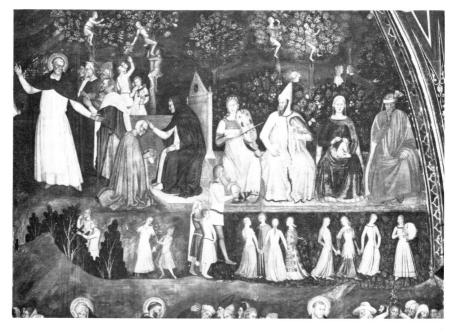

PLATE 46. Jacopo della Quercia, Tomb of Ilaria del Carretto. Duomo, Lucca. PHOTO: ALINARI, FLORENCE.

PLATE 47. Andrea Bonaiuti, *The Way to Salvation.* Spanish Chapel, S. Maria Novella, Florence, 1366–67. PHOTO: ALINARI, FLORENCE.

PLATE 48. Andrea Bonaiuti, *Way to Salvation*, detail showing Garden of Vanity. PHOTO: ALINARI, FLORENCE.

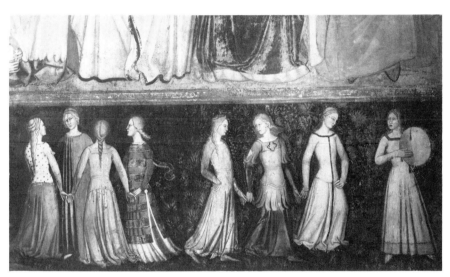

PLATE 49. Andrea Bonaiuti, *Way to Salvation*, detail. PHOTO: ALINARI, FLORENCE.

PLATE 50. Andrea Bonaiuti, *The Liberal Arts*, detail. Spanish Chapel. S. Maria Novella, Florence, 1366–67. PHOTO: ALINARI, FLORENCE.

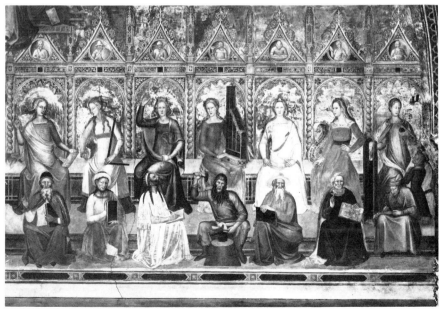

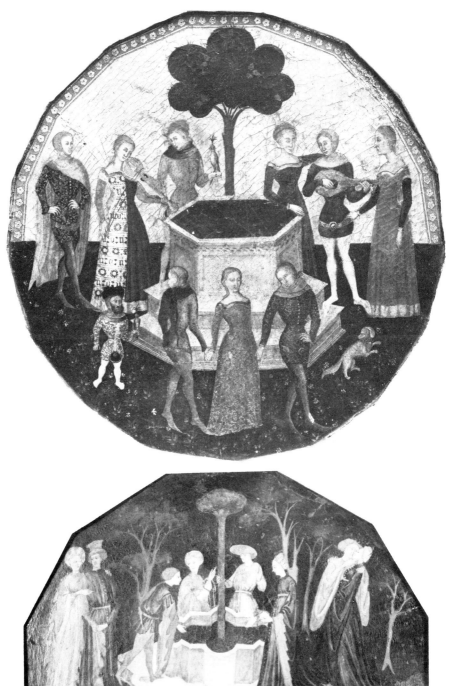
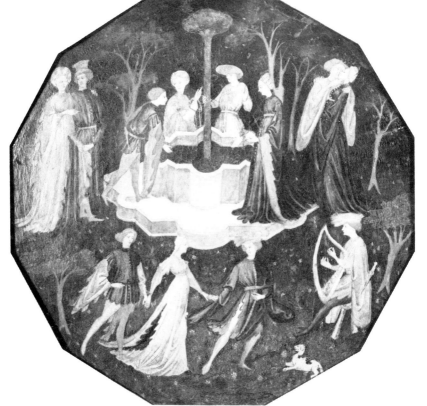

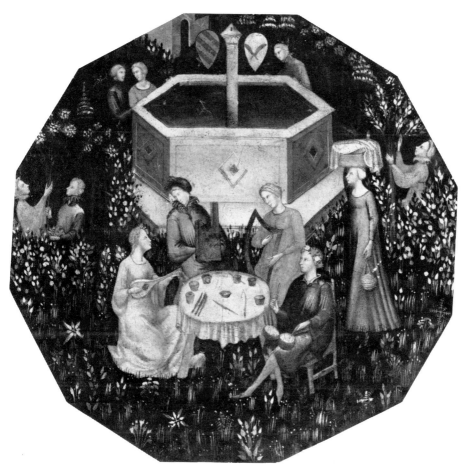

PLATE 56. Florentine close to Pesellino, *Garden of Love*, formerly in the collection of Martin LeRoy, Paris. PHOTO: after *Catalogue raisonné de la collection Martin Le Roy*, vol. 5, pl. 7.

PLATE 54. Florentine close to Mariotto di Nardo, back of *Garden of Love*. PHOTO: WILDENSTEIN.

PLATE 55. Shop of Giovanni di Marco, *Garden of Love*. Yale University Art Gallery, New Haven. Bequest of Maitland Griggs. State before cleaning. PHOTO: YALE UNIVERSITY ART GALLERY.

PLATE 57. Baccio Baldini, *Garden of Love*. Kupferstichkabinett, Staalich Museen Preussischer Kulturbesitz, Berlin. PHOTO: WALTER STEINKOP BERLIN.

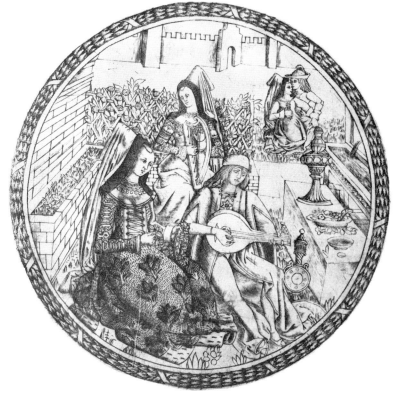

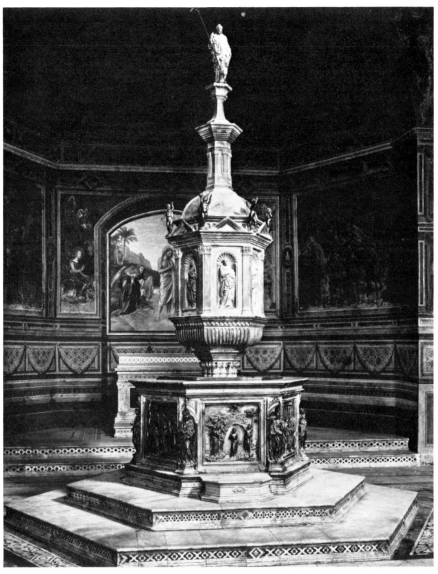

PLATE 58. Jacopo della Quercia and others, Baptismal Font. S. Giovanni, Siena, 1417–1431. PHOTO: ALINARI, FLORENCE.

PLATE 59. Follower of Jaquerio, *Fountain of Youth*. Castello, Manta. PHOTO: ALINARI, FLORENCE.

PLATE 60. Mariotto di Nardo, *Teseida*. Staatsgalerie, Stuttgart. PHOTO: STAATSGALERIE, STUTTGART.

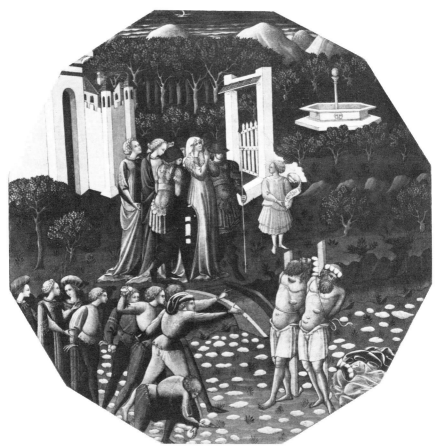

PLATE 61. The Master of the Bargello Tondo, *Susanna*. Serristori Collection, Florence. PHOTO: ALINARI, FLORENCE.

PLATE 62. Follower of Pesellino, *The Triumphs of Love and Chastity*. Formerly in the collection of Major General Sir George Burns, North Mymms Park, Hertfordshire. PHOTO: courtesy of the COURTAULD INSTITUTE OF ART, LONDON.

PLATE 63. The Master of the Bargello Tondo, *The Judgment of Paris*. Bargello, Florence. PHOTO: ALINARI, FLORENCE.

PLATE 64. Giovanni di Marco, *The Paradise of Famous Lovers*, fragment. National Museum, Cracow. The Czartoryski Collection. PHOTO: MALINOWSKI, CRACOW.

PLATE 65. Giovanni di Marco, *Paradise of Famous Lovers*. Musée Jacquemart-André, Paris. PHOTO: BULLOZ, PARIS.

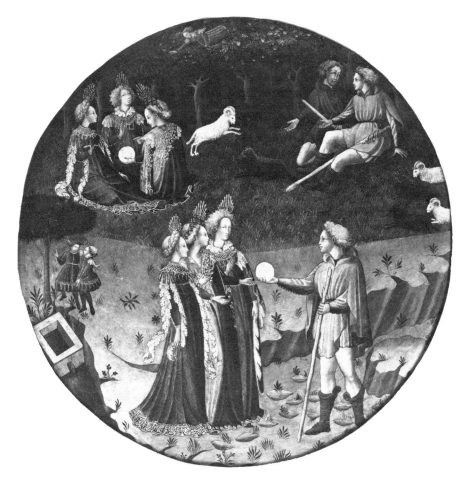

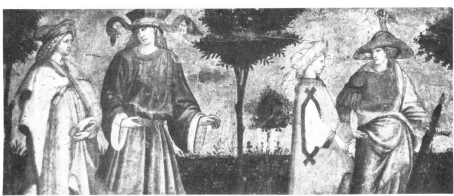

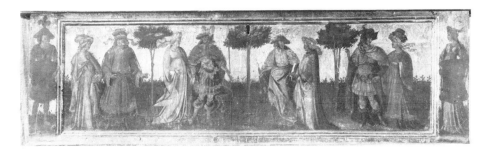

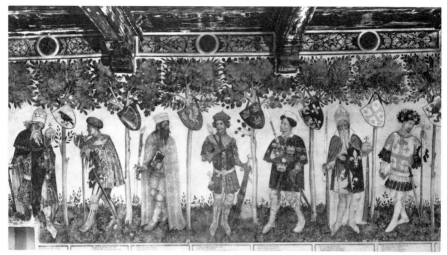

PLATE 66. Jaquerio, *The Nine Worthies*. Castello, Manta. PHOTO: ALINARI, FLORENCE.

PLATE 67. Unknown Florentine, *The Paradise of Venus*. Louvre, Paris. PHOTO: MUSÉES NATIONAUX, PARIS.

PLATE 68. Sienese close to Andrea di Bartolo, *Paradise of Venus*, lid of a coffer. Louvre, Paris, 1421. PHOTO: MUSÉES NATIONAUX, PARIS.

PLATE 69. Unknown Sienese close to Andrea di Bartolo, side of 1421 coffer. PHOTO: MUSÉES NATIONAUX, PARIS.

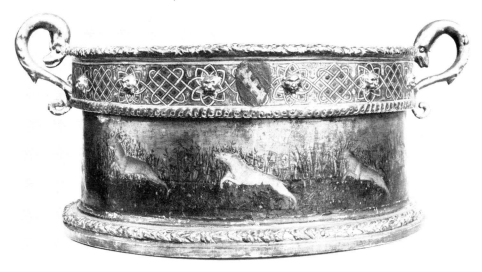

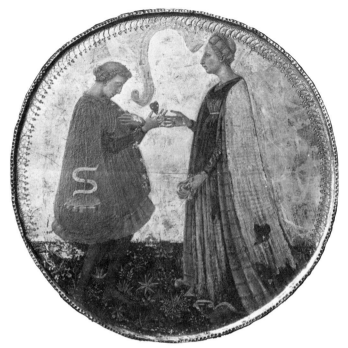

PLATE 70. Domenico di Bartolo, *The Offering of the Heart*, lid of a coffer. Formerly Schlossmuseum, Berlin. PHOTO: STAATLICHE MUSEEN ZU BERLIN.

PLATE 71. French, Ivory mirror-case. Victoria and Albert Museum, London. PHOTO: VICTORIA AND ALBERT MUSEUM.

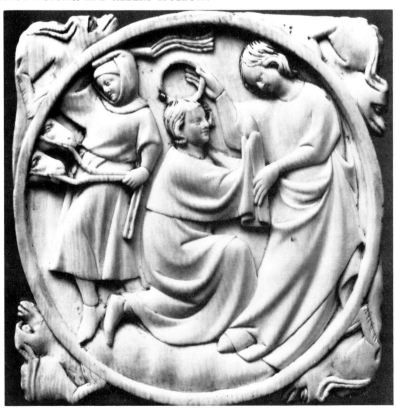

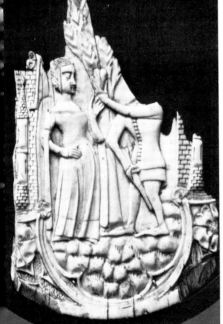

PLATE 72. North Italian, Ivory mirror-case, fragment. Victoria and Albert Museum, London. PHOTO: VICTORIA AND ALBERT MUSEUM.

PLATE 73. Bonifacio Bembo, *Amor*, tarot card. Collection of Conte Visconti di Mondrone, Milan. PHOTO after ARCHAEOLOGIA 57 (1900), pl. XX, fig. 1.

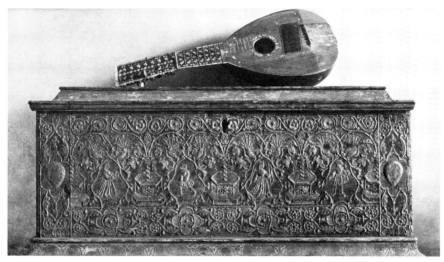

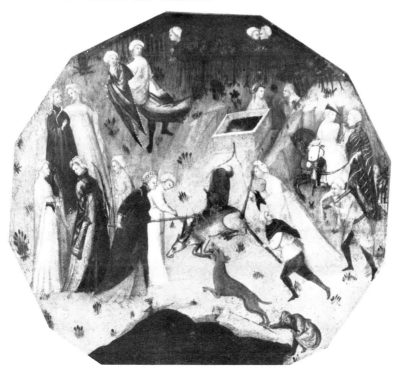

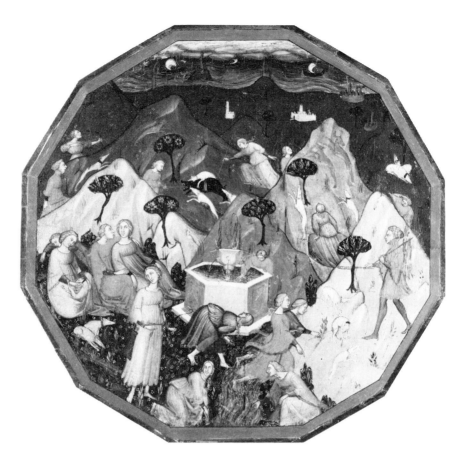

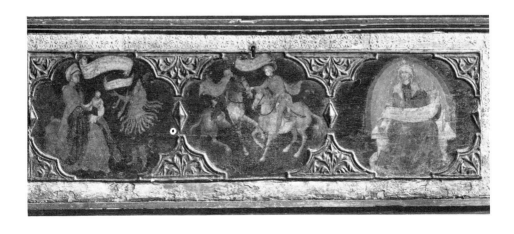

PLATE 79. Lorenzo di Niccolò, *Comedia delle ninfe fiorentine*. The Metropolitan Museum of Art, New York. Rogers Fund, 1926. PHOTO: THE METROPOLITAN MUSEUM OF ART.

PLATE 80. Unknown Florentine (?), *The Myth of Actaeon*. Metropolitan Museum of Art, New York. Gift of George Blumenthal, 1941. PHOTO: THE METROPOLITAN MUSEUM OF ART.

PLATE 81. Unknown Florentine (?), *Episodes from an Allegory*. The Metroplitan Museum of Art, New York. Gift of George Blumenthal, 1941. PHOTO: THE METROPOLITAN MUSEUM OF ART.

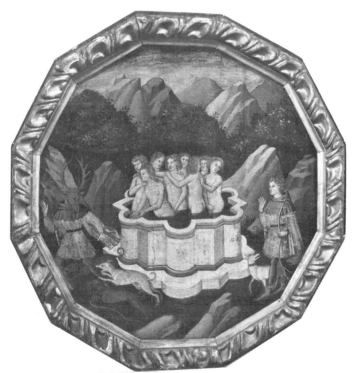

PLATE 82. Follower of Domenico Veneziano, *The Myth of Actaeon*. Williams College Museum of Art, Williamstown. PHOTO: WILLIAMS COLLEGE MUSEUM OF ART.

PLATE 83. Unknown Florentine, Cassone. Museo Stibbert, Florence. PHOTO: ALINARI, FLORENCE.

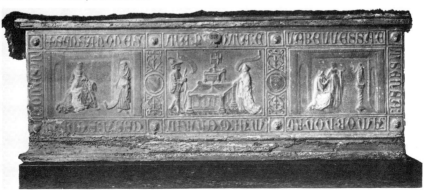

Francisci petrarce poete laureati quorundam clarissimoru heroum epithomatis ad generosissimu patrum dominu iclitu franciscu de canaria Rubeice.

De Romulo pmo Romanoru rege.	De fabricio lucilio.
De numa pôpilio secûdo romanoru rege.	De Alexandro macedone.
De Tullo hostilio tcio romanoru rege.	De pirro epirotali rege.
De Ancho mârio quâto romanoru rege.	De hanibale cârthaginensiû duce.
De Junio bruto pmo romanoru côsule.	De qnto fabio maximo cûctatore.
De horacio cocle.	De marco claudio marcello.
De lucio quirio cicinato.	De claudio nerone er lurio salinatore.
De marco furio camillo.	De publio côrnelio Scipiôe africanno maiore.
De Tito manlio torquato.	De marco pôrcio catone censorino.
De publio decio.	De baio Julio Cesare.
De lucio papirio cursore.	
De marco curio dentato.	De marco valerio corrino.

PLATE 86. Apollonio di Giovanni, *Dante*. Florence, Biblioteca Laurenziana, MS Strozz. 174, fol. 4^v. PHOTO: PINEIDER, FLORENCE.

PLATE 85. Unknown Florentine, *Boccaccio*, 1451. Venice, Biblioteca Nazionale Marciana, MS Ital. X, 127 (26719), fol. 47^r. PHOTO: TOSO, VENICE.

PLATE 87. Fra Angelico, *Last Judgment*. Museo di San Marco, Florence, 1431. PHOTO: ALINARI, FLORENCE.

PLATE 88. Unknown Florentine, *The Myth of Daphne*. Lee of Fareham Collection, Avening, Gloucestershire. PHOTO: BIRMINGHAM CITY MUSEUM AND ART GALLERY, BIRMINGHAM.

PLATE 89. Giotto, *Lamentation*. Arena Chapel, Padua. PHOTO: ANDERSON, ROME.

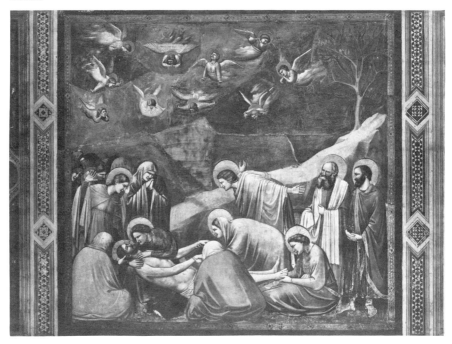

PLATE 90. Follower of Bartolomeo di Fruosino, *Allegory of Love*. Milan, Biblioteca Ambrosiana, MS 1. 69. sup., fol. III^v. PHOTO: MARIO PEROTTI, MILAN.

PLATE 91. Perugino, *The Combat of Chastity and Love*. Louvre, Paris, 1502–1505. PHOTO: MUSÉES NATIONAUX, PARIS.

PLATE 92. Antonio Vivarini, Italian active 1440(?)–1476–80. *The Garden of Love*. Oil on panel 153 cm x 241.3 cm. National Gallery of Victoria, Melbourne. Felton Bequest 1947/48. Reproduced with permission of the NATIONAL GALLERY OF VICTORIA, MELBOURNE.

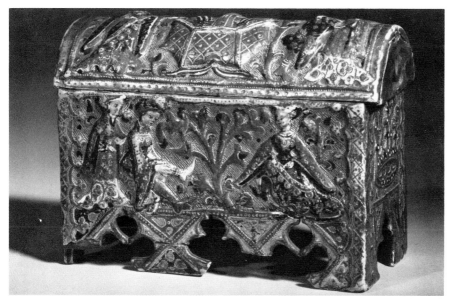

PLATE 93. North Italian, Coffer. Kunstgewerbemuseum, Schloss Charlotten-
burg, Berlin. PHOTO: STAATLICHE MUSEEN PREUSSISCHER KULTURBESITZ,
BERLIN.

PLATE 94. Unknown North Italian, *Garden of Love*. Civiche Raccolte d'Arte
Applicata del Castello Sforzesco, Milan. PHOTO: CASTELLO SFORZESCO.

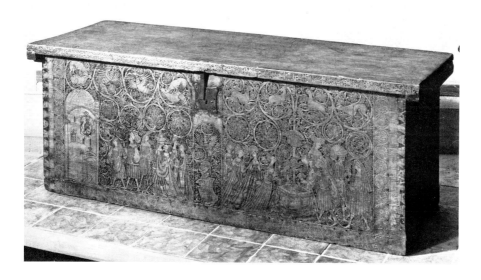

PLATE 95. Unknown North Italian, *Garden of Love*. Kunstgewerbe-Museum, Berlin. PHOTO: STAATLICHE MUSEEN ZU BERLIN.

PLATE 96. Pinturicchio, *Susanna and the Elders*. Appartamento Borgia, Vatican, Rome. PHOTO: ANDERSON, ROME.

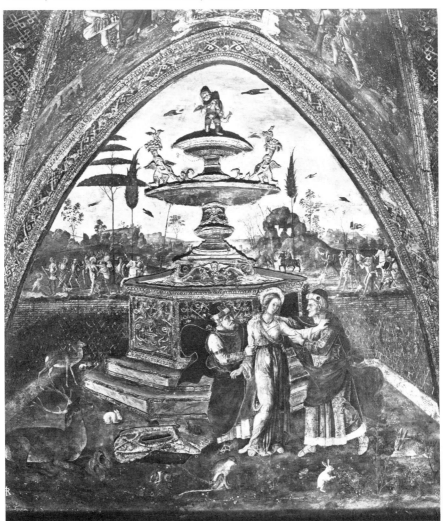

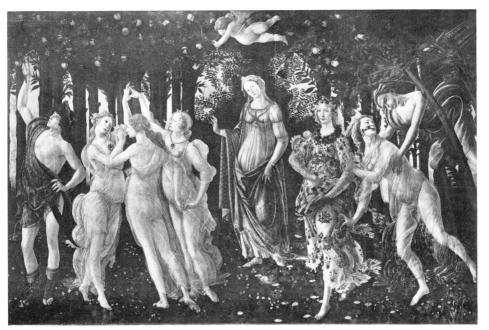

PLATE 97. Sandro Botticelli, *Primavera*. Uffizi, Florence. PHOTO: ALINARI,
FLORENCE.